THE ATHENIANS AND THEIR EMPIRE

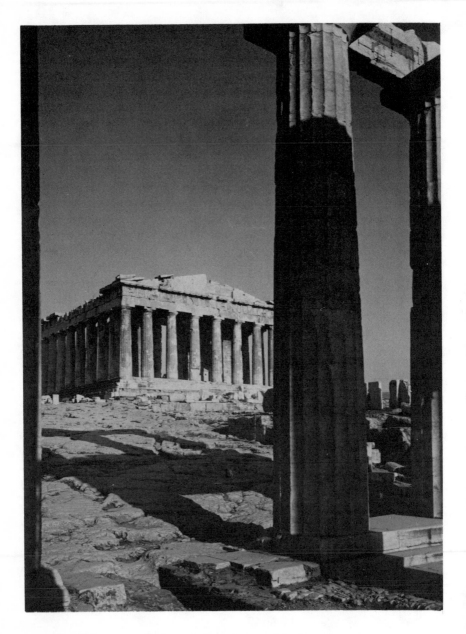

The Parthenon, seen through the columns of the Propylaea.

THE ATHENIANS
AND THEIR EMPIRE

Malcolm F. McGregor

UNIVERSITY OF BRITISH COLUMBIA PRESS
VANCOUVER 1987

THE ATHENIANS AND THEIR EMPIRE

© The University of British Columbia Press 1987

Reprinted 1988

This book has been published with the help of a grant from The Canada Council.

Canadian Catalogue in Publication Data

McGregor, Malcolm Francis, 1910—
 The Athenians and their empire

 Includes index.
 ISBN 0-7748-0269-3 (PBK.)

 1. Greece—History—Athenian supremacy,
479-341 B.C. 2. Athens (Greece)—History.
I. Title.
DF227.M33 1987 938!04 C87-091039-6

International Standard Book Number 0-7748-0269-3 (PBK.)
Printed in Canada

For

MARGUERITE McGREGOR

CONTENTS

Preface *xi*

Glossary *xv*

 I. THE SOURCES 1
 II. HELLENES AND PERSIANS IN ASIA MINOR 8
 III. THE PERSIAN INVASIONS 15
 IV. THE MEETING ON DELOS 30
 V. THE CONFEDERACY IN ACTION 37
 VI. THE FIRST PELOPONNESIAN WAR 50
 VII. THE PEACE OF CALLIAS 65
VIII. THE PANHELLENIC CONFERENCE 70
 IX. A NEW IMPERIALISM 75
 X. FROM ARMISTICE TO PEACE 84
 XI. THE ACME OF EMPIRE 92
 XII. IMPERIAL ADMINISTRATION 106
XIII. GOVERNMENT IN ATHENS 111
XIV. PRELUDE TO WAR 124
 XV. THE GREAT WAR 133
XVI. EMPIRE: A VERDICT 166

Appendices

 1. CHRONOLOGICAL TABLE OF MAJOR EVENTS 179
 2. THUCYDIDES' *PENTEKONTAËTIA* 184
 3. THE ATHENIAN CALENDAR 192
 4. COINAGE 193
 5. THE MEMBERS OF THE EMPIRE 194
 6. THE QUOTA-LISTS 199

Index of Places 205

Index of People 211

MAPS

1. Babylonia and Persia 9
2. The Greek Peninsula and the Western Aegaean 22
3. The Eastern Aegaean and Western Asia Minor 41
4. Attica and its Neighbours 54
5. The Eastern Mediterranean; Inset: Libya and Cyrene 57
6. Sicily and Southern Italy 85
7. Athens and Peiraeus: the Walls 95
8. The Euxine Sea (Black Sea) 103

ILLUSTRATIONS

FRONTISPIECE The Parthenon, seen through the columns of the Propylaea.
PHOTOGRAPH BY THE AUTHOR (A.D. 1934)

1. The copy, inscribed about 280 and found in Troezen in A.D. 1959,
 of the decree voted on motion by Themistocles in 480 as the
 Persians moved towards Athens.
 EPIGRAPHIC MUSEUM 25
2. The *Lapis Primus,* on which were inscribed the annual records of
 the quotas paid to Athena by the tributary states from 453 to 439.
 EPIGRAPHIC MUSEUM 62
3. The epitaph of Myrrhine (about 400), first priestess of the Temple
 of Athena Nike. EPIGRAPHIC MUSEUM 78
4. One of the four surviving fragments of the decree of Cleinias
 voted in 447 to strengthen regulations for the collection of tribute.
 EPIGRAPHIC MUSEUM 80

5. The decree of 426 ordering the appointment of collectors of
 tribute in the cities of the Empire.
 EPIGRAPHIC MUSEUM 143
6. The assessment-decrees of 425 and the list of assessed cities.
 EPIGRAPHIC MUSEUM 144
7. The decrees voted (409 and 406) in honour of Thracian Neapolis.
 EPIGRAPHIC MUSEUM 163

PREFACE

I have long regretted the absence of a book on the Athenian Empire that can be read comfortably by the North American undergraduate, by the many enthusiastic laymen who visit Greece and attend lectures about the ancient Greeks, and by my friends and colleagues whose professional expertise is not the world of the Greeks and Romans. This volume, I hope, will satisfy an obvious need.

In the composition I have certainly not intended to "popularise," in the pejorative sense of that verb. I have, I believe, respected the evidence bequeathed to us by the Greeks themselves. It is incomplete, sometimes tantalizingly so; historians must interpret and conjecture. Debate and controversy have their place in the learned journals. Here I have not engaged in the vigorous and profitable argument that has done so much to enhance and clarify our knowledge of the world of the Hellenes. I have participated in that pleasant strife but in dealing with problems I have in this book followed a Thucydidean principle: I have offered my own judgements, only occasionally adding comment in support.

For reasons that are now apparent these chapters have no Greek and no footnotes. They lack the usual trappings of scholarship, but I shall not, I hope, be deemed immodest when I aver that they are based on many years of critical scholarship. I do, of course, invite the scholar to join my readers.

All who have written on ancient Greece have had to make decisions about spelling and all have discovered that consistency is impossible. With some reluctance I have adopted the English forms that come to us through Latin on the ground that these are more familiar to the Greekless reader; but I have retained the transliterated Greek for the Aegean islands, most of which resist disguise. To a few Greek terms that have become very common to students of Greek History (for example, Demos, Boule) I have, somewhat arbitrarily, granted naturalisation; that is, I have not italicised. I have honoured the (Great) King of Persia by granting a capital initial to his title. The maps are meant to include all places mentioned in the body of the book, but not all members of the Empire, who are registered in Appendix 5. When the initials

A. D. do not precede a date, B. C. should be understood.

I have spent more than half a century in communication with the Athenian Empire. I have learned, with gratitude, from the writing and the spoken words of scores of friends and colleagues and students; I cannot name them all and I cannot identify the source of many of the ideas that I treat as mine. Yet there are those who must not remain anonymous.

Allen West, a gifted polymath at the University of Cincinnati, set me on the road to the Empire and revealed the fascination of Greek History and her handmaiden, Epigraphy. For nearly forty years Geoffrey Woodhead (lately retired from active teaching at Corpus Christi College, Cambridge) and I have corresponded and visited; the Greeks and their history have been a recurring subject of common interest. More, we have three times debated the virtues and faults of the Athenian Empire on public platforms. For over fifty years I have enjoyed a close and fertile collaboration with Benjamin Meritt, a friend whose remarkable and incomparable work has raised Greek Epigraphy to its acknowledged status as an indispensable field of study in historical scholarship.

Philhellenes will return to Greece whenever possible, to appreciate the imperial city and to cruise among the islands once patrolled by Athenian triremes. To the serious student of the Athenian Empire no experience is more rewarding than to work, for long or short periods, in the matchless galleries of the Epigraphic Museum, there to handle and learn from the physical remains, the documents composed by the secretaries and cut by the artisans who were active citizens or resident aliens (metics) in a democracy that administered an Empire. To the hospitable Ephor and Director, Dina Peppa-Delmouzou, and her congenial staff I shall always be conscious of the incalculable debt that I owe. On this occasion I render special gratitude to the Assistant Director, Chara Karapa-Molisani, and to the Museum's skilled photographer, Bas. Stamatopoulou, for the photographs of the inscriptions and of the Mourning Athena.

The zealous interest of my colleagues on the Langara Campus of Vancouver Community College served as an enjoyable stimulus in the writing of this kind of book. I have profited from the constructive comments of my friends C.W.J. Eliot, who read the manuscript, and P.E. Harding, who read both manuscript and proofs. I also register my thanks to the referees appointed by the Press for intelligent and helpful criticisms that certainly led to improvements in what I had written.

I owe an immeasurable debt to A.G. Woodhead, who, throughout the period of composition, subjected the text to his penetrating eye and acute judgement.

I cannot refrain from congratulating myself for having entrusted my book to the University of British Columbia Press. To the understanding and

patience of Jane Fredeman (Managing Editor) I add my appreciation of the technical knowledge so skilfully applied and so generously explained by Ronald McAmmond (Production Manager). A high standard of service is maintained by the staff.

I find it impossible to write appropriately of my partner, my wife, to whom this book is dedicated. To state that Marguerite McGregor prepared the manuscript would be to summarise cruelly the innumerable details of authorship for which she cheerfully assumed responsibility: organising, typing (many drafts), editing, revising, proofreading, directing. Like Pericles, she led. I sometimes have the guilty feeling that her name should be on the title-page, for in so many ways this is OUR book.

Vancouver 1987 Malcolm F. McGregor

GLOSSARY

The descriptions given here, deliberately brief, are meant to facilitate the reading of this book. In general the terms defined and the officials described relate to Athens in the age of Confederacy and Empire, without reference to earlier or later connotations; similarly, when a term has more than one meaning, what is not relevant to this study is ignored. In most cases greater detail will be found in the narrative.

Agoge
> The term applied to the system of training undergone by Spartan youths from about 650.

Agora
> A market-place, in particular the market-place of the Athenians, the centre of civic life.

Amphictyones *(Amphiktyones)*
> *See* Amphictyony.

Amphictyony
> An association of neighbouring communities ("dwellers round about"). The term is especially used of the association based on Delphi, which had evolved into a league of twelve states whose deputies *(Amphiktyones)* met twice a year, at Delphi in the spring and Anthela (near Thermopylae) in the autumn. Originally formed to serve the religious interests of the members, it became political in character.

Aparche (pl. *aparchai*)
> The first-fruits offered to the gods. The term was used of the sixtieth of each *phoros,* which was given to Athena. The quota-lists are the audited records of these *aparchai.*

Arche
> The noun used by the Athenians of their developed Empire.

Archon
> Alone, the noun refers to the eponymous archon, the magistrate who gave his name to the civil year, which began in mid-summer (hence the

double date, e.g., 480/79). Originally he was the chief civilian officer, with wide authority. His colleagues in the fifth century were the archon *basileus* (the king-archon, a title inherited from the regal period), whose duties embraced cult and sacrifice; the *polemarchos* (before 487/6 the commander-in-chief); and the six *thesmothetai* (the junior archons, once lawgivers, keepers of the law). All acquired judicial duties and presided in courts. *See* Chapter XIII.

Archon *basileus*
> *See* Archon.

Archontes (sing. *archon)*
> The italicised forms are restricted to Athenian officers serving in the cities of the Empire. *See* Chapter XII.

Areopagus (Gr. *Areiopagos)*
> The oldest Council in Athens, composed of ex-archons serving for life, in the fifth century stripped of all political powers. Among its functions, it sat as a court for homicide.

Assembly
> *See* Ecclesia.

Arete
> The word defies brief translation; it suggests comprehensive excellence, especially the excellence that one expects of a model citizen.

Athlothetes
> Steward of the Games at the Panathenaic festival.

Autonomia (autonomy)
> The right to live under one's own constitution and laws. *See Eleutheria.*

Boule
> The Council of Five Hundred that prepared business for the Ecclesia (it was thus probouleutic: it planned beforehand). Each of the ten tribes contributed by lot fifty men, each group called a prytany; they held office for one year. Its administrative and executive duties included supervision of magistrates and finances. *See* Chapter XIII.

Bouleutes (pl. *bouleutai)*
> Councillors. *See* Boule.

Cerameicus (Kerameikos)
> The Potters' Quarter, in the area of the Dipylon Gate. Just outside the Gate was the public cemetery where casualties of war were buried.

Cleruch
> *See* Cleruchy.

Cleruchy (*klerouchia)*
> A type of colony favoured by the Athenians in the administration of Empire. Each settler (cleruch, *klerouchos)* received a grant of land (*kleros)* and retained his Athenian citizenship. Thus the cleruchy,

unlike the regular colony, did not become an independent polis. The cleruchies served as garrisons in being. The land was expropriated from the allied states; their assessments for *phoros* were proportionately reduced.

Deme

The demes, local communities (about 140 in number), formed the basis of political organisation in Attica from the time of Cleisthenes. Membership (hereditary) was a fundamental requirement of Athenian citizenship and the affiliation with the deme (demotic) was used as part of a citizen's name.

Demokratia

Government by the citizen-body. *See* Chapter XIII.

Demos

(1) The citizen-body; politically, the adult males sitting in the Ecclesia. (2) The more radical element, the masses (as in modern terminology). In this book the noun conveys the first definition. The critics of the democracy often had the second in mind. In the ancient writers ambiguity sometimes occurs.

Demosion

The public treasury.

Dicast (*dikastes*, pl. *dikastai*)

Juror. *See* Chapter XIII.

*Dikasterion (*pl. *dikasteria*)

Court of law.

*Dikastes (*pl. *dikastai*)

See Dicast.

Dionysia

Of the four Athenian festivals in honour of Dionysus, that of special relevance, called the City Dionysia (the noun is plural), was observed annually in the spring month Elaphebolion. The celebration included productions of tragedy and comedy. Since the *phoros* was due by this date, members of the allied cities were present and were allowed to attend performances.

Dokimasia

The examination of personal record and moral character undergone by candidates elected to office.

Ecclesia (*Ekklesia*)

The Athenian Assembly of adult male citizens, the sovereign body. *See* Chapter XIII.

*Eisagogeis (*sing. *eisagogeus*)

"Introducers," who referred cases to the appropriate courts.

Eisphora
> A special tax on property levied by the Ecclesia only in times of financial urgency. The Athenians did not make use of income-tax in the modern sense.

*Eklogeis (*sing. *eklogeus)*
> Collectors of *phoros* in the cities of the Empire.

Eleutheria
> Freedom or, better, sovereign independence.

Eleven
> The responsibility of the Eleven was to execute sentences imposed in the courts, e.g., the death-penalty.

Eliaia
> The collective name given to the popular courts and the jurors (*eliastai* or *heliastai*); commonly spelled *heliaia*. The name is also applied to a public building used by the courts. *See* Chapter XIII.

Ephor *(ephoros)*
> A Spartan magistrate (literally, "overseer"). Five were elected annually, one of whom was eponymous.

*Episkopos (*pl. *episkopoi)*
> Inspector. *Episkopoi* were appointed to cities of the Empire to protect Athenian interests, especially to supervise the restoration of order after revolt.

Eponymoi
> *See* Archon.

Eponymous archon
> *See* Archon.

*Euergetes (*pl. *euergetai)*
> Benefactor, a title voted to non-Athenians who had deserved well of the polis. *See* Chapter XII.

Euthyna
> The examination of a magistrate's record and accounts at the end of his term of office.

Hegemon
> Leader. *See Hegemonia.*

Hegemonia
> The hegemon exercised *hegemonia*, which involved the assumption of leadership, with all its administrative and executive responsibilities. *See* Chapter IV.

Heliaea (*heliaia*)
> *See Eliaia.*

Hellenotamias (pl. Hellenotamiae, *Hellenotamiai)*
> Treasurer of the Hellenes. The Hellenotamiae, an Athenian board of

ten, stewarded the Confederate and imperial funds, first on Delos and later at Athens.

Helot

The helots, the most subjugated non-slave class in Hellas, approximating to state-owned serfs, tilled Spartan land in Laconia and Messenia. Seven accompanied each Spartan hoplite on campaign.

Hoplite

The heavily-armed infantryman. *See Zeugites.*

Horkotai

Athenian officials who administered the formal oaths of treaties.

Kleros

See Cleruch.

Klerouchia, klerouchos

See Cleruch.

*Kolakretes (*pl. *kolakretai)*

One of a board of ten treasurers.

Liturgy (*leitourgia,* public duty)

(1) The chief recurrent liturgy, the *choregia,* was undertaken by wealthy citizens who paid for the training of the dramatic choruses. A holder became the *choregos* (leader of the chorus). *See* Chapter XIII. (2) For the trierarchy *see* Trierarch and Chapter XIII.

Logistai

The board of thirty auditors.

Metics (*metoikoi*)

The resident aliens, who enjoyed social equality and served in the armed forces but who could not own land or house-property. Most were businessmen or artisans. At law, a metic was represented by a patron.

*Nomothetai (*sing. *nomothetes)*

"Law-givers," a body of ten, concerned with the laws and the courts.

Oikistes

The leader of a colonising venture.

Ostracism

The democratic device whereby in a time of political intensity one of the contestants might be voted into an honourable banishment for ten years. The intention was to forestall *stasis.* The Ecclesia voted annually whether or not to resort to the required procedure (*ostrakophoria*). *See* Chapter XIII.

Ostrakophoria

See Ostracism.

Panathenaea (pl.)

The annual festival in honour of Athena's birthday, observed in the last

few days of Hekatombaion, the first month of the year (mid-summer). Every four years (i.e., 454, 450, etc.) the celebration (the Great Panathenaea) was organised with ostentatious splendour, including musical and athletic competitions. The formal procession that escorted Athena's robe (*peplos*) to the Acropolis is depicted on the Parthenon's frieze.

Pentecontaëtia (*pentekontaëtia*)

The name, which denotes a period of fifty years, given (1) to Thucydides' summary account (*see* Appendix 2) of the growth of Empire between the Persian invasions and the Peloponnesian War; and (2) to the period itself.

Pentekontaëtia

See Pentecontaëtia.

Peraea (*peraia*)

The dependent territory on the continent opposite an island, e.g., Samos, Lesbos (Mytilene), Thasos.

Perioikoi ("dwellers round about")

The non-Spartan and non-helot inhabitants of Laconia and Messenia. They were free but not subject to the Spartan disciplined life.

*Phoros (*pl. *phoroi*)

Literally, "contribution"; commonly translated "tribute," with reference to the cash delivered annually to Athens (from 453) by the assessed cities.

Phrourarchos (phrourarch; pl. *phrourarchoi*)

The commander of a garrison (*phroura*). *See* Chapter XII.

Polemarch (*polemarchos*)

Literally (and in earlier times), "commander in war." He was a member of the board of archons, and his special responsibility was cases dealing with metics and foreigners. *See* Archon.

Poletae *(poletai)*

The board of public auctioneers.

Polis (pl. poleis)

"City-state" is the accepted translation: the independent political unit comprising a central community and its surrounding territory. Topographically, Athens was a polis; politically, the term included the whole of Attica, the area inhabited by Athenians. In documents polis is often used of the Acropolis, the ancient citadel.

Probouleuma (pl. *probouleumata*)

The recommendation drawn up by the Boule for presentation to the Ecclesia. *See* Chapter XIII.

Proboulos (pl. *probouloi*)

In the emergency of 413 the Athenians appointed ten men of experi-

ence as advisers (*probouloi*). Elsewhere, *probouloi* were deputies or agents of a state.

Prokrisis

The preliminary selection (by vote) of candidates for office before the casting of lots.

Proxenia

See Proxenos.

Proxenos (pl. *proxenoi*)

Guest-friend, a title (accompanied by certain privileges) bestowed by the Athenians in the Ecclesia upon a citizen of another state who had proved his friendship and would represent their interests in his own polis. He served much as a consul does today. The grant was called a *proxenia.* The practice was not confined to the Athenians. *See* Chapter XII.

Prytaneum (*prytaneion*)

The "town-hall," residence of the eponymous archon.

Prytanis (pl. prytaneis)

See Prytany.

Prytany

Ten prytanies constituted the Boule, each a tribal group of fifty that, for thirty-six or thirty-seven days in an order determined by lot, initiated business, prepared agenda for the Boule and Ecclesia, provided chairmen, and, in general, served as executive officers. The individual members were prytaneis. *See* Chapter XIII.

Psephisma (pl. *psephismata*)

A decree voted by the Ecclesia, generally (but not always) the decision reached after debate on the *probouleuma* presented by the Boule; hence the preamble: "Resolved by the Boule and the Demos." *See* Chapter XIII.

Satrap

The Greek version of the name for the governor (or viceroy) of a Persian satrapy, province.

Stasis

Civil strife.

Strategia

(1) The office of *strategos.* (2) Collectively, the board of *strategoi. See Strategos.*

Strategos (pl. *strategoi*)

The *strategoi* (usually ten, sometimes eleven in number) were elected annually by direct vote; the collective term is *strategia.* The common translation, "general," is not satisfactory. Although the *strategoi* commanded the forces in the field and at sea, they differed from modern

generals in that many of them became the statesmen who advised and urged the Boule and Ecclesia, in civil affairs as well as military. In this book the Greek noun is transliterated, not translated. *See* Chapter XIII.

Syntaxis

Contribution. The term used in the charter of the Second Athenian Confederacy; a euphemism for *phoros.*

Synteleia

Syntely, "a paying together," a term used of a group of states delivering their *phoroi* together, sometimes under a single name.

Taktes (pl. *taktai*)

Assessor.

Tamias (pl. *tamiai*)

Treasurer.

Thesmothetes (pl. *thesmothetai*)

The *thesmothetai* were the six junior archons, whose duties chiefly concerned the administration of justice. *See* Archon and Chapter XIII.

Thete (Greek *thes,* pl. *thetai*)

The lowest, economically, of the four classes into which Solon divided the Athenians.

Trierarch (Gr. *trierarchos*)

Captain of a trireme. The trierarchy was a naval liturgy. Wealthy citizens were chosen annually, the number varying with the demands of the fleet. The trierarch was responsible for the repair and maintenance of a trireme (warship), which he had the right to captain, for one season.

Trierarchy

See Trierarch.

Trireme

The standard warship of the fifth century, with three banks of oars.

Tyrannos (pl. *tyrannoi*)

The term itself refers to "one who seizes power illegitimately" and implies nothing about the quality of rule. After the eviction of the *tyrannoi* from the Peloponnese and Athens, the word, in the ancient writers, approaches the modern connotation of tyrant (autocrat).

Zeugites (pl. *zeugitai*)

Literally, the possessor of a team of oxen. The *zeugitai*, the middle-class yeomen, were the third of Solon's four census-classes. They served in the forces as hoplites, being able to afford the armour.

THE ATHENIANS AND THEIR EMPIRE

I

THE SOURCES

Critical students of the Athenian Empire will be eager, I hope, to become familiar with the ancient sources of our knowledge. In this chapter I list, briefly, the most important and informative authorities. In each case I refer to readily accessible translations. Two series merit special mention. The Penguin Classics (Harmondsworth, Middlesex) now embody an impressive array of Greek and Roman authors; the same is true of the Loeb Classical Library (Heinemann, London; Harvard University Press, Cambridge, Massachusetts), which offers the Greek or Latin on the left-hand page, the English on the right. In each series the translations are competent and the prices remain moderate.

"Thucydides of Athens composed the history of the war between the Peloponnesians and the Athenians. He described how they fought against one another, beginning at the very outbreak in the expectation that it would be a great war and more worthy of note than all that preceded it, judging that the two combatants entered it at the height of their powers with all their resources available and observing that the other states of Hellas were aligning themselves with one side or the other, some taking action at once while others were at least thinking about it."

Thucydides son of Olorus was born to an aristocratic family about 460 B.C. Like many other members of his class he participated in public affairs. He served as a general (*strategos* is the Athenian term) in 424/3 and, when he failed to reach Amphipolis (an Athenian colony in Thrace) in time to save it from the Spartan Brasidas, he was exiled. For twenty years he lived outside Athens. He was thus enabled to work on his *History*, gathering information

from both sides and constantly revising. He died about 400.

The *History*, in eight books, has reached us unfinished; the narrative breaks off in mid-sentence in 411/0. A contemporary account by an intellectual with a passion for accuracy, it is the indispensable source for the Great War that broke out in 431. To illustrate his thesis that the growth of Athenian power led to the War, Thucydides inserted an Excursus on the events that transpired between the Persian invasions (of 480 and 479) and its outbreak. We call it the Pentecontaëtia (the Fifty Years); it is central to the subject of this book.

In his introductory chapters Thucydides reminds his readers of the difficulties that faced him and sets out the principles to which he has adhered. Because I shall take him at his word, I translate the passage.

"So far as the speeches are concerned that were made on each side either when they were on the point of fighting or when they were already engaged, it was difficult for me, who heard some of them, to remember with complete accuracy the words that were spoken; it was also difficult for those who reported to me from the various other occasions. As, in my judgement, each speaker would most likely have stated what to his mind the particular situation demanded, so have I reported, adhering as closely as possible to the over-all argument of what was actually said. With reference to the incidents that occurred during the war, I considered it defensible to write my narrative not on the basis either of what I learned from the first person I chanced to meet or of my own impressions, but rather after conducting as accurate an investigation as possible in each case both of events at which I was myself present and of those for which I depended on reports from others. My judgements were not reached without toil because the eye-witnesses present on the respective occasions did not produce the same versions of the same actions but spoke according as each one was affected by bias in favour of one side or the other or by failure of memory. It is also possible that the absence of the legendary element in my work will seem less pleasurable to the ear. If, on the other hand, those who wish to examine a clear account of what happened and of what, of a similar and nearly similar nature, is likely, so long as human nature does not change, to recur at some time in the future deem what I have written useful, this will be satisfactory. My history, in a word, has been composed to be a possession for all time, not as a prize-essay to win the immediate favour of the audience."

The translation in the Penguin Classics is by Rex Warner (first printed 1954); in the Loeb Classical Library by C. Forster Smith (4 vols, 1910-1923). Richard Crawley's translation of 1874 retains a place of honour; it has often been reprinted, most recently for the Modern Library, revised and with an introduction by T. E. Wick (New York, 1982). Equally well known is the version by Benjamin Jowett (2 vols, the second containing notes, Oxford,

1881), which has also been revised and reprinted from time to time, e.g., by P. A. Brunt, *Thucydides: The Peloponnesian Wars* (Washington Square Press, New York, 1963), whose abridgement includes an excellent introduction but unaccountably omits the Pentecontaëtia.

A number of fourth-century writers began their *Histories* where Thucydides breaks off; of these, only Xenophon's work, *Hellenica,* survives. Xenophon son of Gryllus, an Athenian aristocrat born about 428, left his native city after the War and was formally exiled in 401. When Cyrus, the younger son of the late Persian King Darius, mounted an army to dispute the succession with his brother Artaxerxes, Xenophon accompanied him up country and won lasting fame when he led the Greek troops (the 10,000) back to the Euxine (the Black Sea) in 401/0; he himself tells the exciting story in his *Anabasis.* For some years, as a gentleman-adventurer, he served the Spartans in Asia Minor and the Peloponnese, becoming an admirer of King Agesilaus. The Spartans gave him a country-estate in Elis, where he could indulge his interests, which included writing. He returned to Athens in 366/5 and died about 354. His impressive bibliography covers an array of subjects, including treatises on the cavalry, the *Memorabilia* of Socrates (whom he had known well), and the finances of Athens. The *Hellenica* (literally, *Hellenic Affairs*), a history in seven books of the Greek states from 411 to 362 (the Spartan defeat at Mantineia), devotes Books I and II to the closing stages of the Peloponnesian War. It is our only contemporary study. The Penguin Classic is the work of Rex Warner, *Xenophon, A History of My Times* (1966); Carleton L. Brownson is responsible for the pertinent volume (*Hellenica I-V,* 1918) in the Loeb Classical Library.

We have one other continuous history of the period that attracts us in this book. Diodorus of Sicily wrote in the first century B.C. in the time of Julius Caesar and Augustus. His world-history (*Bibliotheke, Library,* is the Greek title), in forty books, extended from the earliest times to 54 B.C. Only Books I to V and XI to XX are fully preserved. Book XI begins in 480 and we reach the end of the Great War in XIV. Diodorus had access to many writers whose works are no longer extant and his value fluctuates with his authorities; for the fifth century he depended substantially upon the fourth-century Ephorus of Cyme (in Asia Minor). Diodorus must be read with caution; his historical judgement is often at fault and he lacks chronological understanding. The translation in the Loeb Classical Library is by C. H. Oldfather; of the complete translation volumes IV to VI (1946-1954) cover the relevant books.

Plutarch of Chaeroneia (born before A.D. 50), whose life extended well into the second century, steeped himself in the traditions of the Hellenes and became familiar with and an admirer of Roman institutions; he numbered emperors and other distinguished Romans among his friends. A prolific writer, he has enjoyed a wide reading public for his *Lives,* a series of parallel

biographies of famous Hellenes and Romans. We have twenty-two pairs and four single *Lives*. He was not a historian and he himself distinguishes between biography and history. He might well be termed a polymath: antiquarian, moralist, philosopher. His own library must have been an enviable collection and we profit in the *Lives* from his comprehensive reading. Many fragments of lost earlier writers come from his citations. He was no slavish copier; he possessed the ability to discriminate that Diodorus lacked. Ian Scott-Kilvert's Penguin Classic, *The Rise and Fall of Athens* (1960), serves well for the fifth century (Themistocles, Aristeides, Cimon, Pericles, Nicias, Alcibiades, Lysander). For the complete set of *Lives* the Loeb Classical Library requires eleven volumes, with translations by Bernadotte Perrin; volumes relevant to the Athenian Empire are II to IV (1914-1916). An excellent version is still available in Everyman's Library, which first in 1910 reprinted in three volumes *Plutarch's Lives*, "The Dryden Plutarch" revised by Arthur Hugh Clough (Dent, London and Toronto; Dutton, New York).

For the years that preceded the Persian invasions and for the invasions themselves we turn to the man whom Cicero called "the Father of History." Herodotus of Halicarnassus, born about 485, travelled over much of the world of Hellas, east and west, penetrating as far as Babylon, Egypt, and the Euxine. He spent time in Athens, becoming an admirer of the city and of the Alcmaeonidae, that notable clan to which Pericles belonged through his mother; he participated in the colonisation of Italian Thurii in 444/3. He was a man of remarkable curiosity and remarkable memory. His *History,* in nine books, undertakes to explain why the Hellenes and the barbarians (the Medes and Persians) fought against one another—and to ensure that their wondrous accomplishments should not lack glory. It is, in fact, very close to a universal history. Since Herodotus traces the expansion of Persia into a vast empire, the states of Hellas quite naturally come into the story; and, since he tends to report all that he has seen and heard, he becomes by far our most valuable and copious source of information for archaic Hellas. Aubrey de Sélincourt's Penguin Classic (1954) reproduces something of the casual geniality of the original. A. D. Godley, between 1920 and 1925, published the four volumes of the Loeb Classical Library. The Modern Library adopts (1942) the nineteenth-century translation of George Rawlinson, with minor adjustments by F. R. B. Godolphin.

For an ancient account of the evolution of Athenian government and a description of it as it functioned about 325, we turn to *The Constitution of the Athenians,* a production of the school of Aristotle if not (as I am inclined to believe) from the master's own pen. We are fortunate to possess an almost complete copy of this instructive essay. Written on papyrus about A.D. 100, it turned up in the sands of Egypt rather more than a century ago, to be identified in 1890 by F. G. Kenyon (the Librarian) among a group of rolls

purchased by the British Museum. Previously, only a few random fragments had been known. The translation in the Loeb Classical Library is by H. Rackham (1935, revised in 1952); the Penguin Classic (with useful commentary and illustrations) comes from P. J. Rhodes (1984). From the many other editions in English I cite *Aristotle's Politics and Athenian Constitution,* by John Warrington for Everyman's Library (1959).

Of the dramatic writers Aristophanes (*ca* 455-*ca* 385), the comic poet, demands special mention. His eleven surviving plays extend from the *Acharnians* of 425 to the *Plutus* of 388. The nine produced during the Peloponnesian War are strongly political and teem with pointed references to contemporary institutions and situations as well as to prominent Athenians of all classes. The remarkable freedom allowed on the Athenian stage combines with the acute observations of a concerned and intelligent commentator to make these boisterous comedies a rich source of information with which the historian of Athens and her Empire must be familiar. The Loeb Classical Library has reprinted the rollicking nineteenth-century translation of Benjamin Bickley Rogers (three vols, 1924). The Penguin Classics have so far placed three plays in each of two volumes (1964 and 1973, versions by David Barrett and Alan H. Sommerstein respectively). Other renditions are easily found, among them a series of volumes (one play to a volume) under the heading *The Complete Greek Comedy,* edited by William Arrowsmith (from 1961, translations by Arrowsmith, Douglass Parker, and Richmond Lattimore).

Thucydides' chief ally in conveying to us an understanding of what happened in the fifth century, of the Athenian Empire and its administration, is the epigraphic evidence. The fundamental principle of a Hellenic democracy was that all final decisions affecting the state as a whole were made by the citizen-body sitting as an assembly; in Athens this was called the Ecclesia. Certain of these votes (concerning, for example, alliances, imperial administration, building projects, honorific grants) along with audited financial accounts were inscribed on stone (generally marble) and set up in public, as a rule on the Acropolis. A decree of 449 includes the stipulation that it be erected in front of the mint, "for examination by any man who wishes." Thousands of fragments have survived, the most primary, one might say, of primary sources. The epigraphist-historian essays the reconstruction, and then the restoration, of the original monuments and so the reconstruction of history. Thanks to his labours, we have before us a wealth of information that complements what Thucydides and other writers report.

The best introduction to this field of scholarship, one that will not mystify the layman, is by A. G. Woodhead, *The Study of Greek Inscriptions* (second edition, Cambridge University Press, 1981). Translations of the documents do not abound. In 1971 Naphtali Lewis published a selection: *Greek Histori-*

cal Documents: The Fifth Century B.C. (Hakkert, Toronto). Of a new and promising series, *Translated Documents of Greece and Rome,* edited by E. Badian and Robert K. Sherk, the first volume, by Charles W. Fornara, repays consultation: *Archaic Times to the End of the Peloponnesian War* (Johns Hopkins University Press, Baltimore and London, 1977, 2nd ed., 1983). All Athenian decrees and financial records dating from before 403/2 are now available to the scholar in the recently published third edition of *Inscriptiones Graecae,* I, 1 (Berlin, 1981), edited by David Lewis.

Readers will on occasion find it informative to consult *The Oxford Classical Dictionary,* edited by N. G. L. Hammond and H. H. Scullard (2nd ed., Clarendon, 1970), and *Atlas of the Greek and Roman World,* edited by Nicholas G. L. Hammond (Noyes Press, Park Ridge, New Jersey, 1981), which includes a map (no. 8b) of the Athenian Empire.

For the sake of those whose qualifications allow them to penetrate more deeply into the ancient evidence and the problems that it has bequeathed to us I mention three works that the professional historian must deem indispensable. *The Athenian Tribute Lists,* by Benjamin Dean Meritt, H. T. Wade-Gery, and Malcolm Francis McGregor, was conceived primarily as an effort to place between two covers the epigraphic texts relevant to the Empire, critically edited and in a form immediately usable by historians. Thus, Volume I (Harvard University Press, Cambridge, Massachusetts, 1939) has as its core the quota-lists, the annual record of payments to Athena (from 453) by the allies, and other imperial documents preserved on stone. To these texts are added epigraphic commentary, literary testimonia, a Register of payment and non-payment, a Gazetteer, and various aids to comprehension. Ten years later Volume II (American School of Classical Studies at Athens, Princeton, New Jersey) presented revised and greatly expanded texts and testimonia. The third volume (1950) is devoted to interpretation and problems; Part III, "The Athenian Naval Confederacy," is narrative. Volume IV (1953) contains detailed indices and a comprehensive bibliography, arranged chronologically.

A Historical Commentary on Thucydides, by A. W. Gomme, is majestic in conception and execution. Volume I (Clarendon, 1945), in addition to the commentary on Book I, embraces a number of introductory studies, in particular a notable essay on Plutarch. Gomme died shortly after the publication of Volumes II and III (1956) and the work was brought to completion in two additional volumes (1970, 1981), by A. Andrewes and K. J. Dover, who inherited his notes.

It is a remarkable fact that my subject, which is admittedly central to modern appreciation of the Hellenic achievement, has produced scores of articles in the learned journals but only one comprehensive book, *The Athenian Empire* (Oxford, 1972), by Russell Meiggs. Although its narrative

sections are for the most part intelligible to the layman, this invaluable study was written primarily for the scholar. The twenty-six Endnotes and seventeen Appendices, in which differing views are set out, conscientiously and in detail, identify the problems and controversies bequeathed to us by the incomplete evidence.

The works that have been cited in the last five paragraphs are well supplied with additional bibliography, from which those who wish to pursue their studies of imperial Athens in greater depth may profit. To multiply the bibliographical listings given here would not be in keeping with the aims of the book. Similarly, I have restricted myself to the chief ancient sources (which are readily accessible in English); there are others. We must not forget that what the ancient Hellenes have left for us (in all fields, not merely history in a narrow sense) is fundamental; and I am not ignoring the physical remains, which in the first instance fall within the purview of the archaeologist.

II

HELLENES AND PERSIANS IN ASIA MINOR

A lengthy strip of the coast of Asia Minor, with the off-shore islands, extending from Lesbos and Cyme in the north to Caria and Rhodes in the south, had been occupied by Hellenes since about 1000 B.C., when Aeolians, Ionians, and Dorians from the European homeland moved across the Aegaean. The great age of colonisation (*ca* 750-550) witnessed further expansion, especially to the north and north-east, to embrace the Hellespontine region (the Troad and the Propontis [Sea of Marmara]) as far as Byzantium and Chalcedon, and beyond into the Euxine Sea. By the middle of the sixth century, the tourist could have travelled along the coast from Phaselis in the south all the way into the Euxine and spent scarcely a day off Hellenic soil.

The original twelve Ionian poleis (city-states) held the central section of the Aegaean coast; to the north were the Aeolians, to the south the Dorians had penetrated Caria. The Hellenic writers often used the term "Ionians" of all these Asiatic communities. It is a measure of their prosperity and their intellectual attainments that in the sixth century they produced a series of imaginative thinking men, scholars, who questioned the nature of the universe and the validity of the traditional cosmogonies. The ingrained curiosity of these "Presocratics" was inherited by the later philosophers, of whom Plato is best known.

To the east of Ionia lay the powerful kingdom of Lydia. Croesus ascended the throne about 560 and by mid-century the Hellenic cities of Aeolis and Ionia were paying tribute to him. Servitude to that Hellenized monarch (who enjoyed a close relationship with Apollo's famous oracle at Delphi) appears not to have been oppressive. His realm at its height claimed all the territory

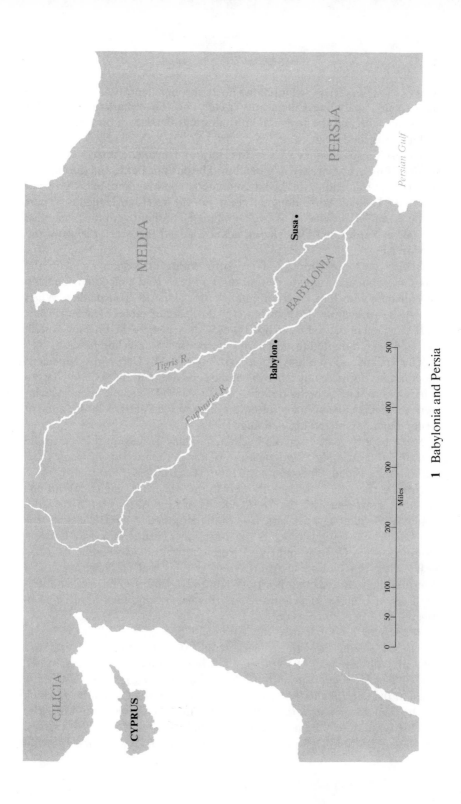

1 Babylonia and Persia

west of the Halys River (which flows north through central Asia Minor into the Euxine), including Cilicia and Lycia. The Halys marked the border between Lydia and the formidable Medes and Persians, now united (549) under Cyrus the Great.

When Croesus advanced across the Halys and invaded Cappadocia to the south (546), Cyrus marched to meet him. The ensuing battle and the capture of Sardes put an end to the Lydian monarchy and kingdom; and Cyrus fell heir to the Hellenic lands along the coast. For the first time, Hellenes, as part of the satrapies (provinces) of Lydia and the Hellespont with the respective capitals at Sardes and Dascyleum, acknowledged the overlordship of the Persian King.

Before we leave Croesus, it is worth noting his connexion with the Spartans, who, according to Herodotus, had been glad to accept friendship and alliance with him. Spartan entanglement abroad is surprising. When Croesus desperately needed help, however, the Spartans, more characteristically, were engaged in their chronic hostilities with Argos; by the time an expedition had been mounted (eagerly, says Herodotus) Sardes had fallen.

The Ionians and Aeolians, about to be absorbed by Cyrus, also appealed; the Spartans dismissed the envoys but did send a ship to the Asiatic coast to warn Cyrus not to harm the Hellenes. Cyrus showed his scorn by asking who were these Lacedaemonians (often a synonym for Spartans in the ancient writers) and completed his campaign.

Some twenty years later the Lacedaemonians again sent a force to the east, this time to fight Polycrates, the tyrant of Samos, during *stasis* (civil strife) on the island. Once again the effort was fruitless.

Nor did the Athenians lack interest in the eastern Aegaean. About 600 B.C. after a struggle with the Mytilenaeans of Lesbos, they had founded a colony at Sigeum on the Asiatic side of the entrance to the Hellespont (the Dardanelles). At some time in the next half-century they lost control. However, when Croesus and Cyrus were confronting each other, or a few years later, the tyrant Peisistratus sent out his son Hegesistratus, who re-established Athenian authority. When the Asiatic Hellenes passed into the Persian Empire, Hegesistratus and his successors must have ruled in Sigeum with Persian consent.

Across the strait extended the Thracian Chersonese (Gallipoli). There, about 560, during Peisistratus' earliest and short-lived effort to establish himself, Miltiades son of Cypselus of Athens settled Athenian colonists, despite persistent opposition from Lampsacus, a Greek polis on the Asiatic coast at the entrance to the Propontis. His base was at Cardia, from which site he built a wall across the neck of the peninsula. At his death Miltiades left his tyranny to Stesagoras son of his half-brother Cimon (nicknamed "Koalemos," stupid), who was succeeded soon after 520, with the approval

of Hippias son of Peisistratus (tyrant of Athens 528 to 510), by his brother Miltiades (the younger, nephew of the founder), Byron's "tyrant of the Chersonese." The result of these colonising ventures was that the Athenians, without Persian opposition, had at least a presence in the region of the Hellespont. The later addition of Lemnos and Imbros (islands of the north Aegaean), for which Miltiades the younger was responsible, brings into greater prominence what was soon to be a vital life-line between Athens and the Euxine as the import of grain became increasingly necessary.

Traditionally, Athens was the mother-city of the Ionians. When Peisistratus, early in his final tyranny (546 to 528), purified Delos, Apollo's island in the central Aegaean and a Pan-Ionian sanctuary, the act must have been recognised as an affirmation of Athens' special status among all Ionian Hellenes.

Darius succeeded to the Persian throne in 522, and it was to him that the tyrants in Asiatic Hellas owed their positions. In 514 (probably) the ambitious Persian crossed the Danube into Scythia, eventually to be driven into ignominious retreat. This was the occasion on which his naval support, Ionian Hellenes, despite the urging of some of their more aggressive leaders, refused to destroy his line of escape, the bridge across the river. The invasion of Scythia was little short of disaster for Darius; yet he enlarged his empire by leaving a Persian force to overrun the northern interiors of the Aegaean and of the Propontis, the ill-defined and sprawling area known as Thrace. The Hellenes in the homeland were now the immediate neighbours of the Persian realm.

While the Persian kings were extending their dominions in Asia and Thrace, the Athenians were living under tyrants ("illegitimate" rulers). After two failures (561-560, 558-556), Peisistratus had finally disposed of opposition in 546 and remained supreme until 528, when he was succeeded by his son Hippias (528-510). The relationship between the Persians and the Peisistratids (the members of the family and the descendants) had not been unfriendly, for, as we have seen, Hegesistratus son of Peisistratus had ruled in Sigeum. Hippias, perhaps having a premonition that his supremacy in Athens was nearing its end, gave his daughter Archedice in marriage to Aeantides son of the tyrant of Lampsacus, Hippoclus, who governed with the blessings of the Persians. Thus he had prepared a safe refuge; and indeed, after his eviction from Athens with his immediate family, he made first for Sigeum and thence for Lampsacus. He owed his safety to the beneficence of the Great King.

Ever since the disappearance of the kings (soon after 700), the ruling power at Athens had rested with the Eupatridae, the "well-born," an aristocratic élite whose status came from the ownership of the best land. Among them, the leading families of the clans (familial groups claiming common ancestors) struggled for primacy. These feuds were all but continuous in the

seventh and sixth centuries; from them in fact emerged the tyranny of Peisistratus and his son (561 to 511/0), after which the quarrelling was resumed. The greatest notoriety is attached to the Alcmaeonidae (the descendants of Alcmaeon [Alkmaion]), a family in a very broad sense, containing many households. From the early days, in every political crisis we find an Alcmaeonid at the centre. As we enter the fifth century and settle into the developed democracy (Cleisthenes, an Alcmaeonid, had constructed the foundations), members of the family retain distinction (for example, Pericles, an Alcmaeonid through his mother). The bitter baronial faction of the sixth century has been replaced by a no less bitter rivalry to win first place as advisers of the Demos, the citizen-body. Throughout these many years, as the political environment kept changing at Athens, the Alcmaeonidae had to contend chiefly with the unrelenting opposition of the Philaidae (the descendants of Philaeus [Philaios]), an equally distinguished and equally ambitious "family"; from it came, for example, Miltiades and Cimon. When the time comes, we shall be unable to ignore these political battles and the manner in which they were fought in the now democratic arena.

The ousting of the Peisistratids, for which the Alcmaeonidae with the aid of the Spartans were ultimately responsible, did not bring political stability to the Athenians. For the moment the oligarchic Isagoras gained the upper hand over Cleisthenes, his Alcmaeonid rival; but so intense was the strife and so threatening were the partisans of Cleisthenes that Isagoras, having been elected archon for 508/7, invited King Cleomenes of Sparta to return to Athens in his support. The Spartans expelled Cleisthenes and seven hundred families from the city. This was too much for the Athenians, who drove Isagoras and the Lacedaemonians from Attica and recalled Cleisthenes along with his banished kinsmen.

The Athenian position was precarious: they had incurred the enmity of the Spartans and further from home the intrigues of Hippias, now a Persian client, with his patrons were ominous. The Athenians therefore sent a delegation to Sardes to seek an alliance with Darius. The satrap Artaphernes, after feigning an insulting ignorance of the Athenians and their homeland, demanded earth and water, the symbols of submission by land and sea, as the price of alliance. The envoys unwisely accepted. Upon their return they fell into deep disgrace and their action was rejected.

Cleomenes was not one to forget a grudge, and the planned three-cornered invasion of Attica two years later (506) by Peloponnesians (who reached Eleusis), Boeotians, and Chalcidians (from the island of Euboea) was certainly his work. Corinthian objections, however, caused the withdrawal of the Peloponnesians, which allowed the Athenians to deal separately, and successfully, with the other two. The outcome was the settling of four thousand Athenians who tilled lots (*kleroi*) on Chalcidian land but retained

Athenian citizenship; this type of colony was called a cleruchy (*klerouchia*). At home the Athenians celebrated their victory. The Spartans nursed their grievance.

In 504 the two threats to Athenian peace of mind coalesced. The Spartans summoned a meeting of their allies, who were by now organised into what modern scholarship calls the Peloponnesian League, and invited Hippias, who was at the time in Sigeum, to attend; the intention was to propose the reinstatement of Hippias in Athens. Once again the Corinthians foiled Spartan plans; Hippias returned to Asia, there to renew his pressure upon Artaphernes to effect the subjection of Athens to himself and Darius.

The Athenians, aware of the treachery of Hippias and conscious of the persistent hazards facing them, dealt directly with Artaphernes in Sardes, urging him to disregard the pleas of the Peisistratidae. The satrap stated bluntly that, if the Athenians wished to be secure, they must accept the return of Hippias. His reply might have been predicted; so might the Athenian refusal of these terms. So far the Athenian policy had been defensive; no irrevocable step had been taken.

In the years after Cleisthenes' recovery of his residence in Athens, he had gradually transformed political life. So far as we know, he occupied no political office; yet he appears to have been given a free hand to put his proposals to the Ecclesia. His achievement must be judged remarkable: he devised a constitution that, in itself democratic, became, with a few adjustments, the fully-developed direct democracy with which we are so familiar in the fifth century (from about 460 B.C.). Sovereign authority rested with the Ecclesia, the assembly of adult male citizens.

So it was that in 499 Aristagoras, the tyrant of Miletus who was plotting a general revolt from Persia, addressed his plea for material support to the democratic assembly. He had failed to convince King Cleomenes in Sparta, whose influence extended far. In Athens, on the other hand, using the emotional argument that the Milesians were colonists of the Athenians, he won the promise of 20 ships, a generous grant in the light of contemporary Athenian naval strength (50 to 70 vessels). "It seems easier," writes Herodotus, "to deceive many men than one man, if we consider that he was unable to deceive Cleomenes the Lacedaemonian, an individual, whereas he accomplished his purpose with thirty thousand." It was a critical and courageous decision by the young democracy after the diplomatic failures of the last decade. "These ships were the beginning of ills for both Hellenes and barbarians": such was the verdict of Herodotus, and it is easy to agree with him.

We shall not trace the details of the Ionian revolt, which came to a disastrous end with the sack of Miletus in 494. Athenian participation, brief though it was, incurred the anger of Darius himself. The Athenians (along

with the crews of 5 Eretrian ships) joined the Ionians in the capture of Sardes; in the ensuing conflagration the temple of Cybele was destroyed (498). After the campaign up-country the Athenians withdrew from the rising. But the unforgivable damage had been done. The enraged Darius ordered a servant to say to him three times, whenever dinner was served, "Master, remember the Athenians."

In some Athenians the sack of Miletus, that most distinguished of the Ionian colonies, stirred deep feeling. When Phrynichus produced a play with a modern theme, *The Burning of Miletus,* his fellow citizens fined him for toying with their emotions.

With the end of the revolt Miltiades the younger, now a fugitive from the Persians, came back to Athens from the Chersonese. The Athenian relationship with the Persians was worse than it had been. In Miltiades the Athenians had an able man with the reputation of his career and the prestige of his family, a man who knew the enemy thoroughly. In the years to come he would be an invaluable asset.

III

THE PERSIAN INVASIONS

The fascinating story of the Persian assaults upon the Hellenic homeland is recounted in all its detail in the gifted prose of Herodotus; moreover, it has attracted the attention of a number of modern writers. Our own subject, however, dictates that we resist temptation, selecting for comment only those circumstances that were to contribute directly to the position in which the Athenians found themselves after the expulsion of the invaders.

With the crushing of the Ionian revolt and the destruction of Miletus, thinking Athenians might well have sensed that a direct clash with the Persians was impending. Among them we can safely identify Themistocles son of Neocles. On his father's side, he sprang from the noble Lycomidae. There was a mystery in ancient times about his mother, who was said to be foreign; the sources, with the exception of Thucydides, are hostile and repeat the probably false allegation that he was of low birth. Cleisthenes and the Alcmaeonidae had appealed for support to the Many; Themistocles, as a popular champion, fostered the impression that he was of them. He made a name for himself in the 490s and in 493 he was elected eponymous archon, still the senior Athenian magistrate.

Thucydides, a perceptive critic who was not inclined to judge a man and an environment by his own knowledge of what actually happened after the event, attributed to Themistocles a remarkable ability to forecast what was likely to occur. It is not rash to keep this assessment in mind as we glance at the archonship of 493, always remembering the now open hostility of the Persians.

As archon, Themistocles, an ambitious patriot, convinced the Athenians

that they must fortify Peiraeus, arguing that prosperity and recognition as a power among the Hellenes lay at sea. He may well have pointed to the chronic feud with the Aeginetans, whose not inconsiderable navy threatened the Attic coast.

About this time Miltiades (of the noble house of the Philaidae) reached home, only to be prosecuted on a trumped-up charge of tyranny by the Alcmaeonidae, traditional rivals of his family. Themistocles, whose political views were far different, nevertheless ranged himself alongside Miltiades, who was acquitted and so at hand in the crisis that was approaching: another example of Themistocles' patriotic foresight? In 490, both Themistocles and Miltiades were elected to the board of *strategoi,* to serve with the polemarch Callimachus, the commander-in-chief.

The Persians had not been inactive. In 492 the King had sent his son-in-law Mardonius, an experienced commander, to restore Persian authority in Thrace and to make a reconnaissance of Greek waters. Although his ships came to grief off the promontory of Athos in a storm, the direct attack was not long delayed. When it did come, two years later (490), a Persian fleet of moderate size, carrying perhaps 25,000 men, crossed the Aegaean and steered up the strait between Attica and Euboea. Eretria, the city that had joined the Athenians a decade earlier in defiance of the Persians, was the obvious immediate target. Athens would be next. This expedition should not be interpreted as a full-scale invasion of European Hellas; rather, it was a punitive venture against the two poleis that had incurred the Great King's wrath. The deposed tyrant, Hippias, now in his eighties and a grimly threatening figure, was to serve as a guide and to be restored at Athens by Datis and Artaphernes, the Persian commanders.

The Athenians responded to the Eretrian cry for help by ordering to the endangered city the four thousand cleruchs who had been planted at Chalcis in 506. Acting upon the advice of the more pessimistic Eretrians, they escaped to the mainland before the Persian assault. The siege lasted into the seventh day and the victorious Persians burned the temples and carried off the inhabitants. A few days later Hippias guided the invaders to Marathon, on the Attic coast. The Athenians hastened northward, 9,000 strong, with a full complement of ten *strategoi* and the polemarch Callimachus; they were joined at Marathon by 1,000 Plataeans. For a few days Persians and Hellenes faced one another. It may be that the Athenians were waiting for expected help from the Spartans. Eventually, the allied Athenians and Plataeans initiated the fighting, "advancing," says Herodotus, "on the run." The battle, thanks to the inspired strategy and tactics of the Athenian command (especially Miltiades), became a rout. In the final stages, the Persian ships were standing off shore picking up survivors, whom the Hellenes were pursuing into the sea.

This was not the time for the Hellenes to savour their victory, for the Persian fleet sailed rapidly down the strait with the intention of falling upon defenceless Athens. The Athenian commanders, however, keeping their wits about them, marched towards the city as rapidly as possible. As the Persians approached the open roadstead off Phalerum, they were made aware of the Athenian presence, their readiness to dispute a landing. The Persians recognised defeat; they turned and began the return voyage to Asia.

If we were to analyse the battle of Marathon coldly in terms of the basic facts, that the numbers of the fighting participants were small, that the Persian objectives were merely the chastisement of two cities and the restoration of Hippias, and that a single defeat put an end to the Persian enterprise, we might easily conclude that the campaign was trivial. It would be a superficial judgement. What we are bound to do is to view the engagement in its context: to examine the impact of the Athenian-Plataean triumph upon the victors and their self-appraisal.

To the Athenians Marathon was a superb achievement. The vast resources of the Persian Empire, extending from the Aegaean to the Indies and the more formidable because little known, had been successfully defied. Herodotus' comment perhaps reflects contemporary opinion: "The Athenians were the first of all the Hellenes whom I know to charge the enemy on the run, they were the first to endure the sight of Median dress and the men wearing it; until this time even the name of the Medes filled the Hellenes who heard it with fear." There was another cause for elation: the victory had been won without the Spartans. We can well appreciate that the reputation of the Athenians had been enhanced throughout the states of Hellas. Among the citizens of Athens we can sense a new spirit of self-confidence, in themselves and in the liberal principles of the constitution recently created by Cleisthenes. The pride engendered by the victory is nowhere more apparent than in the glory that was accorded to those who had fought. The warriors of Marathon, the *Marathonomachai,* enjoyed a prestige that remained a by-word in the generations to come. Even the dead (192, reports Herodotus) received special treatment: in contrast to custom they were buried on the field, where "The mountains look on Marathon—And Marathon looks on the sea." Thus we too can share in the memory, as we stand before the Mound at Marathon, surely a monument to one of the greatest days in Athenian history.

True to their promise, the Spartans did reach Marathon, some days after the crisis. They delivered laconic—and genuine—congratulations and went home. Before the Athenian army left the city for Marathon, a runner, Philippides, had been commissioned to set off for Sparta at top speed to warn of the invasion. Philippides completed his journey (about 150 miles) in the extraordinary time of two days. The Lacedaemonians responded affirmatively but their departure was delayed by religious scruples. In later times

Philippides and his journey were transformed into a more romantic tale, in which "Pheidippides" ran from Marathon to Athens with news of the victory and dropped dead at his destination. On this legend the modern Marathon is based. The race covers 26 miles 385 yards, the alleged distance from Marathon (the modern village) to Athens. In every Olympic year the legend is recounted, in print and over the air-waves. It is drama; but it is not history.

For the next few years life at Athens was not without incident. Miltiades almost immediately incurred disgrace. On the strength of his current popularity and promising rich booty he persuaded the Assembly to approve an expedition against the Cycladic island of Paros. The failure of the enterprise led to his prosecution on the charge of having deceived the Demos. He received no support from Themistocles and was convicted and heavily fined. Shortly afterwards he died of a wound received during the recent campaign, a sad ending for "Freedom's best and bravest friend." His son Cimon paid the fine. The treatment of Miltiades reminds us that even so brilliant a victory as Marathon did not persuade the Demos to forgive a single failure. In our day the unsuccessful general still pays the penalty, regardless of extenuating circumstances.

It would be unwise to believe that the far-sighted Themistocles deemed the Persian problem solved once and for all. Nevertheless, the Athenians had relieved the immediate pressure: it would take time for the Persians to reorganise their resources and alter their strategy. Themistocles could apply himself to the situation inside Athens, where, once again, the family-rivalries rose to the political surface. Nearly twenty years earlier Cleisthenes had invented ostracism, a device that was ostensibly meant, through a vote of the citizens, to protect the polis against a potential tyrant. Each year they decided whether or not to employ ostracism. In the event of an affirmative vote, they cast ballots, incised on sherds, nominating candidates who seemed dangerous. The man who led the poll left Athens for ten years. So far ostracism had not been employed. Now (488/7) the Athenians put the institution into practice; in the following years a number of prominent men were voted into the ten-year absence.

At first sight, the lapse of time between the invention of ostracism and its application seems surprising. Yet it was conceived as a deterrent, and a deterrent is successful if it deters and if the sanctions it entails remain unused. If indeed there were would-be tyrants in Athens (a conditional that I doubt), they did not raise their heads to be recognised. It is very likely, however, that no internal crisis arose that could be settled by an *ostrakophoria;* the only hint of political strife comes from the attack of the Alcmaeonidae upon Miltiades—and the imminent Persian assault (in the 490s), as Themistocles foresaw, required the presence of Athens' most able men. In any case the

Athenians, before their triumph at Marathon, were conscious of their precarious position externally; perhaps, feeling their way, they were slow to use to the full the machinery of their new constitution. From first to last (488/7 to 417/6) the victims of ostracism numbered less than a dozen; an annual *ostrakophoria* was never contemplated, although, to be sure, the Athenians made a conscious decision every year whether or not to scratch the names on the sherds.

In the 480s Themistocles astutely identified the potential of ostracism as a method of getting rid of political opponents. His popularity in these years enabled him, with the help of his followers, to make use of the institution, no doubt parading, at first, the anti-tyrannical intentions of its origin. Aristotle writes that the first Athenian to be ostracized was Hipparchus son of Charmus, a Peisistratid, and that he was followed by friends of the tyrants and by prominent Alcmaeonidae. To believe that a faction favouring tyranny remained in Athens in the 480s is to strain credibility. A resumption of political strife, however, with the ambitious Themistocles at the centre, is easy to accept. Thousands of inscribed *ostraka* have been excavated during the last fifty years in the Agora and the Cerameicus, the majority of them from this very period. Hundreds of them bear the name Themistocles. They testify to the intensive rivalry of the prominent families and to the purpose that the new political weapon came to fulfil. Ostracism was a democratic safety-valve; it was a means of forestalling *stasis,* the civil strife that haunted the Hellenic polis. British countries provide a parallel today: the appeal to the country.

We may reasonably look upon these years after Marathon as the decade of Themistocles. The issues that culminated in ostracisms are sometimes obscure now; but Themistocles had a body of support and one by one his opponents fell. He emerged as the statesman to whom the citizens were most inclined to listen.

An adjustment to the constitution of Cleisthenes reinforced the aspirations of Themistocles. The eponymous archon and his colleagues had been elected by direct ballot; a glance at the list of *eponymoi* reveals many distinguished names. In 487/6 the Athenians voted that henceforth archons would be elected by lot (eligibility was still confined to the top census-classes); at the same time, logically, the *polemarchos* ceased to exercise a military function. Only the board of *strategoi* would be elected by direct vote. An archon could hold office once; a *strategos* was eligible for consecutive re-elections.

These changes had an important and lasting effect on Athenian political life. The eponymous archonship, election to which rested with the Gods, ceased to be the goal of able men anxious to serve the state; it opened no political future. Only the board of *strategoi* offered the opportunity to be

chosen by one's fellow-citizens and then to remain in the public eye. So the *strategoi*, in addition to their duties in the field and at sea, tended to become the statesmen who urged policy in the Assembly and we follow the political vicissitudes of Athenian leaders and statesmen in the composition of the board. A *strategos* who made a name in the field might not become prominent in the Ecclesia, but a political "career" would depend largely on a man's ability to win and to hold a place as *strategos*.

We cannot be sure that Themistocles was behind the constitutional change. Nevertheless, the conjecture is attractive. There is no question that for some ten years Themistocles was the most prominent and persuasive advocate of Athenian policy; he was probably *strategos* in most of these years.

In 483 a rich vein of silver ore came to light in the mines at Maroneia, near Cape Sunium. The first proposal was that the rich yield should be distributed among the citizens, man by man. To Themistocles, the unexpected income must have seemed a gift from the Gods. He saw little hope of persuading his fellow-citizens that, sooner or later, the Persians would renew their offensive. He could, however, make capital of the Aeginetan navy, which had been conducting desultory raids on the Attic coast for some twenty years. A state of war existed with Aegina and the Athenians had lacked the naval strength to take firm measures. So his motion to apply the silver to the construction of war-ships won approval. Work began on a fleet of 200 triremes; thus "the Aeginetan war saved Hellas by forcing the Athenians to become sailors." Herodotus could have been more generous to Themistocles. In the following spring Aristeides son of Lysimachus was ostracized; perhaps, as a conservative believer in the traditional national defence by the middle-class hoplites, the heavy infantry, he had opposed Themistocles' naval policy too zealously. The incidents of this year reinforce our estimates of Themistocles' stature in Athens.

A resumption of the Persian onslaught on European Hellas, already in preparation on a grand scale, was delayed by a revolt in Egypt and the death of Darius (486). His son Xerxes dealt with Egypt; initially, however, he lacked enthusiasm for a· major campaign against Hellas. Eventually, he yielded to the vindictive urgings of Mardonius and the surviving Peisistratidae at court. Once convinced, Xerxes set about mustering a naval and military host such as the world had never seen. By mid-481 the Hellenes in Europe knew that they were the target.

In the late autumn of 481 representatives of the loyal Hellenic states (some had yielded to Persian demands) met at Sparta to deliberate; Xerxes was even now pausing in Sardes.

The Athenians, conscious, thanks to Themistocles' reminders, that they occupied first place among the Persian objectives, had already consulted the

oracle at Delphi. The response dismayed the inquirers, who had the temerity to put their question again. This time the reply offered at least a modicum of hope. "Pallas cannot propitiate Olympian Zeus, though she prays at length with solid guile. . . . Zeus who sees widely grants to Athena that the wooden wall alone shall remain unravaged and shall profit you and your children. . . . Divine Salamis, you shall destroy the children of women when the grain is scattered or harvested."

The enigmatic reference to the wooden wall divided the Athenians, but at length Themistocles' interpretation prevailed: the wooden wall stood for the hulls of the recently-built triremes. Forthwith the Athenians agreed that they should stake all upon their navy; and they backed their resolution by laying down new keels. The Athenians would be ready.

At the conference of the allies the Athenians, in the interests of harmony and despite their naval superiority, handsomely conceded leadership to the Spartans, by sea as well as by land. The defensive strategy was agreed upon after vigorous debate. The defence by land would be made as far north as possible to avoid the loss of Thessaly and to give the fleet the opportunity to win a decisive victory.

In the spring of 480, as Xerxes halted at Abydus on the Hellespont, the allies ordered a force of about 10,000 men to the Vale of Tempe in Thessaly, not far from Mt Olympus, the storied home of the Gods; Themistocles commanded the Athenian contingent. With the realisation that the position could be turned by inland passes, this forward camp was soon abandoned and the Hellenes returned to the Isthmus of Corinth. There, after extended debate, in which Themistocles insisted that their hopes of salvation must be staked primarily upon the navy, the Hellenes decided to attempt a confrontation by sea off Cape Artemisium (the northern tip of Euboea) while a small body of men held the pass at Thermopylae.

The Spartans had persistently argued that the Isthmus, which continued to be the Peloponnesians' base, was the critical site. Thoughtful Athenians must have recognised that the time might come when all Hellas to the north must be abandoned. It was imperative that they be prepared.

We have always known, from tantalizing allusions in Herodotus, that the Athenians voted a decree, moved by Themistocles, in which future strategy was outlined. In 1959 Michael Jameson found in Troezen, in the southeastern Argolid a few miles from the coast, a substantial stele of inscribed marble (broken at the bottom) that turned out to be a copy, slightly edited, of this Decree of Themistocles. It had been set up in Troezen about 280 B.C. in commemoration of the traditional friendly relationship between the Athenians and the Troezenians, who had hospitably received Athenian evacuees in 480. It is a remarkable document, which confirms what we are told of Themistocles' foresight, his eye for detail, and the confidence that he inspired

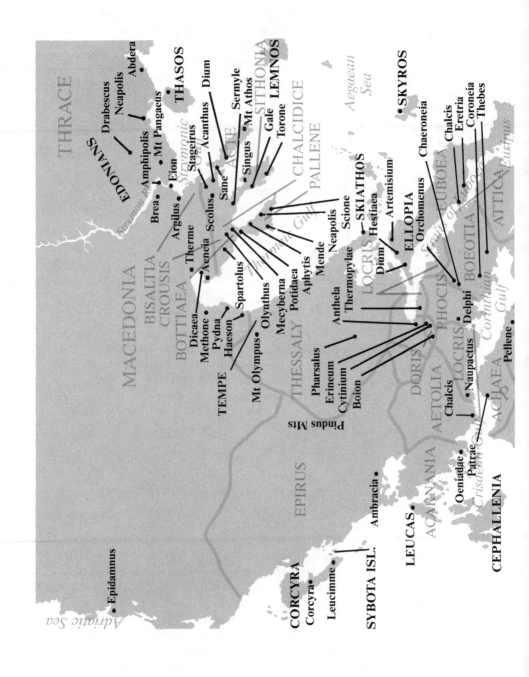

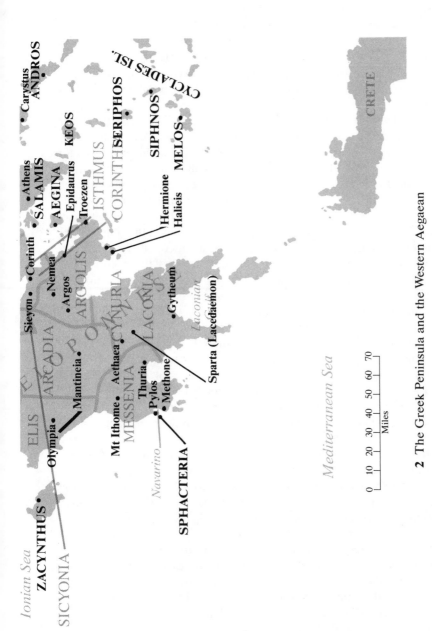

2 The Greek Peninsula and the Western Aegaean

in his fellow-citizens. The stone is broken at the bottom and the surface of the left side has suffered severely, as though it has been attacked by vandals armed with cutting weapons. Nonetheless, the right side and the entire width of the last dozen or so lines have survived almost completely. Thus, despite the damaged area, we are able to produce a continuous text in which only a phrase or two remain in doubt. After the invocation to the gods, the text proceeds:

"Resolved by the Boule [Council] and the Demos, Themistocles son of Neocles of the deme Phrearrhioi made the motion. The Athenians are to entrust the polis to Athena, Guardian of Athens, and to all the other gods for protection and to ward off the barbarian on behalf of the country. All the Athenians and the foreigners who live in Athens are to deposit their children and their women in Troezen. . . . They [the Athenians] are to deposit the elderly and their possessions on Salamis. The treasurers and the priestesses are to remain on the Acropolis protecting the possessions of the gods. All the other adult Athenians and resident aliens are to embark on the 200 ships that have been made ready and resist the barbarian on behalf of the freedom both of themselves and of the other Hellenes in company with the Lacedaemonians and the Corinthians and the Aeginetans and the others who wish to share the danger. Further, the *strategoi,* beginning tomorrow, are to appoint 200 trierarchs [captains], one to each ship, from those who own both land and a house at Athens and who have legitimate children, men who are no older than 50 years, and to assign the ships to them by lot. And they [the *strategoi*] are to enlist 10 marines from those between the ages of 20 and 30 and 4 archers for each ship. They are also to distribute by lot the fighting men [marines and archers] among the ships at the same time as they assign the trierarchs by lot. The *strategoi* are to publish ship by ship the names of the sailors on whitened notice-boards, the Athenians from the demes' registers, the resident aliens from the records deposited with the polemarch. They are to publish their distribution of these men by divisions among the 200 ships, each division to be 100 in number, and they are to record for each division the names of the trireme and the trierarch and the non-rowing fighting men in order that each division may know on which ship it will embark. When all the divisions are distributed and are assigned to the triremes by lot the Council and the *strategoi* are to man all 200 ships, after having conducted a propitiatory sacrifice to Zeus the All-Powerful and to Athena and to Nike and to Poseidon the Securer. When the ships have been manned, with 100 of them they [the Athenians] are to join the defence at Euboic Artemisium and with the other 100 to lie in wait off Salamis and the rest of Attica and protect the land. In order that all Athenians may be of one mind in resisting the barbarian, those who are serving their ten-year ostracisms are to proceed to Salamis and wait there until the Demos make a decision concerning them. . . . "

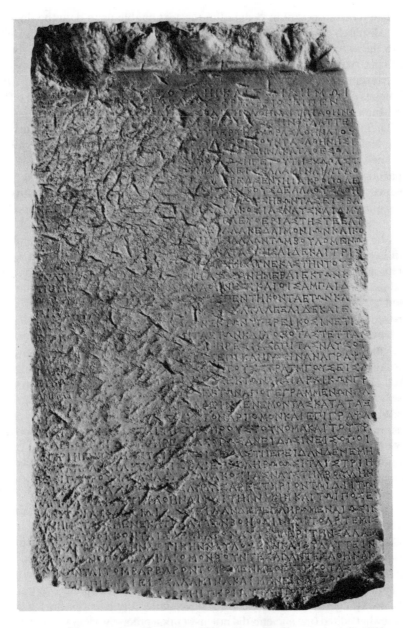

PLATE 1. The copy, inscribed about 280 and found in Troezen in A.D. 1959, of the decree voted on motion by Themistocles in 480 as the Persians moved towards Athens.

EPIGRAPHIC MUSEUM

The naval dispositions ordered in the text enable us to date the decree. The dispatch of a squadron to Artemisium must have been in conformity with the allied strategy to risk battle in that vicinity. The patrol of Salamis and the Attic coast, of course, needs no explanation; it was an obvious precaution at any time. So, as Xerxes entered Pieria in the north, the Hellenes proceeded to their stations at Thermopylae and Artemisium (after mid-summer 480).

Themistocles' wishes were fulfilled: the fleets did fight at Artemisium. The Hellenes were enabled to remain at their post at sea by the gallant defence of Thermopylae conducted by King Leonidas of Sparta, his 300 Spartan hoplites, and a small allied force. Their duty was to hold the pass against the Persian host and thus to give their sailors the opportunity of engaging without the worry that would have been theirs had Boeotia and the south been overrun.

The turning of the pass at Thermopylae, the work of the traitor Ephialtes, left Leonidas in a hopeless position. Nevertheless, dismissing the major part of his army and retaining a handful of men (perhaps 1,000), he adhered to his orders. The Hellenes, inevitably, were overwhelmed; Leonidas and the 300 died almost to a man. In the meantime the engagement off Artemisium proved indecisive. Those who escaped from Thermopylae retreated to the Isthmus; the fleet reached Salamis. The Persians moved by land through Boeotia into Attica and seized Athens. Xerxes and his entourage occupied the Acropolis after massacring the few treasurers and others who, having put their faith in their wooden barricades, had resisted bitterly. The Persian navy anchored in the roadstead at Phalerum.

We should be mistaken in judging the defence of Thermopylae a futile gesture. Hellenes — and Persians too — did not forget the gallantry of Leonidas and his 300; and Thermopylae has remained synonymous with the disciplined Spartan hoplite. The epitaph addressed to the passer-by tells the story: "Stranger, tell the Spartans that here we lie, in obedience to their commands."

Herodotus places the evacuation of Athens after the retreat from Artemisium as the combined fleet concentrated at Salamis; the army remained at the Isthmus. In this and in other details Herodotus and the Decree of Themistocles disagree. As a result, the Decree found at Troezen has been attacked as a later (fourth-century) fabrication. For a decade after the discovery vigorous debate brightened the pages of the journals. Division of opinion continues. My own judgement is that the Gods have smiled upon us: we have a copy, somewhat edited (the ancients did not insist upon precisely accurate quotation), of the decree moved by Themistocles. Disagreements between the document and Herodotus need occasion no discomfort: a decree states what the Athenians *planned* to do, not necessarily what they *did*. Most often, the

difference was negligible. In this case the Decree reveals what was *voted*; Herodotus, what was *done*. In 480 the programme for evacuation was not activated immediately, but the fall of Thermopylae and the retreat from Artemisium necessitated rapid movement; and this perforce entailed some improvisation.

At the council of war assembled on Salamis the consensus leaned towards a retreat to the Isthmus. Once again Themistocles refused to be persuaded: salvation lay in naval combat in narrow waters; the Straits of Salamis offered the ideal environment. Once again Themistocles had his way, although he had to resort to the threat that the Athenians would embark on their ships and seek a new home in the West. Eurybiades, the Spartan commander-in-chief, and other spokesmen realised that they could not afford to lose the Athenian fleet.

Even so, Themistocles initiated a desperate ruse to bring the Hellenes into battle. He sent his slave Sicinnus to Xerxes to profess friendship and to warn him that the allied ships were about to escape by the western mouth of the Salaminian strait. Thereupon the Persians, having sent a detachment to block the western outlet, advanced from the east and landed a body of troops on Psyttaleia, the small island between Salamis and the mainland. For the Hellenes, virtually surrounded, the choice had been made: they emerged from Cynosura, the protective tongue of Salamis, ready for action. Battle was joined.

In the years to come the stubborn valour of the Spartans at Thermopylae lived on in the memory of Western man, all but transforming defeat into victory. It was the battle of Salamis, however, that brought the invasion of 480 to an end. The details of the fighting are reported vividly by Herodotus. From him Byron learned how Xerxes "sate on the rocky brow Which looks o'er sea-born Salamis," glorying in the sheer numbers of his men below. "He counted them at break of day—And when the sun set, where were they?" By the end of the day the Persians were in full retreat; the surviving ships sought Phalerum and the protection of the army.

The Hellenes expected that the Persians would resume the fight. They towed their disabled vessels to Salamis and made their preparation.

Xerxes, however, had seen enough. After a conference with his advisers he issued the orders consequent upon the revised policy. The fleet made for the Hellespont to safeguard the bridges. The Hellenes, now fully confident, pursued as far as Andros before abandoning the chase. Xerxes himself accompanied the army northward. Mardonius, with a force of about 80,000 men, remained in Thessaly for the winter; Xerxes, with the rest, continued his journey to Asia via the Hellespont.

The suspension of battle enforced by the Persian retreat and the approach of winter gave the Hellenes the opportunity to take stock of their accomplish-

ments and their future. Amid the merited self-congratulations the Athenians, whose share in the victory had been major, emerged as an undeniable naval power and Themistocles as the confirmed statesman whose far-sighted naval policy had culminated in the crushing victory at Salamis. He had truly converted the Athenians into men of the seas.

The Hellenes had no illusions: they had won a battle and maintained their freedom; they had not won the war. In the spring of 479 a fleet of 120 ships assembled at Aegina. The Spartan Leotychides commanded; the Athenian squadron was led by Xanthippus (father of Pericles). Here they were visited by a delegation of Chians seeking allied intervention in Asia. The Hellenes, in doubt concerning the situation in the East, proceeded as far as Delos. There they stayed, despite the pleas of the Chians. The Persian fleet, just as loath to move, made Samos its base.

In the meantime Mardonius, his offer of terms having been rejected by the Athenians, marched south. Again Athens was evacuated; again the city was occupied. By now the wall across the Isthmus had been all but completed and the Spartans—or so it seemed to the Athenians—showed some reluctance to put their army into the field. Threats of secession had the desired result and at last Pausanias son of Cleombrotus and regent for the young King Pleistarchus proceeded north to the Isthmus with 5,000 Spartans (each man, as was the custom, attended by seven helots). Thereupon Mardonius burned Athens and moved into Boeotia.

The result of these operations was that the combined Hellenes (including the Athenians who had crossed from Salamis) and the Persians engaged in manoeuvre and counter-manoeuvre in the vicinity of Boeotian Plataea on the Attic border. In the resultant battle the Hellenes' victory was total. The routed Persians fled; few survived to reach the Hellespont. Mardonius himself, who had served Xerxes so well, perished in the fighting.

We return to the fleets. The Hellenes lying at Delos yielded at length to the urging of three Samians and advanced into the waters off Samos. The memory of Salamis lived on and it is a tribute to Hellenic naval prowess that the Persians reached the promontory of Mycale, within sight of the island, and disembarked, having no stomach for battle at sea. At Mycale were fortifications and a Persian army. The Hellenes did not linger: they too landed. So the last battle was ashore and the Persians were put to flight.

The victory at Mycale resulted in the open defection from Persia of many of the Ionian states. The naval captains, having (in deference to Athenian opposition) dismissed the Spartan proposal that the Ionians should be transplanted to Europe, sailed for the Hellespont with the intention of destroying the bridges. Finding that these had already been broken up, Leotychides and the Peloponnesians left for home. Xanthippus and the Athenians, on the other hand, with the non-Dorian allies from Ionia and the

Hellespont who had recently joined the cause, laid siege to Sestus on the European side of the straits. The Persian resistance extended into the winter but the Hellenes did not depart for their respective homes until the town had fallen.

So ended the momentous campaigns of 479 and with them all Persian pretensions to the overlordship of the Hellenes in Europe. For the Hellenes, the past had concerned defence and was over; future policy would look to the offensive.

The Hellenes presented a dedication to Delphi in gratitude for their victory: a tall pillar of bronze (about twenty feet high), fashioned of three intertwined serpents surmounted by a golden tripod. On the lower coils they inscribed a simple heading, "These fought the war," followed by thirty-one ethnics (that is, the names of the peoples rather than the places: "Corinthians," not "Corinth"). The tripod was stolen in the fourth century B.C. and about A.D. 330 the column was moved to Constantinople (formerly Byzantium, now Istanbul) by the Emperor Constantine. Today, minus the heads, which dropped off in 1700 (one survives in a local museum), it still stands there in the Hippodrome. To those who are unaware of its significance, it must seem a miserable waif. To the knowledgeable, however, it rises as a monument to an unprecedented moment in the history of the states of Hellas, a moment when thirty-one poleis fought together for their freedom.

IV

THE MEETING ON DELOS

When the Persians withdrew the Athenians returned to their devastated city and began the work of reconstruction. The surrounding walls, which had suffered grievously, cried for immediate attention. The Spartans, however, made uneasy by the Athenians' proved sea-power and enterprise, proposed that the Hellenes on the mainland dispense with walls. Their intentions were foiled by Themistocles, who, sent to Sparta to negotiate and taking advantage of the respect in which he was held there, repeatedly postponed conference and thus gave the Athenians the necessary time to raise their walls to a defensible height. Spartans accepted the *fait accompli* with good grace in public, resentment in private.

Excavation in the area of the Cerameicus has uncovered a section of the wall into which had been built architectural elements and sculpted statue-bases; the construction illustrates the urgency with which the population went to work, exactly as Thucydides describes it.

At the same time Themistocles prevailed upon the Athenians to bring to completion the ring of fortifications about Peiraeus, where the three natural harbours created, he thought, a splendid base for the ambitions of a seafaring people. "For indeed he was the first with the courage to declare that they must cleave to the sea, and in so doing he became a co-founder of the Empire." So writes Thucydides.

The defence of the Greek homeland had been accomplished with decisive success, but there remained Persians in Hellenic territory, on the Thracian coast of the Aegaean, in the Chersonese, here and there along the coasts of Asia Minor, and in Cyprus, where the Phoenicians had for centuries lived

alongside Hellenes. For the eastern Hellenes, then, especially those who had followed the Athenians to Sestus after the battle of Mycale, the war was not yet over. There was, however, a difference: now they must take the offensive. So in the spring of 478 Pausanias was appointed commander-in-chief by the Spartans to lead 20 ships from the Peloponnese, 30 from Athens, and a substantial number from the allies.

The flotilla penetrated as far as Cyprus, where they subdued the greater part of the island, sweeping the Phoenician navy from the seas and fighting successfully by land. They did not leave garrisons and, although the residing Hellenes may have enjoyed temporary independence, they were never permanently freed from Persian rule. From Cyprus they sailed to Byzantium, took the city, and crushed the occupying Persians. On the voyage, no doubt, they also liberated communities along the coast of Asia Minor.

In Byzantium the allies began to evince their dissatisfaction with the conduct of Pausanias. Away from the archaic restraints of Spartan life and the direct oversight of the ephors, he yielded to the extravagant allurements of the outside world. It was not merely his self-indulgence upon which the Hellenes frowned. He had had the opportunity to observe the Persian style, which appealed to him. He took on the airs of a Persian monarch and treated his allies as slaves. This they would not endure: having fought for their freedom from a Persian king, they had no intention of accepting a Spartan autocrat in his place. Predictably, they turned to the Athenians, who, as the Ionian ringleaders reminded them, were their kinsmen. At the same time they laid charges with the Spartans against Pausanias, accusing him of personal misconduct and, the most serious contemporary crime, medism, that is, trafficking with the Medes (Hellenes made no distinction between Medes and Persians). The result was his recall. In the ensuing investigation he was found guilty of misconduct in his personal relationships with the allies, but of the major charge, medism, he was acquitted; Thucydides expresses the view that the evidence pointed to his guilt.

Inspired by their hatred of Pausanias, the allies in Byzantium aligned themselves with the Athenians, who showed no reluctance to accept a status that promised benefits to them as well as to the Hellenic cause. When the Spartans, to replace Pausanias, sent out Dorcis and other officers with a small force, the allies refused to accept them. They returned home and the Spartans made no further move, then or in the future. The fate of Pausanias had taught them a lesson and they would not again run the risk of exposing good Spartans to the deteriorating influences that they would meet abroad. "Besides," writes Thucydides, "they wanted to be rid of the war against the Mede and they considered that the Athenians were competent to lead and at the present moment sympathetic to them." The first clause of this sentence undoubtedly expresses the true reason for the Spartan withdrawal. Their

foreign policy had been, and continued to be, based upon the maintenance of stability in the Peloponnese that would guarantee security at home against the ever-present menace of the helots. Although some of this subjected class dwelt in Laconia, the majority lived in Messenia (the rich territory west of Laconia), where they tilled the land of their Spartiate masters, whom they outnumbered by a wide margin. For the Spartans, that meant the shunning of adventures overseas. The implication of Thucydides' words ("they considered"), perhaps, is that the Spartans "persuaded themselves" of Athenian good-will and their competence to lead the naval arm of the union that had driven the Persians from European Hellas. The Spartans suppressed the memory of their recent rebuff at the hands of Themistocles and the Athenians. An apposite comment comes to mind in the words put into the mouth of the Athenian speaker before Melos in 416 by Thucydides: "Of the Hellenes whom we know the Lacedaemonians are most notorious for deeming what is pleasant honourable, what is profitable to them just." In 478/7 the Dorian states took Sparta as the model and retired from operations.

In this manner the Athenians inherited the leadership (*hegemonia*, English 'hegemony') of "the Hellenes." The senior Athenian commander this season was Aristeides son of Lysimachus, who was accompanied by the young Cimon son of Miltiades, perhaps not yet an elected *strategos*. Aristeides, whose reputation for fair dealing had already won him the description "The Just," made himself accessible and the allies were comfortable in their approach to him, especially since the Athenian record so far had revealed initiative on their behalf and understanding of their feelings. Cimon, who was later to endear himself to the allies in his own right, supported the popular Aristeides. This unanimity in the command strengthened the credibility of the Athenians.

Such was the atmosphere of trust when the allied delegates, endowed by their states with authority to act, gathered by common consent at the end of the season on Delos, Apollo's island in the central Aegaean where the annual Panionian festival was celebrated. Invitations had no doubt been widely distributed. Aristeides, again by common consent, presided over the deliberations. The agenda are easily summarised: what of the future?

The delegates agreed that the immediate priority must be assigned to the war against the Persians. There remained forts and territories on the Aegaean littoral dominated by Persian garrisons and guerrillas. It went without saying — and Thucydides does not write it specifically — that a major aim was to liberate the Hellenes of Asia Minor from Persian rule. Furthermore, the allies intended, as indeed they proclaimed (and Thucydides reports), to take vengeance on the King for their sufferings at his hands by ravaging his land. They recognised that the vigorous campaigning that they envisaged would require ships, crews to man them, and money. They could not count on

booty proving sufficient to underwrite their operations; and not all pos-
sessed ships of war. The fair method of assembling the requisite resources
was by an assessment of the membership for contributions in proportion to
their means. This responsibility, naturally enough, was entrusted to the
hegemon, the Athenians; they, also naturally, appointed Aristeides, who
thus became the first assessor (*taktes*). Since, if all went well, the contribu-
tions in money would accumulate, the allies set up their treasury at the
Delian sanctuary of Apollo, which was to be the site of their meetings,
synodoi (synods). They acquiesced in the creation of a new board, the
Hellenotamiae. The name, treasurers of the Hellenes, recognises that they
were to serve the allies, not the Athenians alone, although, sensibly, the ten
men were to be appointed annually at Athens and in time became an
Athenian magistracy. The Hellenotamiae, as stewards of the funds (the
phoroi, contributions in cash), would perform their duties on Delos.

So far the delegates had been organising short-term policy and strategy.
For the Persians would not be pursued endlessly and the day would come
when the need for ships and men, and therefore money, would cease to exist.
Now this (478/7) was a moment of spectacular elation. United Hellenes had
driven out the myriads of the Great King, whose vast realm extended into
the unknown east, from the homeland. They had done more: they had
pursued him into Asia, evicted his garrisons, and freed his Greek subjects;
and they were even now laying plans to complete the liberation of Hellenic
Asia and harass him in his own waters. These achievements they owed to
sea-power and, in very large part, to a unity of purpose and action that
Hellenes had never before visualised, let alone practised. All this was upper-
most in the minds of the Hellenes as they conferred on Delos. They could
scarcely avoid asking themselves the question: what could a similar and
permanent collaboration achieve in the years ahead?

These were the thoughts that guided them to the crucial decision, the
formation of a wholly new Confederacy, independent of "the Hellenes," the
union that had fought under Sparta and that remained in being, at least in
theory. Their aspirations are unmistakably reflected in the oath, the equiva-
lent of the modern signature, that was administered by Aristeides. They
swore: "We shall have the same enemies and the same friends"; and as
guarantee of good faith they flung lumps of molten metal into the sea. In
diplomatic terms, this offensive and defensive alliance would last until the
iron ingots floated, that is, for ever. Canadians may be reminded of the
nineteenth-century treaties signed by their government with the Indian
peoples, to last "for as long as the sun shines and river flows."

Taken literally, the oaths prescribed that even peace with the Persians
would not void what they had sworn. Whether the Hellenes actually imag-
ined a time when such a peace would prevail is a question that forbids a

dogmatic answer. From the time of Cyrus the Great Hellenes and Persians had been, if not actually engaged in war, never far from it; the future (which they did not know) held another generation of hostilities. Secure peace was an unfamiliar context for their lives. So it was easy to swear loyalty "for ever," without giving much thought to a world safe from the Persian threat. Nevertheless, there were surely those whose visions penetrated beyond the immediate war.

Sceptics may smile in derision: alliances and treaties do not last for ever, especially when so many signatories pledge their faith. True; but, again, we must place ourselves on Delos in that winter of rejoicing and congratulation. And we must allow men their hopes, their dreams, their ideals; reality would come soon enough. Logically, the oath banned warfare among members of the alliance; and it banned unilateral secession. In sum, a general peace among the Hellenes was deemed attainable. It has been remarked that "A Greek nation was being formed, permanent, as nations believe themselves to be." The sentiment, I suspect, is un-Hellenic; but it catches the mood.

The Confederacy of Delos (the name is modern) was an innovation. The Spartans were not involved and entered no overt objection to the replacement of the naval arm of "the Hellenes," the alliance that they had led to victory. The members were to be autonomous; but foreign policy and strategy would be formulated in the common synods that would meet on Delos. "Autonomous" is the adjective employed by Thucydides, and it is the right word: they were to live under their own constitutions and their own judicial systems. In contrast, since warfare within the Confederacy and secession are implicitly forbidden by the terms of the agreement, sovereignty is perforce infringed. The Greek word is *eleutheria,* which is commonly translated as "freedom"; I have called it "sovereignty." To put the situation in attractive terms, the allies believed that their glimpse of the future justified some sacrifice of absolute freedom of action, which indeed they lacked from the very beginning; this restriction they accepted. The power to make decisions about foreign policy belonged to the Confederacy as a whole, assembled in the synod, not to the individual components.

Among these willing and autonomous allies the Athenians had been granted *hegemonia.* We must be sure that we understand what this status entailed. The Athenians would preside at the synods, they would conduct the prescribed assessments, they would, as we shall see, detail which cities would contribute ships and men and which cash, they would annually dispatch the Hellenotamiae to Delos, they would provide commanders (*strategoi*) to lead the expeditions, and these commanders would inevitably occupy dominating positions in the framing of strategy and tactics in the field; the allies would follow. Thus the Athenians' hegemony postulated administrative and executive power. But the Athenians were, at the outset,

not masters: policy and broad strategy were adopted in the synod. *De iure,* as subscribers to the oath, the Athenians were equal, with one vote; *de facto,* they were bound to be superior, because the allies had made them so; nor were they reticent. We hear of no further debates on policy in the synod nor do we know how often it convened or when it ceased to meet. Ultimately, the Athenians who served the Confederacy as commanders or magistrates (for example, Hellenotamiae) were responsible to the Athenian Ecclesia, which therefore could exercise unique influence and even power among the membership.

Aristeides, the assessor, first drew up a list of members, who by the following spring numbered about 140; these are entitled to be ranked as charter-members. They came in roughly even numbers from what were later to be the five geographic panels in which the Athenians drew up the roster: Ionia (including Aeolis), the Hellespont, the Ionian islands of the Cyclades, Caria, Thrace. The extremities were Aeneia on the Thermaic Gulf (near modern Thessaloniki) in the north-west, Byzantium at the entrance to the Euxine Sea, Cycladic Siphnos in the south-west, and Rhodes in the south-east. Not all had been represented at the synod of organisation; there were adherents during the winter and it was easy to add these to the roster. Plutarch tells us that Aristeides was authorised to inspect the allies' lands and revenues and to assess according to each one's resources and ability to pay. He was undoubtedly spared the necessity of visiting every city. He had his own considerable knowledge and he could confer on Delos with co-operative delegates who had been given power to act by their governments. One other source of reliable information lay ready to hand. The Persian Artaphernes, writes Herodotus, extracted from the Ionians in 493 after the Ionian revolt their promise to keep the peace. Then "he surveyed their lands by parasangs (the name applied to 30 stades by the Persians) and on this basis he assessed tributes (*phoroi*) on each of them; these tributes continue to hold valid on their old scale, just as they were assessed by Artaphernes, from this time right down to my own day." Aristeides very sensibly took advantage of a familiar system that had obviously not been oppressive and adopted the same scale. Herodotus, of course, is not telling us that the Ionians continued to pay tribute to the Persians; he is observing merely that there was no change in the *scale* of the assessment. His judgement is confirmed as a general truth by the extant records of payment (the quota-lists) in Athens from 453 to the beginning of the Great Peloponnesian War (431). Later, "the assessment of Aristeides" became a by-word among the Hellenes as a model of equity. Herodotus knew of Artaphernes' assessment of Ionia; we may take it for granted that a similar system was employed by the Persians in other Hellenic areas subject to them.

Aristeides had made his assessment in cash, the common denominator:

not all had ships, all had cash. The figure totalled approximately 460 talents. It remained to detail which of the cities would provide ships and crews, which (because they lacked warships) the sums entered against their names. For purposes of assessment a ship might be reckoned in terms of an equivalent in cash. He had his own knowledge and the goodwill of the allies; in the first year there would be few defaulters. The allies had furnished a substantial squadron to Pausanias' fleet in the spring of 478. Scholars are far from unanimity regarding the proportions: my estimate, however, is that about 230 of the assessed 460 talents were delivered in cash and that ships accounted for the rest. As the Confederacy evolved into Empire and the naval allies all but disappeared, the noun *phoros* came to mean "tribute" in cash; this is certainly the usage in Thucydides and the other authors. Etymologically, however, the word is neutral in its connotation, "contribution." In the early years, when the naval allies were numerous, it is not inaccurate to apply *phoroi* to both ships and cash.

It is unlikely that the delegates agreed on targets in specific terms, either for the near or the distant future, or that they computed the precise size of the fleet that they would need. The individual assessments on Aristeides' working roster happened to total 460 talents; only about 230 were realised in cash. With the ships made available the commanders would map the immediate campaign. How many reported we cannot say; Thucydides does not give a figure until the year 460, when a squadron of 200 Athenian and allied vessels were engaged off Cyprus. By this time the activities of the Confederates had become more systematic and resources were comfortably dependable; in 478/7 much remained hazy and unplanned.

What we *know* of this well-attended conference on Delos comes from a paragraph of Thucydides supplemented by a sentence or two of Aristotle. That we can partially reconstruct the procedures and decisions we owe chiefly to Thucydides, who wastes no words. But much remains unknown and for knowledge we substitute conjecture. Probably the agreements and practices that I have described here were embodied in a written charter (perhaps engraved on stone). The assessment of Aristeides was certainly a written document; since it was meant to be used for reference it is conceivable that it too was engraved. Contributions in cash, we can assume with confidence, were recorded as they came in, a necessary procedure that was adopted annually. When the accumulated funds were transferred to Athens, in 454/3, the Athenians very quickly devised a rational system to deal comprehensively with assessments and collections. Unfortunately, the evidence is lacking that would allow us to remark that they looked to Delos for precedent.

By the spring of 477 the Hellenes of what we call the Confederacy of Delos were ready. The levied ships assembled and Cimon (as an Athenian *strategos*) led the first combined fleet into action.

V

THE CONFEDERACY IN ACTION

Thucydides, in his examination of the incidents that led to the outbreak of the Great Peloponnesian War (431), emphasises that in his opinion the fundamental cause was the growing power of the Athenians, which forced the Spartans into hostilities. Manifestly, he feels obliged to justify this assertion. This is why he at once turns to the situation of "the Hellenes" after the battle of Mycale (479), here beginning his survey of the period between the Persian invasions and the Peloponnesian War that we call the Pentecontaëtia, "the fifty years." He completes the campaign of 479, he passes to the rebuilding of the fortifications of Athens, and he explains how the conduct of Pausanias in 478 resulted in the withdrawal of the Peloponnesians and the organisation of the Confederacy of Delos. Here, before he confronts the campaigns that eventually brought the Athenians to their domination of the Aegaean, he pauses to express his dissatisfaction with the work of his predecessors: they have omitted the period between the invasions and the Great War, writing either of the events that preceded the invasions or of the invasions themselves; Hellanicus, it is true, touched on the intervening years in his study of Attica, but his account is brief and chronologically inaccurate. To remedy the deficiency, Thucydides has composed what he calls his Excursus.

The principal theme of the Excursus is the growth of Athenian power. It is frequently criticised for its brevity and its omissions. Two pleas may be offered in defence. First, the brevity is deliberate: Thucydides' subject is the Peloponnesian War and he looks on the Excursus as a clarifying preface for his readers; clarifying because it is linked to his view of the "truest" cause of

the War. Second, there is no doubt that, thanks to the passage of the centuries, our historical perspective is sharper than his: our judgement of what is vital to the story is different. We quickly become aware of a further problem. He has not applied to his Excursus the clear chronological system that he adopts for his central subject, the Peloponnesian War. His belief in his chronological superiority to his contemporary, Hellanicus, rests upon his adherence to the precise order of events as they occurred.

The Excursus remains our basic source. To it we add the information supplied by the inscriptions, by Diodorus (who makes errors and adds little to Thucydides), and by Plutarch's *Lives* of Aristeides, Themistocles, Cimon, and Pericles. Other ancient writers contribute incidentally.

The pressing ambition of the Confederates in the spring of 477 was to expel the Persian remnants from Greek lands. They began their programme with an operation that was more domestic than foreign. Pausanias, after his acquittal at Sparta, had set out, in a single ship and unauthorised, for Byzantium. There, supported by a group of friends, a number of whom were Persian, he ensconced himself and resumed (or instigated, if we accept his recent acquittal as a true verdict) his treasonous communication with the King. The Confederates took his quarters by storm and evicted him. They then sailed towards the Aegaean, on their way stopping at Sestus, on the European side of the Hellespont, to repeat its capture. It had been occupied by a party of marauding Persians, stragglers operating perhaps from Thracian Doriscus, still in Persian hands, and certainly with the approval of the satrap stationed at Dascyleum in the interior. Although the military and naval action at Byzantium and Sestus was minor, the Confederates acquired a substantial amount of booty and took a number of prisoners. Of the division of the spoils Plutarch tells an amusing story. Cimon gave his allies the choice: the rich spoils or the prisoners. They took the first, "the bird in hand"; Cimon was left with the prisoners. Subsequently, they were all ransomed for large sums, sufficient for four months' sustenance for Cimon's own fleet with an appreciable balance in gold for Athens. Thus did the proceeds defray, at least in part, the naval expenses.

In the second half of the summer (477) the Confederates arrived at their first major objective, Eion at the mouth of the River Strymon, a powerful fortress defended by a Persian garrison provisioned in part by Thracians from the upper waters of the river. The Persians, defeated in battle, retired to their base and the Confederates set up their lines of siege. Boges, the Persian commander, along with his men lacked nothing in courage. The protracted siege lasted through the winter and it was not until the following mid-summer (476) that starvation brought the end. Boges set fire to the place and committed suicide. The Confederates enslaved the survivors, presumably Persians and their sympathisers.

The siege of Eion did not require the continuous presence of the entire Confederate fleet. Even as the besiegers sat before the walls, perhaps in 476, a squadron assailed Skyros, an Aegaean island situated east of Euboea and populated by Dolopians. These Dolopians, who had come from an isolated tribe in the vicinity of Mount Pindus in Thessaly, had been conducting themselves as pirates, inflicting serious damage upon shipping. The victors enslaved the inhabitants, and the island was then colonised by the Athenians. The Confederates' treatment of Skyros may justly be regarded as a policing action. We may append an Athenian footnote. According to tradition, the Athenian hero Theseus had been buried on the island and some years before the colonisation the Athenians had received an oracle instructing them to recover his bones. Cimon discovered the alleged grave and brought home the remains, thus winning great renown.

The next Confederate offensive of which we hear was directed against Carystus, a town at the southern end of Euboea. The Carystians were suspected of medism, although their record merits sympathy. In 490 the Persians on their way to Eretria had demanded troops and hostages. The Carystians refused initially but Persian force brought capitulation. After the battle of Salamis Themistocles exacted a large sum from them. Nevertheless, the Greek fleet not long afterwards overran their territory. It is true that, about 473, the Carystians alone of the Euboeans remained independent of the Confederacy. Refusal to join brought a war, in which the other Euboeans did not participate, and the Carystians came to terms. They were enrolled in the Confederacy and were assessed an annual contribution in cash.

Thucydides passes from the enforced recruitment of the Carystians to a dispute within the Confederacy that we can date with some confidence to 470. Wearied by almost a decade of campaigning and having convinced themselves that the menace of Persia had been eradicated, the Naxians announced their withdrawal. Unilateral secession breached the Confederate oath and would create a destructive precedent. When the Naxians persisted, the Confederates quelled the revolt, but only after a siege. Thucydides' terse comment invites interpretation: "This was the first Confederate polis to be subjugated in a manner contrary to the accepted practice." I take "the accepted practice" to mean the original agreement of the Confederates that all members would be autonomous. The Naxians were certainly deprived of their ships and were henceforth assessed in cash (compare the fate of Thasos, to which we shall come). This change in itself does not justify Thucydides' strong language, for it did not breach autonomy. The installation of a garrison as an assurance of good behaviour, however, did. This was a measure that we know was applied later by the Athenians after revolt. We are not rash, then, in believing that Naxos was the first to be so disciplined: this was indeed "subjugation." In these early years the synods were meeting

and, probably, the Athenians were not solely responsible for the sentencing of the Naxians.

Later in this chapter we shall inspect the declining fortunes of Themistocles, who was sentenced to exile in 471. The siege of Naxos is connected, quite incidentally, with his flight to Asia Minor. The merchantman on which he was travelling was driven into the vicinity of Naxos and he narrowly escaped capture by the blockading fleet.

In a single chapter Thucydides has recorded first examples of types of Confederate activity. Eion was the first Persian fortress to be recovered. There were others; for example, Doriscus on the north Aegaean coast, where for many years the defence was conducted by the courageous Persian Mascames. It is likely that Persian holdings on this coast and elsewhere were the chief objects of attack in the 470s. Skyros was the first non-Persian centre to incur attention and the venture may have been part of a widespread suppression of piracy. Carystus was the first Hellenic city to be brought into the Confederacy by force; there were others. Naxos was the first member of the Confederacy to attempt withdrawal and to be reminded firmly of the oath. She was not the last, as Thucydides himself notes, even though he later names only one, Thasos, before the signing of peace with Persia.

The campaign of 469 is of the utmost significance to us as we follow the fortunes of the Confederates, because we find Cimon with the fleet at the mouth of the river Eurymedon in Pamphylia. The mere presence of the Confederates in Persian waters so far from the Aegaean reveals the extent of their successes in the 470s. It allows us to compensate for Thucydides' terse and selective narrative. Apart from a few stragglers, the Aegaean was now cleared of Persians. Whatever garrisons had persisted on the Thracian coast and in Asia Minor were no more. The Confederates were now seeking out the enemy in his territory. On Delos they had proclaimed their intention— their primary intention: "to take vengeance on the King by ravaging his land." They had indeed fulfilled their promise, and they were continuing to fulfil it. Despite other operations, the major preoccupation had never ceased to be the Persians.

On their journey eastwards the Confederates put in to Phaselis, a Hellenic city on the east coast of Lycia. They were coldly received by the Phaselites, who had remained on good terms with the King. So they pillaged the land and stormed the walls. The intervention of the Chians in the fleet, however, reconciled the Phaselites to their fellow-Greeks and they joined the Confederates, paying their contribution in cash. During these operations Cimon brought non-Hellenic as well as Hellenic communities in Caria and Lycia into the Confederacy.

The battle fought at the Eurymedon resulted, in a single day, in a double victory, by sea and by land. The Confederates took and destroyed the

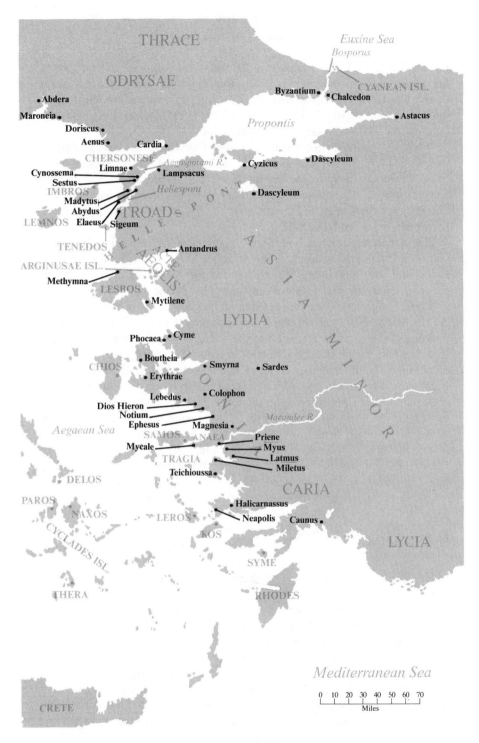

3 The Eastern Aegean and Western Asia Minor

Phoenician fleet, to the number of 200 warships. Adaptations that Cimon had made to the trireme shortly before the campaign were perhaps a factor in the Confederates' signal victory. The Eurymedon was undoubtedly a decisive engagement. Persian shipping henceforth disappeared from the coast of Asia Minor as far east as Pamphylia.

We have previously noted the successes of the Hellenes under Pausanias in Cyprus (478). By 470 the island had once more become a Persian naval base. Curiously, despite the comprehensive Confederate victory at the Eurymedon, no effort seems to have been expended to win Cyprus. It was certainly not garrisoned and the return of the fleet ten years later argues that the Persians continued to hold it.

The Athenians at home had more tangible reasons for rejoicing than the victory itself and the accompanying prestige. The booty proved to be enormous, and with their share of the proceeds the Athenians constructed, or reconstructed, the south wall of the Acropolis, "Cimon's wall."

The triumph of 469 was reflected in an incident of the next spring (468). At the Dionysiac festival (which was celebrated just before the normal opening of the campaigning season) the young Sophocles competed for the first time with the more experienced Aeschylus. The intense rivalry communicated itself to the audience. When Cimon and his nine colleagues entered the theatre, the archon Apsephion, instead of appointing the judges by lot in the usual manner, prevailed upon the ten to take the oath and sit as judges, each man representing his own tribe. This special honour, which contravened tradition, is a measure of the kudos heaped upon Cimon by his fellow-citizens in recognition of his remarkable achievements on behalf of the city. His colleagues shared the applause, but it is unlikely that the entire board of generals had accompanied the Athenian contingent at the Eurymedon.

About this time the Athenians and Phaselites negotiated a commercial pact. A decree of the Demos detailed the judicial procedures that would govern actions at law arising from contracts involving Phaselites. The document alludes to a similar relationship with the Chians, who were naval allies; we may assume that other such contracts had been approved with members of the Confederacy. Athenian willingness to enter into these commercial conventions is a symptom of the gradual evolution in the nature of the alliance and the agreements themselves bespeak the more settled economic conditions encouraged by Confederate successes.

For two or three years after the flight of the Persians from European Hellas Themistocles and Aristeides had exercised most influence at Athens. Themistocles' continued prominence is attested by his rôle as producer of Phrynichus' *Phoenissae (Phoenician Women)* at the Dionysiac festival of 476. It was Aristeides, however, his former rival (pre-war) and more recent collaborator (at Salamis), who commanded the Athenians at sea in 478 and

represented them with such distinction on Delos. We hear little of him after this, although he seems to have lived for another decade; he left behind him a merited reputation as a major founder of the Confederacy. In these early years Cimon son of Miltiades was making a name for himself as commander of the Confederate fleet and simultaneously gaining respect and admiration at home. It is worth noting that all three men agreed in their whole-hearted support of an aggressive naval policy (before the invasions Aristeides' views had perhaps been different). Traditionally, political life at Athens had been marked by the rivalries of the great aristocratic families, especially the Alcmaeonidae and the Philaidae. The issue had come to focus on their constitutional preferences: should the directing power lie in the hands of the citizens as a whole (the Many) or should it be restricted to the well-born, the "best" (the Few)? Cimon, the senior Philaid, favoured the latter; Themistocles (not an Alcmaeonid, although he appealed to the same supporters), the former. By 473 the situation had become so menacing that the Athenians resorted to ostracism; Themistocles was the loser and left Athens for what proved to be the last time.

The Spartan hero of 479, Pausanias, suffered a worse fate. Recalled for a second time, he persisted in his intrigues with the Persians until the ephors (the chief magistrates), watching him carefully, obtained incontrovertible written and oral evidence of his treason. Walled within the precinct where he had sought sanctuary, he died of starvation. The Spartans, through a delegation sent to Athens, charged that the evidence against Pausanias implicated Themistocles, whereupon the Athenians converted his ten-year ostracism into permanent exile (471) and placed a price on his head.

At the time Themistocles was residing in Argos and from that city travelling in the Peloponnese. The case against him for medism is flimsy, but he may well have been collaborating with Pausanias in inciting a rising of the helots. Warned of his danger, he fled and after an adventurous journey reached Asia Minor (470). He remained in hiding for some years before offering his services to King Artaxerxes, who had just (465) succeeded to the Persian throne. Given a welcome, he learned the language and moved up-country to Susa, the Persian capital, where he soon made a favourable impression in the royal court. In time Artaxerxes gave him Magnesia as a domain, which supplied his bread and an annual income of 50 talents, Lampsacus for his wine, and Myus for his meat. These coastal gifts were partially tokens, for Lampsacus and Myus belonged to the Confederacy of Delos, where Themistocles dared not appear. They were no longer within the gift of the King, who perhaps derived some pleasure from a gesture that for him kept alive a futile claim. Themistocles did live in Magnesia, where the inhabitants, after his death in 461, erected a monument in his honour.

Death as an exile put a sad close to the life of a man whose genius had

brought so many benefits to the Hellenes and to the Athenians. One could argue that his work made possible the formation of the Confederacy of Delos, which evolved into the Athenian Empire. Herodotus is not friendly to him but Thucydides, in a rare assessment of an individual and without mention of his flaws of character—he had many—,unerringly identifies his intellectual qualities. His words form an appropriate tribute to one to whom the Athenians owed an enormous debt.

"The fact is that Themistocles was a man who exhibited a natural intellectual strength of the highest order, and, especially in the field of political intelligence, he merited more respect than any other man. For with his native intellect and without reinforcing it by knowledge acquired before or after the event he was, with the least time spent on consideration, a most effective assessor of the problems immediately at hand and an excellent diviner of what was likely to occur over a very wide range of future activity. What he took in hand personally he had the ability to explain and as for those matters with which he was unfamiliar he did not fail to make a competent judgement. He was especially adept at foreseeing both the better and the worse course of action when the future was still unclear. To sum up, this man, by his ingrained power and with brief preparation, was without a doubt the very best at extemporising what the moment needed."

After the major engagement at the Eurymedon, we must wait until 465 for specific news of further Athenian and Confederate enterprise. In that year the people of Thasos, charter-members of the Confederacy, revolted. Their quarrel, however, was not so much with the Confederacy as with the Athenians. It concerned the Thasian marts on the mainland (the Thasian *peraia*) and the mine that the Thasians were exploiting there. This area of Thrace, in the vicinity of Mount Pangaeus, was rich, especially in gold. The Athenian tyrant Peisistratus had owned property there and had used these resources to mount his final and successful attempt to establish himself in Athens. The family of the historian Thucydides, who counted a Thracian king, Olorus, among his ancestors, also had interests in Thrace.

The immediate cause of the revolt may be recognised in the Athenians' intention to found a colony on the Strymon River in a region that, apart from its other attractions, looked like a fertile source for the timber demanded by a tireless navy. The Thasians saw the project as a direct threat.

The response to the Thasian secession was the dispatch of a fleet to the north. The Athenians defeated the Thasians at sea, landed on the island, and by late summer were besieging the town. There is no evidence that the Confederates participated in these aspects of the expedition. In conjunction with the naval squadron the Athenians sent 10,000 colonists, who were by now assembled and ready for departure, comprising their own citizens and allied volunteers, to settle up the Strymon at Ennea Hodoi ("Nine Ways"), a

site that was later to be named Amphipolis. The remarkable numbers of the colonists reflect the importance attached to the undertaking by the Athenians. The Athenian escort, using Eion as a base, seized Ennea Hodoi from the Thracian Edonians who held the place but, upon proceeding further inland, they were utterly destroyed (late in 465) at Drabescus by the united Thracians, who resented foreign intrusion. The Athenian generals, Sophanes and Leagrus son of Glaucus, perished. The triumphant Thracians pursued the survivors as far as Eion and inflicted further casualties. The colonists withdrew and a generation elapsed before the Athenians tried again to acquire a permanent foothold in the region.

Although Cimon commanded in the naval battle that drove the Thasians within their walls, he did not remain for the siege. The quarrel with the Thasians and the attempted penetration into a wealthy area were, despite the international nature of the colony, primarily Athenian concerns. The Confederates and Cimon, and therefore the Athenians, faced dangerous threats elsewhere. The Thracian Chersonese had been cleared of the enemy early and the Hellenic cities of the peninsula had been charter-members of the Confederacy: yet there were still Persians conducting guerrilla warfare in the territory and harassing the Hellenes. To believe that these brigands were stragglers who had survived for well over a decade would be uncritical. It is more probable that they had fled from Doriscus, which, although it resisted for many years, had surely fallen by this time; or that they were raiders whose operations were countenanced by the satrap at Dascyleum. They were certainly given aid and comfort by the Thracians. So Cimon and the Confederate fleet, in a campaign that persisted into the winter of 465/4, swept the barbarian from the Chersonese and asserted firm control of the critical Hellespontine strait, the highway for the grain from the north Euxine coast.

We possess confirmation of the complexities of the fighting in 465 in five fragments of the monument erected by the Athenians in honour of the year's casualties. The theatres in which they fell include Drabescus, Thasos, Eion, Sigeum (on the Asian side of the Hellespont), and Cardia (at the neck of the Chersonese). Under their own ethnic headings are cut the names of men from Madytus (in the Chersonese) and Byzantium. The complete monument, which was the first of its kind to be set up in the Cerameicus, the Athenians' public cemetery, consisted of ten stelae, one for each tribe, positioned alongside one another. This memorial in stone was a precedent for the future.

We left the Thasians under siege by the Athenians. At some time during the winter (465/4) the islanders appealed to the Spartans for assistance, urging an invasion of Attica. The Spartan promise to comply, no rumour of which (says Thucydides) reached the Athenians, is superficially surprising.

Technically, after all, the alliance of 481 against the Mede still bound the Spartans and the Athenians; and the former, unwilling to shoulder the continuing burden of the naval leadership in 478/7, had expressed no dissent when the latter yielded, without reluctance to be sure, to the allies' pleas. The reply to the Thasians must be taken as a reflexion of a shift in internal Spartan politics that favoured the view that the Athenians were becoming too powerful, that Sparta's traditional reputation among the Hellenes was being threatened. To us the incident is a further indication that the nature of the Confederacy was undergoing change.

The Spartans were actually on the point of fulfilling their promise when a major earthquake struck (early summer 464). Great chasms appeared in Laconia and Sparta-town was all but demolished; only five houses survived. The loss of life—men, women, and children—must have been extreme, especially among citizens. The town itself suffered most heavily and it was here that Spartan citizens were concentrated. Sparta could not afford such loss of manpower. The subject Messenians, the helots, saw their opportunity and revolted. Joined by the *perioikoi* ("those who dwell round about," free inhabitants of Messenia and, chiefly, Laconia who lacked full Spartan citizenship) of Thuria (Messenia) and Aethaea (in Laconia), they made Ithome in Messenia their centre of resistance. The Spartans abandoned their proposed invasion of Attica and turned to their domestic crisis.

The besieged Thasians, now without hope, maintained their resistance and it was not until the third year (463/2) that they yielded to the inexorable pressure of starvation and surrendered. The terms required that they tear down their walls and cede their ships. They paid an immediate indemnity and accepted assessment in cash within the Confederacy. The Athenians gained control of the markets across the strait and, presumably, the mine. The quarrel had been between the Thasians and the Athenians, the revolt had been from the Confederacy, and the penalties, for the most part, had been those inflicted upon recalcitrant members of the Confederacy.

Messenian resistance to the Lacedaemonians was as obstinate as Thasian to the Athenians. The war by this time (462) had become the siege of Ithome, the Messenian fortress. The Spartans lacked the experience, the materials, and, we may add, the taste for conducting a prolonged siege. The Athenian reputation was the antithesis in these qualities. Consequently, the Spartans, in the name of the old alliance, appealed for aid to a number of their allies, in particular to the Athenians. The Spartan call precipitated controversy at Athens.

At the birth of the Confederacy (478/7), Cimon was an Athenian *strategos*. He was no doubt assigned by the Demos to the Athenian detachment in the Confederate fleet and so to command of the whole. We have followed his fortunes through the years. His successes won him universal prestige; his

humane relationship with the Confederates brought him popularity with them. At home the Athenian system, in which the *strategoi* were the only magistrates elected by direct vote and eligible for immediate re-election, was bound to put the *strategoi* into prominence in the Ecclesia as advocates and critics of policy. Cimon remained loyal to the political tradition of the Philaids, a tradition that, in the language of the later idiom, favoured government by the Few. Despite the constitution devised by Cleisthenes, the directing influence in the state since the Persian invasions had rested with the moderate conservatives, men like Cimon. In foreign affairs, Cimon's policy can be summarised in simple terms: unrelenting hostility to the Persians abroad, a friendly attitude to the Spartans at home.

When success in war and the safety of the state depended upon an army, the imperative core consisted of the solid middle-class hoplites, at Athens the men who had won the battle of Marathon. While the glories of Marathon were not forgotten, Themistocles' navy effected a fundamental change in the Athenians' attitudes to foreign policy and service in the field. Rowers needed no expensive armour, merely strong backs and willing spirits. So the men at the oars were drawn in large part from the poorest class, the thetes, the majority of whom were landless. They had fought at Salamis, they had made it possible for Athens to accept the hegemony of the Confederacy, they had been responsible for the unsullied Athenian record of the last fifteen years abroad and the city's eminence in Hellas. In them Cimon's political opponents, men who favoured the kind of government in which all power was concentrated in the hands of the Demos as a whole, perceived a formidable body of support. In the late 460s the champions of the popular cause were Ephialtes and the young Pericles.

The Spartan request for collaboration at Ithome provided an issue that allowed his political opponents to attack Cimon before the Demos. Ephialtes urged that no aid be granted to Athens' natural rival. Cimon was of another mind. "Do not suffer Hellas to be lamed," he pleaded, "and the city of Athens to be deprived of her yoke-fellow." His views prevailed; his fellow-citizens, with whom he had always been popular, were not yet ready to forget what he had done for the city. This favourable response to the Spartans helps us to believe that the Athenians did indeed remain ignorant of the bargain made with the Thasians.

Cimon himself was appointed to lead the considerable force that marched to Ithome (462). The ardours of siege-work required enormous patience. As a rule success resulted from treachery or starvation. The first was not likely to occur at Ithome and it was too early for the second. So Ithome did not fall. The Spartans, unreasonably impatient, suffered a change of heart. This may well have been a reflexion of clashing opinions among the authorities (the ephors and the kings) at Sparta and a return to power of those who had been

willing to indulge the Thasians; there were many who genuinely feared Athenian daring and willingness to improvise. "The Athenians," they argued, "are Ionians and we are Dorians. If they remain, they may well yield to Messenian blandishment and effect revolution." So the Spartans dismissed the Athenians, alone of their allies, on the ground that they were no longer needed. Thus, from this unfortunate expedition an atmosphere of mutual distrust came into the open for the first time.

The Athenians knew quite well the true reason for the insulting treatment of their gesture of friendship. They forthwith renounced their membership in the old alliance and ratified an agreement with the Argives, the traditional enemies of the Spartans. Very soon, the new partners swore the same oaths with the Thessalians (462/1).

The incident had its impact on the internal politics of Athens. Ephialtes and his colleagues, using Cimon's alleged failure as a weapon, resumed their attacks upon him and upon the Areopagus, the oldest and still the most conservative body in the state. Politically, the Athenian masses were hearing the doctrine that appealed to them, and in the spring of 461 Cimon was ostracized. He left Athens and the Areopagus lost whatever political power it had retained after Cleisthenes' reforms.

In the south the Spartans eventually (461) forced the Messenians to surrender on terms. The rebels, with their families, were given safe conduct out of the Peloponnese on condition that they never again set foot within the peninsula. The Athenians, inspired by their new hostility to the Spartans, received them and settled them in Naupactus, a harbour-town on the north shore of the entrance to the Corinthian Gulf that they had just taken from the Ozolian Locrians. In this strategic location they were to prove loyal allies.

Within a few months the Athenians were presented with still another opportunity to display their resentment towards the Lacedaemonians. A miserable quarrel broke out between the Megarians and the neighbouring Corinthians over their common border. The Corinthians took up arms, whereupon the Megarians disregarded their membership in the Peloponnesian League and invited Athenian aid. The Athenians entered into alliance. Their troops occupied Megara and Pegae (the harbour on the Gulf of Corinth), built long walls from the town down to Nisaea (the harbour on the Saronic Gulf), and installed garrisons (winter 461/0). From this intervention in the Megarid, says Thucydides, arose the bitter hatred that the Corinthians nourished for the Athenians. Since the Corinthians were the second major power in the League, the Spartans were bound to support them. Although we are not told of a specific declaration, the open breach between Athenians and Peloponnesians may be taken as the outbreak of what is termed the First

Peloponnesian War. For the Athenians it opened a new chapter in the history of their relationship with the states of Hellas, at home and abroad.

Before we turn the page, we should conduct (with the help of Thucydides and Plutarch) an appraisal of the Confederacy of Delos after a decade and a half of vigorous life. I have already emphasised the enthusiasm of the early years and the intention to pursue the barbarian. This the Confederates had done, with such zeal and success that, as major campaigns moved from the Aegaean, some members convinced themselves that dangers from outside Hellas had been eliminated. Weary of continuous campaigning with its attendant hazards and unaccustomed to the inevitable hardships, they relaxed their efforts. Some neglected to man the ships required, some defaulted in their payments of cash, some withdrew from expeditions under way. The Athenians proved to be harsh disciplinarians, reminding their allies of their oaths and insisting upon fulfilment of obligations. Among Athenian generals Cimon was the exception. Sympathetic to the emotions of the naval allies who wished to stay at home and till their fields, he arranged for contributions in cash rather than in ships and men. The change was more economical and safer for those who commuted. For the Athenians it was strategically a boon, since Athenians, joined by volunteers from the allies, could man additional hulls financed by the *phoros* and thus create a more homogeneous Confederate fleet. Athenians were increasingly exposed to naval training; Cimon subjected his squadrons to regular manoeuvres and redesigned the structure of the trireme. The result was that the gap between the highly experienced Athenians and the allies who devoted themselves to farming and commerce grew ever wider. Those who, like the Naxians, refused mediation and revolted were subjugated and in the future contributed cash. Those who, having accepted the change of obligation, revolted later were easily crushed, for, having given up their ships, they no longer possessed an adequate means of defence. At the beginning the Athenians led autonomous allies who formulated policy at the common synods on Delos. The Confederacy remained a Confederacy, at least in name; unilateral withdrawal was "contrary to the agreement" and the Athenians, with the allies who stayed fast, could justify the steps they took to preserve the integrity and strength of the Confederacy. There was, however, no denying the growth of the Athenians' power and the evolution of their status as leaders. The synods may have continued to meet; but there had been infringements of autonomy and unquestionably Confederate policy was now, in effect, debated and voted at Athens; at sea Athenian commanders were supreme. The change in the Athenian position was also responsible for the suspicions, rife in the Peloponnese, that resulted in open warfare in European Hellas. We shall soon have to seek another name for the Confederacy.

VI

THE FIRST PELOPONNESIAN WAR

The disappearance of Cimon from Athenian counsels had no effect upon the Confederate crusade against the Persians. In the spring of 460 a combined fleet of 200 vessels resumed operations in the waters off Cyprus. We have already observed the intensity of internal political strife at Athens between what we may loosely term the conservatives (the Few) and the advocates of outright democracy (the Many); the failure of Cimon's southern policy had opened him to attack and had resulted in his fall. The naval offensive of 460 proves that in their attitude to foreign policy as it concerned the Confederacy and the barbarian the Athenians had been and were in agreement. Nor were they discomfited or embarrassed by the changes that had been evolving within the Confederacy.

Although the Hellenes under Pausanias had in 478 subdued much of Cyprus, which had a substantial Hellenic population, their withdrawal left the island open to recovery by the Persians. In 469, at the time of the battle of the Eurymedon, it served as a Persian naval base. Despite the victory, the Confederates made no effort to incorporate the Hellenic inhabitants or others (Phoenicians) into their alliance. The area east of Phaselis seems to have been looked upon as within the Persian sphere. Now (460), however, we once again follow a large Confederate fleet to Cyprus. Its successful presence was greeted as a stroke of luck by Inaros son of Psammetichus, the king of the Libyans, who, setting out from Mareia, at the western edge of the Nile's delta, brought about the revolt of the greater part of Egypt from the King and astutely invited the Athenian commanders to assist him. The Confederates, loyal to their long-term mission, accepted: a fresh area for

striking at the Persians had been opened to them (let us recall their original intentions: "to take vengeance on the King by plundering his land").

The Confederates' position in Cyprus and its neighbouring seas was by this time sufficiently strong for them to treat the island as a safe base needing minimal defence. The extent of Confederate success may be measured by the fact that a number of cities on the coast of Pamphylia and Caria north of Cyprus had been won and assessed. Previously, the eastern point in the Confederacy had been Phaselis. The fleet left Cyprus for Egypt, on the way landing in Phoenicia, where Doros, a colony of Sidon, was subjected and assessed. In time they moved up the Nile and, as Thucydides puts it, established control of the river. This allowed them passage to Memphis, where they overran two-thirds of the city and attacked the remaining third (the White Fortress), which was defended by Persian fugitives and Egyptian loyalists. There we must leave them temporarily in order to keep abreast of violent disturbances among the Hellenes in the homeland.

The breach with the Corinthians over Megara had indeed been serious, sufficiently serious to cause the Athenians to take the initiative in hostilities. In the spring of 460 a naval expedition landed at Halieis at the southern tip of the Argolid peninsula. In the ensuing battle against Corinthians and Epidaurians the Athenians suffered defeat. What we should remark about this effort is the confidence and energy of the Athenians, who had just assigned a powerful contingent to the Confederate activities in Cyprus. They were now waging two wars simultaneously. Nor had they exhausted their resources, for shortly afterwards we find them in naval conflict with the Peloponnesians off the island of Cecryphaleia, which lies between Aegina and the Argolid. This time they were victorious. In the course of these naval adventures they took Troezen, further to the south.

Relations between the Athenians and the Aeginetans had been strained for half a century; there had been minor skirmishes both before and after the battle of Marathon. Now, in this same summer, the culmination of the feud was at hand. In the major naval engagement the Athenians, commanded by Leocrates son of Stroebus, were the victors, capturing 70 ships. On this occasion the combatants were attended by their allies. No doubt the Corinthians, the leading Peloponnesian naval power, were glad to fight alongside the Aeginetans, fellow-Dorians and themselves of no mean naval reputation. The Athenian allies were probably from Confederate islands of the Cyclades. If so, we have members of the Confederacy supporting a "private" Athenian war. With the destruction of their opponents' fleet the Athenians landed on the island and laid siege to the chief town (Aegina).

The fate of Aegina shook the Peloponnesians. From now on the Spartans, the acknowledged leaders of the Peloponnesian League, asserted themselves and more and more directed operations on behalf of their allies. A

force of 300 hoplites (many of them Spartans) who had been serving along-side the Corinthians and Epidaurians were landed on Aegina to aid the besieged; presumably they made their way into the town. Another force, chiefly Corinthian, seized the heights of Geraneia, the range separating Megarian and Corinthian territory, whence they descended into the Megarid to threaten the Athenian garrisons. These moves were intended to force the Athenians to lift the siege of Aegina. How else could the Athenians send reinforcements to the Megarid? After all, large forces were now engaged in Aegina and in Egypt: the enemy had a right to believe that Athenian man-power had been stretched to the limit.

The Peloponnesians, however, had not reckoned with the ambitious versatility of their opponents. With their men of military age already in the field, the Athenians refused to lift the siege; they mustered an army of "the oldest and youngest," who had remained at home, placed Myronides in command, and directed it to the Megarid. A sharp action ensued in which each side claimed the victory (autumn 460). The Athenians seem to have had the better claim; at all events, they raised a trophy and the Corinthians withdrew temporarily, only to be driven forth twelve days later by the gibes of their elders at home. As they were putting up their own trophy, the Athenians from Megara fell upon them. This time there was no mistake and, although a majority of the Corinthians reached home, their escape was effected only after a demeaning experience at the hands of the victors.

We may well pause to salute the redoubtable energy of the Athenians: all the activities so far described fall in a single campaigning season. As was their custom the Athenians engraved the names of the fallen on ten marble stelae, one for each tribe, which they set up as a public monument. The record for the tribe Erechtheis has survived with only slight damage and is open to inspection in the Louvre. It is an impressive monument. Under the name of the tribe is a simple heading: "These died in war in Cyprus, in Egypt, in Phoenicia, in Halieis, in Aegina, in the Megarid, in the same year." There follow 177 names, including two generals, one seer, and four archers. Even if the tribe Erechtheis suffered exceptional casualties (hence the heading, which would normally apply to all ten stelae), Athenian losses must have been severe. The Athenians were learning the costs of supremacy.

In the winter that followed (460/59) the Athenians began the construction of the Long Walls to the sea, one from the city to Peiraeus, the other to Phalerum. The latter was to be abandoned after a few years in favour of a wall running south of and parallel to the first, a more defensible complex. The project represents the consummation of Themistocles' advice to his fellow-citizens to become a naval people: so long as the fleet sailed the seas the Athenians could shield themselves behind their walls without starving. The building of the Long Walls was another step towards Empire.

The summer of 459 seems to have been free of confrontation between Athenians and Peloponnesians. A warlike act by the Phocians, however, provoked Spartan retaliation and facilitated a resumption of the major conflict. The Phocians, who dwelt in the territory abutting Boeotia on the north-west, invaded Doris, a small neighbouring area in central Greece that claimed to be the original metropolis of the Lacedaemonians. The emotional tie was deeply felt and the Spartans during the winter (459/8) assembled a surprisingly powerful force, 1,500 of their own hoplites and 10,000 allies (chiefly from the Peloponnesian League), that crossed the Gulf of Corinth in the spring and had little difficulty in bringing the Phocians to heel. The return south proved to be less easy.

We accompanied the Confederate fleet to Egypt and up the Nile to Memphis, which was partially won. Since the campaign required siege-work, it was not necessary for the entire fleet to remain there, for the most part idle. A large body of the Athenian squadron returned home, reaching the friendly haven of Peiraeus in the spring or early summer of 458, too late to be deployed in the Corinthian Gulf to oppose the Spartan crossing.

The Athenians, who had been demonstrably short of man-power, were now able to reinforce their garrison in the Megarid and increase their naval strength in the Gulf, using Naupactus and Pegae as bases.

The Lacedaemonian army was thus cut off from the Peloponnese. Nicomedes, their commander, who was acting on behalf of the under-age king Pleistoanax, did not now dare to run the gauntlet by sea. By land the prospect was equally daunting: the path over Mount Geraneia, notoriously difficult, had become even more dangerous now that the strengthened Athenians in Megara and Pegae barred the way. The Spartans encamped in Boeotia and contemplated their choices.

In Athens there was always opposition to government by the Many, democracy; the more radical elements in that opposition could not be termed loyal. At this crisis, these traitors (surely a small minority and not Cimon's confidants) communicated secretly with the Lacedaemonians, offering aid, hoping to put an end to the democracy and halt the building of the Long Walls. The latter hope suggests disapproval of the ambitious foreign policy favoured by the Demos (and not opposed, I am sure, by the leading oligarchs). Suspicions of these intrigues persuaded the Athenians that immediate action was imperative; besides, they were aware of the Spartan dilemma and deemed this the right moment to face the enemy in the field. So they came out against the Spartans with the full strength that had been impossible before the return of the squadron from Egypt. They were accompanied by 1,000 Argives and sundry detachments from the other allies, that is, members of the Confederacy. All told, the army comprised 14,000 men; they were joined by a number of Thessalian cavalry, who in the event deserted to the Lacedaemonians.

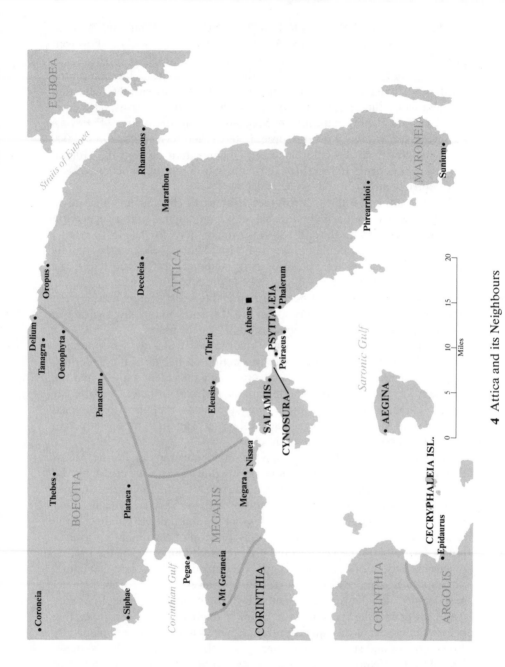

4 Attica and its Neighbours

The engagement at Boeotian Tanagra was the first pitched battle between Athenians and Lacedaemonians. Each side incurred heavy casualties but the Lacedaemonian victory was decisive (mid-summer 458). The Spartan hoplite already commanded tremendous respect. Wise Athenians noted the result and it was not until well after the death of Pericles that an Athenian army was again allowed to meet the Lacedaemonians and their allies in the field face to face. After the battle the Lacedaemonians marched through the Megarid and over Mount Geraneia to their home, felling trees on their way (a serious loss, for the trees were no doubt olives, which require about fifteen years of growth before they yield). They had been encouraged by their victory and the Athenians in the Megarid, depressed by the defeat, offered no opposition.

Yet the resolution of the Athenians had not been shaken. Sixty-two days later Myronides marched against the Boeotians and by his victory at Oenophyta more than compensated for the loss at Tanagra. Thucydides' "Boeotians" must include the Lacedaemonian allies in central Greece, for the Athenians established control over the Boeotians (the Thebans and their League, namely, all Boeotia except Plataea, the Athenians' ally of many years), the Phocians, and the Opuntian Locrians, from whom they took one hundred of the wealthiest as hostages; and they tore down the walls of Tanagra. The Athenians had their naval base at Naupactus, their garrisons occupied Pegae and Megara, and after the battle of Oenophyta they controlled central Greece, notably most of the north coast of the Corinthian Gulf.

One wonders about the nature of this control. The central territories were not annexed or even colonised in the modern style; nor were they garrisoned. In some way they lost their autonomy. The leaders in the chief poleis, surely oligarchs, were banished (the hostages came from this class) and we may conjecture that democracies were established along with Athenian officials who watched over Athenian interests. These new "allies," however, did not become members of the Confederacy and they paid no *phoros*; the Athenians incurred no material gain. It is customary to refer to an Athenian Empire by land. It would be more accurate to think of no more than a sphere of political suzerainty, which nevertheless brought its measure of prestige; and the Athenians treasured prestige. By the end of the season (458), despite the disaster at Tanagra, ambitious Athenians could look back at their accomplishments without displeasure.

That winter saw the completion of the Long Walls; and we hear no more of the dissenting faction within the city. By the spring of 457 the Aeginetans could hold out no longer. They were required to take down their walls and, paying *phoros*, to become members of the Confederacy. Their assessment (30 talents) was at the highest rate, which reflects not Athenian oppression but Aeginetan prosperity. We should not overlook the difference in the

treatment accorded Dorian Aegina, which as an island was added to the Confederacy, and the continental allies of Sparta in central Greece, which were not.

Contemplation of the Athenians' recent problems, at home and abroad, leaves us with the conviction that they had been fully occupied. Consequently, it comes as a surprise to learn that at some time during the year 458/7 they had concluded an alliance and exchanged oaths with the Segestaeans in far-away Sicily. Segesta was a non-Hellenic town of the Elymi situated in north-western Sicily a few miles inland from the north coast. Thucydides, whose subject is the rise of the Empire, says nothing of this alliance, which is guaranteed by the surviving fragment of a dated inscription. It reveals nothing of the circumstances of this fresh obligation and it is necessary to resort to speculation. We know that the alliance was renewed in 427 at the request of the Segestaeans and we know that the Athenian response in 416/5 to another plea from the Segestaeans, in the name of the alliance, was the specific incitement of the great expedition to Sicily. Thucydides' account of this later intercourse reveals a long feud between Segesta and Selinus, a Dorian polis on the south coast founded by Megara Hyblaea. The Segestaeans enjoyed a friendly relationship with their kin in Halicyae, which lay between Segesta and Selinus. We may therefore hazard the guess that the Segestaeans, involved along with the Halicyaeans in a dispute with Selinus, made the first approach; the Athenians accepted. We know from the inscription that the Segestaean embassy were entertained in Athens. When we ask why the Athenians acceded to the Segestaean proposal, the answer must once more be derived from the confident ambitions of the Athenians in these years that we have already identified. The alliance, however, was not immediately followed by Athenian action in the far west; that remained for the future.

In the summer of 457 the Athenians took the offensive against the Lacedaemonians when Tolmides son of Tolmaeus conducted an expedition around the Peloponnese. He burned dockyards at Gytheum, on the west coast of the Gulf of Laconia, raided Methone, on the west coast of the Peloponnese, overran Zacynthus and Cephallenia, islands in the Ionian Sea, took Chalcis, a Corinthian dependency a few miles west of Naupactus at the mouth of the Corinthian Gulf, and, making a landing in Sicyonian territory, defeated the force that issued from the city. With a friendly reception guaranteed at Troezen, Naupactus (occupied by the allied Messenians), and Pegae (garrisoned by the Athenians), Tolmides could demonstrate even more effectively the ability of naval power to strike suddenly at widely separated points that could offer little defence.

We transfer our attention to Egypt, where the Confederates, despite the normal vicissitudes of war, had by this time (457) mastered Lower Egypt. The Persian King, it seems, looked upon this situation as serious if not

5 The Eastern Mediterranean

desperate, for he directed a special envoy, Megabazus, to travel to Lacedaemon carrying money with which to persuade the Lacedaemonians to invade Attica. The cash was not necessarily a direct bribe; rather, the intent was to defray expenses. Thus did the King expect to draw the Athenians from Egypt. He was perhaps not conversant with a similar attempt to force Athenian abandonment of the siege of Aegina three years earlier. In any event the Persian strategy failed and the money was being wasted ("in other ways," writes Thucydides); so Megabazus, with what remained, was summoned back to Asia and the King adopted a more direct method of dealing with the Confederates. This time he ordered Megabyzus to Egypt with a large army (spring 456). Megabyzus defeated the Egyptian rebels and their Hellenic allies by land, drove the Confederates from Memphis, and finally shut them up in Prosopitis, an island in the western arm of the Nile (autumn 456). The besiegers had become the besieged. After eighteen months the wily Persian diverted the waters, thus putting the Confederates out of action and creating a path to the island, and recovered Prosopitis with his infantry. In this way a campaign of six years came to a disastrous end (summer 454). The few who escaped reached safety in Cyrene by traversing Libya. It must have been a long and perilous journey.

The Confederates' losses in Egypt were not yet at an end. A relieving squadron of 50 vessels, in ignorance of what had transpired, anchored off the Egyptian coast. Persian infantry fell upon them when they landed and Phoenician ships completed the rout. Only a minority escaped.

Closer to home in the same summer Orestes, a Thessalian prince who had been driven into exile, urged the Athenians to restore him. Once again they accepted a challenge and, enlisting Boeotians and Phocians, who were now classed as allies, along the way, reached Pharsalus. The Thessalian cavalry, however, were too strong and the Athenians withdrew, their mission unaccomplished.

Shortly afterwards (autumn 454) the tireless Athenians embarked 1,000 fighting men on 100 of the ships based at Pegae and, with Pericles in command, sailed along the coast to Sicyon, where they landed. They swept over the coastal strip and penetrated inland as far as Nemea, where they defeated the Sicyonians who confronted them. From Sicyonia the Athenians sailed westwards. They won some sort of control over Achaea, the northern strip of the Peloponnese, for they enlisted a number of Achaeans before crossing the Gulf, passing friendly Naupactus and proceeding into Acarnania. They mastered the territory and pinned the inhabitants of Oeniadae within their walls. Failing to take the place, they plundered the land and sailed home. It had been a markedly successful expedition.

We are not yet ready to leave the Egyptian expedition. The losses have often been exaggerated; nevertheless, the outcome of the six-year campaign

was sufficiently damaging to bring about a fundamental change in the administrative practice of the Confederacy. In 454 the Samians (who had served loyally in Egypt) proposed that the Confederate treasury be moved from the island of Delos to Athens in order to protect it from the Persians. The transfer was made and henceforth the contributions in cash would be delivered to Athens.

How long the synods continued to meet is a puzzle that has enjoyed perhaps excessive attention; still, their disappearance marked a stage along the path to Empire. Thucydides, discussing the organisation of the Confederacy (478/7), writes of the making of policy in the synods. They then disappear from his pages until 428, when the rebellious Mytilenaeans travel to Olympia and, seeking help from the Peloponnesians, excuse their acquiescence in Athenian domination of the synods in the early years. Now Plutarch, in a confused passage, says that the Samian recommendation was voiced at a meeting of the synod. There is no doubt about the date of the transfer of funds, 454. It is most improbable, I think, that the synod convened after this change: so, if Plutarch is right, we have a date for the last gathering of the synod on Delos.

The suggestion has been made that in the future the Confederate representatives came together as an assembly in Athens at the time of the quadrennial Great Panathenaea (the major celebration of Athena's birthday, in mid-summer, when re-assessments were due). The evidence, however, is slight and such formal gatherings are unlikely; the Confederates, after *ca* 450, had little or no say in the framing of policy.

To accept the Samian argument as it is recorded and to believe that danger of a Persian attack was genuine would be ridiculous. Examination of the closing incidents of the Egyptian campaign reveals that the vital engagements had been by land, not by sea. Even the relieving squadron had beached the ships and landed. The Phoenicians merely crowned the Persian victory ashore. It is true that about this time, as we shall see, the Athenians had to cope with disaffection in Ionian Erythrae and Miletus and that Persian intrigue (from Sardes) had helped to bring the trouble to a head. Such comparatively petty interference, however, was far from constituting a direct threat. The map sets Delos in the central Cyclades, where only naval attack could reach her. The Confederate squadrons dominated these waters; some seventeen members (including the major islands, Lesbos, Chios, and Samos) continued to supply ships and control extended as far as Phaselis, a town that we know paid its contribution of cash in 453. To seek disloyalty among the islands, as some have done, is a futile exercise.

Nevertheless, at this moment in the Confederacy's affairs we must weigh not so much the true strategic position as what many believed it to be. The repercussions of the defeat in Egypt penetrated the Confederacy: the fear

was unjustified but real. At the same time, as I have from time to time mentioned, there were undoubtedly ambitious Athenians who were only too glad to take advantage of a current view, misconception though it be. For them fear of Persian attack was no more than a fair-sounding pretext for the removal of the treasury to Athens.

The responsibility of safeguarding the treasury, the substantial accumulated funds, at Athens brought with it the responsibility of collecting and stewarding the annual *phoroi*. The Athenians, acting in the Ecclesia, met their new obligations systematically.

All we know of the Delian period is that the funds were deposited there. Of Athenian practice we are very well informed indeed, thanks to the Athenians' democratic institutions. The decisions of 454 set the style for the future. In that year a new assessment of the Confederacy was drawn up, the first that we can unhesitatingly call wholly Athenian; we look upon it as the beginning of an era and we number later assessments from it. Here we owe a debt to Fortune. About 300 B.C. a certain Craterus of Macedon put together a collection of Athenian decrees; he included this assessment. Centuries later a writer named Stephanus quoted a small section for its geographical interest: the heading Caric *phoros,* followed by two names: Doros, Phaselitae. The size of the fragment does not measure the amount of information that it conveys. Because Craterus was collecting decrees, we know that this assessment was voted by the Ecclesia. It was more than a mere list; it was accompanied by a text (the decree) in which the procedure was approved in detail. The assessed allies were arranged in geographical panels (as were the quota-lists from 443/2) and Caria included the lands to the east. We have noted Confederate acquisitions east of Phaselis and on the coast of Phoenicia (Doros) during the campaign of 460 and on the way to Egypt. These places were listed in the assessment, although there is no evidence— and it is most unlikely—that they paid. The finished document, decree and list, embodied for Athenians and visitors a public statement of the extent of Athenian power. Whether Craterus copied his text from a stele or in the archives we cannot say; I suspect the first.

Re-assessments now took place, on average, every four years, in the years of the Great Panathenaea. The *phoroi* were due each spring, to coincide with the festival of the Dionysia at the opening of the normal campaigning season. The monies were stored on the Acropolis under the protection of Athena, the city's patron Goddess; later they were placed in the Parthenon. One-sixtieth of each amount, the first fruits (*aparchai*), which we call the quota, was turned over by the Hellenotamiae to Athena; that is, the money was credited to her treasury. We may look upon this as a form of rental for the use of Athena's precinct. The payments of these quotas were carefully audited by the thirty *logistai* (auditors) and each year the audited record was

published, i.e., engraved on stone and set up on the Acropolis. It is to these lists that we are indebted for our knowledge.

In the first year of delivery to Athens (spring 453) the very dimensions of the stele selected to carry the record of the audit are of major import. The block of Pentelic marble, reigning in Athens' Epigraphic Museum today, rises to a height of *ca* 3.61 m., with a width of 1.11 m. and a thickness of 0.39 m. It is inscribed on four sides and served as the record of fifteen years, after which (438) a second stele came into use for eight years. With the opening of the Peloponnesian War a separate stele was inscribed each year. Fragmentary though they are, those financial documents are of incalculable value to the historian of fifth-century Athens.

Of the large stele (the *lapis primus*, the first stone) 183 fragments have been found, a few of which have been lost since they were first reported. Each list, with one exception, is numbered, and so dated, from that of 453. The names, generally ethnics, are arranged in columns, with a quota opposite each name. The space available in List 1 allows for about 140 entries; in this year alone an appendix on the right lateral surface of the stone reveals that the collection amounted to about 390 talents.

The size of the stele merits more than a passing mention. We look back to the formation of the Confederacy in 478/7. The delegates had sworn to have the same friends and the same enemies for ever; but the contributions were to defray the costs of the offensive against Persia, and this would not last for ever. By 453 Persians had to be hunted beyond the Aegaean. Yet the Athenians had the accounts of a single year engraved upon a stele that was to prove adequate for fifteen years. The choice prompts questions about Athenian thoughts of the future. Did peace with Persia, so soon after the Egyptian débâcle, seem far away? Or should we believe that even now there were some whose ambitions looked beyond a peace?

We today are grateful to the Athenians for the mechanism that they adopted in the administration of the Confederacy, for the quota-lists, sometimes in combination with other inscriptions, vouchsafe a good deal of specific information about the relationship with the cash-paying allies of which we should otherwise be deprived. Thus from the early lists we deduce revolts by two of the more important and prosperous of the Ionian states, Miletus and Erythrae.

Erythrae dominated the peninsula on the mainland opposite Chios. The Erythraeans, whose assessment was probably 9 talents (as it was later), defaulted in 453 and in fact do not appear in Lists 1-4 (the first assessment-period). Boutheia, on the other hand, a dependency whose later payments are included in Erythrae's 9 talents, is credited with 3 talents. Erythrae had seceded and the loyal Erythraeans, in company with the people of Boutheia, where they found refuge, sent the 3 talents. The record of 452 is the same.

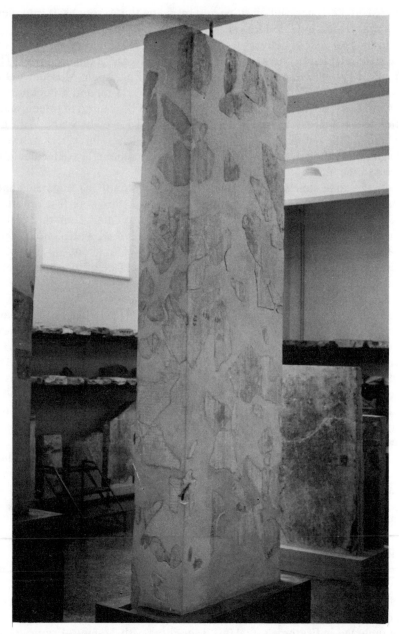

PLATE 2. The *Lapis Primus,* on which were inscribed the annual records of
the quotas paid to Athena by the tributary states from 453 to 439.
EPIGRAPHIC MUSEUM

The Athenians lost little time in recovering Erythrae. Here we are aided by another inscription, a decree voted before mid-summer 452 that details the terms imposed upon the recalcitrant Erythraeans. These "Regulations" are of considerable interest because they reflect the Athenian attitude to rebellious members of the Confederacy in the late 450s, a quarter of a century after the inception of the grand alliance. A democracy after the Athenian model is installed. A Boule of 120 men, aged at least thirty, is to be elected annually by lot, in the first year under the direction of the existing Erythraean Council, Athenian *episkopoi* (inspectors), and the Athenian garrison-commander. The Erythraean Council is to swear an oath of loyalty to the citizen-bodies of the Erythraeans and of the Athenians and their allies. The members will further swear not to receive any exile who has fled to the Medes and not to banish, without express permission from the Athenian Council and Demos, any loyal Erythraean who has remained in the city. Exiles on capital charges are banned from the Athenian alliance as a whole. Any man who betrays the city to "the tyrants" is to be executed.

We thus have sufficient evidence for reconstruction. Civil strife had broken out in Erythrae when a party favouring tyranny had opened negotiations with the Persian satrap stationed at Sardes and proclaimed independence from Athens, and so from the Confederacy. The Athenians moved in; medizers and supporters of tyranny fled. An Athenian garrison and Athenian *episkopoi*, in collaboration with the existing Erythraean Council, supervised the imposition of a democratic constitution.

The revolt of Erythrae coincided with the revolt of Miletus; it is likely that a single Athenian expedition dealt with the two. Miletus, like Erythrae, defaulted in 453, drawing her neighbours Myus and Latmus along with her. Loyal Milesians found safety in two near dependencies, Leros and Teichioussa, and in Neapolis "on the White Promontory," a temporary haven; they raised a substantial part of the assessed 10 talents. By the spring of 452 Miletus, again like Erythrae, had been recovered.

In the case of Miletus we do not have the decree that marked her return to the fold. Two or three years later (450/49), however, the Demos approved a series of Regulations presented by a board of commissioners. The eight extant fragments comprise less than half of the whole but from the mutilated text we can deduce in a very general way how the Athenians dealt with the Milesian problem.

The striking feature of the settlement is that the Athenians did not impose democracy. Five Athenian officials, called *archontes*, are to collaborate with local magistrates in government. Certain trials (for example, for treason) are to be heard in Athens, although others remain within local jurisdiction, with provision for appeals to Athens. Property lost by loyalists during the secession is to be recovered. There is to be an Athenian garrison quartered in the

city. The Milesians are pledged to heed Athenian decrees.

The information gleaned from the Athenian decree is complemented by an inscription found at Miletus in which certain families and their descendants are banished for ever. Their crime must have been treason. The course of events at Miletus resembled that at Erythrae: a *coup d'état* resulted in the establishment of a tyranny, which sought Persian support and renounced Athens. The recovery by Athens, probably in 452, led to the passage of the Milesian decision against the tyrants.

In both Erythrae and Miletus we have identified the *stasis* that was the curse of the Greek polis as the immediate cause of Athenian intervention. There may well, however, have been other provocation. This was the decade of the expedition to Egypt, which seemed too distant to some members of the Confederacy; a few, perhaps, as Thucydides explains in his chapter on revolts, failed to report for duty. Sympathisers with tyranny saw their opportunity, with the collaboration of the Persian satraps of the adjoining provinces, at Sardes and Dascyleum, who were quick to foster anti-Athenian intrigue. Pro-Persian activity within Erythrae and Miletus is attested by inscriptions. Another inscription reminds us of the Persian presence in the north. In 451/0 the Athenians passed a decree honouring the people of Sigeum for their loyalty and guaranteeing protection against "those on the mainland," that is, the Persians of the Hellespontine satrapy. These were critical years; the Athenians met the dangers firmly.

A three-year lull in the war at home brings us to the spring of 451 and the return of Cimon from ostracism. In the same spring the Athenians and Peloponnesians agreed upon an armistice of five years. The theory basic to the ten-year sentence imposed by ostracism was that a decade's absence would ensure a man's silence and undermine his effectiveness as a political influence. Yet Cimon's position had evidently not suffered irretrievable damage. He won election to the board of *strategoi*, and he should be given some credit for the signing of the armistice. The Athenians, with Cimon once more in action, were free to resume aggression against the Persians.

VII

THE PEACE OF CALLIAS

Cimon returned from ostracism in the early spring of 451 and operations against the Persians were resumed in the following year, when a flotilla of 200 ships, Athenian and allied, of which he was in command, challenged the Persians in the waters off Cyprus. From the activities of the fleet we deduce that the Athenians left Peiraeus in the spring at the beginning of the campaigning season. Since Athenian *strategoi* took office with the New Year in mid-summer (a somewhat awkward system, to be sure), Cimon must have been successful at the elections of 451 (spring), shortly after his return, for the year 451/0; he certainly won re-election in 450 for the year 450/49.

Cimon had long been an advocate of peaceful relations with Sparta and persistent war against the Persians. It is easy to relate the five-year armistice and the resumption of hostilities in the east to his reappearance in Athens. The correlation may be justified; we should not, however, overlook the fact that ten years earlier the Confederates off Cyprus, having accepted the invitation of the rebel Inaros, embarked on the Egyptian expedition more than twelve months after Cimon had been compelled to leave Athens. That fleet was commanded by another Athenian, whose name we do not know. Demonstrably, Cimon was not the only Athenian who urged his fellow-citizens to seize every opportunity to hound the Persians. So the aggressive policy adopted by the Demos in 450 was supported, we may assert without hesitation, by both Cimon and Pericles. And in a sense history repeated itself, for 60 of the allied squadron made for Egypt to aid Amyrtaeus, the "king of the marshes," who remained a stubborn rebel against the King.

On their way to Cyprus the Athenians picked up the *phoroi* due from a

dozen or so Carian communities that had defaulted in the spring (450). These payments were dispatched to Athens in time to be recorded in the last column of List 4, an Appendix, so to speak. In the same summer, the contemplated re-assessment of the Confederacy took place. The figures reveal only minor changes from those of 454; but now only the three large islands, Lesbos, Chios, and Samos, plus Thracian Potidaea retained their status as naval allies.

We hear nothing of the fortunes of the squadron detailed for duty in Egypt. The major force laid siege to Citium on the south coast of Cyprus. Two misfortunes befell them: Cimon died and a shortage of supplies developed. Hence they lifted the siege of Citium and proceeded to Salamis on the east coast, where they won a dual victory, by land and by sea, over a Persian force drawn from Phoenicia, Cyprus, and Cilicia. On this triumphant note, accompanied by the ships from Egypt, they dispersed to their respective homes.

Appreciation of the success of the season's campaign is enhanced by Artaxerxes' response. From 477 to 450, with few interruptions, the Confederates had waged relentless warfare against the Persians, most of the time in Persian waters and territory. They had not relaxed their original determination, the stated purpose that had demanded contributions in ships, men, and money. Now the King, despite his victory of 454 in Egypt—a military, not a naval, victory—, had lost his zest for combat against the Hellenes. For the clearest account we turn to Diodorus, who drew from the fourth-century historian Ephorus: "Artaxerxes the King, when he heard of the losses in Cyprus and had taken counsel with his associates about the war, judged that it was to his advantage to conclude a peace with the Hellenes. Consequently he instructed his commanders in Cyprus and the satraps by letter to reach an agreement with the Hellenes on what terms they could negotiate. So Artabazus and Megabyzus and their advisers dispatched envoys to Athens to discuss conditions of settlement. Since the Athenians were amenable and sent envoys with full powers led by Callias son of Hipponicus [Cimon's brother-in-law] , a treaty of peace was concluded by the Athenians and their allies with the Persians."

These protracted negotiations began in the autumn of 450, soon after the Confederate withdrawal from Cyprus; they consumed the winter. The diplomatic exchanges were known to the Hellenes, especially to the members of the Confederacy. Talk of peace was in the air and the atmosphere is reflected in List 5 (spring 449): a number of allies booked partial payments; some did not pay at all. The allied dilemma is comprehensible: if there were to be no further operations at sea, was the *phoros*, the contribution that had been assessed for just this purpose, still obligatory?

In the spring of 449, probably before the Dionysiac festival, when the *phoroi* were due, Callias reached Athens with the news that the Peace had

been ratified in Susa. It was a moment of supreme triumph, the culmination of thirty years of Athenian and allied effort. As for Callias, the Athenians set up a bronze statue in his honour. Later, despite his recent glory, they fined him 50 talents at his audit on the charge of having accepted bribes.

We can with confidence reconstruct the terms of the Peace of Callias:

1. The King formally renounced claims to the seaboard of Asia Minor and the off-shore islands occupied by Hellenes.

2. In the south the King undertook not to sail under arms west of Phaselis along the coast or of the Chelidonian islands (off Lycia at the south-western tip of Asia Minor) on the direct voyage from Cyprus.

3. In the north the King undertook not to sail under arms beyond the Cyanean islands in the Euxine Sea at the mouth of the Bosporus.

4. By land the King undertook not to proceed under arms within three days' march or one day's ride of the Aegaean coast (roughly, the distance from Sardes).

5. The Hellenic cities of Cyprus were to retain their autonomy within the King's realm and were to pay tribute to him on the scale determined in the time of Darius.

6. The Athenians and their allies undertook not to fortify the Hellenic cities of Asia Minor and not to make war on the King and his allies.

The Confederacy was essentially maritime and for this reason there were Hellenic communities inland, such as the two Magnesias, that remained outside the terms of clause 1. They were protected from the King by clause 4. The boast of the orator Isocrates in the next century that the Athenians could dictate some of the tributes that the King would receive is explained by clause 5, which at last determined the equivocal status of the Hellenic poleis of Cyprus.

There are those who reject the Peace of Callias as an Athenian forgery of the fourth century. They overlook the awesome difficulties of manufacturing such a document — it was inscribed on stone — in a society so open as that of Athens, a direct democracy in which the citizens constituted the government. Strongest among various weak (and contradictory) arguments against the Peace is its absence from Thucydides' Pentecontaëtia. No modern historian, in describing the events recounted in this book, would omit the long siege of Doriscus, the fighting in the Chersonese and Hellespont in the mid-sixties, the ostracism of Cimon, the transfer of the Confederate treasury from Delos to Athens (which we recognise as a notable step in the evolution of Empire), and the Peace of Callias; and he would lay stress on the Panhellenic Congress, which lies on our horizon. Not one of them is deemed worthy of mention by Thucydides; all (including the last, which has also been challenged) are affirmed by other evidence, some of it epigraphic (which is indisputable). If we look ahead to Thucydides' history of the Great War we are startled by the

surprising omission of the spectacular re-assessment of 425 B.C.

For the years between the Persian invasions and the outbreak of the Peloponnesian War we lean heavily on Thucydides. As I have already remarked, we tend to forget that these fifty years (the Pentecontaëtia) are not the subject of his *History*. His account is a digression, an "excursus," inserted in order to explain how Athenian power (the Empire, *arche*) evolved. It is terse by design. That his highly selective narrative differs from what we feel should be included merely emphasises that his historical perspective and ours are not identical. Time has in fact made ours sharper, as it was bound to do. And, of course, we want him to be more informative and so, though we ought to discipline our judgement, we resent his brevity and, mistakenly, tend to impose our criteria on him.

Nevertheless, we may enlist Thucydides as an ally who bears witness to the reality of the Peace. It is significant that in the Athenian historian the campaign of 450 concludes formal hostilities against the Persians. The encouraging response of Pissuthnes, satrap in Sardes, to the Samian oligarchs in 440 and the interference of Itamenes in Ionian Colophon in 427 with the connivance of the satrap were, on a strict interpretation, infringements of the Peace; but the Athenians did not promote them into major issues. Rumours of Phoenician ships off the Carian coast in 440 were not substantiated. Thucydides records the interception of a Persian delegate to Sparta and the death of Artaxerxes about the same time (424). Apart from these isolated incidents the Persians disappear from the pages of Thucydides until the naval campaigns in the eastern Aegaean after the Sicilian disaster.

Thucydides, of course, knew of the Peace of Callias. This is proved decisively by his report of the treaties made by the Spartans with the King (Darius II) in 412/1 and the negotiations and plotting that accompanied them. The King's representative was Tissaphernes, the satrap based at Sardes, who "had recently been pressed by the King to pay the tributes from his province that he owed in addition and that because of the Athenians he was unable to exact from the Hellenic cities." The language of the first is typical of the three treaties: "Whatever territory and cities the King and the ancestors of the King held, these are to belong to the King." When Alcibiades in 411 put the King's claims to the Athenians on Samos, "among other demands he insisted that all Ionia be ceded as well as the off-shore islands . . . finally . . . that the Athenians allow the King to build ships and to sail along his own coastal territory wherever and with as many ships as he pleased." Obviously, "his own coastal territory" is the coast of Asia Minor that had once owed allegiance to Persia and of which he had been deprived. Despite the official cession of 449, Artaxerxes and his successor Darius continued to look upon Hellenic Asia Minor as Persian. We are reminded of the empty gifts made by Artaxerxes to Themistocles; and the treaties just

cited show that Darius never relinquished his claims.

It is true that no specific reference to the Peace of Callias has survived from the fifth century; it is also true that few writers of prose have survived and one could scour their work without finding a context in which such reference would be relevant. What vividly reawakened the memories of Hellenes, at Athens and elsewhere, and magnified the glories of the Peace was the shameful pact signed with the King (Artaxerxes II) by Antalcidas on behalf of the Spartans in 387/6. Not only did the King recover Asia Minor *in toto*; he effectively banned leagues and coalitions within what was left of the Hellenic Aegaean. For good reason the Peace of Antalcidas came to be called the King's Peace: he laid down the terms to the Spartans and so to the Hellenes.

Almost immediately the contrast between the brilliant Peace of Callias, in which the Athenians dictated to the King, and the humiliating Peace of 387/6, in which the King dictated to the Hellenes, became a popular theme, especially prominent in the thoughts of Athenian orators and writers. Lysias, Plato, Isocrates, Demosthenes, Lycurgus—all knew the Peace of Callias (they could consult the stele), all praised the magnificence of the Athenian achievement; and the reputation of the Spartans, who had betrayed the Hellenes, suffered. The Peace of Callias, now recognised as the acme of Athenian leadership of the Hellenes, came to occupy its merited place in the historical tradition, which looked back to an ennobling Athenian past. The evidence for the Peace, in fact, is overwhelming.

Aelius Aristeides, writing his homage to the Athenians (with consequent deprecation of the Spartans) about A.D. 170, gave free rein to his rhetoric: "The King yielded to the city so far . . . that he surrendered the whole coastal region, tens of thousands of stades in Asia, quite enough, all told, to constitute a great empire. And so not only were the islands and the Hellenes of all sorts living in them free but the Hellenes inhabiting his territory were further from his power and dominion than the Hellenes in Old Hellas had been earlier."

Perhaps Thucydides failed to recognise the magnitude of accomplishment: he died too soon. Even so, the Peace was a vitally important step in the Athenians' growth of power and we may fairly tax Thucydides with having missed it; such diagnosis is as a rule part of his strength in the writing of history.

Athenian statesmen, men like Pericles, had little time for self-praise: for them a growing problem had become a crisis.

VIII

THE PANHELLENIC CONFERENCE

In 478/7 the Confederates had agreed to contribute ships or cash to the offensive crusade against the Persians. They had also sworn to have the same friends and enemies until the iron should float, that is, for ever. Now the war had been brought to a successful conclusion. They had not sworn to pursue the barbarian for ever or to contribute the *phoros* for ever. How then could the *phoros* be justified? That some of the Confederates entertained the question is proved by the defaulting that occurred in the spring of 449, to which List 5 attests. On the other hand, to have the same friends and enemies, that is, to preserve an offensive and defensive alliance, for ever is a credible, if idealistic, concept; and the iron was not yet afloat. Hellenic Asia was now free; how could a recurrence of Persian rule be prevented? The two questions curtly summarise the problem that faced the statesmen who looked to tomorrow. We may add an incidental query: what should be the disposition of the approximately 5,000 talents of the Confederates' money that had accrued over and above the costs of war against the Persians?

There were other considerations. During the generation that followed the historic meeting on Delos, the character of the Confederacy had been undergoing change, gradual, ineluctable. We have noted the steady commutation of contributions in ships and men to contributions in cash, with encouragement offered by Cimon. As Thucydides remarks, the allies tired of the incessant campaigning; the energetic Athenians did not. The quarrel with the Thasians in 465 had been an Athenian not a Confederate quarrel, although allies may have been present; there were certainly allies among the colonists dispatched to Ennea Hodoi. The war that erupted in 461 was an

Athenian war; but allies fought alongside the Athenians in some of the battles. Simultaneously, the Confederates, after accepting the invitation of Inaros in 460, campaigned for six years in Egypt under Athenian leadership; this was a genuine Confederate venture, in keeping with the original ambition. In 458 the Athenians were engaged on many fronts. Yet they apparently had no hesitation in ratifying an alliance with far-off Segesta in Sicily. Four years later the Confederate funds stewarded on Delos were brought to Athens where a new system of assessment and booking was devised; I have already commented on the dimensions of the stele that was commissioned to carry the annual record of the quotas. The Athenians were looking to a distant future. The revolts of Miletus and Erythrae were quelled and the settlements brought with them constitutions imposed by the Athenians and Athenian officials in residence.

The assessment of 450, in which no major change of scale is perceptible, incorporated further innovations in the status of the allies. The remaining naval members, with the exception of the three large islands (Lesbos, Chios, and Samos, which never paid cash) and Potidaea (which had certainly converted to money by the next assessment, in 446/5), were included in the rolls. Three of the thirteen (Andros, Keos, and Seriphos) had in fact sent cash earlier in the year, in time to be booked in List 4. We may perhaps recognise Cimon's persuasion on his final voyage to Cyprus.

In the same year the Athenians introduced the policy of planting cleruchies in allied territory. The cleruchy was a special type of colony, unique to Athens. Unlike the colonist, who participated in the founding of a new polis, the cleruch retained his Athenian citizenship and therefore his membership in deme and tribe. He occupied land expropriated from the allied state, which was normally granted a reduction in its assessment, and paid no tax to that state. Cleruchs were drawn largely from the hoplite-class, although Athenians of the lowest class (the thetes) may have been accepted and thus enabled to raise their status by the possession of land. In 450 cleruchies were placed on Lemnos (where they strengthened the already loyal colonists of an earlier generation), Andros, Naxos, and Carystus. The policy was continued in the ensuing years. We may look upon these settlements as potential garrisons, placed at strategic points, where there had been or might be dissatisfaction with Athenian domination. There is little doubt that the allies resented what they regarded as an intrusion on their land.

Finally, the Peace of Callias had been negotiated by the Athenians, not by the Confederates, although the latter, to be sure, were beneficiaries. The days when policy was formed in common synods on Delos were over.

Thus, when Callias returned from Susa in 449, "Confederacy" had in practice become an anachronism. The Athenians' awareness of their dominant position was no doubt accentuated by their winning of a sphere of

control by land as the result of their hostilities with the Peloponnesians and their allies during the past decade. Some, undoubtedly, were reluctant to cede the power and, an influential factor, the prestige that had accrued to the polis.

Specific action was initiated by Pericles who, as a *strategos,* could put proposals before the Council; he represented an important body of Athenian thought. I quote the words of Plutarch, who either saw the document (engraved on a stele) or used the work of a predecessor who had seen it: "Pericles moved a decree to invite all Hellenes, wherever resident, in Europe or in Asia, the small community as well as the large, to send to Athens for a conference delegates who would deliberate about (1) the Hellenic sanctuaries that the barbarians had burned; (2) the sacrifices that they had vowed to the gods when they were fighting the barbarians and that they now owed on behalf of Hellas; and (3) the sea, in order that all men might sail it without fear and keep the peace." The Ecclesia voted the decree (spring 449) and, probably at the same time, proclaimed a moratorium in the *phoroi* due next spring (448); but current obligations must be met and arrears paid. Thanks to the moratorium, no *phoroi* were delivered in 448; this explains the gap in the annual records of the quota and the absence of a sixth list.

So wide was the area covered by the invitations that twenty men were required to share the burden of delivery. Word reached the members of the Confederacy and "the Hellenes," Dorian and Ionian, who had resisted the Persian a generation earlier. The Athenians' new allies in central Hellas were included; most of them were members of the Delphic Amphictyony, with whom the Athenians had signed an alliance soon after the battle of Oenophyta (458). The association of Amphictyones ("dwellers round about"), originally a religious organisation, shared responsibility for the safety of the shrine at Delphi and over the years had acquired political importance. The proposed conference had no precedent in its scope. Apart from the extensive list of invitations, the agenda themselves promised vital debate that would affect all Hellenes.

According to a story that circulated in a later age, the Hellenes after the battle of Plataea vowed that they would not rebuild the temples burned by the Persians but would leave them as a monument to the sacrilege committed by the barbarian. The defences of Athens, as we have observed, were hastily reconstructed in 479. Yet in the north wall of the Acropolis the architectural blocks and, especially, the row of column-drums, which the eye cannot miss, persuade the viewer that the placement was deliberate. These fragments of the recently-built temple of the Goddess were intended to serve as a long-lasting memorial of which all would be aware. For a generation the citadel housed ruins. If the story is authentic (the long neglect of the Acropolis tempts one to believe it), the first item on the agenda of the

conference implies a renunciation, or at least a re-interpretation, of the vow. To the Athenians it had become essential that the Acropolis be rebuilt, just as the cities and churches of Britain and Europe were rebuilt or replaced after 1945; other states of Hellas that had suffered would, it was presumed, agree. The second clause, a wholly natural stipulation, reminds us of the services of thanksgiving convened throughout the civilised world in 1945. But the third clause, "the sea, in order that all men may sail it without fear and keep the peace,"—this was statesmanship of a very high quality indeed. We may look upon it as an early bid for that "common peace" that becomes so familiar a quest in the international chaos of the fourth century B.C. We might also glance at the Charter of the United Nations: "We, the peoples of the United Nations, [are] determined to save succeeding generations from the scourge of war . . . to unite our strength to maintain international peace and security . . . to ensure, by the acceptance of principles and the institution of methods, that armed force shall not be used, save in the common interest."

The Athenians, appreciating what Confederate action had accomplished in the past, were now contemplating what a like coalition might effect in the future by the maintenance of peace in the Aegaean. There were two issues. First, as perceptive statesmen realised, it was not sufficient to have forced the King to sue for peace and created a Hellenic world shorn of Persian warships and arms. The freedom won by a generation of persistent campaigns must be made permanent. There must be a force, a navy "in being," preferably supported, at home if not actually at sea, by an alliance of Hellenes with a common purpose. To be fully armed is to discourage hostilities by others. As for the Athenians—and, undeniably, they had intensely personal interests—,twice had they evacuated Athens and Attica, twice had their crops been lost and their citadel pillaged; it must not happen again. United action had freed the Hellenes; could united action perpetuate that freedom for the foreseeable future?

We may here take advantage of knowledge denied to the Hellenes of the mid-century, our knowledge of what was to come. The Persians had been driven from Hellas; the rest of their empire in all its might lived on, the neighbour of the Hellenes. After the collapse in Sicily (413), when the Athenians were threatened by the dissolution of their Empire and Ionia became the naval theatre of war (412), the satraps in Asia Minor at once intruded in Hellenic affairs. The Persians had waited; then, and not until then, they saw their opportunity to regain their losses.

Second, the quarrelsome record of the states of Hellas offered little ground for optimism or for any expectation that the end of the war with the barbarian would be followed by an era of peaceful intercourse among Hellenes. The wording of the decree moved by Pericles entitles us to surmise

that the Athenians who supported him, encouraged by their recent victory but aware of their precarious relationship with the Spartans and their allies, were grasping for the "common peace" for which so many Hellenes longed after the Great War.

We are restricted to speculation, for the Spartans (and in consequence the Dorian Hellenes) declined the invitation. No doubt they were reluctant to acknowledge in any way Athenian leadership in piety to the Gods (clauses 1 and 2) and in a common foreign policy (clause 3). The Panhellenic Congress, which to some promised so much, was aborted.

Thus, the bid for collaboration and a stable future for the states of Hellas had failed utterly, and the Athenian advocates of the enterprise were left disappointed. Cynical critics argue that the Spartans could not possibly have demeaned themselves by attending the conference in Athens and that Pericles and his friends were convinced of this. The interpretation, for which there is not a hint of evidence, attributes extraordinary—even incredible—guile to Pericles. Why should we deny to men, even if as leaders they are subjected to harsh scrutiny, the noble motive, an ambition on behalf of their fellow-men that is perhaps idealistic? It would be equal folly to deny that the Athenians as a body, having experienced a generation of *hegemonia* in which a genuine Confederacy had evolved more and more into an Athenian Alliance, were averse to the surrender of a position that brought with it prosperity and prestige.

The signing of the Peace of Callias, as we have observed, initiated a crisis. The proposals for the Congress had been foiled; the crisis remained.

IX

A NEW IMPERIALISM

The Athenians did not hesitate. If their neighbours held aloof, they would make their own decisions, not merely for their own future but for the future of the Aegaean world. The first step, of enormous significance, was to vote a resumption of the *phoros,* a term that we may now accurately render as "tribute." Superficially, this might be related to the third item on the agenda of the Conference, for the money would provide for the fleet, which would police the seas. In fact, it would do more than that.

By a stroke of good fortune we possess a fragment of papyrus that preserves excerpts from an ancient commentary on a speech by Demosthenes in which the orator looks back at Athenian activities of a century earlier. From the secure part of the text (the left-hand side of the column has perished) we learn that in 450/49, on motion by Pericles, the Athenians voted to transfer 5,000 talents of accumulated *phoros* from the *demosion,* the public treasury, to the Acropolis, that is, to the Treasury of Athena. The transaction is associated in the document with a major programme of building on the Acropolis, which thus could draw upon the funds. Responsibility for the construction of new ships annually is placed with the Boule and again the costs are to be met by the *phoros.* The damaged papyrus has been subjected to intensive study, and restoration has been aided by other evidence, especially two Athenian financial decrees moved by Callias (the financier, not the peace-maker) in 434/3. If we adopt the most persuasive of the restorations and interpretations we can, with reasonable confidence, further reconstruct what happened in 449: the 5,000 talents were to be presented to Athena on her birthday (Hekatombaion 28, mid-summer) at the time of the

Panathenaic festival; an additional 200 talents of the *phoros* were to be deposited in Athena's treasury annually, beginning in the following year, until a total of 3,000 talents had been reached (the Decrees of Callias show that the intention was realised).

The so-called Papyrus-Decree, securely dated by the archon's name, was passed very soon after the collapse of the proposed Panhellenic Conference, before the New Year's Day of 449/8. Its information is of inestimable value. The architectural plans were already under discussion; the funds would come from the amassed *phoroi* and from those that were to come. The 5,000 talents did not exhaust the balance and the release of 200 talents annually would not embarrass the Hellenotamiae, who stewarded the imperial funds. There would remain plenty to underwrite the current expenses of the fleet and the construction of new triremes. The Athenians would retain the allegiance of their maritime allies, resist aggression, and guarantee peace. The resumption of the *phoros* and the programme embodied in the Papyrus-Decree proclaim, overtly, that the Confederacy had become Empire, the *arche,* as the Athenians (and other Hellenes) called it later.

During the same summer (449) the Athenians passed a decree, moved by Clearchus (of whom we know nothing else), that banned the minting of silver in the cities of the Empire and insisted upon the adoption of Attic coins, weights, and measures. A copy of the decree was to be set up in each city. Of these copies seven fragments have been reported: two (now lost) from Syme, an island off the Carian coast, one from Kos (an island north-west of Syme), one from Chalcidic Aphytis (on the east coast of the peninsula of Pallene), one (now lost) from Cycladic Siphnos, one (now lost) from Ionian Smyrna, one brought recently to Odessa (on the north-west coast of the Black Sea). Not all were the original homes, for Smyrna did not exist as a city in the fifth century and Odessa was not in the Empire. Nothing survives of the initial clauses of the decree, which must have specified that henceforth Attic coinage was to be the medium of exchange throughout the Empire, but the seven fragments, which concern the details of the exchange, allow the reconstruction of a composite text, from which I quote the relevant passages.

"The Hellenotamiae are to make a list of the mints in the cities. [Severe penalties are prescribed for those in the cities who fail to observe the Athenian decree.] In the mint in Athens the supervisors, having received the silver, are to remint no less than half and return it in order that the cities may have sufficient cash. The supervisors henceforth are to exact a fee of three per cent. The other half is to be exchanged within five months or the supervisors are to be liable to prosecution according to the law. The surplus of the exacted silver is to be minted and handed over either to the *strategoi* or to the superintendents of public works. When the money is so transferred a temple and an altar for Athena and Hephaestus are to be built on Colonus. If any

man moves or puts to a vote a motion that these funds can be used for any other purpose, he is at once to be surrendered to the Eleven [in charge of prisons and executions] and the Eleven are to put him to death. . . . The Demos are to select heralds to announce to the cities the terms of this decree, one to the Islands, one to Ionia, one to the Hellespont, one to the Thraceward region. The *strategoi* are to prescribe their routes individually and dispatch them; in case of failure, each shall be liable to a fine of 10,000 drachmae. The local *archontes* in the cities are to inscribe this decree on a stone stele and set it up in the agora of each city; the supervisors in Athens are to erect it in front of the mint. . . . In the future the secretary of the Boule is to add to the oath taken by the Boule these words: 'If anyone mints silver coinage in the cities or does not use the coinage of the Athenians or their weights and measures, I shall punish him and fine him according to the present decree that Clearchus moved.' It is to be possible for anyone to submit the foreign silver that he possesses and exchange it on the same terms at his convenience. The city is to return to him Athenian currency. He is himself to bring his money to Athens and deposit it in the mint. The superintendents are to make a record of what is submitted by each man and set it up on a stele in front of the mint for examination by anyone who wishes; they are to record the sum of foreign currency, the silver and gold separately, and the total of Athenian currency."

The Papyrus-Decree concentrated upon Athens and her internal development. The Decree of Clearchus, on the other hand, affected all the cities of the newly proclaimed Empire. It amounted to the first blatant infringement of their autonomy.

Implementation could not have been easy. Our judgement is hampered by our ignorance of the coinage of many states. Nonetheless, studies of the mints that have been carried out show, in the words of one numismatic authority (E. S. G. Robinson), "a sudden and practically universal stoppage in the forties." The transaction of business in the Aegaean, where previously a multiplicity of coinages had circulated, must have been refreshingly eased. Whether the allies fully appreciated such interference by the Athenians in their domestic affairs is another question. Reaction was probably mixed.

The decree also proffers welcome information about the building of the Hephaisteion (Hephaesteum), the temple to Athena and Hephaestus that sits so remarkably well preserved on the low hill called Colonus that overlooks the Agora on the north-west (Kolonos Agoraios). The agio charged by the Athenians for the reminting of allied coinage would contribute to the costs of construction. The decree belongs to the year 449 and the archaeologists assure us that this is the right date for the inception of work on the temple. The first epigraphic accounts for the Parthenon are dated to 448/7; the Hephaisteion was already under way, although the final elements (such

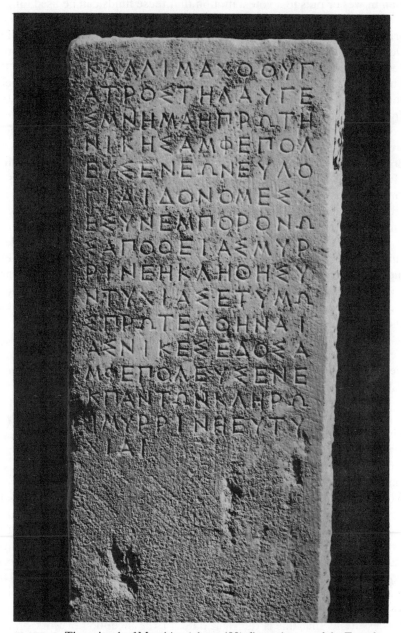

PLATE 3. The epitaph of Myrrhine (about 400), first priestess of the Temple of Athena Nike.

EPIGRAPHIC MUSEUM

as pedimental sculpture, acroteria, cult-statues) were not added until after the Peace of Nicias (421). The Acropolis was given priority. The architect of the Hephaisteion won the admiration of his fellow-citizens, for it was he who designed the temples to Poseidon at Sunium, to Ares at Acharnae, and to Nemesis at Rhamnous, all of which were erected during the next two decades.

The conviction that the Athenians at this time eagerly adopted the comprehensive and ambitious plans put before them for the adornment of their polis is strengthened by still another inscription. As the visitor climbs the winding path to the Acropolis today, a glance upward discloses the temple of Athena Nike, the Victorious Athena, perched like a miniature on a projecting bastion. The decree, passed about 448, authorises the architect Callicrates to design a door for the precinct and to present his plans for the temple and a stone altar to the Boule. A priestess, chosen from all Athenian women, is to be appointed and paid an annual salary of 50 drachmae. The reverse of the stele is occupied by a decree of 424/3. In what is preserved the salary is confirmed; the lost section certainly dealt with the temple. Surprisingly, we know the priestess, Myrrhine, for we have her metrical epitaph, which was engraved at the end of the century. She has been identified with the Myrrhine of Aristophanes' *Lysistrata* (produced in 411). As it turned out, the temple was not built until the mid-420s: a topographical dispute involving the Propylaea postponed construction.

Although work on the Parthenon did not commence until 448/7, we may be sure that Athena's House, which was to crown the Acropolis, had been the subject of discussion for some time. The Papyrus-Decree, of course, reveals that a major programme was taking shape soon after the Peace of Callias.

The Athenians had to wait until the spring of 447 for the material reaction of the allies to the reimposition of *phoros*. The results were disappointing. List 7 records 133 payments delivered before the Dionysia, the due date; by comparison the smallest number in neighbouring lists is 150. Of the 133, twelve are partial; demonstrably, there were absentees. So the allies had not yet been won over to the new policy.

It was a critical moment for the Athenians, who met the challenge firmly, by legislation and, no doubt, by naval persuasion: the allies must be taught that they meant business. The decree moved by Cleinias (father of the notorious Alcibiades) very soon after the Dionysia deals comprehensively with what were to be the permanent obligations of the subject-allies.

"The Boule and the *archontes* in the cities and the overseers are to ensure that the *phoros* is gathered annually and brought to Athens. Seals are to be fashioned in conjunction with the cities in order that it may be impossible for the tribute-carriers to do wrong. Each city is to enter in an invoice the

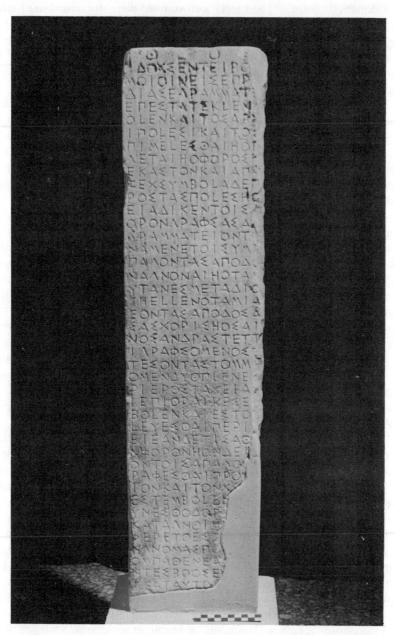

PLATE 4. One of the four surviving fragments of the decree of Cleinias
voted in 447 to strengthen regulations for the collection of tribute.
EPIGRAPHIC MUSEUM

amount of tribute that it is dispatching and, having sealed the invoice, is to send it to Athens. The carriers are to surrender the invoice in the Boule to be read when they deliver the *phoros*. After the Dionysia the prytaneis are to convoke a meeting of the Ecclesia for the Hellenotamiae to reveal to the Athenians those of the cities that have paid the *phoros* in full and, separately, those that are in arrears, however many they may be. The Athenians are to choose four men and send them to the cities to give receipts to those that have paid the *phoros* and to demand what has not been paid from the defaulters; two men are to sail to the Islands and Ionia on a swift trireme, two to the Hellespont and Thrace. These agenda the prytaneis are to lay before the Boule and the Demos immediately after the Dionysia and they are to be debated continuously until the business is completely transacted. If any Athenian or ally commits misconduct in connexion with the *phoros* that the cities must transmit to Athens by the carriers after entering the amount in the invoice, he may be indicted before the prytaneis by any Athenian or ally who is willing to lay information. The prytaneis are to introduce into the Boule the indictment that anyone may bring or each prytanis is to be fined 10,000 drachmae. When the Boule finds a true bill against a man, it is not to have the authority to set the punishment but it is to refer him at once to the heliaea. When he is convicted the prytaneis are to propose a suitable physical or financial penalty. And if any man commits wrong in connexion with the transport of the cow or the panoply, his indictment and punishment are to be governed by the same regulations. The Hellenotamiae are to inscribe on a whitened tablet and publish both the assessment of the *phoros* and those cities that pay in full. . . . In addition the Boule entering office are to deliberate concerning the tribute-carriers. All the carriers of tribute to Athens who have been inscribed in the tablet in the Boule as in default are to be reported by the Boule to the Demos city by city. If any city appeals concerning the payment of the tribute, claiming that it has paid. . . . "

The Athenians resolved not only to enforce discipline now but also to provide for the future, placing the responsibility henceforth for the assembling of the tribute and its shipment to Athens squarely on the shoulders of the local magistrates, establishing regulations to ensure the honesty of the carriers, and specifying severe penalties for crimes involving the tribute. It is of interest to learn that the tributary cities are to have the status of Athenian colonists in that each city is required to present a cow and a panoply to Athena (at the Panathenaic festival). The last dozen lines of the text are fragmentary but sufficient is extant to show that they dealt with procedures for appeals, with erring carriers, and with "the current tribute and last year's."

In the last column of List 7, under the heading "After the Dionysia," are entered nine complete payments. These reached Athens late, but before the

end of the fiscal year, in time for inclusion in the receipts of 448/7. They reflect either simple tardiness or a notably quick response to the Decree of Cleinias. The most spectacular witness to the success of the Athenians' enactments, however, is List 8 (spring, 446). It contained about 213 entries. A number of cities pay more than once, to discharge current obligations and to meet the arrears of the previous year, arrears complete or partial. A score or so that are absent from List 7 make complete payments. In a few cases sums are acknowledged that have been supplied to Athenian officers in the field, at Eion (at the mouth of the River Strymon) and Tenedos (the island off the coast of the Troad south of the Chersonese). The presence of these naval detachments is to be explained partly by the continued disturbances engendered by Thracian tribes and by Persian guerrillas in the Hellespontine district and partly by the desirability of maintaining surveillance of the route travelled by the grain on its way from the Euxine. Athenian officers had no doubt been ordered in addition to enforce the provisions of the Decree of Cleinias.

The Athenians' intention to acquire a foothold in Thrace in the 460s had been foiled by the Edonians. Now they placed a colony at Brea, on or near the upper Strymon in the district called Bisaltia; the assessment of neighbouring Argilus was lowered. The document (on stone) authorising this colony will be discussed in a later chapter.

In the Thracian Chersonese the Athenians answered the threat, whether of disaffection or of the Persian irregulars, by the organisation of a cleruchy. In the quota-lists the ethnic term Cherronesitai had covered the payments of Agora (the "capital") at the neck, four poleis of the peninsula (Elaeus, Madytus, Sestus, Limnae), and the island of Imbros. This type of collaboration (there are several instances in the records) was called a syntely (*synteleia*, a group paying jointly). Now the syntely was dissolved into its component units and the total assessment reduced from 18 to no more than 3 talents. At the same time a cleruchy arrived on Imbros.

An inscription of this very year (447/6) bears witness to troubles in Ionian Colophon, which lay a short distance inland from the coast at Notium. Colophon had paid a tribute of 3 talents in the first assessment-period (Lists 1-4); in the second (Lists 5, 7, 8), however, she defaulted. This recalcitrance may have taken the form of active revolt. The fragmentary inscription tells us that Colophon, having come to terms, agreed to the planting of a colony on her territory. Colophon resumes her payments in List 9, with an assessment of 1½ talents; the reduction was intended to balance the loss of the colonised land. The colony also impinged upon the property of neighbouring Lebedus and Dios Hieron, both of which are named in the inscription. The two poleis had paid regularly in the first and second periods (454/3-447/6). Now, each was granted a reduction, Lebedus from 3 talents to 1, Dios Hieron

from 1,000 drachmae to 500. The latter in fact received total exemption from the *phoros* in the third period (Lists 9-11).

Yet another inscription, this time a dedication, seeks divine favour for a colony on the Erythraean peninsula. The Erythraeans, who, as we have seen, had revolted in the mid-450s, had been assessed for 9 talents. In 449 (List 5) their first payment was very small indeed and the balance reached Athens late in the year. Along with others the Erythraeans were unwilling to contribute to a war that seemed to be over. They submitted the assessed amount in 447 (List 7) but in the next year (446) the booking of the 9 talents in two instalments implies a persisting reluctance. The Athenian solution was to settle a colony near the city and reduce the assessment to 7 talents, a sum that was forthcoming regularly for a decade.

The decree concerning Colophon gives the wording of the oath to be sworn by the Colophonians. They are to swear loyalty to the Demos of the Athenians and to the colony and to the democracy that had been imposed. In the regulations voted for Erythrae earlier, after the revolt, the Erythraeans are to swear loyalty to "the allies of the Athenians." The absence of this clause in the case of Colophon is a subtle acknowledgement of the emergence of imperial Athens and the altered relationship with her allies.

The inscriptions, fragmentary though they be, enable us to recreate what was happening in these critical years in which the literary sources fail us. Evidently the Athenians met resistance, if not outright revolt, in their determination to re-impose the tribute and so to prolong the life of the transformed Confederacy. The hostility is reflected by the many irregularities in Lists 7 and 8. In most cases all that was needed to exact the amounts owed was a manifestation of power. Where the danger seemed more serious, whether because of defiance or because of a foreign menace, the Athenians resorted to the cleruchy or the colony. The terms of the Peace of Callias forbade the installation of overt garrisons; this is why colonies, not cleruchies, were founded in Asia. Colony or cleruchy, the settlement was accompanied by a reduction in tribute for the polis whose land had been expropriated. The lowered assessments in List 9 suggest that the Hellenes of the Aegaean had witnessed the birth of more communities than we can identify.

Along with all this Athenian energy we must not under-value the testimony of the lengthy and unorthodox eighth quota-list. It assures us that the Athenians had attained success in convincing the allies, by persuasion or by force, that they must heed the directions of the Athenian Demos, that they were now obedient members of the Athenian Empire, the *arche*. The delivery of the tribute at the Dionysia, the festival of Dionysus, in the spring of 446 tied up the loose ends.

List 9 of 445 is "normal" in its composition and establishes a pattern that endures for many years. The obstacles encountered in transforming Confederacy to Empire had been comprehensively surmounted.

X

FROM ARMISTICE TO PEACE

We have examined the boldly innovative resolutions entertained by the Athenians in the aftermath of the still-born Panhellenic Conference. Their preoccupation with the ambitious proposals put before them by Pericles and his colleagues did not dim their awareness of their delicate relationship with their neighbours on the mainland and their interests further from home.

The Athenians had, probably in 450 before the death of Cimon and possibly at his behest, entered into an alliance with Hermione, a Dorian city on the southern coast of the Argolid. A few months earlier (451) the Spartans had not only agreed to the armistice of five years with the Athenians; they had also reached a thirty-year concord with the Argives, who were hostile to Hermione. The Athenian inscription does not preserve the terms of the alliance. Presumably, the Athenians looked on Hermione as a base of sorts to replace their treaty with the Argives. The Spartans, surprisingly, expressed no open objection.

The invitations to the Congress were still topical when the Lacedaemonians took the field to initiate what Thucydides describes as "the so-called Sacred War" (summer 449). Communication between north and south had been difficult for the Spartans during the recent war; this time, apparently, they took advantage of the "cease-fire" laid down by the armistice and crossed the Gulf on ships provided by the Corinthians. In a brief campaign they seized the sanctuary at Delphi from the Phocians and placed it under the control of the Delphians. There are two comments to be made about this act of aggression, at first sight so uncharacteristic of the Spartans, who as a policy customarily resisted efforts to lure them far from home. First, they had

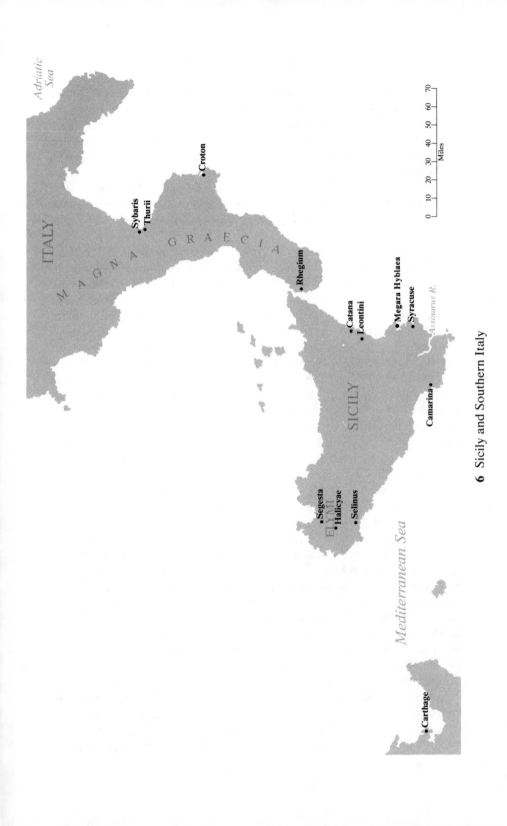

6 Sicily and Southern Italy

inherited the long tradition of an especially close relationship with Delphi. Second, the present action may be interpreted as an indirect reply to the recently issued invitation of the Athenians. The Spartans resented, even feared, Athenian influence at Delphi and primacy within the Amphictyony; the Phocians, after all, were allied to the Athenians, whose pact (of 458) with the Amphictyones, so far as we know, remained valid. The Amphictyony had originated in the long ago as a religious league. By now the twelve members from central Greece, meeting twice a year with two delegates from each state, had become strongly political. And invitations had gone to all of them.

Within the next year (448) the Athenians, their interests in the West re-awakened, entered into alliances with Ionian Leontini, in Sicily not far from Dorian Syracuse, and Rhegium, on the toe of Italy. In each case (we have fragments of both) the agreement is to last "for ever," and in each case the decree of ratification is moved by Callias, the same son of Hipponicus who had negotiated the treaty with Persia. The knowledge that the Athenians were already in alliance with Sicilian Segesta (458/7) further whets our appetite for knowledge of Athenian aspirations in the West in mid-century.

In the summer of 447 the Athenians, somewhat belatedly, reversed the Spartans' intercession at Delphi when an expedition of their own commanded by Pericles restored the sanctuary to the Phocians. Thucydides' single-sentence notice of move and counter-move at Delphi is little more than a footnote. Apparently the armistice had not officially been infringed, even though on each occasion a military force had imposed its will.

The clash, however, was not long delayed. The armistice was due to expire in the summer of 446. A month or two earlier a group of Boeotian exiles, that is, oligarchs displaced by the Athenians, occupied Orchomenus, Chaeroneia, and a few other Boeotian towns. Thereupon Tolmides led an army of 1,000 Athenian hoplites with allied contingents against these malcontents, took Chaeroneia, enslaved the inhabitants, and installed a garrison. On their way home Tolmides was attacked at Coroneia and defeated by a combined force of exiles from Orchomenus, Locrians, Euboean fugitives, and others of like political views. Athenian losses were heavy (Tolmides himself and Cleinias, whose administrative decree has been quoted, fell in the fighting) and some were taken alive. The Athenians by agreement abandoned Boeotia and recovered the prisoners. The exiles now returned and the Boeotians won back their autonomy. By the decisive battle of Coroneia the Athenians had lost control of affairs in central Greece.

Further crises ensued, just as the armistice ran out. First, Euboea revolted, a major defection, for this was the "home" island, a vital Athenian base. Evidently all the current tributaries, nine in number, joined the uprising. Probably the Chalcidians and Eretrians took the lead, although, to judge

from the punishment meted out afterwards, the Hestiaeans, on the northern tip of the island, must have been prominent. The revolt must have been simmering for some time since collaborative action requires planning. That the Athenians had not been without their suspicions is implied by the cleruchies that Tolmides had recently planted in Chalcis and Eretria, possibly as a preliminary to his campaign in Boeotia. And we have identified Euboeans among the plotters there.

The Athenians lost no time in detailing troops under Pericles to bring the Euboeans to heel. He had just crossed the strait to the island when an urgent message of recall reached him. The Megarians had invited the assistance of the Corinthians (their quarrel with whom had begun the war in 461), the Sicyonians, and the Epidaurians, and had then massacred their Athenian garrison, save those who escaped to Nisaea, which was still in Athenian hands. Even more serious, the Peloponnesians were reported to be on the point of invading Attica. Pericles and his army returned forthwith to deal with these two crises.

The Peloponnesians were commanded by the Spartan king Pleistoanax, whose youth was fortified by the presence of Cleandridas, an experienced officer. The invaders, ravaging the countryside, reached Eleusis and Thria, thus blocking the main road from Athens to the south and isolating the Athenian survivors in the Megarid. Then, surprisingly, they turned for home. It was charged later that Pericles had bribed Pleistoanax. The latter, in any case, was heavily fined; because he was unable to pay, he withdrew to Arcadia and did not reappear for twenty years. Cleandridas fled and was condemned to death. Plutarch adds an interesting anecdote: when Pericles rendered his accounts, he included an item of 10 talents "for necessities"; the Ecclesia, untypically, accepted the claim. Anecdotes are sometimes true.

The threat to Attica having been dissolved, Pericles was ordered back to Euboea, where the Athenians quickly reduced the whole island. With most Euboeans satisfactory agreements were reached. Additional cleruchs were settled in Chalcis and Eretria and hostages were taken as collateral for good behaviour. The Hestiaeans suffered more severe retribution: they were expelled from their land and the site was appropriated for Athenian colonists.

The visitor to the Acropolis Museum today may examine at his leisure the marble stele set up late in 446 on which the oaths to be exchanged by the Athenians and the Chalcidians are inscribed, along with a rider bearing the Athenian reply to representations by the Chalcidians concerning the main terms of settlement. These were cut on a stele that was originally locked to the left-hand side of the extant monument. What we have is a rare document, for it has withstood the passing centuries without serious damage; only a few scattered letters are illegible and not a single word depends upon restoration. Because it is complete and because it tells us something of the relationship

between imperial Athens and a rebel city that has been recovered, I quote it in its entirety.

"Resolved by the Boule and the Demos, Antiochis held the prytany, Dracontides presided, Diognetus made the motion: the Boule of the Athenians and the dicasts are to swear the oath in the following terms: 'I shall not drive the Chalcidians from Chalcis nor shall I raze their city nor shall I disfranchise any private citizen nor shall I punish him with exile nor shall I arrest him nor shall I execute him nor shall I deprive him of his property untried without the consent of the Demos of the Athenians, nor shall I put a motion to the vote against a party without a summons to attend trial, whether the party be the state or any individual whatever; and when an embassy arrives I shall introduce it to the Boule and the Demos within ten days when I am serving in the prytany, in so far as is within my power. All this I shall guarantee the Chalcidians so long as they are obedient to the Demos of the Athenians.' An embassy coming from Chalcis, along with the *horkotai* [the board that administered oaths at Athens], are to swear the Athenians to the oath and are to record the names of those who have sworn. It is to be the responsibility of the *strategoi* to see that all swear the oath.

"The Chalcidians are to swear the oath in the following terms: 'I shall not revolt from the Demos of the Athenians either by guile or by any device whatever, either in word or in deed, nor shall I yield to one who revolts; and if anyone does revolt I shall denounce him to the Athenians. And I shall pay to the Athenians the tribute that I persuade them is just to assess and I shall be as far as I possibly can the best and the most conscientious ally. And I shall bring aid to and defend the Demos of the Athenians if anyone wrongs the Demos of the Athenians and I shall heed the wishes of the Demos of the Athenians'. All adult Chalcidians are to swear the oath. Whoever fails to swear is to be stripped of his citizenship, his property is to be confiscated, and a tithe of his property is to be consecrated to Olympian Zeus. An embassy of Athenians journeying to Chalcis, along with the Chalcidian *horkotai*, are to swear the Chalcidians to the oath and are to record the names of the Chalcidians who have sworn.

"Anticles made the motion: with Good Fortune for the Athenians, the oath is to be sworn by the Athenians and the Chalcidians just as the Demos have voted it for the Eretrians. That the transaction may be completed with all possible speed is to be the responsibility of the *strategoi*. The Demos are at once to choose five men who will journey to Chalcis and administer the oath. Concerning the hostages, reply is to be made to the Chalcidians that for the present the Athenians are resolved to leave the question in accordance with what has been voted. When the time seems right, after deliberation they will make the exchange in terms that suit the Athenians and the Chalcidians. As for the aliens who live in Chalcis and do not pay taxes to

Athens, with the exception of those granted immunity by the Demos of the Athenians—the rest are to pay taxes to Chalcis like the other Chalcidians. At Athens the secretary of the Boule is to record this decree and the oath on a marble stele and place it on the Acropolis at the expense of the Chalcidians; in Chalcis the Boule of the Chalcidians are to record it and place it in the sanctuary of Olympian Zeus. This procedure is hereby voted for the Chalcidians. Hierocles and three men chosen by the Boule from their own ranks are as quickly as possible to perform the sacrifices on behalf of Euboea that arise from the oracles. The *strategoi* are to collaborate in seeing that the sacrifices are offered with all possible dispatch and are to furnish the money for the operation.

"Archestratus made the motion: all this is to be as Anticles has put it, but the hearings of charges by Chalcidians against their own citizens are to take place at Chalcis just as charges against Athenians take place at Athens, except for charges involving exile, execution, and loss of citizenship. For these there is to be appeal to the heliaea of the *thesmothetai* [the six "junior" archons] at Athens in accordance with the decree of the Demos. The *strategoi* are to exercise supreme care for the defence of Euboea in order that conditions may be as advantageous as possible for the Athenians."

Of the contemporaneous decree regulating the affairs of the Eretrians, to whom reference is made by Anticles, we have a single damaged fragment carrying part of the oaths. The Chalcidians and Eretrians received similar treatment. At the re-assessment of 446, the tributes were lowered, in recognition of the appropriation of land for the cleruchs conducted by Tolmides. The additional cleruchs did not arrive until late in the year after the recovery of the island.

To Chalcis and Eretria (and to most of the other tributaries) the Athenians had not been harsh or vengeful. The tone of the long inscription about Chalcis, though firm, is pleasant enough. A polite answer, promising reconsideration in the future, is given to Chalcidian inquiries about hostages; the taxable status of aliens (not Athenian cleruchs, who are exempt in their new home) is clarified, in somewhat clumsy language; and it is laid down that in certain major cases, which, conceivably, could affect the Empire, appeal is to lie with the heliaea at Athens. In conformity with the new policy, the oath of loyalty is to be sworn to the Demos of the Athenians, not to the Athenians and their allies.

In the Euboean dispositions the exception was Hestiaea, which would now be an Athenian colony and so, according to custom, an independent polis not subject to tribute. As a rule a Greek colony established its own government and institutions; these would, not unnaturally, tend to reflect the familiar life of the mother-city. In the case of Hestiaea, however, the Athenians themselves took some of the requisite decisions from the hands of

the colonists. These were inscribed on both surfaces of a sizeable stele of which we have seven tantalising fragments, the largest housed in the British Museum. The losses are so severe that we cannot reconstruct a continuous text. We are sure that it was a comprehensive charter that dealt with the internal, especially the judicial, institutions and practices of the polis and its relationship with Athens. It laid down the fares for a triangular ferry-service connecting Oropus (on the mainland), Chalcis, and Hestiaea; and Dium and Ellopia, neighbours and perhaps dependencies of the old city, came in some way within the scope of the regulations.

In the late autumn or early winter of 446/5, soon after the suppression of the rising in Euboea, the Athenians signed a Thirty-Years' Peace with the Peloponnesians and their allies. In passing we observe with interest that Callias son of Hipponicus, who had already given his name to the Peace with Persia and the treaties with Leontini and Rhegium, had (appropriately, as the proxenus—"consul"—of the Lacedaemonians at Athens) served on the embassy that travelled to Sparta to conclude the Thirty-Years' Peace. By the terms the Athenians renounced all control over their recent gains, with the exception of Naupactus, which was their own colony, and Dorian Aegina. That commercial island, lying in the Saronic Gulf in sight of Peiraeus (gossip said that Pericles once called it the "eyesore of Peiraeus"), was to continue to pay tribute but the autonomy of the inhabitants was guaranteed. The Athenian Empire and the Peloponnesian League were reciprocally recognised and each side swore not to accept members who seceded from the other; but any state that was now a member of neither alliance was to be free to join either. In the future, controversies were to be submitted to arbitration.

The Athenians had been driven to the conviction of their inability to maintain a position of domination in central Hellas (Boeotia, Locris, Phocis). At best their hold had been tenuous: one battle (Oenophyta, 458) had won it; one battle (Coroneia, 446) had lost it. At the same time some credit is due to the statesmanship displayed in the cession of their holdings, whatever their nature, on the mainland. Henceforth, they would concentrate on the maritime Empire, which could be protected and policed, in peace, by the most powerful fleet in Hellas—and beyond Hellas to the east. The ungrateful Megarians returned to the Peloponnesian League; but the Athenians did not forget their treachery.

Before we turn our attention to the stable years of the new era, we should pause to reflect upon the prominence of Pericles in the turbulent period that we have just examined. He moved the invitation to the Panhellenic Congress and the agenda (spring 449); he moved the Papyrus-Decree (late spring 449); his was the brain that conceived the majestic programme of building; he directed the restoration of Delphi to the Phocians (447); he commanded the army that was first detailed to quell the revolt of Euboea (early summer 446);

he was recalled to deal with the Peloponnesian invasion; and he was ordered back to Euboea to complete the subjugation (late summer 446).

The legislative machinery at Athens required that a decree originate in the Boule upon motion by a *bouleutes* (councillor). To the orthodox procedure the *strategoi* became the exception. They exercised privileges that matched their vital responsibilities in the field and at sea: they could attend meetings of the Boule and propose recommendations (*probouleumata*) for translation into decrees (*psephismata*) by the Ecclesia. They were among the very few officials who were elected by direct vote and they were eligible for immediate re-election, wise constitutional procedure. Thus the *strategoi* were in a good position to become the advisers and leaders of the Demos at home. We know that Pericles was successful in winning election for the last fifteen years of his life (443-429). Since, in addition to the record cited above, he moved the decree of 451 concerning citizenship, it is all but certain that he was elected to the board (*strategia*) by his fellow-citizens from 451 to 446 inclusive. He was one of a board of ten; yet he was singled out for the campaign to Euboea, for the defence against Pleistoanax, for the return to Euboea. These tasks were all military and it was the Ecclesia that made the decisions. It is sometimes remarked that Pericles achieved no distinction in the field. The critical appointments made in desperate moments refute that opinion and justify the conjecture that from 460 he had seldom been out of office.

Such already was his reputation; such was the confidence that his fellow-citizens placed in him.

XI

THE ACME OF EMPIRE

The first *phoros* to be delivered to Athens arrived in the spring of 453 in response to an assessment drawn up in the preceding summer (454). That was a year in which the quadrennial Great Panathenaic festival was celebrated. That this assessment and the Great Panathenaea fell in the same year may have been no more than coincidence; if so, it was a happy one, of which the Athenians took full advantage. As the Confederacy evolved into Empire, more and more attention was focused upon Athena, the patron Deity, and her festival. As a rule, re-assessments would be undertaken in the years of the Great Panathenaea to coincide with that celebration.

As we have seen, the activities of the year 446 left the Athenians little time for leisure: the battles of Chaeroneia and Coroneia, revolt in Euboea and Megara, the Peloponnesian invasion, the reduction of Euboea, negotiations for peace. Nevertheless, the scheduled re-assessment was completed, probably before the envoys went to Sparta to negotiate the peace. The scrupulous care exercised by the assessors is proved by the payments of the next three years (Lists 9, 10, 11): in more than thirty cases assessments have been lowered, sometimes substantially. The Thraceward area in particular was the recipient of favoured treatment. The precedent laid down by Aristeides in 478/7 had been to assess according to the members' resources and ability to pay. That policy meant that assessments might vary from one time to another; thirty years later the Athenians were conscientiously maintaining the policy.

In the general trend to reductions there is one notable exception, the Thasians, whose figure leaps from 3 talents to 30 (the highest amount before

the Great War). When the Athenians quelled the island's revolt in 462, they confiscated rich Thasian holdings on the mainland opposite (the peraea, which included a mine) and imposed an assessment of 3 talents in cash in place of the ships that the Thasians had been contributing to the Confederacy. Now, in 446, the peraea was returned to Thasian control and the assessment was raised accordingly. The assessment of 30 talents, superficially startling, should not be branded as inequitable; rather, it deserves to be understood as a measure of the economic potential of the Thasian peraea.

The records of the second assessment-period (Lists 5, 7, 8) allow the deduction that the Athenians had been disturbed by conditions in Thracian Bisaltia, a district in the vicinity of the River Strymon, with its unreliable neighbours, Macedonia and the tribes of Thrace. We think that in 446 they sent a colony to Brea because we have fragments of the authorising decree. All the ancient geographers tell us about Brea is that it was in Thrace. It is a persuasive hypothesis that this colony is to be identified with the one mentioned by Plutarch as having been established in Bisaltia. If we accept the identification, then Brea can be recognised as an Athenian effort to plant a foothold in the vicinity of the upper Strymon. It will explain logically the simultaneous lowering of the assessment of neighbouring Argilus from 9,000 drachmae to 6,000 (1 talent). The decree possesses an interesting rider moved by a certain Phantocles in the Ecclesia: the colonists are to be enrolled from the thetes and zeugitae, the lower two of the four economic classes into which Solon had divided the citizens. This clause has often been associated with Plutarch's comment upon Athenian colonial enterprise in these years: Pericles "was responsible for this, thus relieving the city of a lazy and idly meddlesome mob, correcting the needy status of the people, and settling among the allies a formidable garrison that would deter them from rebellion."

Let us remember that not all the landless were poor and not all the poor were landless. Thetes, however, were by definition poor; many of them might have welcomed the opportunity to work small (or more fertile) estates. The zeugitae, on the other hand, formed the solid middle class, who could afford the costly armour that equipped them as hoplites. Plutarch's remark in fact gives a false impression of Athens in the 440s. Even in times of peace Athenian squadrons patrolled the sea (some surely remained on duty even in the months of winter); the majority of the rowers were of the thetic class. The building programme was begun early in the decade and brought with it many openings for employment. The imperial administration also drew a considerable number of Athenians into its service. Citizens of all classes drew their livelihoods in one way or another from the state. Plutarch himself puts into Pericles' mouth the phrase "a polis drawing pay." The unavoidable truth is that unemployment was not an Athenian problem in the imperial era.

The city was busy and so were its citizens—as well as its metics (resident aliens).

Plutarch has leapt to an anachronistic conclusion to explain the establishing of colonies and cleruchies. Yet the right explanation is present, at least partially, in his own words. The new foundations certainly discouraged thoughts of rebellion in the allied cities. They did more: with substantial cores of zeugitae they represented garrisons in being, protection against external dangers, especially on the periphery of Empire. Thrace and the Hellespontine Chersonese are manifest examples. The sensitivity of the Athenians to threats in the north is confirmed by a clause in the decree about Brea that refers to existing Regulations for the cities of Thrace requiring that in the event of attack they are to come to the aid of the colony and its territory. Military activity is to be reciprocal. The rider to the decree preserves an example of the freedom of expression that prevailed in the Ecclesia, where Phantocles, a man of the people, resentful on principle of those who were better off (today's "establishment"), in excluding them from the colony was merely stating the obvious: the colony would of course attract landless thetes; as for the zeugitae, their military potential was vital.

About this time (446/5) the Athenians, possibly on the advice of Pericles, devised a more compact defensive circumvallation by the erection of a south wall from Athens to Peiraeus parallel to the northern that had been constructed a dozen years earlier; the wall to Phalerum fell into disuse. A drawing of the revised walled complex of Athens and Peiraeus resembles, to the observer's eye, a giant dumb-bell.

In 446 the expelled people of Sybaris, on the south coast of Italy, invited the Athenians to assist them in the refounding of their city, which had been destroyed by its neighbour Croton in 510. To accept the plea was not out of character: the Athenians of this geneiation had not shunned distant involvement and, so far as the West was concerned, they were already in alliance with Sicilian Segesta and Leontini and with Italian Rhegium. The Athenian colonists, somewhat ungratefully, ousted the Sybarites. It was now proposed in Athens that a colony should be established on a new site (Thourioi, Thurii to the Romans). By this time (444) the project had become entangled in a political struggle in Athens.

The rivalry between the Alcmaeonidae and the Philaidae had a long history. The former could claim a more popular tradition; in recent times Cleisthenes had laid the basis for the democratic constitution and Pericles had collaborated with Ephialtes in the assault that stripped the Areopagus of its remaining political power (461). After the Peace of Callias, it was Pericles who guided the Athenians along the path that led to overt Empire; and it was Pericles who conceived the grandiose building programme. Cimon, of the other clan, had done quite as much as Pericles to make Empire possible. But

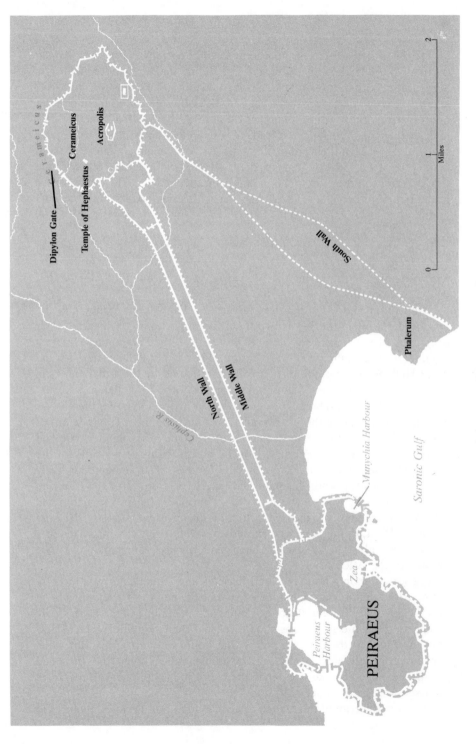

7 Athens and Peiraeus: the Walls

he had been consistently sympathetic to the Spartans, whom he deemed partners in the leadership of the states of Hellas, and he favoured a far less democratic, perhaps even an oligarchic, constitution. To think of the "Few" and the "Many" is an over-simplification. Cimon represented the moderate conservatives, those whom today we often term the political "centre." We must distinguish them from the "radical" oligarchs who would go so far as to betray their polis in their political fanaticism. We caught a glimpse of them in the year of the battle of Tanagra; they will reappear in the late stages of the Great War. In mid-century Cimon had been succeeded as the conservative leader by his brother-in-law, Thucydides son of Melesias (possibly the historian's grandfather), who, inheriting the family's tradition, contested the influential position of Pericles.

In the absence of specific testimony we can conjecture that Pericles had been elected annually to the *strategia* for a number of years. That he failed to win re-election in the spring of 444 testifies to the strength of Thucydides, who was successful.

Thucydides and his supporters favoured a Panhellenic policy and the proposed colony in the West gave them the opportunity to illustrate their principles. Heralds were sent around the cities of the Peloponnese inviting volunteers to participate in the venture. That many Peloponnesians and other Hellenes responded affirmatively is reflected by the tribal names in Thurii. Thus did a planned imperial colony become Panhellenic.

Not all colonists left home to acquire land or in order to better themselves in other ways. Among those who sailed to Thurii we meet Hippodamus of Miletus (born *ca* 500), the most famous of Hellenic town-planners. He had already laid out the new Peiraeus; now he was probably responsible for the rectangular design of Thurii. We may be forgiven if we imagine his lively conversations with other distinguished travellers, Herodotus the historian and Protagoras of Abdera (born *ca* 485). Herodotus (again I imagine) had seized the opportunity to indulge further his ever-present curiosity, this time about the West. Protagoras, who earned an enviable reputation as a teacher of ethics (a sophist) in Athens, had been given the task of formulating a code of laws for the colony.

The long-standing issue between Pericles and Thucydides was the pro-gramme for building on a grand scale to which the name of Pericles had been inextricably tied since the Peace of Callias and the failure of the Panhellenic Congress. That the Athenians should rebuild their temples (or build new ones) and add to them was a policy that could defy criticism. But when Pericles proposed, successfully, that the monies should come from the allied *phoros*, he placed a stout weapon in the hands of his opponent. Henceforth the issue was the morality of this policy.

Plutarch, describing the malign attacks made upon Pericles, pictures in

vivid terms the confrontation in the Ecclesia. He had, of course, no text before him of the speeches that were made. What he knew was that the debate took place; and he knew the subject of contention and the gist of what was said. It was a famous occasion that became part of Athenian lore and here and there a quotable phrase might well have become embedded in the story. Nevertheless, although we may reconstruct the dramatic scene in the Ecclesia, with Thucydides as the champion of the allies (a convenient rôle), without distorting history, we must not forget that in so doing we are also paying homage to the art of Plutarch in fashioning a historical playlet.

"The Athenians," says Thucydides, "are in disrepute for having moved the common funds of the Hellenes from Delos for their own purposes; and that most seemly of reasons that they had to answer their critics, that in fear of the barbarians they took the funds from Delos and were standing guard over them in a secure place—of this Pericles has deprived them. And it is clear that Hellas is suffering the vilest of abuses and is demonstrably subjected to tyranny when she sees us, with the funds contributed by her perforce for the war, begilding and embellishing the city like a brazen woman, decking her out with precious stones and statues and thousand-talent temples."

Pericles, far from admitting guilt, justifies what has been done. "We owe no accounting of the funds to the allies, so long as we serve as their defenders and keep the barbarians away from them while they contribute not a horse, not a ship, not a hoplite, but money alone; and this belongs not to those who supply it but to those who receive it, so long as they provide the services for which they receive it. It is the responsibility of the city, when she has equipped herself sufficiently with the necessities for waging war, to turn her riches to those works from which, when they are completed, everlasting glory will spring, works that, in the building, will make prosperity readily available; tasks of every kind will emerge and varied requirements, which will awaken every skill, move every hand, place little short of the entire city under pay, as she both adorns and nourishes herself from her own resources."

We must not base argument on the precise language of these passages. For example, "they contribute not a horse, not a ship, not a hoplite" is gripping rhetoric. It is manifestly untrue.

The political strife had been continuous since the activation of the building programme, which gave it impetus. It reached its climax in 444, after Thucydides achieved office and Pericles lost. In the ensuing months the bitterness became so intense that the Athenians deemed the stability of the polis to be endangered and resorted to their safety-valve, ostracism. In the spring of 443 the ballots went against Thucydides, who departed, in accordance with the law, for a ten-year furlough. In the election that followed, Pericles regained office as *strategos*, the first of fifteen successive re-elections.

Never again would he fail at the polls, although we must not conclude that opposition disappeared (his personal friends were attacked in the 430s). His most formidable challenger had been repelled, and for the next decade and a half Pericles' statesmanship endured as the persuasive advocate of Athenian policy.

In the summer of 443, a year earlier than the normal schedule, the Athenians re-assessed the tributary allies. The quota-lists (12-16) of the period (442-438) reflect a moderate assessment; changes in scale were trivial. A more systematic method of entering payments was introduced. The lists are now cut in geographic panels: Ionia, Hellespont, Thrace, Caria, Islands. List 12 preserves an item of interest: Sophocles of Colonus, the tragic poet, is named as Hellenotamias for 443/2. By a fortunate chance another financial record cut in marble notes that in the spring of 442 the collected tribute amounted to approximately 377 talents.

With the exposure to ostracism behind him, Athena's new house, the Parthenon, rising on the Acropolis, and his personal horizon all but cloudless, Pericles initiated plans to produce an especially scintillating observation of the Great Panathenaea next year. On his motion, the Athenians voted to add a musical contest, instrumental and vocal, to the festival; further, they appointed him *athlothetes* (Steward of the Competition). It is likely that the desire to keep the summer of 442 as free as possible from other business persuaded the Athenians to face the complexity of re-assessment in 443.

The year 442 enjoyed peace, without visible threat. In the absence of ancient description we can allow our imaginations to visualise the splendour of the mid-summer celebration of Athena's birthday. She was now the patron Deity of the Empire and each colony and allied city, as had become the convention, sent the dedicatory cow and panoply to the goddess. It has been remarked that the Great Panathenaea of this year were meant to identify Athens as "the centre of the civilised world." The exaggeration stirs no indignation.

The peaceful stability abroad that had been the rule since the reclamation of the Euboean dissidents was interrupted in 440 when the Samians and Milesians went to war. Hostilities resulted after a wretched dispute about the territory of Priene, which lay on the south coast of the promontory of Mycale that juts into the sea between the island and Miletus on the mainland. The Samians possessed holdings on the mainland (a peraea) that bordered the territory of Priene. The worsted Milesians appealed to the Athenians; the envoys were accompanied by a disgruntled group of Samians who sought the over-turning of their own oligarchic government. Thus a local dispute became an imperial problem.

The agenda announced for the Panhellenic Congress give firm evidence of the more idealistic aims of Athenian statesmen: the Congress would

discuss "the sea, in order that all may sail it in safety and keep the peace." The principle was retained: within the Empire there would be no war. Apart from ideals, the ban was a matter of common sense and discipline. The navy would protect the allies from the external enemy; it would enforce internal peace.

Even before the Milesian plea the Athenians had (vainly) ordered the Samians to suspend the fighting and await arbitration. Now the principle became action. Pericles commanded the 40 ships detailed to discipline the Samians. The Athenians, without naval opposition, established democracy, took hostages (fifty boys and fifty men), whom they deposited on Lemnos, left a garrison, and returned home. The Samian democrats who had appealed to the Athenians no doubt influenced the decision that was made by the Ecclesia. The operation as a whole was carried out with tidy efficiency.

The Samians, however, were not ready for tame submission. They had a record of uninterrupted loyalty to the Athenians, they had fought at the Eurymedon and in Egypt, and they were among the three remaining naval allies (with Lesbos and Chios). They deserved better of the Athenians. This, at least, was the view of the Samian oligarchs, whose most indignant grievance, perhaps, was aroused by their loss of control locally to their traditional enemies, the democrats.

A number of the Samian oligarchs fled to the mainland, where they conspired with influential colleagues who had remained in the city and with Pissuthnes, the Persian satrap in Sardes. Gathering a mercenary force of about 700, they crossed to the island by night and overthrew the Commons. Having stealthily recovered their hostages from Lemnos, they proclaimed revolt from Athens. As for the Athenian garrison and the *archontes* who had been assisting the Samian democrats, they were handed to Pissuthnes. The optimistic oligarchs at once prepared to attack Miletus. At about the same time the Byzantines revolted (mid-summer, 440). Byzantium, originally a Megarian colony, lay on the European side of the Bosporus and controlled the straits *en route* to the Euxine and the grain-fields so vital to the Athenians.

What had begun as a minor infraction of the rules had developed into a major act of defiance by the Samians; the crisis was accentuated by the simultaneous revolt of Byzantium. The Athenians assigned the entire board of *strategoi,* which included Pericles, to the 60 triremes mustered for action (summer 440). Of these, 16 were detached for duty away from Samos: some to patrol off Caria to look out for the Phoenician fleet, some to seek reinforcement from Chios and Lesbos, naval allies. With the remaining 44 Pericles defeated 70 Samian vessels (20 were troop-carriers) on their way from Miletus. Soon afterwards 40 ships arrived from Athens and 25 from Chios and Lesbos. With the additional strength the Athenians disembarked on the island, won a victory on foot, built encircling walls on the three

landward sides, and laid siege to the town by land and sea (late summer, 440).

Athenian operations were interrupted by a rumour that a Phoenician squadron was advancing along the Carian coast; indeed, 5 Samian ships slipped away to fetch these reinforcements. The Athenians took the rumour seriously enough for Pericles with 60 ships to hasten towards Carian waters. Whether the earlier patrol participated in operations we do not know.

The Samians made the most of this weakening of Athenian forces. In a quick sally they fell upon the unguarded naval camp, destroyed the vessels on look-out, and defeated the ships that were launched to oppose them. For fourteen days they were masters of their own seas, bringing in and out what they wished. Then, after the rumour about the proximity of Phoenician ships had proved to be baseless, Pericles returned, and once more the Samians were enclosed within their walls. The arrival of 60 Athenian ships (with five of the *strategoi* elected for 440/39) and 30 from Chios and Lesbos emphasised the hopelessness of the Samian position. A naval engagement was as futile as it was brief; and in the ninth month of the circumvallation Samos fell (mid-summer, 439).

The terms were not ungenerous. The Samians took down their walls, gave hostages, surrendered their ships, and agreed to pay the costs of their own reduction by instalments. Epigraphic evidence informs us that the indemnity amounted to about 1300 talents, repaid at the rate of 50 talents *per annum*. The Samians, however, unlike the rebellious Thasians of twenty years before, were not assessed *phoros*. The Samian ring-leaders were surely exiled, but the Athenians (probably) allowed an oligarchic form of constitution to survive.

The revolt of Byzantium bequeaths to us a minor mystery. Thucydides notes that the rising coincided with the Samian action; after describing the capitulation of Samos, he adds that the Byzantines also came to terms. The quota-lists guarantee that they reverted to their status as tribute-paying allies. That is all we know, except that, according to a financial record on stone, the cost of the Byzantine affair to the Athenians was about 130 talents. We must conjecture that, once the lines of siege had been firmly set about Samos, part of the Athenian fleet was detached to deal with the Byzantines, whose revolt never became truly effective.

The Persian involvement in these two years, to which Thucydides refers so tantalisingly, merits further comment. We might well believe that Pissuthnes, in collaborating with the Samians and accepting Athenian prisoners, had infringed the terms of the Peace of Callias, at least in spirit. More than likely he had abetted the oligarchic faction throughout. Yet the Athenians, so far as we know, evinced no resentment. Satraps often took independent action, without specific approval or direction from Susa (the King could use the blind eye when it suited him). This must have been an example; and it was

recognised as such by the Athenians. Without a doubt the prisoners were recovered and the Athenians were satisfied. Thucydides twice mentions the reported proximity of Phoenician ships. Yet there is no evidence whatever that they were a reality. The expedition led by Pericles found no trace. We too may dismiss the rumour as illusory.

A few years later the Corinthians, urging the Athenians to reject a proffered alliance with Corcyra, recalled self-righteously that they, on the occasion of the Samian revolt, had dissuaded the members of the Peloponnesian League assembled in Sparta from intervening on behalf of Samos: "each power is entitled to punish her own allies." The Corinthians may be exaggerating their own part. What is certain is that the Samian crisis was discussed by the League. There is even some evidence that the Spartan assembly actually voted for war. It looks as though a clash with Sparta was narrowly avoided.

The Samian adventure coincided with a significant change in policy towards the tributary members of the Empire. Some forty Carian communities were dropped from the rolls: all but a few lay inland. The logical consolidation was effected in the assessment of 438 (a Great Panathenaic year), when the Ionic and Carian panels were merged under the heading *Ionikos.* These inland poleis may have been subject to Persian influence. The governing reason for their disappearance, however, was that they were difficult of access. The Athenians were administering a maritime Empire and it was not worth while for the disciplinary arm to apply compulsion far inland. Besides, the income at stake was trivial.

Among the few to incur increases in the re-assessment of 438 were about half a dozen poleis of the Thracian district, an area that was a source of nagging concern to the Athenians.

From the settlement of the Euboean dissidents in 446 to the preliminary stages of the Peloponnesian War only the Samian Revolt interrupted the peace enjoyed by the Athenians and the allies of the Empire. The Athenians had not allowed the official relationship with Persia to be disturbed by an irresponsible satrap. The other area of potential danger was in the north, where the tribal kingdoms of Thrace bordered the coastal Hellenes. Nor should the Macedonian kingdom to the west be overlooked.

The River Strymon, flowing south, formed a natural boundary between Macedon and Thrace. Just to the east the Athenians drew revenue from the mines; Peisistratus had possessed property here and the historian Thucydides owned a gold-mining concession. Strategically, the area attracted a continuing Athenian interest. Apart from these manifest factors, however, we may reasonably conjecture that the plentiful timber in those northern territories offered an irresistible lure to a city that was dependent on its navy, the "Wooden Walls," for the perpetuation of its imperial dominion. The

Confederates, in their first campaign (477/6), had stormed Persian-held Eion, at the mouth of the river; the town was now an Athenian naval base. In 465 the attempt to found a colony at Ennea Hodoi had failed disastrously. In 446 the Athenians had been more successful at Brea. Now, in 437, the Athenians colonised Amphipolis, on the west bank some three miles from the mouth, on a site that invited the most convenient crossing. Of the fortunes of Brea after its settlement we hear nothing. The explanation is that it was absorbed by Amphipolis, which also incorporated a substantial part of the territory of Argilus, whose tribute was correspondingly lowered; nevertheless, the Argilians harboured resentment. Amphipolis became more valuable with the outbreak of the War, for from it the Athenians drew revenue and timber for their ship-yards. When Brasidas attacked Amphipolis in 424/3, the divided loyalties of the residents facilitated his success. The founding of the colony had been a major project and would have formed a serious drain on the Athenians alone. So the policy of the Athenians in inviting Hellenes from neighbouring communities (including Argilus) to share in the adventure was incited by necessity as well as by generosity. The policy brought no dividends; the fact that the Athenians were in a minority may explain the later reluctance of the Amphipolitans to rejoin Athens.

The founding of Amphipolis was part of a flurry of Athenian activity in the north. We know that before the War King Perdiccas of Macedon became an ally and friend; we should connect this diplomatic advance with the colony. At about the same time Pericles, with a lavishly-equipped squadron, showed the flag in the Euxine Sea. The Hellenic cities on the south coast had welcomed the Athenian presence, partly to impress the barbarian tribes and kings, partly to expel the pro-Persian tyrant Timesileos from Sinope, a Milesian colony, and restore the exiles. Lamachus, assigned to the task with a small force, carried out his orders efficiently. When Pericles reached home, the Ecclesia approved his motion inviting six hundred Athenian volunteers to settle in Sinope. Others colonised Amisus (in part a Milesian colony), rather less than one hundred miles east of Sinope.

Some six years earlier (*ca* 443) the Athenians had sent colonists to Astacus, a tributary polis tucked into a south-eastern bay of the Propontis. The assessment of Astacus had been lowered from 9,000 drachmae to 1,000 in 446. With the arrival of Athenian colonists she was completely relieved of her liability. The careful treatment of Astacus belongs to the same political design that aimed at safeguarding and strengthening the northern frontier.

Examination of a map gives the impression that the south coast of the Euxine lay within Persian jurisdiction. By the terms of the Peace of Callias Persian shipping was denied passage west of the Cyanean Islands (at the mouth of the Bosporus). The question has been asked, did the Athenians infringe the terms of the Peace? So far as we know, the boundary laid down

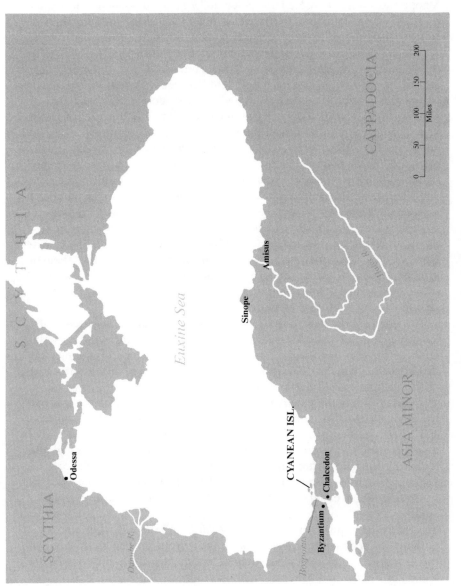

8 The Euxine Sea (Black Sea)

was unilateral, that is, Athenian ships were not banned from the Euxine. Sinope and Amisus were Hellenic poleis and we may reasonably believe that they had gained liberation from Persian rule in 449 along with the cities of western Asia Minor. There is certainly no hint of Persian protest in the 430s.

The quota-lists of the fifth assessment-period (438/7-435/4) corroborate the belief that the Athenians deemed the Thracian district the most likely area of disaffection. Before long they identified signs of unrest in Potidaea, a prosperous Corinthian colony situated on the neck of the peninsula of Pallene. Potidaea had been a charter member of the Confederacy of Delos and remained a naval ally until the assessment of 446; she was the last to commute from ships to cash. She had been well treated: the Athenians tolerated the annual appointment of magistrates especially sent by her mother-city, Corinth, which means that her goverment was oligarchic. She had been paying an annual tribute of 6 talents; now (436/5), in the middle of an assessment-period, a spectacular increase to 15 talents was imposed.

In the same year an Athenian force or delegation levied tribute from five poleis in the interior of Chalcidice that had not been entered in the assessment of 438. They may not have been unwilling to invest in Athenian protection, to judge from the terms to which they, along with a few other tributaries, agreed in a special rubric of the re-assessment of 434: they were guaranteed against future increases.

A second rubric, new to the lists, houses thirteen names inserted in the assessment by individual Athenians, presumably at a meeting of the Ecclesia. Of these, ten are Thracian, five of them (grouped together and making their first appearance in the records) from Crousis, a section of the eastern coast of the Thermaic Gulf, north-west of Potidaea.

In discussion of the Papyrus-Decree of 449 and its financial implications we alluded to the corroborating evidence of the decrees moved by Callias in 434. These decrees, voted a few months after the Great Panathenaea, reveal a systematic reorganisation of Athenian resources: the treasures of the temples throughout Attica are to be assembled on the Acropolis for safe-keeping; treasurers of the Other Gods are henceforth to be selected, to carry out their duties in collaboration with the treasurers of Athena and to render audited accounts of the money in their charge; surplus funds are to be applied to the requirements of the dock-yards and the walls; certain work, perhaps landscaping, is provided for on the Acropolis. The prominence of the Acropolis in Athenian plans reminds us that Athens was meant to be the capital of Empire and Athena its patron Goddess.

The Decrees of Callias must also be interpreted alongside the ominous contemporary rumours of a coming war. The movement of treasures and wealth from the countryside was meant to be a guarantee of their security: war would mean invasion. Shortly after the passage of the decrees, the

the metamorphosis of the Confederacy was all but complete and the synod had ceased to fulfil a directing function. From now on administration, control, and the determination of policy rested with the Athenian Ecclesia. The revolts of Miletus and Erythrae were revolts against the Athenians and in the settlements, attested epigraphically, we see for the first time the institutions that were meant to guarantee the coherence and stability of Empire.

Aristotle notes that about seven hundred Athenians were engaged on the state's business abroad; it is a credible figure. In a number of cities "*archontes* of the Athenians" were placed to protect the interests of the imperial city. They collaborated with local officials in easing the collection and dispatch of *phoros*, they encouraged respect for imperial decrees, and they kept a friendly eye upon local citizens (*proxenoi*) who had been honoured by the Athenian Ecclesia. The Regulations approved by the Ecclesia in 450/49 for Miletus after her revolt provided for the appointment of five Athenian *archontes* to serve in that city. They were to assist in constitutional and judicial reconstruction. *Archontes* were not stationed in all the cities. Epigraphic documents bear witness to their presence in only nine communities by name; but this is an accident of survival. Their casual references to "the *archontes* in the cities" suggest that this magistracy gave employment to a great many Athenians.

The *episkopoi* (inspectors) worked hand in hand with the *archontes*. They too might be involved in local government and in ensuring that the *phoros* was paid; they too collaborated with the *proxenoi* in the interests of Athens.

We do not possess a specific definition of the duties of the *archontes* and the *episkopoi*. That they were well-known instruments in the management of Empire is proved by a scene in Aristophanes' *Birds* (produced in 414). Euelpides and Pisthetairos, disgusted by the atmosphere in which they live, found their own city, Cloud-Cuckoo-Land. Here they are at once importuned by a series of visitors representative of the familiar pests from the world that they had hoped to escape. Among these are an *Episkopos* (who utters pompous threats and demands introduction to the *proxenoi*) and a Seller of Decrees, who intones from an Athenian enactment: "If any man drives out the *archontes* and fails to receive them in accordance with the stele. . . . "

On occasion, particularly after revolt (for example, at Erythrae, Miletus, Samos), the Athenians installed a garrison with a commander (*phrourarchos*). At Erythrae the *phrourarchos* and the *episkopoi* were made responsible for the establishment of the new Council. Military forces, obviously, were to impose order and guarantee security against the Persians, who were not far away. No such forces were encamped on the mainland of Asia Minor after

the Peace of Callias; elsewhere *phrourarchoi* and garrisons were few, in part, perhaps, because they constituted such blatant infringements of autonomy, in part because of distance from a foreign threat.

The Athenians, nevertheless, were appreciative of the advisability of taking precautions to maintain order within the Empire and security against the enemies without, real or potential. They found the answer in the foundation of colonies and cleruchies. In Asia Minor, after the withdrawal of garrisons, they planted colonies in the territories of Erythrae and Colophon and probably elsewhere. Mention has already been made of colonies and cleruchies in other parts of the Empire. These were strategically placed.

The Athenians put to good imperial use an already known device, the *proxenia*. They conferred by vote the title *proxenos*, and sometimes *euergetes* (benefactor), upon an alien who had deserved well of them. The *proxenos* looked after Athenian interests in his own city. He might provide hospitality to Athenian visitors, facilitate their approach to local governments, and introduce them according to their needs to commercial or religious groups. He also assumed responsibility for Athenian public relations. He exercised a far-ranging portfolio. His function was much like that of the consul of today who is a national of his country of residence, not of the country he represents. The institution was used elsewhere in Hellas, but nowhere on such a scale as by the Athenians. We know of nearly one hundred men to whom the title *proxenos* had been voted by the Athenians in the period of the Confederacy and Empire. It is probable that the Athenians endeavoured to place a *proxenos* in each city of the Empire. The appointment, along with certain privileges, was embodied in a decree, often engraved on a marble stele, and set up on the Acropolis. We have fragments of nearly seventy such decrees. A typical document reads as follows: "Resolved by the Boule and the Demos . . . that Oeniades of Palaiskiathos, because he is beneficent to the polis of the Athenians and eager to do whatever good he can, and because he welcomes generously Athenian visitors to Skiathos, be officially thanked and entered in the record as *proxenos* and *euergetes*, both himself and his descendants. Resolved too that the Boule in office at the time and the *strategoi* and the [Athenian] *archon* in Skiathos, whoever he may be, shall see to it that he suffer no injustice. The secretary of the Boule is to have this decree inscribed on a stele of marble and set up on the Acropolis. Oeniades moreover is to be invited to entertainment in the *prytaneion* tomorrow. . . . "

From time to time the Athenians voted decrees and approved Regulations that dealt with the Empire as a whole or with individual poleis. The Decree of Clearchus concerning coinage and the Decree of Cleinias that systematised the collection of tribute come to mind. The Regulations for the Milesians and the decree about Chalcis are examples of the measures taken to ensure stability and obedience after revolts. When Erythrae and Miletus resumed

their allegiance, the Athenians dictated the new constitutions and partici-
pated in their installations.

Revolt, not unnaturally, forced Athenian interference in local affairs and
institutions. The representatives of the now-reduced state were required to
swear an oath of loyalty. In return, the Athenians swore to treat the state and
its individual citizens fairly. The decree about Chalcis, which has been
quoted in full in Chapter X, is illustrative. Revolts in other cities of the
Empire in the 450s and 440s were followed by similar dispositions. We have
fragments of the Regulations adopted for Erythrae, Miletus, Colophon,
Eretria, and Samos, as well as for Chalcis. In these texts the tone is firm but
not arrogant. The Athenians supervise the organisation of the government
that is to prevail in the future; and major attention is paid to the establish-
ment of courts and the dispensation of justice. The requirement that trials
for major offences, such as murder and treason, be heard at Athens before
Athenian jurors had validity throughout the Empire. The principle is easily
recognised: treason against one polis was treason against all poleis, the
Empire as a single entity. An Athenian might point out that a defendant was
likely to get a fairer hearing at Athens than in his own city, where feelings
could run high and a jury be affected by prejudice. The litigant might reply
that travel to Athens, costs of living, and court-fees were expensive; Athenians
(merchants and polis) profited. We are perhaps not over-cynical in advanc-
ing a further motive: the holding of these trials at Athens was likely to
protect pro-Athenians in some of the cities from judicial murder by their
political opponents.

Comparatively, the surviving, and for the most part fragmentary, inscrip-
tions of the type that I have cited ("Regulations") are a minority alongside
our losses, as the tantalizing cross-references and hints within them make
clear. There must have been many more decisions voted concerning impe-
rial administration (not all, of course, were published on marble). I have
mentioned the stele of the 460s carrying the commercial pact negotiated
with Phaselis; we are quite sure that similar agreements were reached later
within the Confederacy or Empire, although we lack the physical evidence.
Again, we should like to know more of Athenian efforts to regulate trade in
grain throughout the Empire. If the *Birds* of Aristophanes is reflective of life
within the cities of the Empire as well as within Athens, we might well
speculate that many of the Athenian rescripts came to be looked upon as
officious nuisances.

This was the century in which many of the Hellenic states became
democracies. While it is true that Athens served as a persuasive model,
especially within the Empire, it is also true that democratic constitutions
multiplied in consequence of a natural political evolution. We have noted
that the struggles among the great families in Athens were eventually refined

into rivalry between the Many and the Few; the situation was matched in the other poleis of the Hellenic world. When the Athenians were compelled by revolt or by internal *stasis* to interfere, they tended, not unreasonably, to sympathise with the Many, whom they looked upon as their friends; the resultant constitution, then, was likely to be democratic, with institutions similar to those with which we are familiar at Athens. There were exceptions (Miletus and, probably, Samos); and, where there had been no disturbance, the Athenians left the cities free to live under the constitutions of their choice. Oligarchy was not rare, and from Caria a number of tributaries appear in the records under the names of dynastic rulers.

The concept of unity (which, if welcomed, brings loyalty as its companion) was assiduously fostered by the Athenians to the extent that they introduced a religious element to be allied to the sentiment of a nexus existing by nature between a colony and a mother-city. Thus, each polis (and each colony) was obligated to send offerings to Athena at the Great Panathenaea. No doubt representatives of the allied states accompanied the offerings; normally, the new assessment was initiated at the time of the Great Panathenaea and the coincidence helped to attract an allied presence.

The basic requirement from the tributary poleis (apart from keeping the peace) was payment of the assessed *phoroi*, preferably no later than the celebration of the urban festival in honour of Dionysus (the Dionysia) in the spring. Again, representatives of the allies journeyed to Athens, where they could transact their business and attend the dramatic performances connected with the festival. A considerable number took advantage of the opportunity. In his funeral-address of 431 Pericles assured his fellow-citizens that the allies could take pride in their association with the imperial city. This nurturing of unity and loyalty was adopted early as a deliberate policy.

The foundation upon which the Empire rested was the indispensable Athenian navy. The triremes patrolled the seas, maintaining peace and, therefore, prosperity for Athenians and allies alike. They were ready at all times to enforce the implementation of Athenian ordinances, to oversee, if necessary, the dispatch of the *phoros*, to persuade the recalcitrant.

Within a very few years the Athenians constructed an administrative machine that merits praise for two qualities, its competence and its novelty. Among earlier powers we find no parallel.

XIII

GOVERNMENT IN ATHENS

"We, you see, take advantage of a constitution that does not try to emulate the laws of our neighbours. No, we are an example to others rather than imitators. And our way of life is called democracy (*demokratia*), because the management of affairs rests in the hands not of a few but of the majority. In the area of the laws all have equal rights to justice in their private concerns, whereas in the area of reputation each man, as he attains some sort of distinction, is preferred to high public office not so much in rotation as on the basis of his quality; remember, moreover, that, though a man be poor, if he has the ability to confer a benefit on the city, he is not debarred by the obscurity of his status. In our management of public affairs we conduct ourselves as free men; at the same time, in regard to the mutual suspicions that often arise from our daily relationships, we do not look upon our neighbour with anger if he does something to please himself, nor do we put on expressions of irritation that, although they involve no penalty, are unpleasant to gaze upon. While we conduct our private lives without giving offence, in the public realm we are law-abiding, primarily because of due respect for and obedience to both those in authority and the laws, especially those laws that are laid down for the support of the wronged and those that, although unwritten, bring upon the transgressor universally acknowledged reprobation." Thus did Thucydides recall Pericles' proud boast to his fellow-citizens.

The political evolution of the Athenians seems to be paralleled in most of the states of Hellas of which we have knowledge. Monarchy gave way to aristocracy or oligarchy, which was often succeeded (or at least interrupted)

by autocracy (the Hellenes called it tyranny). The fall of the tyrannies, where they occurred, was normally followed by reversion to a moderate form of oligarchy; Corinth and neighbouring Peloponnesian cities offer the best-known instances. But in Athens a brief period of *stasis* resulted in the emergence of Cleisthenes the Alcmaeonid, who devised the fundamental structure prerequisite to democracy. Certain elements had already been introduced by Solon (archon in 594/3), who is often called the Father of Democracy; he was an unwitting sire.

As we proceed into the fifth century, the democracies increase in number. Moreover, in every state political life now turned upon the persistent and often fatal rivalry between the Many and the Few. In some cases—and this is especially true of the years of the Empire—the awing prominence of the Athenian model, as Pericles rightly perceived, was the decisive factor.

Familiarity with the history of the ancient world cannot fail to bring home to the thoughtful reader the remarkable political intensity of the Hellenes and the consequent political experience that alone justifies the appearance of true democracy. One reservation to this brief sketch needs expression: conservative Sparta, with her special problems and her dual kingship, remained the exception. Free from *stasis*, according to Thucydides, since the reformation of the late eighth century, she is best termed oligarchic. Certainly the Spartans saw to it that the politics of the members of the Peloponnesian League remained stable; and stability to them meant oligarchy.

In the half-century after Cleisthenes the creative statesmanship of Themistocles, Ephialtes, and Pericles was chiefly responsible for the constitutional adjustments that allowed the full development of democracy and Empire to coincide. This is the period upon which we shall concentrate.

Few words have suffered such misinterpretation and misapplication as "democracy" and its cognates. The endemic abuse of the noun makes definition a necessity. Democracy (*demokratia*), literally defined, is government by the Demos; the Demos are the citizen-body. So far as Athenian political life was concerned, the Demos comprised the adult male citizens. This is not to deny that women and children were citizens: citizenship and possession of the franchise are not synonymous, as our female forebears well knew. A law proposed by Pericles in 451 restated Athenian tradition: an Athenian citizen must be born of two citizens. But women in Athens (as in the other poleis) exercised no political functions; if we wish to be strict, if we are over-sensitive to modern western practice, we may call this exclusion an undemocratic element in the Athenian way of life. In the Hellenic polis it was not an issue.

In rendering "Demos" in English (as it appears in *demokratia*), it is well to avoid "the people," a term that we employ in two senses: sometimes we mean the citizens of a country, sometimes its inhabitants. In this book "Demos"

connotes the citizen-body (adult males) in the Ecclesia. Greek writers (for example, Thucydides), in political contexts, often employ the noun of the masses, or Commons, as opposed to the upper or middle class; this usage will be avoided here.

Government is identified and classified according to the privileges and responsibilities granted to and exercised by the citizens. The status of the non-citizen, be it equitable or deplorable, is irrelevant to the identification. In the absence of direct evidence we cannot be dogmatic about the size of the population. Even so, we shall not be far wrong if, with A. W. Gomme, we estimate the population (man, woman, and child) of Attica in the 430s as 172,000 citizens along with 28,500 metics (resident-aliens) and 115,000 slaves; the first two figures are minima, the last is a maximum. We must never forget that democracy and slavery are not incompatible. Democracy guarantees not that all men are equal in status but that all citizens are. The brotherhood of man is not a democratic doctrine.

In the context of the present study citizenship must be defined naturally, as, indeed, the Athenians defined it, and not arbitrarily, according, for example, to the size of one's material possessions. I clarify "naturally" by borrowing the words of A. W. Gomme: "in accordance with the traditional view of kinship and society." Once more we turn to Pericles: "The same people, generation after generation, have always inhabited our land." Kinship was the basis of membership in the state throughout Hellas, and in Athens, where no racial or semi-racial problem ever arose, kinship, real or fictitious, remained peculiarly strong. The first Hellenic inhabitants arrived about 1900 B.C. The site has been occupied continuously ever since. The Athenians believed that they had always been there, that they were autochthonous. Every Athenian possessed, inherently, a quality that we may call "Athenianness." This, to an Athenian, defined citizenship. It also explains why we so seldom hear of grants of citizenship. When the benefaction did occur, it was voted as a very special privilege by the Demos sitting as the Assembly, not as a transaction in a bureau or by a magistrate in a court.

Political analysis ought to avail itself of "democracy" and its related adjectives as descriptive terms. In practice, however, democracy, which requires generations of political experience and education, is today in western society placed uncritically upon a pedestal as the ideal form of government in any context (a compliment, perhaps, to the Athenian prototype); and we are encouraged to believe that friendly nations must be democracies. It is no wonder that in public and private life "democratic" and "undemocratic" are (mistakenly) applied to behaviour of which we approve or disapprove.

Armed with these warnings and definitions, we are in a position to inspect the distinctive features of the government of the Athenians in the hey-day of Empire.

The first principle of democracy to a Hellene was that the citizen-body governed directly, not through representatives. An ancient Hellene would have no hesitation in designating the governments of the major English-speaking nations as oligarchies. He would also agree that their physical sizes and the numbers of their citizens make direct democracy impossible and unattainable, even with the assistance of modern technology. The polis of the Athenians, that is, the city (the administrative centre) and Attica, encompassed about one thousand square miles. Yet it is instructive to observe that Thucydides does not refer to the political entity by the term "Athens" (for example, "the policy of Athens"); he writes the ethnic adjective ("the policy of the Athenians"). To him "Athens" is a topographical noun.

In fifth-century Athens all final decisions affecting the state as a whole were made by the Ecclesia. Every adult male had the right to sit. In the early years of the century the Ecclesia may have met irregularly. The burdens of Empire and the accompanying increase of public and private business, however, made more frequent meetings necessary. A firm schedule developed and henceforth (from about mid-century, I suspect; but the question remains *sub iudice*) the Demos convened formally forty times a year (at regular intervals) and on other occasions as prompt decisions were demanded (by, for example, the international situation). Certain meetings were regularly set aside for the hearing of magistrates' reports and the conclusion of routine civil business. When we move to what on modern agenda is called "new business," the comprehensive and absolute sovereignty of the Ecclesia may well seem remarkable: commercial pacts, alliances, declarations of war, ratification of peace with specification of terms, grants of citizenship, bestowal of honours, public construction, assessments of tribute, dispatch of colonies and cleruchies, imperial administration and settlement (in detail). I dwell separately on the responsibilities of the Ecclesia in time of war: it was the citizens assembled as a body who determined the over-all strategy, where to send a force or flotilla and in what numbers, who should command. The *strategoi* and other prominent men of experience spoke and advised, of course; and in the field the *strategoi* planned tactics, although even here the citizens in the Ecclesia could prove to be stern and sometimes unsympathetic or ill-informed critics. In modern warfare crucial strategies are adopted by the High Command or a Cabinet; they may reflect the powerful influence of a Prime Minister or a President. They are seldom made public at the time. In Athens they were debated and voted by a mass meeting; the nearest modern equivalent would be a plebiscite, which for such decisions is unthinkable.

The Ecclesia did not lack guidance; an orderly procedure was respected that averted the prodigal fumbling to put a motion into words that we witness

so often in today's large body. The agenda were prepared by the Boule (which we shall discuss shortly) and recommendations (*probouleumata*), formally moved by members, were drawn up that supplied likely answers and solutions for consideration by the Ecclesia. Here a *probouleuma* placed before it was freely debated. It might be adopted by majority vote as referred, it might be adjusted, a rider might be added on motion by a citizen, it might be returned to the Boule with instructions for reframing, or it might be rejected altogether. In the course of business, the Ecclesia had the right to refer any matter to the Boule with the request that a *probouleuma* be prepared, sometimes in stipulated terms. At times, I suspect, a motion put forward in the Ecclesia might be voted on without referral. Once ratified, a *probouleuma* became a decree (*psephisma*) with the force of law. Certain decrees and decisions of the Ecclesia, especially those affecting foreign policy and imperial administration, as well as ratification of financial audits, were published on marble stelae and set up on the Acropolis or elsewhere in the city. The procedure suggested an element of permanence and the texts were open to inspection by any citizen. Thousands of fragments of these documents have survived; they enable us to reconstruct not only what the Athenians voted but the machinery whereby those decisions were made and were to be put into effect. Other details of public business were committed to more perishable materials and housed in the archives; these we have lost. The vital lesson that has been transmitted is that the business of the polis was public: information was not classified; records were accessible to all because all were part of government. The contrast with unavoidable modern practice needs no comment.

Attendance at the Ecclesia was governed by several factors. When, on the eve of the Great War, the Athenians, in obedience to the advice of Pericles, moved themselves, their animals, and their inanimate possessions into the city, "the upheaval was a harsh experience, for most of them had always been accustomed to live in the country. . . . In their grave depression they took it badly that they were abandoning their homes and the shrines that had been theirs traditionally from the very earliest days of the community, and that they were about to change their style of life." Of 172,000 citizens only about 60,000 (with 25,000 metics and 70,000 slaves) lived in the city and its environs (including Peiraeus). The economy had remained basically agricultural; the very large proportion of urban metics were the business-class. The adult male citizens numbered 43,000, of whom some 15,000 lived in Athens and its vicinity. The normal method of travel was on foot, and what appear long distances to us were modest in Attica. We must recall that much rural territory seemed within comparatively easy reach of Athens; nor should we exaggerate the influence of the town against the interest of the country. Nevertheless, substantial numbers must have had their farms so far from the

city as to make visits inconvenient. We may doubt whether the Athenian with land in the area of Marathon, twenty-five to thirty miles away, regularly sat in the Ecclesia, especially in the ten routine meetings a year that were allotted to the hearing of reports. Regular attendance was precluded for those magistrates, officials, commanders, and garrisons who served from time to time in the cities of the Empire. The cleruchs, who retained their citizenship even though distance deprived them of its political responsibilities, are not included in the figures cited above. We should not pass over those Athenian citizens engaged in commercial enterprises that took them to sea. We complete the tally of absentees with the fleet. The trireme, the fifth-century man-of-war, carried a crew of 200 men. In time of peace naval squadrons of various sizes cruised the Aegaean; in war 200 ships were ready for action. The eight months of summer were by custom looked upon as the sailing season, but in the years of Empire winter by no means excluded activity at sea. Service was open to volunteers from the Empire and to metics; basically, however, the navy was manned by citizens. Those of substantial means could afford the armour of the hoplite; the poor, of the thetic class, found their satisfaction as citizens and their security in the navy. The "naval mob" in Plutarch is a realistic term.

All these factors, which varied with the season, with individual residence, and with the imperial situation, influenced attendance in the Ecclesia. The evidence, which is difficult to interpret, supports two conclusions: (1) those who participated in a given meeting formed a minority of the eligible electorate; (2) a quorum consisted of 6,000, a figure that seems reasonable and intelligible. The crucial decisions that governed the daily lives and prospects of the Athenians, then, were voted by a mass-meeting, convened in the open air on the Pnyx Hill (due west of the Acropolis). What made the system practicable was the Boule of Five Hundred. In the spring of each year the Athenians chose by lot from each of the ten tribes fifty men (a prytany) aged at least thirty to serve as a Council for one year. A councillor (*bouleutes*) drew a small daily fee and was eligible for a second term (but no more) only after an interval (length unknown). This rotation of office meant that each male Athenian might expect to sit in the Boule at least once in his life; it also clarifies what Aristotle means when he writes that in a democracy the citizens govern and are governed in turn (although we must not read too much into the term "govern"). A sophisticated geographical machinery guaranteed representation of all interests from all parts of Attica. This safeguard, coupled with the use of the lot, annual tenure, and the impossibility of immediate re-election, effectively aborted the growth of cliques; even the chairman, who could occupy his position once only, changed daily. The nature of the Boule explains why the title "Senate," a Roman—and modern—term, should be rigorously avoided.

The agenda to be placed before the Ecclesia were fully discussed by the Boule, which, in theory at any rate, met daily. This is why the Boule is described as probouleutic: it deliberated in advance. The formulation of *probouleumata* has already been noted. The system allowed free debate in the Ecclesia but did not make it necessary for motions to be put into words in that large arena. The Boule was both the clearing house and the screening committee.

The comprehensive administrative duties of the councillors were fulfilled in collaboration with the magistrates, whom they supervised. In general, the councillors saw to it that no detail indispensable to the orderly administration and functioning of the polis was neglected.

The apparent awkwardness of so large a body was reduced by its adroit division into ten tribal units (prytanies), each one comprising members drawn from the major parts of Attica (interior, coast, city). The conciliar year, which was approximately solar, was divided into ten parts and the prytanies served in rotation, the order determined by lot. As the Boule acted as the clearing house and prepared the agenda for the Ecclesia, so the prytany served and represented the Boule. The prytany provided the daily chairman and was responsible for the summoning of meetings of Boule and Ecclesia alike. One-third of the body passed the night in the Agora: thus formal representatives of the state could be located on duty at all times. The Boule was the administrative arm of the state; the prytany in office was the executive. The decrees of the Demos are replete with instructions to the prytaneis, who kept the machinery running smoothly. Their part in the daily functioning of the polis is commemorated in the preambles of decrees as partial indications of date. A typical example, which illustrates procedure, reads: "Resolved by the Council and the Demos; Erechtheis held the prytany, Scopas was secretary, Timonides presided, Diopeithes made the motion."

Along with the legislative sovereignty exercised in the Ecclesia, the citizens, in keeping with democratic theory, controlled the administration of justice. Each year 6,000 men aged thirty or more were selected by lot for service as jurors (dicasts, *dikastai*) in the courts (*dikasteria*). Collectively, these popular courts are referred to as the heliaea (*heliaia*). The word is puzzling. When Solon originated the system, *heliaia* perhaps connoted groups of citizens (drawn from all classes and therefore representing the citizen-body) sitting as courts of appeal. In the fifth century these, retaining their collective name, became courts of the first instance, with final authority; *dikastai* and *heliastai* were interchangeable nouns meaning jurors. They were quite separate from the Ecclesia. Recent investigations suggest that the correct form was *eliaia,* without the aspirate. These dicasts were assigned to their respective courts daily by allotment-machines. They tended to be elderly, and they earned a daily fee, two obols, increased to three in the early

years of the War. Aristophanes depicts this as a sort of old-age pension.

The courts, with their large juries, convened under the respective chair-manships of magistrates or officials appointed for the purpose as calendars became crowded. The chairman must not be likened to the modern judge: he did not interpret the law or instruct the jury; he watched the water-clock and kept order. The litigants pleaded their own cases. In consequence, the barrister or lawyer of our society made no appearance. Not every litigant felt competent to prepare his own address; so we hear more and more of professional speech-writing, the primary activity of the famed Attic orators. The decision in the court-room was reached by majority-vote of the dicasts, who also assessed penalties. The lesson to be learned from this brief descrip-tion of a skilfully-contrived system is that in the Athenian democracy a citizen had the right to be heard by a substantial jury (in Socrates' case, for example, 501 men) of his peers, selected at random. Essentially, the system and its principles are not unlike our own. The Council of the Areopagus, composed of ex-archons and revered for its age and traditions, lived on as a court for trials of homicide and with certain religious duties. It had lost the residue of its political powers, which had once been supreme, in the reforms accepted upon the advocacy of Ephialtes in 461.

The acquisition of Empire, with its attendant responsibilities, and the physical and numerical growth of the polis, especially the city itself, led to an increase in the number of citizens engaged in administrative and executive duties. These officials served for the most part in boards of ten, selected by lot, one from each tribe, with annual tenure, and receiving modest daily salaries. Aristotle writes that seven hundred citizens were so engaged in Athens at the peak of Empire; we have already noted his figure of seven hundred abroad.

In Athens these boards oversaw the daily life of the city and its inhabitants in all its detail. They correspond to the officials, sometimes called the bureaucracy or civil service, of a modern city. We shall glance at the chronologically senior body, the archons. They had gradually evolved from the monarchy and by the mid-seventh century constituted a board of nine: eponymous archon (who gave his name to the year), polemarch (commander-in-chief until 487/6, when he became a wholly civil magistrate), archon *basileus* ("king" archon, the name a relic of the monarchy), and six *thesmothetai* (keepers of the law). From 487/6 they were elected by lot and in 457 the office, previously restricted to the top two census-classes, was opened to the zeugitae, the third class; a comment in Aristotle suggests that in practice thetes (the fourth and lowest class) might also be elected. Like the other boards, they drew small daily fees, held their positions for one year, and were not eligible for re-election. As befitted their history, they should be regarded as the senior board. Apart from other civic functions, they sat as chairmen of

the various courts, an essential and time-consuming task. Some time later, a secretary was added to the board, which could then conform to the representative principle, one from each tribe.

Election by lot and pay for public service have been mentioned frequently as democratic institutions. Critics of democracy (such as Plato) argue that sortition militated against efficiency and expertise. It was bound to produce egalitarianism carried to an extreme of absurdity. The argument is not without truth. The convinced believer in popular government replies that the lot entailed two democratic principles: it guaranteed equality of opportunity to serve and it ensured that, over a period, all interests and groups were represented. Among the Athenians, of course, no racial or religious divisions existed. If the system cost something in efficiency, argues the defender, the loss was justified by the democratic practice. Pericles, in 431, perhaps expresses an ideal when he assures the Athenians that "we in any case form sound judgements, even if we do not originate policy."

The lot was adopted by Cleisthenes as a democratic device. The board of archons were elected by this method first in 487/6. The sortition was preceded by a preliminary election (*prokrisis*) of ten candidates from each tribe, from whom the nine winners were then drawn, the choice determined by the Gods, as an Athenian might have said. Later, the *prokrisis* was also conducted by lot, producing a double sortition. The adjustment of 487/6 brought with it, inevitably, a major change in political life. Previously, the eponymous archon had been the senior magistrate. Competition for the office had been at the centre of the strife that marked the interval between the reforms of Solon and the advent of tyranny. Under Peisistratus and Hippias, the archonship retained its nature as the senior magistracy. When Cleisthenes finally worsted his rival Isagoras, the latter was holding the eponymous archonship. The distinction of the position and its inherent powers are made manifest by the names recorded in the archon-list before 487/6: here we find the politically prominent. The application of the lot meant that henceforth the eponymous archonship (with the holder's subsequent admission to the Areopagus) ceased to be the culmination of an ambitious man's career: attainment rested on the favour of the Gods, not on the citizen's qualities of leadership. After 487/6 not one of the Athenian statesmen who advised the Demos held the archonship; for us, the names on the archon-list serve merely as chronological pegs. The last restriction was taken from the magistracy in 457, when it was opened to the zeugitae, in fact (probably) to all classes, a logical consummation of the principle that in a democracy all men are equal in opportunity.

We take it for granted that, except in very small communities, public servants receive compensation. From time to time, it is claimed that the compensation is insufficient to attract the most able men. In the ancient

world, however, the introduction of pay (the motion is credited to Pericles) for Athenian councillors and magistrates was a major innovation. So far as I am aware, the practice was unknown in earlier societies, which, of course, were far from being democracies; in Republican Rome a public career was an expensive undertaking, and the absence of salaries contributed to political corruption on a wide scale. If "equality of opportunity for all" is a basic principle of *demokratia,* then it must be possible for all to take advantage of this kind of equality: practice must conform to theory. "No man is barred by the obscurity of his [financial] status." Thus the adoption of election by lot and pay for public service was viewed by the Athenians as vital to the functioning of democracy (*demokratia*).

With the transformation of the archonship and the employment of the lot, one might well ask how the Athenians in such a state could find and benefit from individual excellence. The answer is found in the *strategia*, the board of *strategoi*, who emerged as the striking exception to what has so far been described. The ten *strategoi*, one from each tribe, were brought into existence by Cleisthenes, who saw them as a necessary military support for the polemarch, who had previously borne sole responsibility as commander-in-chief. The deliberations of the polemarch and the *strategoi* before the battle of Marathon, as described by Herodotus, give us an example of the new command in operation.

As the constitutional changes of 487/6 affected the archons, so did they redirect the functions of the *strategoi*. The polemarch was divested of his military duties and the *strategoi* were left as the only significant magistrates who were elected by direct vote: the responsibility of selecting men upon whose judgement and experience the very lives of the citizens would depend was far too serious a burden to be left to the Gods. The *strategoi* were also exceptional in that they were eligible for re-election immediately and as often as the citizens pleased; and, when pay for service was introduced, the *strategoi* were excepted. The Athenians recognised the folly of annual tenure of command in war, wisdom that the Roman Senate long resisted.

In the new order, then, only the *strategoi* enjoyed the right to continuity of office. With the disappearance of the archon as a political force, the *strategoi* became the advocates of policy and the leaders in the Ecclesia. Indeed, quality won its recognition by performance in this public arena; that recognition often had its issue in election to the *strategia*. This is surely what is in Pericles' mind: "each man, according as he attains some sort of distinction, is preferred to public office not so much in rotation as on the basis of his quality." Symptoms of the evolution of the strategic office are recognisable in the attendance of *strategoi* at meetings of the Boule, their right to make motions there (this is why Pericles' name is attached to so many decrees), and their power to have the Ecclesia convened. Now that the *strategoi* were

expected to initiate policy in the Boule and the Ecclesia as well as command by land and sea, the translation "general" for "*strategos*" is seen to be misleading. For Athenian leaders in the sixth century we refer to the archon-list; in the fifth century we look to the roster of *strategoi*. Such was the dignity and reputation of the *strategia* that during the life-time of Pericles the Athenians, political realists, on occasion elected one member of the board "from all," that is, irrespective of tribal affiliation: one tribe might have double representation and another none; or a board of eleven might result.

Scrutiny of a list of fifth-century *strategoi* reveals not a cross-section of Athenian society but a disproportionate number of names coming from the distinguished families; they did not need the daily stipend. They won office by direct vote and their success is reflective of the insistence of the citizens in this democracy on making the best possible use of their élite.

Accountability of magistrates was built into the system. Before taking office the citizen underwent a preliminary examination (*dokimasia*) that would attest his age, his citizenship, and his good character. During his term his record might be scanned once in each prytany. Upon leaving office he was required to pass an audit (*euthyna*). The accounts of financial boards were often published, after approval by the thirty auditors (*logistai*). At any time during the year a magistrate could be arraigned before the Ecclesia and penalised by fine or removal from office. Towards the end of the century a method of discouraging irresponsible action in the Boule or the Ecclesia was introduced in the formal impeachment of one who introduced a motion that was contrary to prevailing laws. All these precautions helped the Demos to become a severe master.

The bitter rivalry of the great families in the sixth century, suspended by the tyranny, was resumed after the expulsion of Hippias (511/0). The genius of Cleisthenes, victor in the ensuing *stasis*, devised a constitutional reform that aimed at eliminating such divisiveness and forestalling the rise of tyranny in the future. The weapon that he fashioned against tyranny was ostracism, an institution that functioned successfully until 416, when it was used for the last time. Each year the Athenians voted, in the context of the political situation, whether to hold an ostracism. In the event of an affirmative vote, the citizens, a few weeks later but before elections (in the early spring), reassembled. Each one scratched on a sherd the name of the man who seemed most to threaten stability; such, at any rate, is the theory. He who polled most votes (6,000 had to be cast) withdrew from the polis for ten years without loss of property or citizenship. Ostracism came to be employed when the intensity of political controversy became menacing. It can be likened to what in Canada and England is called the appeal to the country. The ballot was a peaceful means of choosing between leaders and their sharply differing policies. A list of those against whom votes were cast

approximates a list of prominent Athenian statesmen of the fifth century: many were or had been *strategoi.*

The Athenians imposed no universal direct levy that can be likened to our income-tax. Certain expenses, however, were underwritten by a curious institution, the liturgy ("the burden of the people"), which took two forms. The recurrent (choregic) liturgy required that wealthy citizens pay for some of the costs involved in the annual festivals, especially the training of the choruses for the dramatic performances. We may think of them as patrons of culture and recreation. The trierarchy (command of a trireme), on the other hand, was bound inextricably with the preservation of the polis and the Empire. Every year perhaps as many as two hundred wealthy citizens and metics were appointed (by the *strategoi?*), each to be responsible for the maintenance of a trireme (which he had the right to captain) for the campaigning season. The polis supplied the hull with its initial equipment and paid and fed the crew. As the Demos came to depend upon the city's élite for leadership so they took full advantage of the wealthy. In the imperial era the trierarchs did not complain; rather, they took pride in their ability and willingness to contribute.

In this system, in which final sovereignty remained the perquisite of the Ecclesia alone and annual magistrates, with one exception, were chosen by lot, we can identify two elements in the modern world that could not appear in Athens: the acquisition of individual power and the pursuit of a political career, the Roman *cursus honorum.* The ambitious Athenian of the imperial age who wished to be a "champion of the Demos" (to borrow Aristotle's term), whether Demos be read as "the citizen-body" or "the masses," which it sometimes means, had to make his name in the Ecclesia and hope to be elected to the *strategia.* Once successful, he had to retain the confidence of his fellow-citizens to win re-election. No contemporary man equalled the remarkable record of Pericles, who was seldom out of office from the late 460s to his death in 429. In this milieu, in which reputation and opportunity were first won and then maintained in the Ecclesia, the ability to speak persuasively in public became a necessary asset. This is why the Golden Age of Attic oratory begins in the fifth century.

The evolution we have witnessed in the jurisdiction of the *strategoi* and, especially, the exceptional career of Pericles raise the question of power. Pericles will be the model. How much real power did he possess? We read in modern studies that Pericles "sent ships," "established colonies," "yielded Central Greece." It is an easy transition to promote him to the rank of "ruler" or "*princeps.*" It must be admitted that Plutarch fell into this trap long before the·moderns. For trap it is. Pericles was not a ruler nor did he receive or exercise any personal power that placed him above the state; in no way is his position reminiscent of that of the Roman Augustus. Like his

colleagues, he faced a critical electorate once a year; he was continuously subject to the pleasure of a sometimes fickle Ecclesia, ever jealous of its own decisive prerogatives. In 444 he failed of election; in 430 he was dismissed from office and fined—and re-elected, to be sure, in the following spring.

Thucydides himself is responsible for some of the modern misunderstanding that is prevalent about the status of Pericles. His judgement is frequently quoted: "What was in theory democracy (*demokratia*) was proving to be government by the first citizen." Thucydides did not approve of democracy, although he was one of those well-born Athenians who, "caught by the glamour of Pericles" (the phrase is H. T. Wade-Gery's), admired the way in which the state functioned in this era, when Pericles' influence was paramount; he did not (or could not) bring himself to praise democracy. Indeed, his work contains a number of scornful references to the behaviour of the democratic Ecclesia.

We speak of Pericles' law concerning citizenship, Pericles' building programme, Pericles' policy. We are justified in so doing providing that we clearly understand what we mean: we attach the advocate's name to the measure. Pericles could make proposals and speak to them. If his proposals seemed well advised, if his wisdom and judgement seemed to match his eloquence, then his peers in the Ecclesia accepted what he urged (sometimes they differed and rejected it). He could formulate; his fellow-citizens decided. Thucydides' own narrative contradicts the judgement quoted above. "He persuaded," he writes, of the decision to go to war. The glimpses that the historian gives of activity in the Ecclesia confirm that so long as *demokratia* prevailed that body never surrendered its sovereignty, whether to an individual or to a group.

We revert to the question: "How much real power did he possess?" I have criticised Thucydides' judgement; yet it is Thucydides who, in the same passage, puts into words the answer to the question. "For as long as he was prominent in the city in peace-time he guided with moderation and preserved her in safety, and in his time she became very great. . . . The fact is that he retained the power of his influence by reason of his reputation, the quality of his mind, and his utter integrity, and so was able to restrain his fellow-citizens by his moderation, free though they were: he was not led by the Many, he led them."

XIV

PRELUDE TO WAR

The Thirty-Years' Peace created the conditions in which Athenian power and prestige could increase. Yet resentments were merely lulled, not erased. Of Corinthian emotions when the Athenians interfered in the Megarid in 461 Thucydides uses the term "hatred." Hatreds linger. The Corinthians, it is true, did the Athenians a service at the time of the Samian revolt (or claimed to have done so). Nevertheless, their fears were certainly exacerbated by the Athenian enterprises of the next few years in Thrace and the Euxine; they must too have sensed Athenian ambitions in the West. The disciplining of Potidaea deepened the wounds.

Thucydides identifies four specific grievances as the immediate causes of the Peloponnesian War. Two affected the Corinthians directly.

The troubles began in the Adriatic in 435 with *stasis* in Epidamnus (now Albanian Durazzo), a colony of the Corcyraeans, who held aloof. The Corinthians, who had supplied the *oikistes* (the founder) and had never been on good terms with their own colonists on Corcyra, responded to the plea of the Epidamnian democrats with alacrity. The result was a battle between the Corcyraeans and the Corinthians, each of whom claimed second place among Hellenic naval powers, in the waters off Leucimme, a headland of Corcyra. The Corcyraeans won a convincing victory.

Although both sides put to sea the following summer, no clash occurred. The Corinthians were building ships, and their preparations for a major campaign included the enlistment of help from the Peloponnese. Alarmed, the Corcyraeans sent representatives to Athens to ask for alliance. The Corinthians thereupon dispatched their own spokesmen to foil their enemy's

hopes (433). Once more the aggravation of a local quarrel reached the Athenians and offered temptation. Each delegation addressed the assembly.

Thucydides puts the two arguments into direct discourse. It is probable that he was himself present, and we can assume that the speeches, although they do not repeat the precise words, do convey accurately the sense of what was said and the apprehensions that were current among the Hellenes.

The Corcyraeans addressed the gathering first. I quote those passages that were meant to influence the Athenians most deeply. "We possess, apart from you, the greatest naval power. . . . As for war, in which we should be useful to you, if any man among you thinks that it is not coming, he is mistaken; he fails to perceive that the Lacedaemonians, in their fear of you, want to make war and that the Corinthians are influential with them and are your enemies. . . . Nor will you break the treaty with the Lacedaemonians by receiving us, who are allied with neither side: for it is prescribed therein that any of the cities of Hellas that is allied with neither side is free to join whichever it pleases. . . . the war that is coming and is already all but here. . . . For Corcyra lies strategically on the coastal voyage to Italy and Sicily so as not to allow naval forces to reach the Peloponnesians or the Peloponnesians to send warships to those parts. . . . There are three formidable naval powers among the Hellenes: yours, ours, and the Corinthians'. If you allow two of these to merge into one and the Corinthians overpower us first, you will be fighting the combined Corcyraean and Peloponnesian navies; whereas, if you accept us, you will be able to face your enemies with our ships added to your own."

The Corinthian reply opens with castigation of the Corcyraeans' conduct towards their mother-city. To the Corcyraeans' citation of the treaty the Corinthians argue that the clause allowing the ally of neither side to join either "does not apply to those who seek alliance for the purpose of doing harm to others but to those whose need for security is not based upon abandonment of others and to those who will not bring war in place of peace to those who have received them, if the receivers are wise. And this is what you would suffer if we should not persuade you. You would not merely be helping them, you would also be at war with us instead of bound to us by treaty. For, if you align yourselves with them, we shall be forced to punish you along with them." This interpretation places colonists (that is, the Corcyraeans) in virtually the same category as those "written" into an alliance (that is, members of the Peloponnesian League): a pact voted with the Corcyraeans would amount to a commitment to fight against the Corinthians, who were on the brink of war against their colonists. Whether the argument has legal validity is moot. The Corinthians recall the favours done to the Athenians in the past (the gift of 20 ships in the 480s, their recent blocking of Peloponnesian aid to the Samians). "The coming war, with

which the Corcyraeans alarm you in bidding you do wrong, lies still in the uncertain future. . . . The wiser course is gradually to diminish the suspicion existing heretofore on account of the Megarians." The Corinthians had helped the Athenians in the Samian affair: "now we ask the same courtesy of you, that, having been assisted by our vote, you not harm us by yours."

The Athenians recognised the gravity of the situation, and debate in the Ecclesia leaned towards the Corinthians. The following day, at a second meeting, they changed their minds and concluded a defensive alliance with the Corcyraeans: if either party or its allies should be attacked, the other would provide military aid. The Athenians had no intention of breaking the treaty by participating in offensive action: "for they thought that the war with the Peloponnesians would nevertheless fall upon them and they had no wish to yield Corcyra, with her powerful navy, to the Corinthians. . . . At the same time they saw that the island was well situated on the coastal voyage to Italy and Sicily."

Soon afterwards (433) the Athenians sent 10 ships to Corcyra with instructions not to engage in offensive action. When the Corinthian and Corcyraean fleets clashed near the Sybota Islands, which lie between Corcyra and the mainland, the Athenians joined their new allies. The Corinthians, having had the better of the engagement and about to deliver the final blow, were deprived of their victory by the appearance of 20 supporting Athenian ships. The Corinthian withdrawal at this potentially decisive moment is telling evidence of the prestige and reputation of the Athenians at sea. In this way the Corcyraean affair became "the first grievance."

The Corcyraean mention of their island's strategic position on the coastal voyage to Italy and Sicily and Thucydides' recognition that the Athenians were conscious of this factor as they agreed to a defensive alliance remind us once again of Athenian interest in the West. When the Athenians voted an alliance with Sicilian Segesta in 458/7, we expressed wonder; we wondered again when they swore to alliances with Leontini and Rhegium in 448. Now we hear the Corcyraeans speaking of their own strategic position along a coastal voyage. The allusion is unquestionably to naval vessels rather than to merchantmen, which carried their own supplies and so had no need to hug the coast. We have already remarked upon the renewal of the alliances with Leontini and Rhegium and the signing of a pact with Halicyae. These moves follow closely (433/2) the altercations with the Corinthians. The diplomatic offensive was not coincidental.

The steady deterioration of relations with the Corinthians accentuated Athenian anxieties in the north. Although the severe increase of tribute imposed upon Potidaea in 436/5 was dutifully paid for the next three years (434-432), Athenian suspicions were not allayed. Now, in 433/2 (winter), the Athenians demanded that the Potidaeans dismantle their fortifications fac-

ing Pallene, surrender hostages, dismiss their Corinthian magistrates, and decline to receive them in the future. Not only were the Corinthians dangerously hostile; so too was Perdiccas of Macedon, who had already approached the Lacedaemonians and the Corinthians with a view to fomenting revolt in Potidaea and among the neighbouring tributary allies of Chalcidice and Bottiaea.

An embassy from Potidaea to Athens proved ineffective. At Sparta, the Potidaeans gained the promise of an invasion of Attica should the Athenians attack their city. The Athenians had mounted an expedition to deal with Perdiccas; it was now instructed to enforce Athenian demands on Potidaea and to avert, if possible, revolt among Chalcidians and Bottiaeans. The combination of action and diplomacy persuaded the Potidaeans: making common cause with the tributaries of Chalcidice and Bottiaea, they openly renounced allegiance to the Athenians. The critical decision was made in the late spring of 432, after the payment of tribute. The complete Thracian panel of quota-list 23 (spring 431) allows us to identify the rebels by their absence: the hinterland (Chalcidice and Bottiaea) behind the three elongated promontories of Thrace was almost wholly lost to the Athenians (about twenty-five tributaries). Two other absentees invite conjecture: wealthy Maroneia and Aenus, harbour-towns far along the Aegaean coast. Maroneia is booked, with a considerable reduction of tribute (10 to 3 talents), in Lists 25 and 26 (List 24 is not extant); whatever difficulty existed in 432/1 had been quickly dissolved. Aenus, however, is absent from the full panel of List 20 (435/4) and does not reappear until the assessment of 425; there is no evidence that she ever paid after 435.

When the small Athenian force (30 ships and 1,000 hoplites) arrived in the Thermaic Gulf, the commanders found Potidaea already in revolt. Lacking the strength to cope with two objectives, they concentrated upon Perdiccas. The news of the revolt quickened action in Athens and Corinth. The Corinthians ordered Aristeus, with a small body of volunteers (from Corinth and the Peloponnese), to Potidaea to conduct the defence. The Athenians for their part assembled reinforcements (40 ships and 2,000 hoplites) to join the troops dealing with Perdiccas. The Athenians had recovered Therme (at the head of the Gulf) and were besieging Pydna (on the west coast of the Gulf). When Perdiccas sought negotiation, the Athenians were glad to agree to terms and receive him as an ally, pressed as they were by the arrival of Aristeus in Potidaea. The battle that ensued in the area between Potidaea and Olynthus, the Chalcidian centre, drove Aristeus into Potidaea, which that summer (432) was placed under siege by land and sea. Perdiccas, surely one of the most arrant turn-coats of history, had by now thrown in his lot with the Corinthians. Aristeus himself slipped from the town and conducted guerrilla operations against the Athenians. Phormio, who had arrived from

Athens with further reinforcements, recovered a number of Chalcidian and Bottiaean towns in the course of the next few months. The Potidaean affair (there were Corinthians and Peloponnesians inside the walls) became "the second grievance."

So far the Corinthians had been acting on their own initiative. Now, foiled in the Adriatic and with their own citizens trapped in Potidaea, they brought about a meeting of the Peloponnesian League at Sparta. Among the delegates, a contingent from Megara complained before the Spartan assembly that, contrary to the terms of the treaty and in addition to other hostile acts, they were banned from the harbours of the Athenians' Empire and from the Athenian Agora. This decree threatened economic ruin for the Megarians and it takes its place as "the third grievance."

The Aeginetans, tributary members of the Empire, could scarcely send spokesmen officially; covertly, however, they worked with the Corinthians in fostering war: they were not, they said, living autonomously, as had been guaranteed by the treaty. The alleged mistreatment of the Aeginetans was "the fourth grievance."

The Corinthian address to the assembly, with the representatives of the League present, is partly an attack on Athenian imperial ambitions—which is also highly complimentary to the innate energy of the Athenian character— and partly an attack on the Spartans' traditional reluctance to become embroiled far from home.

"It chanced," writes Thucydides, "that there was already an Athenian commission in Sparta engaged on other business." The sceptic may conjecture that foreknowledge rather than chance brought these Athenians to Sparta. In any case, their request to speak was granted. The spokesman refers to the Athenian record against the Persians but, rather than indulging in a defence of Empire against the Corinthian charges, he emphasises to the Spartans the imperative need for caution before declaration of a potentially ruinous war; "we say to you, settle our disagreements by arbitration in accordance with the treaty."

The Spartans then considered the situation *in camera*. King Archidamus advised against haste, preferring to create time for preparation by offering arbitration. The ephor Sthenelaidas urged an immediate declaration that the treaty had been broken and in the division that ensued his persuasion gained a comfortable majority. The decision was at once announced to the allies, who confirmed it unanimously by vote (summer 432).

A month later the Spartans reconvened their allies of the Peloponnesian League to seek a vote for a declaration of war. The Corinthians were the last to speak to a receptive audience. The Spartans put the question city by city and the majority voted for war.

In practical terms the Peloponnesians were not ready to take the field and

during the winter the Spartans sent at least three embassies to Athens. Apart from an indirect attack on Pericles they demanded "that the Athenians withdraw from Potidaea and allow Aegina her autonomy; their most emphatic and most direct stipulation was that war could be avoided by the annulment of the Megarian Decree." The final embassy delivered a brief ultimatum: "The Lacedaemonians want peace to prevail; there can be peace if you grant the Hellenes autonomy."

At the many sessions of the Athenian Ecclesia that debated the issues that winter opinions were divided. Finally, in response to the Spartan ultimatum, Pericles, "the most prominent Athenian of the time" (in Thucydides' introductory description), mounted the rostrum.

In our own century we have suffered from the dire results of appeasement. The views ascribed to Pericles by Thucydides in 432 B.C. are a model for those who would unflinchingly resist international blackmail. I choose the passages most apposite to the Athenian dilemma.

"Men of Athens, I hold to the opinion that I have maintained consistently: do not yield to the Peloponnesians. . . . Before, the Lacedaemonians were clearly plotting against us; now, it is especially obvious. For it is specified in the treaty that we grant and accept arbitration of our mutual disputes and that we and they hold what we have; they on their side have never yet asked for arbitration nor do they accept it when we offer it; no, they prefer to settle their grievances by war rather than by discussion, and they now come here no longer expressing censure of us but imposing orders. For they command us to withdraw from Potidaea, to leave Aegina autonomous, and to revoke the Megarian Decree; the last spokesmen who came here even announced publicly that the Hellenes are to be autonomous. Let no man among you believe that we should be going to war for a triviality if we should not revoke the Megarian Decree. . . . For if you concede the point to them you will at once be the recipients of still more significant commands, as if you had given in on this present point through fear. . . . For any claim, be it very large or very small, coming from equals and pressed upon neighbours as a demand before arbitration can imply the same slavery. . . . Let us now dismiss the delegates with the following admonitions: that we shall allow the Megarians the use of the Agora and the harbours if the Lacedaemonians too cease to practise their expulsion of aliens against both us and our allies (for the treaty forbids neither one policy nor the other); that we shall concede to the cities autonomy if they were also autonomous when we signed the treaty and when the Lacedaemonians on their part grant to their cities the right to live autonomously, in accordance not with Lacedaemonian convenience but with the wishes of each ally; that we are willing to submit to arbitration as the treaty lays down; that we shall not initiate war but we shall resist those who do initiate it. For this is the just answer, the answer that, above all else, is

appropriate to this city. We must convince ourselves that war is inevitable: the more willing we are to accept it, the less willing shall we find our enemies to begin it."

As I have insisted previously, the precise status of Pericles has been misrepresented since at least the time of Plutarch. He was not a dictator, he was not a President or a Prime Minister, he was not an Augustan *princeps,* he had no final power. His position as "the most influential" (and so "the first") of the citizens is accurately reported in Thucydides' comment on the impact of this speech: "The Athenians believed that he was giving them the best possible advice; so they voted as he urged. They replied to the Lacedaemonians as he had recommended, point by point and *in toto*: they would do nothing on order, but they were ready to settle their differences in fair and equitable arbitration, as the treaty stipulated."

In the spring of 431 the Thebans, allies of the Spartans, attacked Plataea, the Athenians' old ally (since 519, or perhaps 509) on the Boeotian border of Attica. This was the first act of war. About eighty days later, when the grain was ripe, the Peloponnesians under King Archidamus, with a Theban contingent that included cavalry, invaded Attica.

I have narrated the four grievances, the immediate causes of the war. Thucydides unambiguously identifies the fundamental cause: "It is my judgement that the truest cause, though it appeared least in what was said, was the steadily increasing power of the Athenians, which instilled fear in the Lacedaemonians and drove them to war."

A review of the evolution of the Confederacy of Delos into the Athenian Empire and the consequent transformation of the status and prestige of the Athenians among the states of Hellas uncovers cogent reasons for respecting Thucydides' perceptive—and contemporary—observation.

The Spartans' foreign policy had long been dictated by the continuous presence of menace across the borders: to the west, the state-owned helots tilled the rich soil of Messenia for their heavily-outnumbered Spartan masters; to the north-east, the Argives had never abandoned their claims to domination of the Peloponnese. Years ago the Spartans had taken two counter-measures. Their way of life (the *agoge*), with its rigid discipline, had produced the finest hoplite-force in all Hellas; the life-long duty of this army in being was to safeguard the homeland. By the end of the sixth century the Peloponnesian League, a triumph for Spartan diplomacy that excluded only the Argives, had become an effective power in the inter-state relations of the peninsula. Each member was pledged to supply armed assistance to the Spartans as needed. The synod of the allies debated questions of policy affecting the Peloponnese as a whole. The Spartan assembly did likewise and sought agreement with the synod. Spartan influence saw to it that the members lived under sympathetic oligarchic constitutions. The Spartans

themselves aimed at perpetuating a balance of power that, along with their own isolationism, would guarantee their peace and safety.

A survey of the Spartans' record in the fifth century reveals the policy in action. In 499 they refused assistance to the distant Ionians. When the Persians invaded in 480 and 479 the Spartans, loath to leave the Peloponnese, advocated the building of a defensive wall at the Isthmus. In 478, without enthusiasm for an aggressive campaign against the Persians and persuading themselves that the Athenians were competent and friendly, they withdrew from operations; they neither opposed the formation of the Confederacy of Delos nor shared in its activities. The Spartans' promise to aid the Thasians in 465/4 seems so out of character that its authenticity has been doubted. I see no reason, however, to doubt Thucydides ("they intended to do so"). When the earthquake of 464 (which invalidated the promise) encouraged the helots to revolt, the Spartans called upon their allies of the League. The Athenians were present in the name of the still-valid alliance against the Mede; their quick dismissal seems more typical of the Spartan character. In the first Peloponnesian War, in which the Corinthians were certainly protagonists, the Spartans made few ventures northward; the Thirty-Years' Peace recognised the Athenian Empire. At Sparta in 432 the Corinthians claim that they prevented the dispatch of aid to the rebellious Samians in 440. We are not rash when we suspect that the Corinthians are distorting history and that the Spartans were far from eager to become embroiled in military and naval action in Ionia.

From the disturbances affecting the Corcyraeans and the Potidaeans in the 430s the Corinthians emerged as the aggrieved party. Their resentment was no doubt accentuated by the increasing evidence of Athenian interests in the West, where Athenian wares and merchants had by now outstripped Corinthian. The passage of the Megarian Decree, a flinging of the gauntlet by the Athenians that may be deemed provocative, did nothing to assuage the Corinthians' indignation. It is thus not difficult to understand their state of mind and their reasons for convening the League in the summer of 432. They encouraged the complaint lodged by the Aeginetans and had infected the other delegates with their discontent.

The speeches of the Corinthians at Sparta are denunciations of the Spartans as much as of the Athenians. They contrast the tireless enterprise of the Athenians with the sluggish failure of the Spartans to fulfil their responsibilities as leaders. Their most telling argument threatens to destroy the League: "Do not turn the rest of us in desperation towards a different alliance." The allusion to the Argives is plain.

This critical situation, as even the cautious Archidamus admitted, had been brought about by the versatile restlessness of the imperial Athenians. To the Spartans the future looked bleak. So far they had attempted to ignore

the dangers. Now, however, "the mounting power of the Athenians could not be ignored and they were beginning to infringe upon the Lacedaemonians' own alliance. At this juncture the Lacedaemonians judged the position to be no longer endurable; they decided that they must face the problem with all possible zeal and by undertaking this war destroy the power of the Athenians."

XV

THE GREAT WAR

1. THE FIRST TEN YEARS

With open warfare a reality, the two sides could number their allies, take stock of their resources, and ponder their strategies.

Within the Peloponnese only Argos, naturally, held aloof from the Spartan alliance; neutral at first, the poleis of Achaea (the wedge along the southern coast of the Gulf of Corinth) soon followed Achaean Pellene into the League. Outside, the Peloponnesians could count on the Megarians, Central Hellas (the Phocians, the Locrians, and the Boeotians with the exception of the Plataeans), the Ambraciotes of the west, and the islanders of Leucas off Acarnania in the Ionian Sea. In addition, the Spartans looked to some of the cities of Italy and Sicily (the Dorian colonies, no doubt) as their friends and requested that ships be built and money contributed.

The cities of the Empire, the core of Athenian strength, were reinforced by the Plataeans (now under siege, along with an Athenian garrison), the Messenians of Naupactus, the Acarnanians in the west, and the islanders of Corcyra and Zacynthus (off the north-western Peloponnese). The Chians and Lesbians within the Empire and the Corcyraeans possessed sizeable navies.

The Peloponnesians were conscious of their financial weakness at the outset. They apparently relied upon offerings in cash and kind and their hope, based on their experience, that the war would not be prolonged. They boasted far and wide that they were the Liberators of Hellas and they must have been heartened by the sympathy to their cause that was prevalent

among the Hellenes. Thucydides (who emphasises this) adds that most harboured bitter resentment towards the Athenians, some anxious to be freed from the Empire, others in fear that they might be forced into it. It is a remark that must be viewed with some reservation, for according to his own later accounts the Many in the cities that revolted or were traduced by the Spartans retained their loyalties to the Athenians in opposition to the rebellious Few. Peloponnesian propaganda was no doubt responsible for the rumours of 431 that hailed the Spartans as liberators.

Pericles had for some years been suffering the not unparalleled fate of great men, indirect and personal attacks through his friends. With the city on the brink of war, however, it was to him that the Athenians listened. His masterly exposition of Athenian resources stressed naval power and its flexibility, along with Athenian expertise, centralised command, the solidarity of the Empire, the fortifications of the city, the annual revenues from the allies and elsewhere, and the existing surpluses, in cash and plate (gold and silver): "it is reserves that sustain wars, rather than enforced levies." (The noun rendered as "reserves" implies superiority, that is, more than one's opponent.) The contrast with the Spartans is intended. His conception of the winning strategy, which I paraphrase, was equally persuasive: "We must let go our land and houses and stand guard over the sea and the city itself; we must not, when our passions are aroused, confront the numerically superior Peloponnesians in pitched battle; we must not attempt to add to the Empire in time of war; we must not incur new dangers of our own choosing; we must keep our navy, our special strength, in fighting trim; we must administer efficiently the affairs of the allies, the chief source of our revenues—wars are won by intelligence of mind and abundance of money."

We are reminded of Thucydides' opening sentence: " . . . the combatants were at the height of their power with all their resources available . . . the other states of Hellas were aligning themselves with one side or the other, some taking action at once while others were thinking about it."

When war could no longer be avoided, the Spartans, who had been driven into their decision, employed their self-styled designation, the Liberators of Hellas, as a war-cry. On the other side, Pericles expressed what he judged to be the views of responsible Athenians—and he convinced the Ecclesia: they were fighting for the right to retain their Empire.

I do not intend to narrate the story of the long conflict (431-404) in all its detail. Every reader will have Thucydides' comprehensive *History*, which takes us to 411, on his shelves; Xenophon's continuation and a number of modern studies of the War are readily accessible. My sketch will dwell upon the phases—the many phases, to be sure—that especially affected the Empire.

The first stage, called the Archidamian War after the Spartan king, lasted ten years, with a year of armistice from the spring of 423 to the spring of 422.

The signing of the Peace of Nicias (spring 421) brought an official cessation of hostilities.

In the spring of 431 the Peloponnesians invaded Attica and laid waste the land. Between 431 and 425, the years of the first and last invasions of Attica, the Athenians in the countryside were spared only twice, in 429 and 426, when the enemy stayed away in fear of contagion. The usual answer to invasion was a naval raid around the Peloponnese. In each year the Athenians attacked and ravaged the Megarid until Nicias in 424 captured Nisaea (Megara's harbour on the Saronic Gulf). In 431 the Athenians expelled the Aeginetans from their island, which they themselves settled.

Among the qualities that Thucydides most admired in Pericles were his foresight and his ability to assess a situation. Like Thucydides, we can look back over the course of the long war and appreciate these attributes during the vicissitudes suffered by the Athenians. Few are tempted to dispute Thucydides' verdict. History, however, has a way of defying logic and reason, and the foresight of man. What Pericles could not foresee was the virulent plague that swept through the city in 430, carrying off perhaps a quarter of the population. The suffering was aggravated by the miserable conditions in which the Athenians from the country, which was enduring the second Peloponnesian invasion, were compelled to live behind the walls.

The minor successes of a strong force led by Pericles along the Peloponnesian coast did little for the despondency permeating the city, and of the 4,000 hoplites who carried the plague with them to Potidaea more than 1,000 were fatally stricken.

The Athenians, in their utter despair, turned on Pericles: he had guided them into war; he was responsible for the insanitary hovels in which the rural population were crammed in the city. They went so far as to treat with the Spartans. Pericles met the crisis by addressing a special meeting of the assembly. It is the speech of a resolute statesman. He had advised war; the Athenians, he reminds them, had voted for it—responsibility must be shared. The initial strategy is the right strategy and the navy is without equal. War brings suffering; even so, the plague has fallen on them unpredictably. As the holders of Empire, with their traditions of accomplishment and power, they must remain steadfast. "Send no more embassies to the Lacedaemonians; do not give the impression that you are overwhelmed by your present misfortunes. Those who, in the face of disaster, are least affected in spirit but most active in their resistance—these, both cities and individuals, are the strongest."

The strictures and encouragement had the desired effect: they sent no more delegations to the Lacedaemonians and they renewed their concentration on the war. Privately, however, their resentment festered, and they sought relief by fining Pericles and removing him from office (as *strategos*). A little later (spring 429)—"with a change of heart typical of the masses,"

writes Thucydides, scornfully—they re-elected him and once more looked to him for leadership. Pericles had himself contracted the plague and had apparently not fully recovered. He died in the autumn of 429; he was about sixty-five.

From now on the advocate of Periclean policy was Nicias son of Niceratus, who was confronted in the assembly by the flamboyant opposition of Cleon son of Cleaenetus. Nicias, who was greatly admired by Thucydides, matched Pericles in integrity and selfless devotion to duty (*arete*), but not in political flair and intellect. Thucydides, who very seldom lets bias show elsewhere, cannot disguise his intense dislike of Cleon, whom he introduces as "the most violent of the citizens and the most persuasive." The first adjective refers to his oratorical style ("most forceful" would also render the Greek), to the conservative historian an unpleasant contrast to Pericles' "Olympian" and reserved manner. At every turn Cleon persistently contradicted the policy of Pericles.

The area of gravest concern to the Athenians had for some time been the north, the Thraceward division of the Empire, where, even before diplomatic exchanges with the Peloponnesians had broken off, the expeditionary forces, beset by the revolts in Chalcidice and Bottiaea and continually discomfited by the unreliable Perdiccas, were laying siege to Potidaea. The gaining of the friendship of Sitalces, the Thracian king of the Odrysae, brought a measure of relief to the Athenians. This wealthy kingdom extended from the Danube to the Aegaean and west as far as the Strymon River. Sitalces collected tribute from the natives and even from the Hellenic cities of Thrace; Thucydides is impressed by his power. Sitalces was instrumental in bringing Perdiccas to the Athenian side (431), if only temporarily; Perdiccas assisted in the recovery of a few towns in Chalcidice, and, best of all from the Athenian point of view, he gave practical support to the capture of Potidaea (winter, 430/29). Colonists were settled in Potidaea, which could be used as a base; but there were still the rebels and Perdiccas had again become hostile. The Athenians, in this uneasy atmosphere, were compelled to maintain their forces in the area.

In the summer (430) before the fall of Potidaea the Athenians, with necessary assistance from Sitalces, intercepted in Thrace a Peloponnesian embassy en route to the Hellespontine satrap Pharnabazus and thence to the King, from whom they were to seek financial and other help. This was the first bid by either side to involve the traditional enemy as an ally. The execution of the captives in Athens (they included Aristeus, that staunch Corinthian defender of Potidaea) in retaliation for the Spartan killing of Athenians and allies picked up in the Aegaean reflects the dreadful effects of war upon the characters of men.

Strategy in the north was not confined to the field. At the time of the

re-assessment of 430, the Athenians revealed their awareness of the situation by voting a decree that created a new status for Methone, a town on the west coast of the Thermaic Gulf abutting Macedonia. Methone had been assessed for the first time in 434, no doubt as part of Athenian precautionary steps in the area. Now, in 430, as we learn from inscriptions, she was granted the privilege of paying only the *aparche*, Athena's sixtieth part of the *phoros*. Apparently, the Methonaeans were in arrears: on condition of continued good behaviour, the Athenians would not press for payment. Further, legates would be sent to Perdiccas, warning him that the Methonaeans were to enjoy freedom of movement by sea and land. At the same time, Haeson, to the south of Methone, and Dicaea, on the east coast of the same gulf, were assessed for the *aparche* alone, to make a group of three who appear together with their own heading in Lists 25 and 26 (429 and 428). These privileged few were joined in 428 by Aphytis, near Potidaea and the isthmus of Pallene. Although the Aphytaeans' tribute had been raised from 3 to 5 talents in the assessment of that year, they now received permission to pay the *aparche* alone. We are so informed by an agreement, of which we possess three fragments, defining the special status of Aphytis (like that of Methone) in relation to the colonists at Potidaea and to other cities in the neighbourhood. These documents supply further evidence of the Athenians' concern about the north and the lengths to which they would go to avoid a deterioration of their imperial position.

On the Asiatic side of the Aegean the Athenians felt less immediate pressure at the beginning of the war. They could not neglect the presence of the Persian satraps, ever a potential danger, and they knew that they must not relax their vigilance in the protection of Empire.

Indeed, as early as the second invasion of Attica (430), *stasis* in Ionian Colophon led to the issuing of an invitation by the oligarchic faction to the Persians. The satrap Pissuthnes (at Sardes), in flagrant disregard of the Peace of Callias, sent troops under Itamenes, who seized the city. The loyal Colophonians fled to their harbour, Notium. Further strife in that town allowed the Persians, aided by the pro-Persians of the upper city, to take it also. The defeated element, who must have been the committed democrats still loyal to the Athenians, chose exile. The Athenians took no immediate counter-measures; at the time they were coping with the northern theatre of war and were mortally distracted by the plague. For three years (430-428) no tribute came from the two poleis.

The other area of disaffection in which the Athenians, for the same reasons, failed to act promptly, despite warnings from the Tenedians (their island is situated a few miles south of the entrance to the Hellespont) and their friends in the city, was Mytilene, where the oligarchs in power planned to take over the whole island of Lesbos and abandon the Athenians. In 428

(summer), after the arrest of the crews of 10 Mytilenaean ships that were serving with the Athenians and the approval of a futile armistice by an Athenian squadron of moderate size, the Mytilenaeans and the rest of the Lesbians, with the exception of the Methymnaeans (in the north), revolted openly. The Athenians were now compelled to deal seriously with a major problem: the loss of one of the two remaining naval allies (Chios was the other). Lemnians, Imbrians, and the Methymnaeans fought alongside the Athenians, who were reinforced by a squadron from home under Paches, and by the autumn Mytilene was under siege by land and sea.

The Mytilenaeans had previously sent ambassadors to beg assistance from Sparta. They appeared before the Peloponnesians at Olympia after the completion of the festival (late summer, 428). The speech put into the mouth of the Mytilenaean speaker by Thucydides has sometimes been cited at face value as an indictment of the Athenians and their Empire. This view ignores the circumstances. The Mytilenaean aristocrats were pleading a case. Their interpretation of the facts as they sought to win the support they desperately needed may have been honest; the dispassionate observer condemns it as distorted. We are reminded of the Corinthians' performance at Athens in 433 and before the League in 432. As a reconstruction of the argument by a conscientious and perceptive historian the Mytilenaeans' presentation should be deemed a brilliant piece of writing. It surely prepares us for the result: the Spartans and their allies were convinced, welcomed the Mytilenaeans as friends, and energetically made plans to aid them.

In the event, however, immediate action was not forthcoming. The promised invasion of Attica collapsed when a hastily-manned Athenian fleet raided the Peloponnesian coast and 40 requisitioned ships under the Spartan Alcidas made no move eastwards. In the spring (427) the regular invasion proved to be especially destructive but by this time the Mytilenaeans had capitulated. Alcidas, who might at least have harassed the Athenians with his 40 ships, dallied and showed no disposition to come to grips with the besiegers, a tribute to the Athenians' naval reputation.

The surrender of Mytilene had been brought about partly by a shortage of food and partly by the refusal of the Many to obey the oligarchic government, a situation that prevailed in a number of the allied states. The Mytilenaeans were allowed to send representatives to Athens to plead for generous terms.

Paches took advantage of the interval to recover Notium, banishing the pro-Persians. The scattered Colophonians returned to Notium and later the Athenians established colonists there, to live under Athenian laws. The "colonists" may have consisted merely of an Athenian reinforcement of the Colophonian remnant. In the spring of 427 the Colophonians paid a *phoros* of 500 drachmae (in place of the former 3 talents); these were the Colophonians now living in Notium, who were insistent on keeping their identity. At the

same time Notium delivered a token amount, 100 drachmae.

The initial reaction of the Athenians to the revolt expressed their bitter anger that the Mytilenaeans, naval allies and generously treated, had betrayed them. They approved the motion of Cleon to execute all male Mytilenaeans and enslave the women and children. Overnight, the savagery of the sentence preyed upon their minds and, reinforced by the Mytilenaean delegates, the more moderate brought about a reconsideration at a special meeting of the Ecclesia.

Thucydides puts the arguments vividly in the form of a debate between Cleon and Diodotus son of Eucrates (of whom we hear no more). Cleon, in a powerful speech, adheres to his original proposal and his principles of imperial management. I summarise his appeal. "Do not be influenced by compassion or by the words of a clever speaker. When you have been wronged, your immediate judgement is best, before time eases your anger. The imperial state cannot afford the appearance of weakness. The Mytilenaeans live on an island, with fortifications and ships, autonomous and notably honoured by us. They did not secede, they committed an act of unprovoked and premeditated aggression, in collusion with our enemies. They are all guilty, the Many as well as the Few. Make them an example that will deter others."

Diodotus does not deny the guilt of the Mytilenaeans nor is he moved by compassion; he bases his case firmly upon what is in the best interests of the Athenians. "The fact is that severe punishment does not deter. Now, if a city revolts and then foresees failure, it will submit and survive to pay tribute and indemnity, revenue that we need. If we follow Cleon, that city, recognising that submission will bring no mercy and therefore having nothing to lose, will continue to resist, to endure siege and destruction, thus depriving us of future revenue. As matters stand, the Many in the cities are well disposed to you; in Mytilene, as soon as they had the chance, they surrendered the city to you. If you destroy them, the innocent with the guilty, you will drive the Many in the other cities to collaborate in revolt with the Few. Even if they are guilty, you should pretend that they are not, in order to retain the loyalty of the one group that is not hostile to you."

The final vote was close, but the view of Diodotus prevailed. After the first meeting a trireme carrying the original sentence had set out for Mytilene. A second vessel was now prepared and dispatched with all haste to bring news of the remission. The crew rowed continuously and arrived just as Paches finished his reading of the previous orders. "So near did Mytilene come to destruction."

Some 1,000 ringleaders of the revolt were executed, on motion by Cleon. The Mytilenaeans pulled down their fortifications and ceded their ships; their constitution became democratic. The Athenians divided the lands of

Lesbos (Methymna was exempted) into 3,000 lots: 300 they dedicated to the Gods; on the rest they settled cleruchs chosen by lot. Later in the same year the Athenians relented: political autonomy was restored (by the removal of a garrison?) and the allotments were returned to the original owners, who were required to pay a "rental" of 2 minas (200 drachmae) annually to each cleruch. These rentals took the place of *phoros*. The cleruchs themselves were planted on the confiscated lands of the executed oligarchs and, as a virtual garrison in being in a critical area, illustrate well the basic purpose of a cleruchy. Ultimately, then, the Athenian disposition of the Mytilenaean problem cannot be considered excessively harsh.

Mytilene had controlled cities on the Asiatic mainland. The Athenians appropriated these and subjected them to assessment: in the lists they appear as the Actaean Cities (Cities of the Acte, "promontory").

This (427) was the year in which the Plataeans, the Athenians' oldest allies, finally capitulated. The Spartans, in weak appeasement of the vindictive Thebans, executed about 235 men (including 25 Athenians) and enslaved the women.

So far the Athenians had ventured no further west than the coasts of Acarnania and Ambracia, where Phormio, making adroit use of the naval base at Naupactus, had in 430 and 429 enhanced Athenian prestige at sea. Intermittently, we have had occasion to register Athenian diplomatic activity in Sicily and Magna Graecia. In 427 war had broken out between Leontini (with the other Ionians) and Syracuse (with the Dorian colonies, except Camarina); Rhegium, on the toe of Italy, had joined Leontini. The Leontine appeal in the name of the old alliance brought in the late summer 20 Athenian ships. The Athenians renewed their alliance with Segesta and, establishing themselves at Rhegium, collaborated with their western allies. "They wished to prevent the export of grain from there into the Peloponnese and to test the possibility of acquiring control of Sicilian affairs." The Athenian response was a direct contradiction of the more cautious policy of Pericles. The Athenians, reinforced in the summer of 425 by 40 additional vessels, fought with varying success until the summer of 424, when representatives of the Sicilian Greeks met at Gela (on the south coast). Here the Syracusan Hermocrates pleaded successfully for unity against the dangerous oppression of the Athenians. The result was a general peace, in which the three Athenian *strategoi* acquiesced. They had little choice. Nevertheless, the Athenians, their spirits lifted by a spectacular success elsewhere, exiled two *strategoi* and fined the other. The Athenians were not taking their Sicilian intervention lightly.

The 40 reinforcements assigned to Sicily in the early summer of 425 encountered unplanned adventure on the voyage. As they rounded the Peloponnese they were driven by a storm to seek shelter at Pylos, a small

uninhabited peninsula on the west coast of Messenia. The *strategoi*, Eurymedon and Sophocles, were accompanied by Demosthenes, who had made a name for himself in Acarnania. "He held no command but at his request the Athenians had given him authority to make what use he wished of the ships around the Peloponnese."

Reluctantly, we must content ourselves with a summary of Thucydides' dramatic story: the fortification of Pylos, the withdrawal of the Peloponnesians from Attica and their assembly in the vicinity of Pylos, the naval battle, and the isolation of 440 hoplites (including Spartiates, full Spartan citizens) on the island of Sphacteria, which, running south about three miles from Pylos, forms the Bay that in modern times has been given the name Navarino.

With this victory the Athenians might have won a peace on the basis of the *status quo*. Instead, however, they listened to Cleon and the Spartan ambassadors retired in failure. The Athenians "were grasping for more." The siege of Sphacteria dragged on through the summer. As winter approached (when naval patrols could no longer be maintained), Cleon confronted Nicias, the senior *strategos,* in the Ecclesia and denounced the lack of progress at Pylos. Trapped into personal command, he boasted with typical flamboyance that "within twenty days he would either capture the Lacedaemonians alive or kill them on the spot." Thucydides' comment betrays his dislike of Cleon: "Sensible Athenians were delighted by the boast, reflecting that of two possible blessings they would gain one: either they would be rid of Cleon, which they rather expected, or, if they proved to be mistaken in their opinion, he would subdue the Lacedaemonians for them."

A combination of Good Luck and the skill of Demosthenes, *strategos* since mid-summer, brought success to the final assault. Of the 292 survivors on the island, 120 were Spartiates. These Cleon conducted back to Athens, within the twenty days: "Cleon's promise, mad though it was, came to pass."

At the beginning of 424 Aristophanes produced *The Knights,* in which Demos, the master, has two faithful slaves, Demosthenes and Nicias, who are much distressed by the toadying conduct of a new slave, Paphlagon (a thinly disguised Cleon). Demosthenes has a personal grievance: "Just recently I baked a Laconian barley-cake in Pylos for Master; Paphlagon, that model of villainy, sneaked around me, filched the cake that I had baked, and offered it to Master as his own." There were certainly Athenians who believed that Cleon had appropriated the glory that belonged to Demosthenes. Just as certainly Cleon, who had had the advantage of being present when the Peloponnesian resistance collapsed, became the hero of the hour. The suspicions that he was the advocate of the sensational imperial re-assessment of 425 are quite justified.

Most Athenians (perhaps even Pericles) had not contemplated so prolonged a war, nor the mounting expenses that accompanied it. The long

siege of Potidaea, the annual naval expeditions, the campaigns by land, and the reduction of Mytilene had applied severe strain to the treasury. All the martial expenditures fell upon Athens, whereas on the Peloponnesian side the burdens were shared by the members of the League. The Athenians, of course, did have the income that accrued annually from the *phoros*.

The first assessment of war-time, on schedule in 430, shows little change of scale, except in the Hellespontine area (from *ca* 77 talents to *ca* 98); Dorian Thera (in the southern Cyclades) was entered for the first time. The resort to a re-assessment in 428, two years before the next Great Panathenaea, brings home the financial exigencies of war. Athenian anxiety to gather funds and allied failure to pay the *phoros* promptly are indicated by tribute-collecting expeditions in the winters of 430/29 (in Caria and Lycia) and 428/7 (in Caria). In 428/7 Mytilene was under siege; for the first time the Athenians imposed upon themselves a direct tax (*eisphora*), which raised 200 talents. Two years later (summer, 426) they voted measures that were intended to guarantee a more efficient delivery of the *phoros*. We possess thirteen fragments of the decree moved by Cleonymus that instructs the tributary states to appoint local collectors (*eklogeis*) who will be responsible annually for gathering the tribute in their respective communities and remitting it to Athens. I cite the relevant sections.

"Those cities that pay tribute to the Athenians are to choose, in each city, collectors of tribute in order that in each case the tribute may be gathered for the Athenians in its entirety; otherwise the collectors are to be liable [that is, for the payment] The prytany that is in office is to be required [annually] to convene for the Hellenotamiae a meeting of the Ecclesia to discuss the cities within twenty days after the Dionysiac festival. The cities that pay tribute are to be named publicly as are those that do not pay and those that pay in part. Five men are to be sent to those that default to exact the tribute. The Hellenotamiae are to record on a wooden plaque the cities that fail to pay the tribute and the names of the carriers and place it each year in front of the statues of the Heroes. Let there be in addition a similar decree for the Samians and the Theraeans, and any other city that has accepted the obligation to deliver money to Athens, concerning their money and what they must do—except that they are not to appoint collectors."

The money that the Samians and Theraeans are paying is obviously not *phoros*. We know from Thucydides of the indemnity imposed upon the Samians after their revolt; the inscription shows that the Theraeans are being treated similarly. We surmise, then, that they offered resistance when they were brought into the Empire (430).

Later, according to another inscription, which, frustratingly, we cannot date securely, the collectors of the *phoros* were joined in the cities by locally-appointed collectors of the first fruits of grain and oil for dispatch as

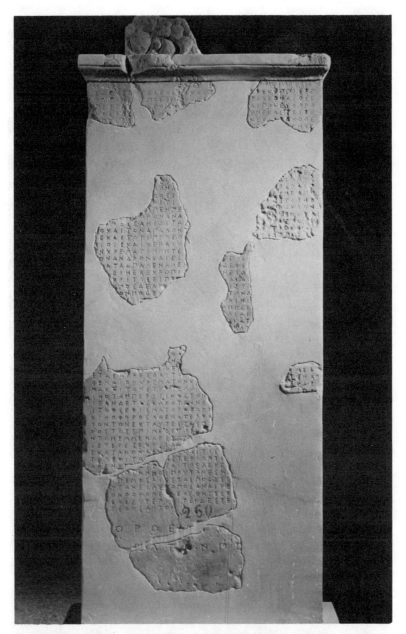

PLATE 5. The decree of 426 ordering the appointment of collectors of tribute in the cities of the Empire.

EPIGRAPHIC MUSEUM

PLATE 6. The assessment-decrees of 425 and the list of assessed cities.
EPIGRAPHIC MUSEUM

offerings to the goddesses at Eleusis (the Athenian farmers also were liable for the first fruits of grain). Invitations to participate in this act of reverence were extended to the Hellenic world as a whole. The allies were already sending the cow and the panoply to Athena at the Great Panathenaea. The offerings to Eleusis formed an additional religious bond between the Athenians and their allies.

We return to the Athenians' financial problems. In the light of the exigencies of the past few years a comprehensive survey of the Empire in 425, in the aftermath of the satisfying victory at Pylos, comes as no surprise.

Astonishingly, "Cleon's assessment" is ignored by Thucydides, who does not overlook the fundamental need of financial resources in war. Fortune, however, has been generous: we know 43 fragments (one has been lost) of the decrees and the list of the cities that constituted the assessment; 41 of them have been built into the reconstructed stele that now stands in the Epigraphic Museum in Athens. As a manifestation of Athenian power and ambition the list of assessed cities must have impressed citizens and visitors alike. About 410 names were entered, including 14 Actaean cities and a panel of 44 lines under the heading "Cities from the Euxine." When we compare the figure 410 with the pre-war roster of 160 to 180 and inspect the names, we realise that the Athenians scoured the records to include every state that had ever been claimed; an uncritical enthusiasm is betrayed by the double presence of a Carian tributary with different spellings. The assessed amounts, which show startling rises, total over 1,460 talents, a far cry from a maximum of 400 talents before the war.

This is the only assessment that is substantially preserved. The register of cities is preceded by two decrees, which inform us of the care taken by the Athenians in the preparation of an assessment and the introduction of the requisite administrative machinery, information that is found nowhere else. Although the operation of 425 was planned on a grander scale than its predecessors, the decrees give us a dependable idea of what had always been involved in an assessment and of the Athenian relationship with the tributaries. For this reason I quote it at some length.

"Resolved by the Council and the Demos. . . . Thudippus made the motion. The Demos shall send heralds . . . to the cities, two to Ionia and Caria, two to Thrace, two to the Islands, and two to the Hellespont. These men are to announce in the commune of each city that representatives are to be present in Athens in the month of Maimakterion [early winter]. The Demos shall elect by lot thirty *eisagogeis* [introducers]; they shall choose a secretary and an assistant-secretary from their own number. The Boule are to select ten men at once to serve as *taktai* [assessors]. These men within five days of their selection and the swearing of their oaths are to enrol the cities, or each man is to pay a fine of 1,000 drachmae. The administrators of the

oath are to swear in the *taktai* the very day of their selection, or each one is to be liable to the same fine. The *eisagogeis* are to be responsible for the adjudications concerning the tribute in accordance with the vote of the Demos. The *eisagogeus* who is selected by lot and the polemarch are to hold preliminary hearings of the cases in the Heliaea [the building] as is done with the other cases that come before the heliastic jurors. If the *taktai* fail to impose assessment on the cities according to the adjudications, each man of them is to be liable at his *euthyna* [final audit] to a fine of 10,000 drachmae according to the law. The *nomothetai* [revisers of law] are to establish a new court of one thousand jurors. Since the tribute has become too small, the jurors are to collaborate with the Boule in making the current assessments [after appeal] just as in the last administrative period, all in due proportion during the month of Posideion [winter]. They are also to deliberate daily from the first of the month according to the same procedure in order that the assessment of tribute may be completed in the month of Posideion. The Boule are to deliberate in full session and continuously in order that the assessments may be made unless the Demos vote otherwise. They are not to assess now a smaller tribute on any city than it has been paying previously except when a manifest failure of resources in the country makes it impossible for the city to pay more. This recommendation and this decree and the tribute that is assessed on each city the secretary of the Boule is to inscribe on two stone stelae and set them up, one in the Bouleuterion, one on the Acropolis. The *poletai* [public auctioneers] are to let the contract, the *kolakretai* [treasurers] are to release the funds. In the future announcements concerning the tribute shall be made to the cities before the Great Panathenaea. The prytany that happens to be in office shall introduce the business of the assessments at the time of the Panathenaea. If the prytaneis do not at that time introduce the business to the Demos and if they do not vote a court concerning the tribute and if they do not then deliberate in their own term of office, each man of the prytaneis shall be liable to a fine of 100 drachmae to be consecrated to Athena and 100 to the public treasury and each man of the prytaneis is to be liable to a fine of 1,000 drachmae at his *euthyna*; and if anyone else introduces a motion that the cities are not to be assessed at the time of the Great Panathenaea during the prytany that first holds office, let him be deprived of his civic rights and let his property be confiscated, a tenth to go to the Goddess. Let the prytany of Oeneis of necessity introduce this business into the Demos as the first item on the agenda after the religious rites on the second day after the expedition returns. If the business is not completed on this day, the Demos shall deliberate about it on the next day continuously until it is completed in the term of the named prytany. If the prytaneis do not place the matter before the Demos or do not consummate the business in their own term of office, each man of the prytaneis is to be

liable at his *euthyna* to a fine of 10,000 drachmae on the charge of impeding the allotment of tribute to the military campaigns. The heralds who have been summoned are to be brought by the public summoners in order that the Boule may judge them if they seem not to be performing their duties efficiently. The *taktai*, in accordance with the oath, shall prescribe the routes for the heralds who are to travel, indicating how far they are to proceed, in order that they may not journey uninstructed. The heralds are to be required to announce the making of the assessments to the cities wherever the local *archontes* deem best. What must be said to the cities about the assessments and the decree, concerning this the Demos shall vote, and as well concerning anything else that the prytaneis may introduce as necessary. The *strategoi* are to see to it that the cities deliver the tribute as soon as the Boule complete the assessment of the tribute in order that the Demos may have sufficient money for the war. The *strategoi* shall deliberate concerning the tribute each year after first investigating by land and sea how much must be spent for military purposes or anything else. They are regularly to introduce suits concerning this at the first session of the Boule without consulting the heliaea [the court] and the other courts unless the Demos vote that they do so after the *dikastai* [jurors] have first made a decision. The *kolakretai* are to issue pay for the heralds who are to travel.

" . . . moved: that the resolution of the Boule be adopted with the following addition: the assessments that are determined for individual cities after appeal the prytaneis who are in office at the time and the secretary of the Boule shall lay before the court when it deals with assessments in order that the *dikastai* may express their concurrence.

"Resolved by the Boule and the Demos. . . . Thudippus made the motion. All the cities upon whom tribute has been assessed . . . shall bring to the Great Panathenaea a cow and a panoply of armour; they are to participate in the procession just as do colonists. . . . "

It may be—it probably is—true that Cleon, taking advantage of his sudden popularity, had much to do with the scale of the assessment and the length of the roster of the cities. The final decisions, however, were made in the Ecclesia, after detailed research and painstaking toil by individuals and by the Boule; the decrees, with all their provisions for the present and future, enshrine the work of many Athenians, not of one man. "Cleon's assessment," a popular label, invites misunderstanding.

Another feature of the decrees should be emphasised: the attitude shown to the allies. The need for the rises in the assessments is explained ("the tribute has become too small" to meet the demands of the war). The time-table for the completion of the procedure is set out clearly. There is a specific provision for appeal against an assessment. Manifest inability to pay is recognised. We may grant that the war made increases unavoidable and

that the Athenians intended to use—and did use—the complete document as propaganda; nevertheless, the decrees advertise a policy towards the allies that is far from oppressive.

To believe that tribute would in fact be forthcoming from every name on the list required unthinking optimism. The demonstrated and confessed financial urgency explains the presence of a tribute-collecting expedition under Aristeides in the Thraceward region in the winter of 425/4, after the assessment had been finally approved but before the Dionysia, when payments were due. Aristeides found himself the beneficiary of a bonus: at Eion he intercepted the Persian Artaphernes, whose destination was Sparta. His documents revealed negotiations between the Spartans and the Persians, whereupon the Athenians detailed ambassadors of their own to escort him back to Persian territory. At Ephesus, however, they learned of the death of King Artaxerxes and so they returned home. Darius II succeeded to the Persian throne and it is likely that during this winter the Peace of Callias (of 449) was reaffirmed.

In the following summer (424), well after the Dionysia, we find a tribute-collecting squadron (commanded by Demodocus, Aristeides, and Lamachus) in the Hellespontine region, well placed to deal with the exiled Mytilenaeans who had captured Antandrus, an assessed Actaean polis. Demodocus and Aristeides re-possessed the place; they had no intention of allowing the Actaean area to become a base of disaffection as had Anaea, the peraea in which Samian exiles had been operating against Athenian interests. Next, Lamachus sailed into the Euxine to confirm Athenian authority, lost his ships as the result of a natural phenomenon, and was lucky to get away on foot to the safety of Chalcedon, on the Asiatic side of the Bosporus.

The Athenians, since the revolt of Mytilene, had been watching the Asiatic coast with care. Perhaps they were over-sensitive: in the winter of 425/4 they required the Chians (who had from time to time sent contingents to fight alongside them) to pull down their walls; there was no further interference in Chian affairs.

In the summer of 424 the Athenians struck two more effective blows. A considerable force of ships and hoplites, with contingents from Miletus and elsewhere, commanded by Nicias and two colleagues, landed on Cythera, the island off the south coast of Laconia inhabited by Lacedaemonian *perioikoi.* The surrender of Cythera-town owed much to sympathetic negotiation by Nicias. From Cythera the Athenians successfully raided the coasts of the Argolid and of Cynuria, the borderland of Argolis and Laconia now occupied by exiled Aeginetans. A number of the latter were taken to Athens and executed; the Spartan commander was added to the captives from Pylos, and Cythera was assessed a tribute of 4 talents. The Athenians now held two fortified posts within Spartan territory. The taking of Nisaea, the

Megarian harbour on the Saronic Gulf, by the Athenians (Demosthenes was one of the *strategoi*) in the same summer brought the Athenians to the pinnacle of their successes.

No doubt the more offensive Athenian policy of this year was engendered by the success at Pylos. The presence of the Spartan hostages in Athens had put an end to the annual invasions and the Athenians were conscious of an increased freedom of movement by land. Thus, in the summer of 424, the Athenians conceived a grand plan that would, they hoped, by taking advantage of the endemic political dissension in the cities of Boeotia, bring them control of central Hellas, the area that they had dominated in the first war. Demosthenes, operating from the secure base at Naupactus, assembled allies in Acarnania, where his earlier campaigns were still remembered with respect, and then proceeded by sea to Boeotian Siphae, on the Corinthian Gulf. Simultaneously, Hippocrates was to create a diversion by occupying Delium, on the Boeotian coast opposite Euboea, just over the Attic border. Someone, however, made a blunder in the timing and the projected synchronism failed. The result (in the early winter) was the decisive defeat of Hippocrates, with his substantial army (1,000 Athenians perished with the *strategos*), at Delium in the first pitched battle of the war between armies. We can imagine Athenians who remembered Pericles' advice against such a confrontation.

So far the Athenians had put two outstanding commanders in the field, Phormio and Demosthenes. On the Spartan side, without question, Brasidas son of Tellis had earned special citation for his courage, his imaginative leadership, and his un-Spartan willingness to take the initiative. He had saved Messenian Methone in 431, had foiled the Athenians at the mouth of the Corinthian Gulf in 429, had planned a bold attack on Peiraeus in 429/8, had served as a firm adviser to Alcidas in the West in 427, had been seriously wounded in the naval battle at Pylos in 425, and had forced an Athenian change of plan in the Megarid in 424. Now he slipped north through Thessaly into Chalcidice, where, making common cause with Perdiccas, he increased the area of disaffection in the Thraceward district. Acanthus and Stageira were notable among his acquisitions.

With the coming of winter (424/3) Brasidas moved on Amphipolis, where the mixture of colonists, incited by the Spartan's blandishments and the intrigues of the people of Argilus, soon surrendered the city. This was the occasion when the historian Thucydides, serving as *strategos* in an area he knew well, failed to reach the threatened city in time. The Ecclesia voted him into exile, despite his skill in saving Eion from Brasidas.

The Spartan general combined force and persuasion in the exploitation of his victory. He won a number of towns on the coast opposite Thasos, all peninsular Acte except Sane and Dium, and, finally, Torone, an important

tributary on the south-western coast of Sithone, the middle of the three peninsulas projecting into the Aegaean (424/3). In all this, Perdiccas had collaborated. The Athenians, for their part, constrained by the season (winter) and the short notice, had sent garrisons to a number of cities; these, obviously, had not slowed the progress of Brasidas.

The one-year armistice that was signed in the spring of 423 should have brought a suspension of hostilities in the north. The revolt of Scione, however, a tributary on the west coast of Pallene, attracted Brasidas by sea from his base at Torone. The revolt in fact took place two days after the armistice, of which Brasidas was ignorant, although, supported by the Spartans at home, he refused to surrender the town to the indignant Athenians. When neighbouring Mende joined Scione as the ward of Brasidas, there could be no doubt whatever about the date: the armistice was in effect and Brasidas knew it. The Athenians prepared to recover both towns. Cleon's motion stipulated execution for the inhabitants of Scione.

The altercation about the date of the armistice meant that fighting continued in the Thraceward area, even though it had come to an end elsewhere. A strong Athenian force commanded by Nicias and Nicostratus son of Dieitrephes, with the assistance of a few light-armed troops from Methone, assaulted Mende, which they captured after a resolute defence aided by Scionaeans and Peloponnesians. The Athenians sacked the town and only the intervention of the commanders saved the inhabitants, who were advised to punish those responsible for the revolt and allowed to resume their customary form of political life.

The Athenians now turned to the investment of Scione, where the Mendaean fugitives sought refuge. Perdiccas had fallen out with Brasidas, who was using Torone as a base. Despite intervention by the Macedonian king, a Spartan reinforcement reached Brasidas (summer 423). During the respite that ensued an Athenian garrison manned the walls around Scione. It was not until the end of winter (423/2) that Brasidas failed in his effort to take Potidaea.

We possess nine fragments of an alliance signed by the Athenians and Perdiccas. Regrettably, the date is not preserved and various years have been proposed. A clause in the oath sworn by Perdiccas, however, is suggestive: "I shall guarantee to the Athenians a monopoly for the export of oars." The loss of Amphipolis meant that Macedon had become a major source for timber. The events that we are discussing were occurring during one (423-422) of those few brief interludes in which Perdiccas professed friendship for the Athenians. Perhaps the nomadic treaty belongs here.

At some time in 422, probably as a result of Athenian counter-measures in the preceding winter, a number of Bottiaean communities (but not Spartolus, their chief polis) came to terms and formally signed a mutual agreement and

alliance with the Athenians. The eight extant fragments of the document preserve an offensive and defensive treaty along with an interesting clause declaring an amnesty for past actions. The participating poleis were listed at the end but only four names survive (of about ten).

Upon the expiry of the armistice (spring 422) Cleon, anxious to regain military reputation, persuaded the Athenians to mount a major expedition for the recovery of Amphipolis and to appoint him to the command. In the absence of Brasidas he stormed Torone, enslaved the women and children, and sent the men to Athens. After summoning Perdiccas (who seems not to have responded), he then took up a position at Eion, at the mouth of the Strymon, and occupied Galepsus. The objective was Amphipolis, where Brasidas conducted the defence.

Cleon commanded a force of quality that included a powerful contingent of Lesbians and Imbrians. In Brasidas, however, he was facing a gifted and experienced soldier, who enjoyed the utter confidence of his men. The Athenians fought well but were eventually scattered; Cleon, in flight, was killed. Brasidas died of his wounds; the Athenians returned to Athens and Amphipolis remained in Peloponnesian hands (late summer 422).

Neither the Athenians nor the Spartans were anxious to continue hostilities. The Athenians had suffered two grievous blows, at Delium and at Amphipolis; in their dejection they regretted the opportunities that they had spurned and they feared additional defections. The Spartans, who had failed to win the anticipated quick triumph, were enduring the gnawing aggravation of seeing Pylos and Cythera in Athenian hands, bases for raids on their territory and inviting havens for fugitive Messenians. Further incentive came from the presence of the Spartan hostages in Athens, discontent within the League, and the imminent termination of their thirty-year treaty with the Argives, who coveted the return of Cynuria.

Brasidas and Cleon, deemed war-mongers by Thucydides, were now dead; no serious barrier prevented the combatants, for whom Nicias and Pleistoanax, the Spartan king, were protagonists, from discussing terms of peace. And in the spring of 421, after ten costly years, the Peace that bears the name of Nicias was signed.

Within the Peloponnesian League, the Corinthians, the Eleians, and the Megarians had joined the Boeotians in opposing the termination of the war but had been out-voted. Thus the Athenians and the Lacedaemonians, with their respective allies, swore to keep the peace for fifty years. I summarise the terms that are of immediate concern to us. "Those places that have been taken during the war are to be returned to their former allegiances (these include Amphipolis, Pylos, Cythera); Nisaea is to be excepted. Prisoners of war are to be returned. As for the cities in the Thraceward area, the following (to be returned to the Athenians) are to pay the tribute of Aristeides'

day, are to be autonomous, and are to be allies neither of the Lacedaemonians nor of the Athenians (unless they choose to join the Athenians), although their inhabitants, with their property, may move wherever they wish: Argilus, Stageirus, Acanthus, Scolus, Olynthus, Spartolus. The following (held by the Athenians) are to inhabit their own cities, as do the Olynthians and Acanthians: the Mecybernaeans, Galaeans, and Singians. The Scionaeans, Toronaeans, Sermylians, and the residents of other cities in Athenian hands are to be treated as the Athenians may decide."

In this document, cited in full by Thucydides, there is no mention of the specific causes of the war (Corcyra, Potidaea, Megara, Aegina); and "the truest cause," which drove the Spartans to war, is a notable absentee. Pericles had believed that the Athenians were fighting for their right to hold their Empire. What the Peace proclaimed was the *status quo*. It does not require an acute aural sense to overhear the admirers of Pericles (men like Nicias) gloating about a "Periclean Peace." As F. E. Adcock put it years ago, "If the war was an attack on the Empire of Athens, the Peace acknowledged its failure."

Initiation of preparations for the re-assessment of tribute had been due at the Great Panathenaea of 422. The battle of Amphipolis, with the deaths of Cleon and Brasidas, and the consequent talk of peace had delayed implementation. The tribute delivered at the City Dionysia of 421 (spring) was therefore reckoned in conformity with the assessment of 425. At this same festival the allied carriers could have attended the production of Aristophanes' *Peace,* a fitting subject for the occasion. The Peace of Nicias was signed just after the Dionysia. The re-assessment, which was now drawn up, could reflect the changed international conditions and the Athenians' revised financial requirements. From the three extant fragments and the little that survives of List 34 (spring 420), we surmise that the guiding principle was a return to the pre-war scale of assessment. The three cities of Chalcidice (Mecyberna, Gale, and Singus) that had lost much of their populations during the war and had been named for special treatment in the Peace were registered with token figures of 10 drachmae each, as they had been in 425. Chalcidice was far from pacified: within a year the Olynthians, still tributary but with ambitions to build a league of cities, took Mecyberna. The reduction of Scione (421) by the Athenians brought the punishment urged by Cleon: execution of the adult males and enslavement of the women and children.

2. THE PEACE OF NICIAS

The Peace of Nicias, pledged to last fifty years, brought little relief to the European states of Hellas. Technically, it endured for six years and ten

months; but infringements were committed on both sides and Thucydides himself declines to designate this interval as a peace.

On the Spartan side some of the allies, inside and outside the Peloponnese, refused to accept the terms: Amphipolis was not returned as promised and the Boeotians continued to hold Panactum, the Attic frontier-fort recently seized by them. In consequence, the Athenians maintained a garrison at Pylos, the majority of whom were Messenians. Relations with Argos caused further embarrassment, for the thirty-year treaty between these traditional rivals for primacy in the Peloponnese was about to expire and the Argives' aspirations were cheered by the Spartans' loss of prestige.

Shortly after the signing of the Peace, the Athenians and the Spartans (who were the instigators) swore to a defensive alliance for fifty years. The Spartans saw this as a counter to the Argive threat.

Not all Athenians had welcomed the Peace. Cleon was dead, to be sure, and Nicias commanded respect for his record and his part in putting an official end to the war. Now, however, he had to deal with a more formidable rival for leadership in the Ecclesia, Alcibiades son of the Cleinias who had perished as *strategos* at Coroneia in 446. Born an Alcmaeonid in the mid-450s, he had been brought up in the household of Pericles, had served (with Socrates, his mentor and friend) at Potidaea and Delium, and was now making it plain that he would have to be reckoned with in the guidance of the city's affairs. The insolence of his boyhood scrapes and the charm of his manner had beguiled many of his fellow-citizens. The uneasy relationship with the Spartans had given him a cause. In introducing him Thucydides writes: "Alcibiades . . . still a young man . . . owed his position of honour to the prestige of his ancestors. He really believed that rapprochement with the Argives was the preferable course; even so, a major motive for his opposition to the Spartans came from the offence given his personal dignity when the Lacedaemonians had negotiated through Nicias and Laches, passing him over because of his youth and neglecting the respect due to his family's ancient *proxenia* [their representation of Spartan interests]."

The history of the next three years is a complex chronicle of anti-Spartan intrigue (skilfully fostered by Alcibiades) among the Eleians, Mantineians, Argives, Corinthians, and Boeotians. In 420 the first three of these committed themselves (for one hundred years!) to a defensive quadruple alliance with the Athenians after Alcibiades had craftily destroyed the efforts of Spartan delegates in Athens who were prepared at least to discuss problems that were still in dispute.

The presence of Alcibiades (now *strategos*) in the Peloponnese in the summer of 419 with a small Athenian force and local allies guaranteed that turmoil would continue. He ranged from Patrae (in the west) to Epidaurus (on the coast of the Argolid), now hostile to Argos and therefore under naval

blockade by the Athenians. The Athenian aggression was clearly an infringe-
ment of the Peace; nor did it conform to the terms of the Quadruple
Alliance, which was defensive.

Spartan fortunes had touched unprecedented depths. In the following
summer (418) King Agis commanded a strong army that included Peloponnesian
loyalists and allies from outside (principally Boeotians). After an initial
failure, he faced the enemy (Argives, Mantineians, Athenians) at Mantineia
and won a major victory. "It was surely the greatest battle fought by the states
of Hellas for a long time."

"By this one action the Spartans erased the charges then being levelled
against them by the Hellenes. . . . They had, it seemed, been the victims of
misfortune but in fact they were still what they had always been."

One thousand Athenian hoplites and 300 cavalry had fought at Mantineia.
A further 1,000 arrived too late to be involved. At the beginning of winter
(418/7) the Spartans and Argives concluded an alliance (for fifty years) and
the Argives withdrew from the Quadruple Alliance despite Alcibiades'
presence in Argos. His southern policy must have seemed disastrous to more
conservative Athenians. Yet, if war there must be with the Spartans, the
most effective means of destroying their power was to destroy their hege-
mony in the Peloponnese. In fact, civil strife soon broke out in Argos (417)
and the Many looked to the Athenians. The outcome was the signing of an
alliance by the Athenians and the Argives (416). Alcibiades could at last
claim some justification for his policy.

The text (we have seven fragments) specifies that the alliance is to last for
fifty years. The clause requiring that one side support the other militarily in
case of attack is common in such documents. Here, however, an aggressor is
named: "if the Lacedaemonians or any others invade. . . . " The other
unusual clause obligates the Athenians to take money from the *phoros*
annually to be used "for the war in order that the Argives may have sufficient
funds." Yet the Athenians and the Lacedaemonians were nominally at
peace!

From the time of the battle of Mantineia, the Athenians had dabbled in
Argive affairs, especially in their relationship with the Spartans. In 417
Athenian craftsmen helped to rebuild the walls of Argos. In 416 Alcibiades
sailed to Argos and operated against Spartan sympathisers. In the same year
Athenians from Pylos raided Spartan territory. In the winter of 416/5 both
Lacedaemonian and Athenian forces were on the move in the Argolid. What
is remarkable about these and similar activities is that the Spartans did not
interpret any incident as a *casus belli* and declare that the Peace had been
broken.

The battle of Mantineia and continuing unrest in Chalcidice increased
tensions in Athens. The relationship between Alcibiades and Nicias, the

leading advocates of policy, seemed so threatening that the Athenians, in the spring of 416, resorted to ostracism. Neither felt secure; both felt it essential to remain in Athens. So, when Alcibiades took the initiative, the two obvious candidates, with the support of their followers, collaborated to subvert the institution by the casting of votes for a third party. The victim was Hyperbolus, a third-rate demagogue who must have been surprised to find himself in the company of the distinguished men who had been ostracized in the past. The incident takes its place among the disservices rendered to his polis by Alcibiades: ostracism, that effective safety-valve, was not employed again.

The authority of Alcibiades should probably be credited with the Athenian offensive of 416, when a powerful force, including allies, demanded the surrender of Melos, in the southern Cyclades. This Dorian island had abandoned its professed neutrality after an unsuccessful raid by Nicias in 426. Assessed in 425, the Melians had not paid tribute. Now they were not prepared to surrender. Thucydides puts the Athenian demands and the Melian response into the form of a debate, the famous Melian Dialogue.

Here we meet brutal expression of the temper of Athenian imperialism in the period when Alcibiades had reached the aggressive acme of his dominating influence on the Demos. I select one representative passage. Brushing aside the arguments of justice, the Athenians assert bluntly: "The strong do what is in their power to do, the weak accede."

When the Melians chose stubborn—and courageous—resistance, the Athenians established the lines of siege and blockade. The inevitable result came in the following winter (416/5): unconditional surrender. The adult males were executed, the women and children were enslaved, and the island received a colony of five hundred Athenians.

The arrival of delegates from Sicilian Segesta in the winter of 416/5 aggravated the bitterly divisive relationship between Alcibiades and Nicias and their respective followers. The Segestaeans, in the name of their existing alliance, sought military assistance against their Dorian neighbours of Selinus (on the south coast), who were already supported by the Syracusans; the Athenians would also be in a position to save the Leontines (Ionians and therefore kinsmen) from the Syracusans. After lengthy negotiation, which included an Athenian visit of investigation in Sicily, the Athenians voted (spring, 415) to send 60 ships under Alcibiades, Nicias, and Lamachus son of Xenophanes, " . . . to aid the Segestaeans . . . to re-establish Leontini . . . and to make such disposition of Sicilian affairs as they deemed in the best interests of the Athenians."

The Athenians, we again recall, had long had Sicily in their minds. Thucydides believed that "they wanted to subjugate Sicily if they could, most of them being ignorant of the size of the island and the large number of its inhabitants, not knowing that they were undertaking a war of a magnitude

not much smaller than that against the Peloponnesians." Four days after the vote Nicias, in a sensible—and pessimistic—address to the Ecclesia, urged reconsideration. I summarise: "The treaty with the Lacedaemonians is nominal and some of their allies remain at war. The Chalcidians are still in revolt. Sicily is far away and in any event could not be controlled. We have not recovered from the War and the plague. We live in a dangerous world. Let caution be our watch-word." He concludes with a personal attack on Alcibiades, chief advocate of the expedition, to whom he refers with disdain as young (he was about forty) and irresponsible.

The majority of the many speakers favoured the original vote. The most ardent and persuasive opposition to Nicias came from Alcibiades. In a caustic reply to Nicias, he defends his record as an Olympic winner, which brought prestige to Athens, and he boasts of the brilliance of his southern policy, which compelled Sparta to stake all on the outcome of a single battle. "Sicily," he says (I paraphrase), "is weaker than you realise. Our fleet will protect the home-front. We have a duty to our allies in Sicily. Finally, empires must be aggressive—or they fall." Thucydides' introduction of Alcibiades on this occasion, while appreciating his military and intellectual talents, amounts to a condemnation of his motives and reveals what some Athenians were thinking: "In particular, he was eager to command and it was his innate desire that the taking of both Sicily and Carthage would be credited to him and that at the same time his success would enhance his personal standing in both wealth and honour."

Nicias, recognising a losing cause, nevertheless expressed a demand for much increased forces, hoping thus to induce a change of mind. It was a vain hope: the Athenians had now been seduced into a passion for the enterprise and voted to give the *strategoi* a free hand. So the preparations began on a grand scale.

Amid the excitement natural to the coming venture an act of sacrilege spread consternation throughout the city. In a single night nearly all the Herms, busts of Hermes set on rectangular pillars of stone that stood before houses and in the temples and public places, were desecrated. Immediate investigation revealed that in addition it had been the practice in some dwellings to conduct parodies of the Mysteries (of Eleusis). The city was rife with gossip, charge and counter-charge; the acts of sacrilege were interpreted as evil omens for the expedition to Sicily and as symbols of a wide-spread political conspiracy. The immediate victim of rumour was Alcibiades, whose enemies took advantage of the fact that these crimes against the Gods were similar to his past escapades. Alcibiades (who was certainly innocent of the mutilation of the Herms and just as certainly guilty of the parodying) demanded in vain that he be charged at once. The opposition, however, had no wish to place Alcibiades on trial when the city was filled with the eager

crews. So the decision was made that the fleet should sail; the investigation would continue.

In mid-summer all Athens went down to Peiraeus to wave farewell to "by far the most costly and in appearance most splendid expedition that had ever sailed from one Hellenic city." It would be joined by an equally impressive force of allies now assembling in Corcyra.

Not long after the Athenians reached Sicilian waters the "Salaminia," the official trireme, overtook them with orders to escort Alcibiades and others back to Athens to face charges arising from the recent crimes. Alcibiades, allowed to travel in his own ship, slipped his escort and eventually reappeared at Sparta. The expedition was thus deprived of an able commander, its most committed supporter. The Athenians condemned him and his companions to death.

The arrival of Alcibiades in Sparta coincided roughly with that of a joint delegation from Syracuse and Corinth. It was the Athenian who delivered the telling speech to the assembly. After an arrogant and sophistic defence of his own treacherous conduct, he urges two specific courses of action: "you must send to Sicily troops . . . and (this I consider still more useful) a Spartan commander both to organise those who are there and to apply pressure to those who are holding back. . . . You must fortify Deceleia in Attica, the thought of which has always terrified the Athenians." The Spartans at once appointed Gylippus to the Sicilian mission.

In Sicily the Athenians had made satisfactory progress and after wintering in Catana (on the coast a few miles north of Syracuse) were ready for the assault on Syracuse. All went well until the arrival of Gylippus, who took charge of the defence so effectively that by the end of the summer (414) the Athenians themselves, from being besiegers, had become the besieged. Lamachus had been killed and Nicias stricken by a renal disease. In this crisis Nicias wrote to the Athenians at home. He states bluntly the factors that have created his precarious situation and, asking to be relieved of the command, puts a choice to the assembly: "You must either recall us or you must send another force, just as large, naval and military, and an ample supply of money."

The Athenians, far away from the theatre of war and obstinately persistent, voted to retain Nicias in office and to send the requested reinforcements under Eurymedon and Demosthenes. The former set out forthwith with 10 ships and a supply of money; the latter spent the rest of the winter (414/3) assembling an adequate force.

In the spring of 413 the Spartans finally struck by land. Athenian meddling in the Argolid had given them ample cause for declaring the Peace at an end. Now a Peloponnesian army under King Agis occupied and fortified Deceleia, which they would hold until the fall of Athens. Thus they con-

trolled rural Attica; the Athenians were confined to the city and their communications by land with Euboea were cut.

The repercussions were felt at once and persisted until the end of the War. The Athenians looked upon Euboea as the "home" island, an important source of food, which until the seizure of Deceleia could be transported to Athens through Attica (a more convenient method than passage by sea). Many Attic flocks and herds pastured on the island were now cut off as movement through Attica became impossible. The conversion of the fortress into a permanent base made it a safe and attractive haven for hordes of deserting slaves (all told, some 20,000), many of them fugitives from the vital silver-mines along the south coast.

The Athenians now had two wars on their hands. Thucydides pauses to comment on their astonishing demonstration of power and daring to the Hellenes—astonishing because at the very beginning of the war there had been some who doubted if they could hold out for more than two or three years. Furthermore, the occupation of Deceleia and the enormous expense of maintaining their presence in Sicily had brought them near to bankruptcy. Our sparse evidence suggests that little change of scale had been made in the assessment of 418, a time of nominal peace. Whether the scheduled assessment of 414 was effected we cannot say. In the summer of 413, however, the financial outlook had become so bleak that the Athenians, in lieu of tribute, imposed on the allies a five per cent tax on sea-borne traffic, believing that this would bring in greater revenue.

Demosthenes, *en route* to Sicily, directed raids on the Peloponnesian coast, supported the Athenian squadron based at Naupactus, picked up troops in Acarnania, and added others on his voyage of consolidation off southern Italy, where he was joined by Eurymedon. As a result it was mid-summer (413) by the time he reached Nicias, who had just suffered a sharp defeat in the Great Harbour of Syracuse. Demosthenes' reinforcements, in ships, hoplites, and other fighting men, were sufficient to discourage the Syracusans and restore a measure of self-confidence to the Athenians.

Demosthenes planned a vigorous offensive. Regrettably for the Athenians, his well-conceived attack by night on a Syracusan counter-wall ended in defeat. Realising the fundamental weakness of his position, the despondency of the men, many of whom were ill, and the ever-increasing numbers of the enemy, who were being reinforced from the Peloponnese and by the energy of Gylippus in Sicily, he advocated retreat by land and a transfer of the naval base to a point within the Great Harbour. Nicias, apprehensive about Athenian interpretations at home and desperately hoping for assistance from sympathisers within Syracuse, refused to agree. He was a superstitious man and when an eclipse of the moon occurred he insisted, on the advice of his soothsayers, that no move be made for thrice nine days. A

major naval defeat in the Great Harbour completed the destruction of Athenian morale. Correspondingly, the Syracusans' naval success brought about a metamorphosis in their strategy: no longer on the defensive, they contemplated the utter destruction of their opponents.

Nicias and Demosthenes decided upon a last effort to escape and to this end all seaworthy vessels (there were 110) advanced to meet the enemy. This final naval battle in the Great Harbour, described by Thucydides with a vivid and gripping realism that is unsurpassed in Greek historical writing, lasted all day. At the end the Athenians had lost their fleet and the survivors clambered ashore to join the stricken army. Two days later all those who were mobile began their retreat by land. For seven days they marched, continuously under attack by their enemies. The two groups, led respectively by Nicias and Demosthenes (in the rear), became separated and on the seventh day Demosthenes surrendered. Nicias reached the Assinarus River the next day; here his exhausted, hungry, and thirsty men were cut to pieces. Nicias surrendered.

Despite the opposition of Gylippus (who wished to return to Sparta with distinguished prisoners), Demosthenes and Nicias were executed. Generosity was not a quality displayed by the Syracusans (and Corinthians) in victory. Neither man merited such a fate. Demosthenes was perhaps the most able soldier produced by Athens in the war. As for the loyal Nicias, the unwavering servant of integrity, "of the Hellenes of my day, he least of all deserved to meet such an end, for throughout his whole life he had devoted himself to the practice of *arete*."

The prisoners who fell into the hands of the Syracusans were assigned to the stone-quarries, to exist and to die amid inhuman conditions.

I quote Thucydides' verdict. "Of all the actions that occurred in the war, this was the greatest—in my judgement, indeed, greater than any of which we hear in the affairs of the Hellenes: to the victors a most brilliant success, to the routed a most disastrous calamity. For the vanquished had been utterly and comprehensively beaten, all their sufferings had been on the grand scale—it was, in fact, what is called total destruction; army, navy, everything perished. And of the many who sailed few returned home."

3. THE WAR IN THE EAST

Among the states of Hellas the shock occasioned by the annihilation of the Athenian forces and ambitions in Sicily matched the reactions to the Athenian victory at Marathon and the surrender of the Spartans on Sphacteria.

The dazed Athenians faced the exigencies of the present and the future. They pressed the construction of warships, they practised every possible economy, they increased vigilance within the Empire. Their resolution to hold out is confirmed by their immediate appointment of ten experienced men of mature years (*probouloi*) to serve as an advisory body and by their appropriation (in 412) of the "Iron Reserve" of 1,000 talents that had been laid aside at the outbreak of war in 431.

The loyalties of the allies on the Asiatic side of the Aegaean had at last been shaken and in fact from 412 to the end this remains the major theatre of war.

At home the presence of Agis at Deceleia and the unrelaxing threat to Euboea allowed the Athenians no peace of mind. Abroad, a number of new factors transformed what had been a relatively stable area. The Peloponnesians, elated by the Athenians' débâcle in Sicily and heartened by rumblings from Asia, launched an unprecedented programme of ship-building. Later, their fleets in the east were reinforced by squadrons from Sicily, as well as by the presence of Hermocrates, to whom the Syracusans owed so much. Revolt began in Chios, Lesbos, Erythrae, and Miletus, all substantial entities. Over the next few years, few of the Asiatic tributaries were completely free of the taint of rebellion. We find Peloponnesian contingents at many of these points, from Phaselis on the south coast to Byzantium on the Bosporus. The Athenians made Samos, where the inhabitants were comfortingly loyal, their base and allowed the dissidents and the Spartan commanders few moments for peaceful consolidation.

Anticipation of Athenian collapse attracted direct interference by the Persians. The Great King, despite the formal cession in the Peace of Callias, had never abandoned his claims to the Hellenic cities of Asia Minor. Now the two satraps, Tissaphernes in Lydia and Pharnabazus in the Hellespont, opened communication with the Spartans and collaborated in fostering revolt among the Athenian allies. Tissaphernes became a major factor in the combatants' strategy. What the Spartans wanted more than anything else was money to pay their crews, now that they were committed to maintaining a substantial fleet. Tissaphernes could supply the funds but was far too wily to do so without guarantees, namely, that his reward would be Hellenic Asia. The Spartans, not without embarrassment, signed three successive treaties with the King (negotiated through Tissaphernes) in 412/1 that, in return for immediate assistance, virtually promised the King a free hand in Asia.

Apart from the many clashes at sea, most of them minor, the atmosphere was clouded by the plotting and counter-plotting that were to be expected with both Athenians and Spartans prepared at least to listen to the Persian satraps. Into this murky arena came Alcibiades. Having seduced the wife of King Agis, he was glad, in 412, to accompany a Spartan contingent to the

east. At first, he incited revolt among the Athenian allies and acted as intermediary between the Spartans and Tissaphernes. That the latter never fully honoured his promises was due to the scheming of Alcibiades, who did not long remain in favour with the Spartans. Facing a precarious future, Alcibiades opened communications with the Athenians on Samos. If the Athenians would change their government, he promised, he could enlist the support of Tissaphernes. The result of months of scheming was an oligarchic revolution at Athens (spring, 411): the democracy, completely deluded, voted itself out of existence. For four months the Four Hundred, an oligarchic directorate, governed and went so far as to approach the Spartans for terms of peace.

The Athenians on Samos remained unshaken, proclaiming themselves the true Ecclesia and recalling Alcibiades, who from this time aimed at return to Athens and repatriation. In fact, it was Alcibiades who persuaded the fleet at Samos not to sail to Athens, a course that would have abandoned Ionia and the Hellespont to the enemy. "Then for the first time, I think, Alcibiades performed an act of invaluable benefit to his polis"; Thucydides' pronouncement betrays his opinion of Alcibiades.

The minor successes of Alcibiades, who continued to employ Persian aid as bait, the misrule of the Four Hundred, and a distressing naval defeat off Eretria that meant the loss of Euboea combined to put an end to the narrow oligarchy, which was replaced by a mixed form of government (the "Five Thousand") that drew praise from Thucydides, who had no love for democracy: "In the first phases the Athenians clearly conducted their affairs as well as they had ever done, at least in my time. For the change involved a moderate blending of the interests of the Few and the Many and this first revived the spirits of the city from the depths of despair." The initial act of the new government was to recall Alcibiades. Although he did not return to Athens immediately, there was no longer doubt about his official status.

During the eight months of government by the Five Thousand, the Athenians reversed their fortunes in the east. A major victory at Cynossema in the straits of the Hellespont in the late summer of 411 was responsible for the rebirth of naval confidence among the crews and helped revive morale at home: a concerted effort might yet bring victory. Before the year's end the Athenians recovered Cyzicus (in the southern Propontis) and Alcibiades raised funds at Kos and Halicarnassus in southern Asia Minor.

Here the *History* of Thucydides breaks off. Henceforth our chief informant is Xenophon.

The spring of 410 witnessed a second major naval triumph, this time at Cyzicus, which, along with the insistence of Alcibiades, had a significant impact on Athens: the democracy was completely restored.

Alcibiades remained in the east and his direction of Athenian operations

went well; a number of cities were recovered. The recent misfortunes of the Athenians had caused a serious depletion in the treasury. Of the assessment of 410 we have five small fragments that tell us little. With the wide-spread revolts that began in 412 income from the Ionian and Hellespontine districts had all but disappeared. This is why Alcibiades felt such urgency not only to recover disloyal cities but himself to collect the due *phoros* from loyal and disloyal alike, an intention that kept him constantly on the move.

During these grim years the Athenians had been forced to concentrate upon the eastern districts of the Empire. The many revolts, often incited by Spartan agents among the Few in the various cities, the movements of the Peloponnesian fleet, and the machinations of Tissaphernes (to say nothing of Alcibiades before his recall) had allowed them little rest. Yet it would be a mistake to picture an Empire on the verge of disintegration. In fact, the evidence suggests that outside Ionia and the Hellespont the cities for the most part stood firmly with the Athenians; and even in those districts the supporters of democracy (the Many) frequently preferred the Athenians to life under the oligarchies (the Few) favoured by the Spartans.

The loyalty that prevailed in much of the Empire is illustrated by the nine surviving fragments of a document that carried two decrees, one passed early in 409, the second in the first half of 406. The marble stele was inscribed and published in honour of the Thracian Neopolitae, the inhabitants of Neapolis (modern Kavalla) on the coast opposite Thasos, whose colonists they were; indeed, their name is cut in large letters as a heading. Above the inscription stands Athena, sculpted in relief, holding out her hand to the now-lost local Goddess (Parthenos). What we learn (the information is not elsewhere reported) is that the Neopolitae, though under siege, refused to yield to the Thasians, who had revolted. Moreover, they had advanced money to the Athenians for the expenses of war. In the first decree the Neopolitae are formally praised and named as benefactors; their ambassadors are invited to entertainment in the Prytaneum. The second decree acknowledges that the Neopolitae have fought along with the Athenians throughout the war against the Thasians and the successful siege of the city that put an end to the revolt. Again the Neopolitae are praised and privileges are guaranteed; again their ambassadors are invited to formal entertainment. The Neopolitae were undoubtedly not alone in their attitude to the Athenians or in rendering practical military and financial aid. The document shows also that the Athenians could be generous in their appreciation of unshaken loyalty.

It was not until 407 that Alcibiades dared to return to the city; he sensed that not all would welcome him. The majority, however, treated him as a saviour, and four months later he sailed east as *strategos* with special powers.

Intensive study of two joining fragments of a decree honouring Archelaus,

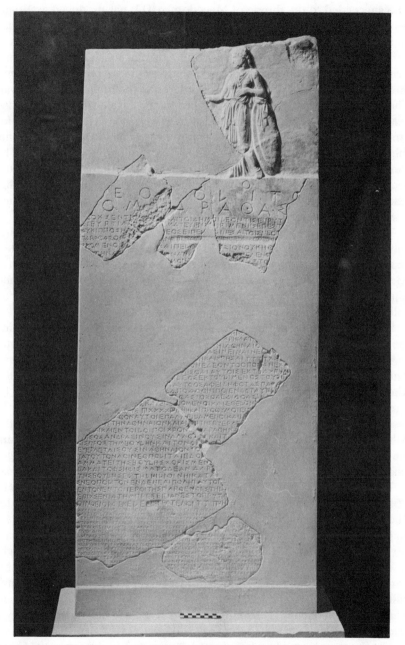

PLATE 7. The decrees voted (409 and 406) in honour of Thracian Neapolis.
EPIGRAPHIC MUSEUM

who succeeded to the throne of Macedon *ca* 413, has produced gratifying results. If we accept the reconstruction to which the cumulative evidence and argument lead, we add the following to our conception of events in Athens during Alcibiades' short stay: the Athenians plan to dispatch shipwrights to Macedon to build triremes; these are to be brought to Athens, there to be fully manned, and at once ordered to the Ionian theatre of war. The catastrophic losses in Sicily, followed by the naval war in the east, had resulted in an unrelenting shortage of ships as well as funds. The demand for timber had become desperate. It was more expedient and safer to build the ships in Macedonian ports than to transport the lumber to Athens. The cleverness of the scheme helps us to believe that Alcibiades moved the decree (his name fits exactly the space available). Archelaus' genuine friendship made the enterprise practicable. He merited his status as *proxenos* and *euergetes* (benefactor).

This was the year in which Lysander's arrival as the Spartan admiral coincided with the appearance of Cyrus, the King's younger son, at Sardes; he replaced the now-disgraced Tissaphernes as satrap. The two able men at once agreed to collaborate: Lysander would plan operations; Cyrus would supply the requested pay for the fleet without stint. They were more than collaborators; they became close personal friends.

In the spring of 406 we find the main Athenian fleet at Notium, controlling the approach to Ephesus. Alcibiades now paid a visit to Thrasybulus, who was engaged in a blockade of Ionian Phocaea to the north, having ordered Antiochus, his second-in-command, on no account to engage Lysander, whose fleet was hovering close at hand. Antiochus allowed himself to be lured into battle and the Athenians suffered a sharp reverse, losing 15 vessels. More ominous, perhaps, was the effect of the bad news on the Athenians. They held Alcibiades responsible and for him the verdict meant the end of a career. Wanted by the Spartans and the Persians, in danger among the Athenians, he sailed away to his property in the Thracian Chersonese.

The Athenians now redoubled their efforts to bring their damaged fleet to a fighting standard. This accomplishment, coupled with the recall of Lysander (the Spartans believed in the principle of annual tenure), made possible a major confrontation (late summer, 406) among the islands called Arginusae, between Lesbos and the mainland. The victory won by the Athenians might have put an end to the war, had it not been for the folly of the Demos, by this time driven to distraction by the vicissitudes of war and the brash irresponsibility of their demagogic speakers. First they condemned the triumphant *strategoi* for not having picked up survivors (they had been hampered by a storm); then they rejected Spartan offers of peace.

The Spartans learned from their misfortunes and, at the request of Cyrus and the Chians, reappointed Lysander to the naval command. The liaison

with Cyrus produced funds, and Lysander was able to damage Athenian interests along the coast from Rhodes to the Hellespont. The threat to the straits (and hence the grain-supply) drew the Athenian fleet, which anchored off Aegospotami, on the Chersonese opposite Lampsacus, where lay the Peloponnesians. Alcibiades, coming down from his castle, warned the Athenians of their exposed position but was abruptly dismissed. On the fifth day (late summer, 405) Lysander astutely caught the Athenians ships off guard while the crews were ashore for a meal. The result was devastating: of 180 ships, Lysander took 160. He executed the Athenian captives (about 3,000).

The Athenians were now without a navy. They had strained their resources to the utmost to put this last fleet to sea; their desperation may be measured by the fact that some 30,000 non-Athenians were serving. Lysander, now unopposed, sailed without haste for Peiraeus (late autumn), accepting the surrender of former Athenian allies on the way and installing oligarchies. Only the Samians remained and upon them the Athenians, in a most uncharacteristic move, bestowed citizenship.

Agis moved from Deceleia to the walls of Athens; the other Spartan king, Pausanias, joined him. With Lysander off Peiraeus, the blockade was complete.

In the spring of 404 the starving and hopeless Athenians surrendered. They had lost the war and the Empire; and they were bankrupt.

XVI

EMPIRE: A VERDICT

We have traced the fortunes of the Athenians in their relationships with Hellenes and barbarians, within the Aegaean and beyond, from their first clash with the Persians in 499 to the destruction of their fleet and the subsequent fall of their city to the Peloponnesians in 404. We have shared their vicissitudes in war and peace, their leadership of a Confederacy that became an Empire, and the concomitant emergence of the polis designated by Pericles as "the education of Hellas." In that eventful century the most influential and dominating factor, for Hellenes and barbarians, was the Empire, which indeed has been our chief concern. We have witnessed its conception and, after a protracted labour, its birth; we have witnessed its death. It is now fitting to conduct the *post mortem* examination and, if possible, to fashion a verdict.

In our recapitulation we shall be wise to bear in mind the regrettable fact that since the Second World War the very words "empire" and "imperialism" have acquired unpleasant connotations. Under the impact of what he reads and hears the layman—especially the young layman—is inclined to view empire and imperialism with uncritical hostility. The historian's duty, on the other hand, is to gather and analyse the evidence, dispassionately; only then will he express a judgement. The analysis may expose benefits conferred that should not be obscured by incidents that merit castigation.

The many variations of empire demand that the word be given a broadly flexible definition, such as I find in *The Shorter Oxford English Dictionary*: "An extensive territory (*esp.* an aggregate of many states) ruled over by an emperor, or by a sovereign state." The Athenian Empire, a pioneering effort

extending over a comparatively small area, cannot be placed in the same category as the Empire of Alexander or of the Romans; nor had it precedent ("ruled over," in the definition, is not really accurate). As we proceed with our review, we should also grant that imperialism usually implies an element of exploitation, more or less benign.

When, after the successes of 478 and the disgrace of Pausanias, the Athenians accepted the pressing invitation of the allies to become the naval leaders of "the Hellenes," the Persians were the immediate target; much remained to be done.

The subsequent meeting on Delos reflects allied determination to proceed systematically. Action against the Persians demanded ships, men, and money. All would contribute; "for they intended to take vengeance on the King." This was one aspect of their deliberations. The other grew from their awareness of what they had so far achieved by collaboration. To expel the Persians from Hellenic lands was not enough; the enemy must be kept out. This is why the allies swore to have the same friends and the same enemies until the iron floated; the price of permanent safety was permanent vigilance.

The Athenians, naturally, were given the hegemony, the *responsibility* of leadership, which quite logically included the administrative and executive duties connected with the *phoroi*. To ascribe imperialistic or, for that matter, selfish motives to the Athenians at this optimistic moment is to commit a ludicrous anachronism. The details of what transpired on Delos in 478/7 may *seem* complex (because we *know* only the outline); the situation that produced the meeting and the goals of the collaborators, with their contemplated procedures, were very simple indeed. What facilitated the progressive metamorphosis of the Confederacy of Delos was the oath, with its long-term implications.

The campaigns of the 470s gratified allied aspirations. Yet the very successes won by the union in driving the Persians to distant horizons made that union seem less urgent. Two kinds of reaction followed. In the apparent disappearance of danger, some announced withdrawal from the Confederacy, only, like the Naxians (470), to suffer siege and subjugation. Others, in many cases yielding to the diplomacy of Cimon, negotiated a change in contributions from ships and men to cash. In this first decade, and probably for a few more years, the decisions to apply force, to accept cash, and even to compel membership (for example, Carystus) were decisions voted by the synods, where each member might cast one vote. To disallow secession was common sense; the alternative meant erosion.

Over the years the authority of the hegemon was bound to increase as the fleet became more and more homogeneous. Simultaneously, the nature of the Confederacy changed. We should not waste our energy in an illusory search for a precise date after which the term "Empire" may be claimed to

apply. We should, however, give due weight to a number of indicative factors. (1) When the business of assessment and collection of *phoros* was transferred to Athens in 454, those in charge selected, to carry the audited accounts, a stele that served for fifteen years. (2) By 450 only four of the original naval allies were preserving their status as contributors of ships; the rest were now assessed for cash. (3) In the 450s the character and treatment of revolt had changed. Naxos—and others in the early years—had been disciplined by the Confederacy. The revolts of Miletus and Erythrae in the 450s, on the other hand, took the form rather of revolts from the Athenians themselves. Athenian decrees inform us of the terms of their renewed allegiance; Athenian officials supervised the rewriting of their constitutions, which included clauses meshing their judicial systems with the Athenian. (4) The combination of hegemonial authority and naval growth in the generation after the invasions was such that the emergence of the Athenians as the dominating power seems to us predestined. (5) Finally, we must admit as an influential element in the Athenians' attitude the enhanced prestige of which they were proudly conscious. A new generation, accustomed to command and relishing its benefits, took the dominating position for granted.

The Peace of Callias and the failure of the contemplated Panhellenic Congress put an end to a somewhat ambiguous situation: an overt decision could not be avoided. The order for the resumption of the *phoros* ("tribute") proclaimed to the allies that collaboration would continue, without pretence. It was a new relationship, and the rules would be enforced: the Athenians would make policy, the allies would be answerable to the Athenians. In practice, this involved little change; the synods (probably) had already ceased to meet. The noun *arche* ("Empire") becomes common and soon, in the inscriptions and the literature, we meet the clause "the cities that the Athenians control"; the more innocuous and technically correct phrase, "the Athenians and their allies," nevertheless remains in use.

For the future the Athenians continued some of the administrative policies that had already proved satisfactory and devised others. At the risk of some repetition we shall examine the policies that guided the reconstructed Empire.

We need not doubt that the Decree of Clearchus, which banned the use of all but Attic silver coinage, benefited the merchants of the Empire, those from the cities as much as those from Athens. One standard replaced many. It is true that the Athenians collected a service-charge for making the exchange to Attic coinage; but this was a trivial single transaction, not recurrent.

The polis itself was engaged in trade on only a minor scale, and foreign policy was seldom if ever formulated to gratify commercial interests. The Athenians did watch zealously over the route from the Euxine Sea through

the Hellespont for the sake of the grain-supply (carried by private traders). Early in the War, Guardians of the Hellespont (*Hellespontophylakes*) were stationed to control the shipping of grain through the vital straits. The other commodity that provoked official action by the state was timber. We have from time to time remarked upon the recurrent moves to institute and maintain a foothold in the area of Thrace and Macedon. The timber was no doubt carried on behalf of Athens by private contractors. Merchants from Athens, the majority of whom were metics, sailed freely in the Mediterranean and the Euxine. Pericles, in 431, boasts that "because of the greatness of our city all the crops of the whole earth flow in, and we enjoy the good things that appear here with no more native pleasure than we enjoy the products of the rest of mankind." The Decree of Clearchus is to be linked to this activity; and we can posit similar benefits elsewhere than at Athens.

It is likely that the regulation enacting that certain cases be heard at Athens belongs before the Peace of Callias. From the Athenian point of view capital charges such as treason affected the Empire as a whole and so should be heard in the capital city. Defenders of the policy could argue that in Athens the litigants were guaranteed appearance before a democratically appointed and disinterested jury. It may be argued in return that, if the case had political overtones, Athenian jurors would lean to the Many. Travel to Athens, of course, had to be paid for, and the merchants of Peiraeus and Athens profited from the presence of visitors. The court-fees went to the polis. Allied resentment is understandable.

The purist might well insist that the decree about coinage and the judicial requirements infringed autonomy, although no complaints survive concerning the first and comment on the second comes from Athenian speakers. For the charge that has sometimes been made, that the Athenians imposed unwelcome constitutions on the cities, there is no evidence at all, even in the case of revolt. That only democracy was tolerated is demonstrably false.

A major cause of bitterness was the founding of settlements (cleruchies and colonies) and the ownership of land by Athenians in allied territory. We remind ourselves that these colonies and cleruchies were placed on strategic sites, ostensibly as guarantees against an enemy without or disaffection within. They also provided land to Athenians, many of whom had perhaps been landless.

In the pre-War years the tributary cities may have objected to the imposition of *phoros*; they could not have objected to it as excessive. The expense of maintaining the vital fleet justified the *phoros* in the first place: the allies would pay the bills, the Athenians would risk their lives. The Empire might be likened to an insurance company: the members paid their annual premiums (the *phoroi*); the company (the Athenians), with its resources (the fleet), guaranteed security (peace). Sceptical critics might reply, in modern terms,

that the Athenians were operating a "protection-racket," based upon brute force.

Still, the navy welcomed volunteers and men from the allied cities served in substantial numbers, especially in critical times; the Athenians could scarcely, by themselves, man 200 warships, with a complement of 200 hands each. From the time of Aristeides the scale of assessment had varied little and account had been taken of a city's annual ability to pay. The Peace of Nicias (421) enacted that certain Thracian cities that had been disloyal were to retain their autonomy and deliver the *phoros* according to the scale set by Aristeides; this clause was an Athenian concession. The quota-lists record, spasmodically, failures to pay, late payments, and partial payments, all of which suggest reluctance in the cities, not to the amount but to the principle. It is worth stressing that autonomy and the payment of tribute to a dominant power are not regarded as incompatible.

On all these allied obligations there is scarcely a contemporary comment. For an impression of what may well have been an underlying feeling in the cities we must wait until 378/7, when in the charter of the Second Athenian Confederacy (cut on a marble stele) we find stipulations that echo unmistakably the practices of the fifth-century Empire: membership is open to any eligible community that wishes to join, "with the guarantee that it will be free and autonomous, enjoying the constitution of its choice, without receiving a garrison or accepting an Athenian *archon,* and without paying *phoros* The Athenian Demos are to release all properties, private or public, held by Athenians in the territory of those who enter the alliance. . . . From now on no Athenian, either privately or publicly, is to be allowed to own in the territories of the allies either a house or a property, whether by purchase or by mortgage or by any means whatever." Funds, of course, were needed; so the noun *syntaxis* was employed as a euphemism for *phoros*. The alliance, unlike its predecessor, was planned to be bicameral, with an allied synod that met separately from the Athenian Assembly.

The popularity of the Athenians among their allies has been the subject of vigorous controversy; each side appeals to Thucydides. At the beginning of the War the historian's conclusion is that "the sympathy of most leaned decidedly to the side of the Lacedaemonians, especially since the latter were proclaiming their intention to free Hellas. . . . So passionate was the feeling of the majority against the Athenians, some wanting to be released from the Empire, others fearful that they might become subjects of the Empire." In 413/2, immediately after the catastrophe in Sicily, Thucydides again expresses an opinion: "All the Hellenes were at once elated. . . . The subjects of the Athenians were especially ready to revolt. . . . "

Archidamus, the Spartan king, refers in his moderate speech of 432 to "the goodwill of all Hellas towards the Lacedaemonians thanks to the

hostility felt for the Athenians." Pericles himself admits to "the hatred incurred in the administration of Empire." He looks upon this as natural: "For to be hated and deemed obnoxious for the time being has certainly been the fate of all who think they have earned the right to rule over others." The speeches of the Corinthian in 432 and the Mytilenaean in 428, delivered in order to inflame the Lacedaemonians, falsify history wilfully and cannot be taken at face value.

When we turn to the narrative, time and again we are told that the Many in the cities not only felt sympathetic to the Athenians; they fought actively against oligarchic factions that wished to secede. So, when the Athenians used force to recover losses, they were able as a rule to depend upon help from the popular leaders within the cities that had seceded or were threatening to secede. This is especially notable in Thrace, where Brasidas had been so successful, often in collaboration with the Few, and later in Ionia and the Hellespont. The ties of friendship between the Many in the cities and the Athenians are emphasised appositely by Diodotus when he advocates moderate punishment for the Mytilenaeans in 427.

The record of the allies down to 413, when it seemed that nothing could save the Athenians, does not, despite Thucydides' dictum, leave the impression of a host of subjects ready to revolt at the slightest opportunity. At the outset of the War (432/1), it is true, there was wide-spread disaffection in Thracian Chalcidice; here we take into consideration the effective pressure brought to bear for several years previously by the Corinthians and by Perdiccas. Elsewhere, the members of the Empire (again we have Thucydides in mind) remained astonishingly loyal; the Mytilenaeans were the only serious exception. It was not until the major scene of fighting shifted to the eastern Aegaean (after 413) that revolt spread like a contagious disease from city to city. Oligarchic factions greedy as ever for power may have been willing to abandon the Athenians. Even so, it was the appearance of external stimuli that persuaded them that the time was right and the risks minimal: Peloponnesian agents, Persian blandishments, the apparent inability of the weakened Athenians to restrain them or protect them, the (unexpected) appearance of a Peloponnesian fleet, and (later) the wiles of the renegade Alcibiades. Disaffection was general and critical; but to the same sentence we can add that, especially after Alcibiades' return, the impressive rate of recovery owed much to the collaboration of popular elements within the cities. Special commendation is merited by the Samian Demos, who remained true to their allegiance throughout the War. During the oligarchic interlude at Athens in 411/0 Samos served as the Athenians' naval and democratic base; this hospitality made it possible for the stricken Athenians to maintain hostilities in the east. In 404/3, when the War was lost and the Empire in shambles, the Samians proclaimed their persisting loyalty. To match such

exceptional loyalty the Athenians voted an exceptional measure: they granted Athenian citizenship to the Samians.

If we pass from one campaign to another in the pages of Thucydides, we cannot fail to notice how frequently allied contingents reinforced Athenian expeditions, by land as well as by sea. Before the final battle in Sicily he marshals the troops under Athenian command by categories: colonists, tribute-paying subjects, autonomous naval allies, autonomous allies (outside the Empire), mercenaries; the numbers are substantial. He does state that some of these were present under compulsion, which probably means that such service was part of their permanent obligations rather than that specific force had been applied. More revealing, perhaps, is the answer of the islanders after the decisive battle in Sicily, when they faced certain death and the Syracusans offered freedom in return for surrender; few responded.

Thus we cannot fail to register the contradiction in Thucydides. As one scholar has put it, his editorial columns are at odds with his reporting of the news.

The reciprocal sympathy that existed between the Many in Athens and the popular elements in the cities is emphasised in a political tract written about 424 by an anonymous author whom we call the Old Oligarch (A. G. Woodhead has aptly remarked that the "Young Oligarch" would be more appropriate to the tone). A sentence from one of Plato's *Letters* tells the same story: "The Athenians preserved their Empire for seventy years by acquiring citizens as friends in each city."

Wise observers will agree that no brief answer satisfies the question, "Were the Athenians popular among the allies?" Yes, there were feelings of resentment; at the same time, when *stasis* threatened, there were many who preferred the Athenians (and internal peace) to their oligarchic political opponents (and, in some cases, Persian interference).

The speech given by Thucydides to the Athenian spokesman at Sparta in 432 after the denunciation of his polis by the Corinthians is in many ways representative of a point of view that had, quite understandably, accompanied the growth of Athenian prestige: pride in achievement is not without an element of arrogance. The blunt words of defiance in the face of threats are those of the man who boasts that he calls a spade a spade. He reminds the Spartans of the Athenians' record against the Persians, a well-known story. "The fact is that we did not take this Empire by force but, when you were unwilling to stand against the barbarian to the end, the allies approached us and begged us to remain as leaders. . . . We have done nothing that is alien to human nature if we accepted a proffered Empire and then, overcome by the three all-powerful influences, a sense of prestige, fear, and self-interest, refused to yield it. . . . It is an established rule that the weaker be restrained by the more powerful and in our case we think ourselves worthy to rule. . . .

Our subjects are accustomed to associate with us on equal terms. . . . "

Pericles, in his address to the suffering Athenians in 430, minces no words. "Yet the city you inhabit is a great one and you have been nurtured in habits of life that correspond to it. . . . There is no-one—not the King nor any other power in our world—who will prevent you, with your present naval resources, from sailing where you wish. . . . Nor is it any longer possible to resign from Empire. . . . For now the Empire you hold is like a tyranny: to possess it is in the popular view unjust, to let it go exceedingly dangerous To be hated and targets of jealousy for the time being has been the lot of all who have deemed themselves worthy of exercising power over others; but whoever incurs envy in pursuing great causes is in his policymaking moving in the right direction. For hatred does not last long, but the brilliance of today persists into the future as an everlasting glory."

Cleon, urging the supreme penalty for the Mytilenaean rebels, comes close at times to agreeing with Pericles. Both are realistic: but Cleon introduces an aura of brutality that is foreign to Pericles. "I have often on other occasions observed that a democracy lacks the competence to rule over others; I am especially convinced of it now by your change of mind about the Mytilenaeans. . . . You do not recognise that the Empire you hold is a tyranny, a tyranny exercised over unwilling subjects who are ever plotting against you. . . . Your survival depends upon your strength rather than their good will. . . . I beseech you not to make the mistake of yielding to the three temptations that are most catastrophic to an imperial power, pity, pleasing words, a sense of fairness." We note that, while Pericles says that the Empire is *like* a tyranny, Cleon states that it *is* a tyranny. That the sentiment was not foreign to Athenian thought is suggested by the words addressed to Demos by the chorus in Aristophanes' *Knights* (424): "Oh, Demos, it is a fine domain that you have, when men fear you as they would a tyrant." In these passages, tyranny is the equivalent of autocracy. The Athenian Euphemus, in reply to Hermocrates' polemic at Sicilian Camarina in the winter of 415/4, voices equally frank words. He too mentions the record against the Persians and the motives, fear and self-interest, that developed to make preservation of Empire essential. "The fact is that we exercise leadership over our allies at home in accordance with each one's usefulness to us: the Chians and Methymnaeans, who furnish ships, are autonomous; the majority, who bring in money, we control with more severity; and others are allied quite freely, even though they are islanders and easy to take, because they lie in convenient positions around the Peloponnese. . . . For we claim that we rule our allies in the Empire to avoid yielding to another."

The doctrine that might makes right appears in its most savage form in the Athenian's words before Melos in 416. The atrocity committed there and the like fate inflicted on the Scionaeans a few years earlier are often made part of

the indictment of Empire. They should rather be ascribed to the evil effects that war has upon the character of man. In this respect human behaviour has not changed. Nor had the Athenians a monopoly in the commission of atrocity. When in 430 they summarily executed the Corinthian Aristeus and his fellow-envoys, they were, says Thucydides, "following the precedent set by the Lacedaemonians, who killed . . . the Athenian and allied merchants whom they caught on cargo-vessels sailing around the Peloponnese. Moreover at the beginning of the War the Lacedaemonians slaughtered all whom they captured at sea as hostile, both those collaborating with the Athenians and those affiliated with neither side." Warfare, in ancient times and modern, has corrupted each side into the commission of horrifying deeds. The Athenians did what they did at Melos not because they were an imperial power but because they had been at war for half a generation.

The Confederacy whose major purpose was to wage offensive warfare against the Persians became an Empire whose more specific ambition, as embodied in the agenda of the Panhellenic Conference (449), was to patrol the seas, "in order that all men may sail them without fear and keep the peace." In the fourth century we read much of the desperate need for a "Common Peace." We see the beginnings of the idea in the words of the oath sworn in 478/7; we move a step towards realisation with the proclamation of 449. This was the concept of Athenian statesmen; the Empire supported the navy, or, to use the modern idiom, the peace-keeping force. The Athenians developed the structure and the administrative methods that they thought necessary. They allowed a generous measure of autonomy and the *phoros* was not oppressive. In return, the allies were to enjoy safety and peace.

The charges levelled against the Athenians, the so-called "abuses," when assembled to form a single bill of particulars, create a misleading impression. This assembling of complaints is modern; no-one put them together in the fifth century. The truth is that no single imperial practice could be judged gravely oppressive, irritating in individual cases though it might be.

In their endeavour to guarantee safety and bring about a Common Peace, the Athenians were pioneers. They were ever confronting new situations and seeking or inventing new solutions. We cannot expect them to have avoided error or misjudgement entirely. They believed that control must be firm and that the responsibility of formulating foreign policy must be theirs. Internally, they claimed, a fair degree of autonomy was practised.

For Hellenes, however, autonomy was not enough. To paraphrase Thucydidean language, "the truest cause of resentment, though little was said about it, was their loss of freedom." In 411, the Athenian Phrynichus, in the midst of a complex and personally dangerous situation on Samos, argues that the allies "would not want to be in subjection under oligarchy or democracy in preference to being free under whichever type of government

they happened to have"; they wanted freedom at any price. Although the assertion is adapted to the speaker's circumstances, it reflects a view that was never absent in the cities of the Empire (even if it seems erratically supported by Thucydides' narrative); rebels, of course, like the Mytilenaeans, could make the lack of freedom a major issue.

"Freedom" is the usual translation of the Greek *eleutheria*. To the modern ear, perhaps, "sovereignty," or "sovereign independence," best conveys the meaning. The reader will at once recognise a problem that remains unsolved to this day: the refusal of the state to sacrifice an iota of sovereignty. He will think of the League of Nations, the United Nations, the veto. In the fifth century before Christ the Athenians were confronted by the same intense particularism (that is, nationalism) among the cities. It was one of the factors that helped to destroy the Empire. It was the major factor that foiled later efforts to agree on a "Common Peace" and abetted the ruinous jealousies that ended in capitulation to Macedon at Chaeroneia in 338.

The Athenians learned the lesson, as we see in the charter of the Second Confederacy. The members are to be "free and autonomous": the word translated "free" is the adjective that comes from *eleutheria*. The Confederacy was to be guided by the Athenian Ecclesia and a synod of the allies, with equal authority; the intent, obviously, was to solve the problem of sovereignty. It failed (it was bound to fail), and within twenty-five years the Confederacy had all but perished. Of all the ancient peoples who built empires, the Romans were most successful, with their formidable legions. But their methods were very different and they are not part of our story.

My own judgement of the Athenians and their Empire, I suspect, does not conform to that of the majority of critics. Throughout this book I have, in a number of contexts, pointed to Athenian ambitions, to their love of prestige and enjoyment of power, to their assiduity in protecting their own interests, to the gains that accrued to them from their dominion. All this, accompanied by a vulgar prejudice against Empire, which is made somehow to seem immoral, can be built into a strong case against the Athenians.

In redressing the balance, I summon my conviction that, especially in the crucial formative years of Empire, the major policies were formulated and put into words by men whom I have called statesmen. I conjecture that Aristeides was of this stature in 478/7; from about 460 Pericles spoke for such men. Their intellects might have been wasted had not the Demos recognised them as an élite and made adroit and wise use of them. The "revisionists" seem to resent the presence in "Great Men" of qualities that raise them above their contemporaries; it is a pessimistic view of human nature.

Let us linger for a moment with Pericles, who dominated the Athenian scene for so long. What did he gain? The answer is not money. There have

been men who have gloried in their personal authority, men who have been (and are), to employ the vernacular, "power-hungry." But all we know of Pericles, who notoriously shunned the limelight, denies the charge. I find it difficult to avoid the conclusion that in Pericles we have the selfless patriot, an aristocrat devoted to the form of government called *demokratia*; devoted also to the Empire, which brought glory to Athens and, in addition, seemed to offer, certainly in the 440s, the prospect of peace among the states of Aegaean Hellas.

It was such men who were responsible for what must appear to be somewhat idealistic aims; more, they persuaded the Athenians to adopt their proposals. The Ecclesia, however, showed many differences of opinion, many shades of opinion, as indeed we expect in so large a body with its freedom of speech; and over a long period it would be ridiculous to seek utter consistency in policy and attitude. At the beginning of the War Pericles thought it desirable to remind his fellow-citizens of their past and of the more burdensome obligations of Empire. Not all his hearers were similarly lofty of mind.

With these reservations I stress the original objectives of Confederacy and Empire and I stress the nature of the Hellenes whom the Athenians, as things evolved, would strive to usher into a world of safety and peace. I recognise the exaggeration: the Hellenes were the Hellenes of the Aegaean, the Empire was an Aegaean Empire, the hoped-for peace was an Aegaean peace. To the objection that the Dorian states did not participate the answer is that the membership of the Empire covered a substantial part of the Aegaean: only the Peloponnese and the southern islands remained outside. In 446 the Thirty-Years' Peace recognised the Athenian holdings and affiliations. This, to the statesmen whom I have posited, amounted to a broad stride in the right direction.

The Athenians did, until the last decade of the War, live up to their promises in keeping Hellas safe from the Persians. I also place in the positive column the tolerant and successful administrative system for their Empire that these pioneers devised and the fact that in the process they brought into being that internal democratic administrative system to which later ages in the West have looked as the ancestor of their own principles of government. The Great War put an end to what had been in origin a noble concept. Fourteen years of peace may seem a trifling reward. Yet when were the Hellenes of the Aegaean to know another such period? How did it compare with past experience?

The years of leadership after the Persian invasions coincided with that extraordinary manifestation of human genius that is known as the "Golden Age." The city in which democracy attained its full development nurtured or entertained the masters of dramatic tragedy and comedy, of architecture, of

sculpture and painting, of historical writing. It would be controversial to write that Empire was responsible; yet it would be folly to deny connexions among government, Empire, and the culture that we associate with the Liberal Arts. These connexions account for the admirable pride that characterises what was done and what was written. Some fifty years ago W. S. Ferguson of Harvard University described his impressions of imperial Athens in a notable paragraph. "The age of Pericles was an age of idealization, of the state by Thucydides, of its citizens by Pericles, of humanity in the heroic characters of Sophocles, and of the human frame and features in the sculptures of Phidias." Let him who seeks the ancient atmosphere re-read the speech of Pericles—the Funeral Speech—over the casualties of the first year of the War (431).

The Athenians resolved that peace and safety brought greater blessings than sovereignty. Let no reader scorn the threat from Persia as an illusion. When Samos threatened secession in 440, we are at once alerted to the presence of the Persian satrap. At Colophon in 430 the Persians were again in the wings. With the destruction of the Athenian fleet in Sicily in 413, the shifting of the theatre of war to the east, and wide-spread revolt, the Persians became major characters in the action. The Lacedaemonians, with some discomfort, were ready to trade Hellenic Asia, to which the King had never abandoned his claim, for Persian gold. To Sparta's shame, the King realised his ambition at the end of the War. Belatedly, the Lacedaemonians took up arms on behalf of the eastern Hellenes with the result that in the 390s coastal Asia Minor became a battle-ground. Simultaneously, war broke out in the homeland to perpetuate the post-War chaos.

I conclude by asking my readers to make an imaginative leap in time. The year is 387/6 B.C. and the Lacedaemonians have just signed the Peace of Antalcidas at the dictation of the King of Persia: all the lands of Asia Minor are to belong to the Great King. The Hellenes of Aeolis, of Ionia, and of Caria look back ninety years to that inspired meeting of idealists on the island of Delos; they consider what followed.

What now do they think of the Athenian Empire?

Appendix 1
CHRONOLOGICAL TABLE OF MAJOR EVENTS

(Events are selected with particular reference to the rise and fall of the Athenian Empire.)

By 1000	Occupation of the Cycladic islands and the Asiatic coast by Hellenes from the European mainland
750-550	Age of colonisation (Mediterranean and Euxine)
Ca 600	Athenian colony at Sigeum
Ca 560	Athenian colonists in the Thracian Chersonese
560-546	Reign of Croesus of Lydia
550	Control of Asiatic Hellenes by Croesus
549-529	Reign of Cyrus the Great of Persia
546	Fall of Croesus to Cyrus; submission of Asiatic Hellenes
546-528/7	Final tyranny of Peisistratus at Athens
528/7-511/0	Tyranny of Hippias at Athens
Ca 520	Athenian colonists on Lemnos and Imbros
514	Darius' Scythian expedition; Persian forces in Thrace
511/0	Expulsion of Hippias; *stasis* in Athens
508	Emergence of Cleisthenes; hostility of Spartans and Persians aroused by the Athenians
508-501	Adoption of Cleisthenes' constitution
506	Athenian cleruchy at Chalcis (Euboea)
499	Ionian Revolt assisted by 20 Athenian ships and 5 Eretrian
498	Athenian withdrawal
494	Fall of Miletus; end of Revolt
493/2	Archonship of Themistocles at Athens
	Beginning of fortification of Peiraeus
490	Athenian victory at Marathon
487	Ostracism used for the first time
486	Accession of Xerxes of Persia
483	Construction of 200 ships at Athens
481	Meeting of "The Hellenes" to discuss the threat of invasion
480	Battles of Thermopylae and Salamis

479	Battles of Plataea and Mycale
479/8	Rebuilding of Athenian walls
478	Hellenic naval offensive
	Disgrace of Pausanias; withdrawal of Lacedaemonians
478/7	Acceptance of hegemony by the Athenians
	Organisation of Confederacy of Delos
	First assessment
476/5	Capture of Eion and Skyros
473	Ostracism of Themistocles
Ca 473	Carystus forced into the Confederacy
472	Death of Pausanias
471	Exile of Themistocles
470	Revolt and reduction of Naxos
469	Confederate victory at the Eurymedon
465	Revolt and siege of Thasos
	Accession of Artaxerxes of Persia
465/4	Athenian defeat by Thracians at Drabescus; failure of colony at Ennea Hodoi
	Confederate successes against Persians in Hellespontine area
	Thasian appeal to Spartans
464	Earthquake at Sparta; revolt of Messenians
463/2	Fall of Thasos
462	Dismissal of Athenian assistance by Lacedaemonians
462/1	Athenian alliances with Argives and Thessalians
461	Ostracism of Cimon
	Fall of Messenian Ithome
	Settlement of Messenians at Naupactus by Athenians
461/0	Athenian alliance with Megarians
	Revolt of Egypt (under Inaros) from Persia
460	Confederate expedition to Cyprus; acceptance of invitation to aid Inaros
460-454	Confederate expedition in Egypt
460	Naval engagements off the Argolid
	Athenian capture of Troezen
	Siege of Aegina
460/59	Long Walls begun to Peiraeus and Phalerum
458	Spartan invasion of central Hellas
	Spartan victory at Tanagra
	Athenian victory at Oenophyta: alliances with Boeotians, Phocians, Locrians
458/7	Completion of Long Walls
	Athenian alliance with Segesta
457	Surrender of Aegina
	Voyage of Tolmides round Peloponnese
454	Final defeat of Confederates in Egypt

	Transfer of Confederate treasury to Athens
	Assessment
	Voyage of Pericles round Peloponnese; subjection of Achaeans
454/3	Revolts of Erythrae and Miletus
452	Recovery of Erythrae and Miletus
451	Return of Cimon
	Five-year armistice with the Peloponnesians
450	Expedition to Cyprus under Cimon
	Aid sent to Amyrtaeus in Egypt
	Death of Cimon
	Assessment
	Cleruchies sent to Lemnos, Naxos, Andros, Carystus
449	Peace of Callias
	Failure of Panhellenic Congress
	Transfer of 5,000 talents to Treasury of Athena
	Decree of Clearchus about coinage
	Inception of building programme at Athens
	Sacred War: Spartan interference at Delphi
448	No tribute paid (moratorium)
	Athenian alliances with Leontini and Rhegium
447	Resumption of payment of tribute
	Cleruchy sent to Thracian Chersonese
	Sacred War: Athenian reprisal at Delphi
447/6	Colony sent to Colophon
446	Athenian defeat at Coroneia; Athenian loss of influence in central Greece
	Revolt of Euboea and Megara
	Peloponnesian invasion of Attica
	Reduction of Euboea; cleruchies sent to Chalcis and Eretria
	Colony sent to Brea
	Assessment
446/5	Thirty-Years' Peace
	Building of southern Long Wall to Peiraeus
444	Colony sent to Thurii
443	Ostracism of Thucydides son of Melesias
	Colonists sent to Astacus
	Assessment
442	Special celebration of Great Panathenaea
440	Revolts of Samos and Byzantium
439	Recovery of Samos and Byzantium
438	Assessment: *ca* forty communities dropped
437	Colony sent to Amphipolis
436	Colonists sent to Sinope and Amisus
435	Battle of Leucimme (Corcyraeans defeat Corinthians)
434	Assessment

434/3	Decrees of Callias
433	Athenian-Corcyraean alliance
	Renewal of alliances with Leontini and Rhegium; alliance with Sicilian Halicyae
	Battle of Sybota
	Megarian Decree
432	Revolts of Potidaea and Chalcidians; Perdiccas of Macedon hostile
	Meetings of Peloponnesian League
431	Theban attack on Plataea
	Peloponnesian invasion of Attica
	Aeginetans expelled; island colonised
430	Peloponnesian invasion of Attica
	Onset of the plague
	Assessment
	Stasis and defection in Colophon
430/29	Fall of Potidaea
428	Peloponnesian invasion of Attica
	Revolt of Mytilene
	Assessment
427	Peloponnesian invasion of Attica
	Recovery of Mytilene; debate at Athens
	Fall of Plataea to Thebans and Peloponnesians
	Athenian assistance sent to Leontini
	Renewal of alliance with Segesta
426	Recurrence of the plague
425	Peloponnesian invasion of Attica
	Athenian victory at Pylos
	Assessment
425/4	Accession of Darius II
424	Athenian withdrawal from Sicily
	Athenian capture of Cythera
424/3	Athenian defeat at Delium
	Capture of Amphipolis by Brasidas
	Exile of Thucydides
423	One-year armistice
	Brasidas' successes in Thrace
422	Failure and death of Cleon at Amphipolis
421	Peace of Nicias
	Reduction and punishment of Scione
	Assessment
	Athenian-Spartan alliance
420	Quadruple alliance (Athenians, Eleians, Mantineians, Argives)
420-417	Intrigues of Alcibiades in the Peloponnese
418	Battle of Mantineia
	Assessment

418/7	Spartan-Argive alliance
416	Athenian-Argive alliance
	Ostracism of Hyperbolus
	Capture of Melos by the Athenians
416/5	Expedition to Sicily voted
415	Mutilation of the Herms
	Departure of the fleet for Sicily
	Recall of Alcibiades; his flight to Sparta
414	Arrival of Gylippus in Sicily
413	Occupation of Deceleia by Peloponnesians
	Replacement of tribute by five per cent tax
	Final disaster in Sicily
412	Alcibiades in the eastern Aegaean
	Wide-spread revolt in the east
	Persian intervention
411	Oligarchic *coup* at Athens
	Revolt of Euboea
410	Restoration of democracy at Athens
	Tribute restored (the last assessment)
407	Return of Alcibiades to Athens
406	Athenian defeat at Notium
	Flight of Alcibiades
	Athenian victory at Arginusae
405	Final defeat at Aegospotami
	Siege of Athens
404	Surrender of Athens

Appendix 2
THUCYDIDES' **PENTEKONTAËTIA**

In the summer of 432 the Lacedaemonians, after a meeting of the Peloponnesian League, voted that the Thirty-Years' Peace had been broken by the Athenians and that they must go to war. In chapter 88 of his first book Thucydides adds that they took this decision "not so much because they had been persuaded by the arguments of their allies as because they feared that the Athenians were becoming too powerful, perceiving that most of Hellas was already subject to them." He continues in the next chapter (89): "For the Athenians reached their position of prosperity in the following manner." This is the beginning of his excursus on the period between the Persian invasions and the Great War that we call the Pentecontaëtia, the Fifty Years.

In chapters 89-93 Thucydides describes the capture of Sestus (479), the deception of the Spartans by Themistocles that enabled the Athenians to build their walls of fortification, and the nature of those walls. He resumes his narrative in chapter 94 and there we join him, in the spring of 478.

94. Pausanias son of Cleombrotus was sent out from Lacedaemon as commander-in-chief of the Hellenes with 20 Peloponnesian ships. Athenians with 30 ships and a number of the other allies sailed with him. They campaigned against Cyprus and subjugated the greater part of the island; later they operated against Byzantium, which was in the hands of the Medes, and they took it by storm during this campaigning season.

95. As Pausanias was already behaving arrogantly, the rest of the Hellenes, not least the Ionians and all those who had lately been freed from the King, began to be angry with him. They kept going to the Athenians and asking them in recognition of their kinship to become their leaders and also not to entrust them to Pausanias in case he should in any circumstance try to use violence. The Athenians heeded what they had to say and made up their minds not to ignore Pausanias' behaviour and also to deal with the whole situation in a way that seemed best to suit their own interests. At this juncture the Lacedaemonians recalled Pausanias in order to make inquiries concerning the reports that they had received; for it was a fact that charges of serious misconduct were being laid against him by the Hellenes who had journeyed to Sparta, and his conduct seemed more an imitation of tyranny than the execution of a formal command. His recall coincided with the action of the allies, with the exception of the troops from the Peloponnese, as in their hatred of Pausanias they ranged themselves alongside the Athenians. Upon his arrival in Lacedaemon he was censured for his

private injustices against individuals but of the major charges he was acquitted; not least of the charges brought against him was medism and this seemed to be most clearly demonstrable. In any case they did not send him out again as commander but they dispatched Dorcis and other officers with him accompanied by a small force. To these the allies no longer yielded the command. Aware of the atmosphere, they went home and after this the Lacedaemonians, in their fear that officers who went forth would suffer deterioration of character, which they had indeed seen in the person of Pausanias, no longer sent out others; besides, they wanted to be free of the war against the Mede and they considered that the Athenians were competent to lead and at that present moment sympathetic to themselves.

96. The Athenians, having in this way succeeded to the hegemony of the allies, who were willing because of their hatred of Pausanias, detailed which of the cities should provide money against the barbarian and which ships; for it was a professed intention to seek vengeance for what they had suffered by ravaging the King's land. And then for the first time there were established as a magistracy by the Athenians Hellenotamiae, who would receive the *phoros*; for the contribution of the money was so called. The first assessment of *phoros* amounted to 460 talents. Delos was their treasury and the synods met inside the precinct.

97. The Athenians, as leaders of the allies who were at first autonomous and formulated their policy in common synods, between the present war and the war against the Mede achieved the many successes that I shall now relate, both in war and in the administration of policy, successes that were theirs in their dealings both with the barbarian and with their own allies who revolted and with those of the Peloponnesians who from time to time became involved with them. I have written of these exploits and have inserted the digression into my *History* for this reason, that the topic has been omitted by all my predecessors, who composed accounts either of Hellenic affairs before the Persian invasions or of the Persian invasions themselves. Hellanicus, who did touch upon this period in his history of Attica, made mention of it briefly as well as with chronological inaccuracy. At the same time my digression also demonstrates how the Empire of the Athenians came to be.

98. First of all, with Cimon son of Miltiades in command, they took by siege Eion on the Strymon, which was held by the Medes, and enslaved it. Then they enslaved Skyros, the island in the Aegaean, which Dolopians inhabited, and colonised it themselves. Next they made war against the Carystians (the other Euboean cities were not involved), who in due course came to terms. After this they campaigned against the Naxians, who had revolted, and placed them under siege; this was the first allied city to be subjugated contrary to the law of the Confederacy, but later the same fate also befell the others as each occasion arose.

99. Of all the causes of revolt the greatest were failure to pay the financial levies and to supply ships, and failure to serve, as happened in some cases. For the Athenians were exacting in their behaviour and were offensive in applying pressure to men who were not accustomed and indeed not willing to endure hardship. In one way or another the Athenians no longer led with their former popularity; they participated in campaigns on an unequal basis and it was easy for them to coerce those who rebelled. It was the allies themselves who were responsible for these developments. For because of this reluctance of theirs to participate in the expeditions,

the majority of those in question, in order not to be away from home, had accepted an assessment in cash as their appropriate future contribution in place of their ships; thus the Athenians' naval strength was gradually increasing from the funds that the allies contributed, while the latter, whenever they revolted, found themselves un-equipped and without fighting experience.

100. After this a battle by land and sea was fought at the Eurymedon River in Pamphylia by the Athenians and their allies against the Medes; the Athenians, under the command of Cimon son of Miltiades, were victorious in both arenas on the same day. They took and destroyed all the Phoenician warships to the number of 200. Somewhat later the Thasians revolted from the Athenians after a quarrel concerning the markets and the mine on the Thracian mainland opposite, all of which they [the Thasians] were exploiting. In reply the Athenians, having proceeded against Thasos with a fleet, won a victory at sea and made a landing on the island. About the same time they sent ten thousand colonists, Athenians and allies, to the vicinity of the Strymon River to settle the place then called Ennea Hodoi, which is now Amphipolis. The Athenian troops took control of Ennea Hodoi, which was held by the Edonians, but, after they had advanced into the interior of Thrace, they were utterly destroyed at Edonian Drabescus by the Thracians, by whom the founding of the colony was regarded as an act of hostility.

101. The Thasians, defeated in the field and now under siege, appealed to the Lacedaemonians and asked them to render assistance by invading Attica. The Lacedaemonians, without the knowledge of the Athenians, pledged assistance and were on the point of acting but were prevented by the earthquake that had just occurred, at which time both their helots and, of the *perioikoi,* the Thuriatae and Aethaeans revolted and made Ithome their base. Most of the helots were the descendants of the ancient Messenians who had lost their freedom in the distant past; and for this reason they were all called Messenians. Consequently, war against the rebels in Ithome engaged the Lacedaemonians, whereas the Thasians in the third year of siege came to terms with the Athenians. They tore down their walls, surren-dered their ships, accepted assessment of the money they were required to pay immediately and to contribute as *phoros* in the future, and abandoned their holdings and the mine on the mainland.

102. The Lacedaemonians, since their war against the rebels in Ithome was prolonged, invited the assistance of their allies, among them the Athenians, who responded with a substantial force commanded by Cimon. Their chief reason for inviting the Athenians was that the latter had the reputation of competence in siege-warfare, whereas their own resources in this area, in a protracted siege, were obviously wanting; for otherwise they would have taken the place by assault. From this campaign too there arose for the first time an open difference between the Lacedaemonians and the Athenians. For the Lacedaemonians, when the fortress was not taken by assault, were apprehensive about the daring character of the Athenians and their propensity for innovative experiment. At the same time they reflected that they were of a different branch of the Hellenic race, and were afraid that, if they remained, they would, under the influence of the rebels in Ithome, engage in revolutionary action; so they dismissed them alone of the allies. The Lacedaemonians did not reveal their suspicions but said they had no further need of the Athenians.

The latter recognised that their services were being dispensed with not for a more honourable reason but because an atmosphere of suspicion had developed. Taking this amiss and deeming it improper to suffer such indignity at the hands of the Lacedaemonians, immediately after the return of the army they renounced the alliance that had been made with the Lacedaemonians against the Mede and entered into alliance with their enemies the Argives; and at the same time both parties swore the same oaths with the Thessalians and established alliance.

103. The rebels in Ithome, in the fourth year of the siege, since they were no longer able to resist, came to terms with the Lacedaemonians: they would depart from Peloponnese under truce and never again set foot in it; if any man should be taken, he would be the slave of his captor. Now the Lacedaemonians before this time had received an oracle from Delphi instructing them to release the suppliant of Zeus of Ithome. The Messenians in Ithome, along with their children and wives, departed from the Peloponnese and the Athenians, because they were already at odds with the Lacedaemonians, received them and settled them in Naupactus, which, as it happened, they had just taken from the occupying Ozolian Locrians. It was about this time that the Megarians, who had abandoned the Lacedaemonians because the Corinthians had engaged them in war over boundaries, agreed to an alliance with the Athenians; and the latter held Megara and Pegae, built the long walls for the Megarians from the city to Nisaea, and themselves provided garrisons. And it was as a result of this action in particular that the bitter hatred of the Corinthians for the Athenians first began to develop.

104. Inaros son of Psammetichus, a Libyan and king of the Libyans, whose territory abuts Egypt, setting out from Mareia, a town that lies above Pharus, brought about the revolt of the greater part of Egypt from King Artaxerxes: and becoming commander he invited the Athenians to join him. Now they at the time were campaigning in Cyprian waters with 200 ships of their own and of the allies; so they abandoned Cyprus and responded to the invitation. Sailing from the open sea up the Nile they won control of the river and two-thirds of Memphis and attacked the remaining third, which is called White Fortress. Within it were the Persian and Median fugitives and those of the Egyptians who had not joined the revolt.

105. The Athenians, having made a landing at Halieis, engaged in battle against the Corinthians and the Epidaurians; the Corinthians were victorious. Later the Athenians fought by sea against a Peloponnesian squadron off Cecryphaleia and the Athenians were victorious. After this, war having broken out between the Athenians and the Aeginetans, a great naval battle was fought off Aegina in which allies were involved on each side; the Athenians were victorious and, after capturing 70 Aeginetan vessels, landed in Aeginetan territory and, commanded by Leocrates son of Stroebus, laid siege to the town. Then the Peloponnesians, wishing to aid the Aeginetans, effected the entry of 300 hoplites into Aegina-town, troops who had previously been supporting the Corinthians and Epidaurians. The Corinthians in their turn, with their allies, occupied the heights of Geraneia and made a descent into the Megarid, believing that the Athenians would be unable to render assistance to the Megarians because of the absence of a large force in Aegina as well as in Egypt; but, if they were to send help, they would lift the siege of Aegina. The Athenians, however, did not move the army at Aegina; but, under the command of Myronides, the oldest and the

youngest of the men remaining in the city marched into the Megarid. After an indecisive battle had been fought against the Corinthians the two sides withdrew from one another and each force believed that they had not had the worse of the action. The Athenians indeed (for they had really had the advantage), upon the departure of the Corinthians, set up a trophy. The Corinthians, reviled by their elderly fellow-citizens, made their own preparations and, about twelve days later, marched out and set up a trophy in opposition as though they themselves had been the victors. In answer the Athenians, making a sortie from Megara, destroyed those who were erecting the trophy and fell upon the rest and defeated them.

106. The vanquished Corinthians retreated and a fairly substantial number, under pressure, lost their way and tumbled into a privately-owned property that was enclosed by a deep ditch with no way out. When the Athenians became aware of this turn of events they barred the front with their hoplites and, stationing their light-armed men in a circle, stoned all those who had entered. This was a great disaster to the Corinthians, but the greater part of their army made its way home.

107. At about this time the Athenians began the building of the long walls to the sea, one to Phalerum and one to Peiraeus. Then, since the Phocians had invaded the territory of Doris, the homeland of the Lacedaemonians, to attack Boion, Cytinium, and Erineum, and had taken one of these towns, the Lacedaemonians, led by Nicomedes son of Cleombrotus acting for the king Pleistoanax son of Pausanias, who was not yet of age, came to the rescue of the Dorians with 1,500 of their own hoplites and 10,000 of the allies. Having forced the Phocians by agreement to return the town, they began their journey home. Now if they wished to make the journey by sea across the Crisaean Gulf, the Athenians, sailing around, were likely to stop them. On the other hand the journey by the pass of Geraneia did not seem safe, with the Athenians holding Megara and Pegae; for Geraneia was a difficult march and was under continuous patrol by the Athenians; and at that moment the Lacedaemonians sensed that the Athenians intended to bar the way by this route also. They decided to remain in Boeotia and to investigate the manner by which they would proceed in the greatest safety. On the other hand there were men in Athens giving them clandestine encouragement, men who hoped to destroy the power of the Demos and put an end to the building of the long walls. The Athenians came out against the Lacedaemonians in full force along with 1,000 Argives and detachments from various of the allies. All told they numbered 14,000. The Athenians mounted their attack in their belief that the Lacedaemonians were uncertain by which route to cross into the Peloponnese and also because they were somewhat suspicious of an attempt to bring down the democracy. In addition the Athenians were joined, in accordance with the alliance, by Thessalian cavalry, who in the action deserted to the Lacedaemonians.

108. In the battle, which was fought at Boeotian Tanagra, the Lacedaemonians and their allies were victorious; the loss of life on each side was substantial. Subsequently the Lacedaemonians entered the Megarid and, after cutting down the trees, departed once more for home through Geraneia and the Isthmus. On the sixty-second day after the battle the Athenians, under the command of Myronides, marched against the Boeotians and defeated them in the field at Oenophyta. They won control of the territory of Boeotia and Phocis, tore down the Tanagraeans' walls, seized one hundred men of the Opuntian Locrians, the most wealthy, as hostages, and

completed their own long walls. Shortly afterwards the Aeginetans came to terms with the Athenians; they dismantled their walls, surrendered their ships, and accepted assessment in cash for the future. Then the Athenians, led by Tolmides son of Tolmaeus, sailed around the Peloponnese; they burned the dockyards of the Lacedaemonians, took Chalcis, a Corinthian settlement, and, making a landing in Sicyonia, defeated the inhabitants in battle.

109. The Athenians in Egypt and their allies maintained their presence and experienced the changing vicissitudes of war. For in the first place the Athenians were gaining control of Egypt; to counteract them the King sent the Persian Megabazus to Lacedaemon with money to draw the Athenians from Egypt by bribing the Peloponnesians to invade Attica. When his mission fared badly and the money was spent to no purpose, Megabazus with what was left returned to Asia, but the Persian Megabyzus son of Zopyrus was ordered to Egypt with a strong force. Arriving by land, he defeated both the Egyptians and their allies, drove the Hellenes from Memphis, and finally shut them up on the island of Prosopitis. There he held them under siege for a year and a half; at that time, by draining the canal and diverting the water he stranded the ships on dry land and converted most of the island into mainland. Crossing over on foot he took the island.

110. In this way the fortunes of the Hellenes were destroyed after six years of war. And of the many who participated a few marched through Libya to reach Cyrene in safety; but the majority lost their lives. Egypt was brought back to its allegiance to the King; the exception was Amyrtaeus, the king in the marshes, whom the Persians were unable to capture, thanks to the broad area of the marshes combined with the exceedingly warlike nature of the Egyptians who inhabited them. As for Inaros, the Libyan king who had been responsible for the entire Egyptian interlude, he was betrayed and impaled. Fifty triremes, sailing to Egypt in support from Athens and the rest of the Confederacy, put in at the Mendesian arm of the Nile, completely unaware of what had transpired. They were promptly set upon, ashore by infantry and at sea by a Phoenician squadron that destroyed most of their ships; the surviving minority escaped. Thus the great Athenian and Confederate expedition to Egypt came to an end.

111. Orestes, son of the Thessalian king Echecratidas, in exile from Thessaly, persuaded the Athenians to restore him. The Athenians, taking with them Boeotian and Phocian allies, marched against Thessalian Pharsalus. They gained control of as much of the country as they could without straying far from their camp (for the Thessalian cavalry restricted them) but failed to take the town. No additional success came their way to further the purpose of the expedition; so they retreated, taking Orestes with them, their mission unaccomplished. Shortly afterwards 1,000 Athenians, boarding the ships stationed at Pegae (the Athenians themselves held Pegae), sailed along the coast to Sicyon under the command of Pericles son of Xanthippus, made a landing, and defeated the Sicyonians who had come to engage them. Picking up Achaeans and at once crossing the Gulf, they attacked and laid siege to Acarnanian Oeniadae. Having failed, however, to take the place, they thereupon returned home.

112. Later, after an interval of three years, a five-year armistice was arranged between the Peloponnesians and Athenians. Thereupon, while the Athenians held aloof from the Hellenic war, they did dispatch a fleet of 200 of their own and

Confederate ships to Cyprus, commanded by Cimon. Sixty of these sailed to Egypt in response to a summons from Amyrtaeus, king in the marshes, and the rest laid siege to Citium. When Cimon died and a serious shortage of food developed, they withdrew from Citium and sailed to the waters off Cyprian Salamis. There, having confronted Phoenicians, Cyprians, and Cilicians by sea and land simultaneously, they were victorious in both arenas and returned home; the ships from Egypt accompanied them. After this the Lacedaemonians undertook the so-called Sacred War and, having gained control of the sanctuary at Delphi, handed it over to the Delphians. Later, when they had departed, the Athenians in reprisal marched to Delphi and, after victory in the field, returned the sanctuary to the Phocians.

113. Some time after this the Athenians, because the Boeotian exiles were holding Orchomenus, Chaeroneia, and a number of other places in Boeotia, marched against these towns, which were hostile to them, with 1,000 of their own hoplites and varied allied detachments, under the command of Tolmides son of Tolmaeus. After taking Chaeroneia and enslaving the inhabitants they installed a garrison and withdrew. On their march they were attacked at Coroneia by the Boeotian refugees from Orchomenus in collaboration with Locrians as well as Euboean exiles and a number of others who shared their politics. The joint force, winning the battle, slew some of the Athenians and captured others alive. So the Athenians abandoned Boeotia completely, having made a truce on condition that they recovered their men. Then the Boeotian exiles and all the others returned and became autonomous once again.

114. Shortly after these events Euboea revolted from the Athenians. Pericles had already crossed to the island with an Athenian army when the news reached him that Megara had revolted, that the Peloponnesians were about to invade Attica, and that the Athenian garrison had been massacred by the Megarians, with the exception of those who escaped to Nisaea. The Megarians had revolted after inviting the assistance of the Corinthians, the Sicyonians, and the Epidaurians. Pericles brought back the army from Euboea post-haste. After this the Peloponnesians, penetrating Attica as far as Eleusis and Thria, pillaged the countryside, under the direction of the Lacedaemonian king Pleistoanax son of Pausanias; and advancing no further they returned home. The Athenians, commanded by Pericles, again crossed to Euboea and subjugated the whole island; with the other cities they reached agreement but the Hestiaeans they dispossessed and themselves occupied their land.

115. Soon after their withdrawal from Euboea they concluded a thirty-year peace with the Lacedaemonians and their allies: they gave up Nisaea, Pegae, Troezen, and Achaea, Peloponnesian territories that the Athenians had held. Six years later war broke out between the Samians and the Milesians over Priene. The Milesians, worsted in the fighting, went to the Athenians and laid charges against the Samians. A number of private citizens from Samos itself, wishing to effect revolution at home, collaborated with them. The Athenians therefore, sailing to Samos with 40 ships, established a democratic form of government. They took hostages from the Samians, fifty boys and an equal number of men, and lodged them in Lemnos; then, having left behind a garrison, they departed for home. The fact was that there were certain Samians who had not remained in the city but had fled to the mainland. These men, effecting alliance with the most powerful of those in the city and with Pissuthnes son of Hystaspes, the then satrap in Sardes, gathered mercenaries to the number of 700

and crossed to Samos by night. Their first act was to rise against the democracy and get the better of most of its supporters. Next, having stolen away their own hostages from Lemnos, they revolted from Athens and gave the Athenian garrison and the Athenian *archontes* stationed in Samos to Pissuthnes; and now they lost no time in preparing an expedition against Miletus. The Byzantines joined them in revolt.

116. When the Athenians learned what had happened they dispatched a fleet of 60 ships against Samos. Sixteen of these they did not employ, for in the event some made for Caria to look out for the Phoenician vessels and others moved towards Chios and Lesbos to summon assistance. With the remaining 44, commanded by Pericles and his nine colleagues, they fought at sea off the island of Tragia against 70 Samian ships, of which 20 were transports (the entire squadron was at the time sailing from Miletus), and were victorious. Later 40 ships arrived as reinforcements from Athens and 25 from Chios and Lesbos. Disembarking and achieving control by land, they placed the city under siege by construction of three walls and simultaneously maintained investment by sea. Pericles, taking 60 ships from the blockading fleet, set off at speed towards Caunus and Caria, reports having arrived that Phoenician ships were proceeding against them; for Stesagoras and others had left Samos with 5 ships to meet the Phoenicians.

117. In this interval the Samians made an unexpected sally by sea, fell upon the unguarded camp, destroyed the naval scouts, and defeated the ships that put out to oppose them; thus they controlled their own waters for about fourteen days and imported and exported what they wished. Upon the return of Pericles they were once more subjected to naval blockade. Later, further reinforcements reached the area: 40 ships with Thucydides and Hagnon and Phormion, 20 with Tlepolemus and Anticles, and 30 from Chios and Lesbos. The Samians fought a brief naval engagement but, without the resources to hold out, were stormed in the ninth month of siege and agreed to terms: they took down their walls, gave hostages, surrendered their ships, and accepted assessment for the costs of the siege, to be paid in instalments. The Byzantines also agreed to accept their former status as subject-allies.

Appendix 3
THE ATHENIAN CALENDAR

These were the months:

Hekatombaion	Maimakterion	Elaphebolion
Metageitnion	Posideion	Mounychion
Boedromion	Gamelion	Thargelion
Pyanepsion	Anthesterion	Skirophorion

The Athenians, like other Hellenes, struggled with the problem of reconciling the lunar month (approximately 29½ days) with the solar (seasonal) year (approximately 365¼ days). They could accommodate the moon with months of 30 (full) or 29 (hollow) days. They more or less harnessed sun and moon by the periodic insertion of an extra month (a second Posideion). The year thus totalled 354 days (ordinary) or 384 (intercalary). Until 432/1 a cycle of 8 years included 3 intercalations. The astronomer Meton then devised a cycle of 19 years, with 7 intercalations; of the 235 months 125 were full. Astronomically, the 6940 days miss precision by about a quarter of a day; slight adjustments in the fourth century dealt with this. Most officials held office by this civil calendar, in which New Year's Day, Hekatombaion 1, fell in mid-summer. The eponymous archon gave his name to the year, which explains why we must express a date in a double form, for example, 403/2 B.C., the archonship of Eucleides.

The Boule (Council), however, had its own calendar, which we call conciliar. The year was divided into 10 prytanies, named for the Attic tribes that they respectively represented. Each prytany rendered special service for one-tenth of the year, as a rule six for 37 days, four for 36; the order was determined by lot, drawn towards the end of each prytany, except, of course, the ninth. The year of 366 days was thus essentially solar and the two calendars were not co-terminous until a change was made near the end of the century. The ten tribes, in their official order, were:

I Erechtheis	VI Oineis
II Aigeis	VII Kekropis
III Pandionis	VIII Hippothontis
IV Leontis	IX Aiantis
V Akamantis	X Antiochis

The treasurers of Athena held office from Panathenaea (that is, Hekatombaion 28) to Panathenaea.

Appendix 4
COINAGE

The Athenian system was based on the drachma (originally meaning "a handful").

$$6 \text{ obols } (oboloi, \text{"spits"}) = 1 \text{ drachma}$$
$$100 \text{ drachmae} = 1 \text{ mina } (mna)$$
$$60 \text{ minae} = 1 \text{ talent}$$

The talent and mina were weights, which represented sums of money. Coins (of silver) were minted in the following values: 1 dr., 2 dr., 4 dr., 10 dr.; obols (1, 1½, 2, 3) and half-obols. It is impossible to equate values with pounds and dollars. An artisan after mid-century earned 1 drachma *per diem*.

Appendix 5
THE MEMBERS OF THE EMPIRE

This roster, arranged by geographical districts and compiled from the epigraphic documents, includes all who were assessed or who paid *phoros* at least once. The numbers alone thus attest vividly the range of the Athenians' aspirations. Assessment did not guarantee payment. In the assessment of 425 especially there are entered poleis that did not heed Athenian demands. Other communtiies are seen once or twice and then disappear from the records. The total registry should be contrasted with the quota-lists between the Thirty-Years' Peace and the outbreak of the War; they average about 170 names annually. The three large islands, Lesbos*, Chios*, and Samos*, were naval allies and so were never assessed cash (even after the revolts of Samos in 440 and Mytilene in 428). Many of these names are rarely found outside Greek writings (several locations remain unknown); I therefore employ the transliterated spelling for all. Asterisks identify probable charter-members of the Confederacy.

ISLANDS

Aigina
Anaphe
Andros*
Athenai Diades* (Euboia)
Belbina
Chalkis* (Euboia)
Diakres (Euboia)
Diakrioi (Euboia)
Dion* (Euboia)
Eretria* (Euboia)
Grynche* (Euboia)
Hestiaia* (Euboia)
Hephaistia* (Lemnos)
Ios*
Imbros
Karystos (Euboia)
Keos*
Keria

Kimolos
Koresia* (Keos)
Kythera
Kythnos*
Melos
Mykonos*
Myrina* (Lemnos)
Naxos*
Paros*
Pholegandros
Posideion (Euboia)
Rhenaia*
Seriphos*
Sikinos
Siphnos*
Styra* (Euboia)
Syros*
Tenos*

IONIA

Assos*
Astyra* (Mysia)
Boutheia*
Dios Hieron*
Elaia*
Elaiousa* (island)
Ephesos*
Erythrai*
Gargara*
Gryneion*
Hairai*
Isinda*
Karene*
Klazomenai*
Kolophon*
Kyme*
Lebedos*
Leros* (island)
Larisa

Maiandros*
Marathesion*
Miletos* (including Neapolis)
Myous*
Myrina*
Nisyros*
Notion*
Oine* (Ikaros)
Phokaia*
Pitane*
Polichna*
Priene*
Pteleon*
Pygela*
Sidousa*
Teichioussa*
Teos*
Thermai* (Ikaros)

CARIA

Alinda
Amos
Amorgos (island)
Amynanda*
Arkesseia (Karpathos)
Arlissos
Aspendos
Astypalaia (island)
Aulai*
Bargylia*
Bolbai
Brikindarioi (Rhodes)
Brykous (Karpathos)
Chalke* (island)
Chalketor
Cherronesioi*
Chios (near Knidos)
Diakrioi (Rhodes)
Doros (Phoenicia)
Erine
Eteokarpathioi (Karpathos)
Euromos
Halikarnassos*
Hyblissos
Hylima

Kos*
Krousa
Krya
Kydai
Kyllandos
Kyrbissos
Latmos*
Lepsimandos* (island)
Lindos* (Rhodes)
Loryma
Lykioi
Madnasa*
Milyai
Mydon
Mylasa
Myndos*
Naxia
Narisbara
Oiai (Rhodes)
Olymos
Oula
Ouranion
Pargasa
Parpariotai
Pasanda

Ialysos* (Rhodes)
Iasos*
Idrias
Idyma
Iera
Ityra
Kalymna* (island)
Kalynda
Kameiros* (Rhodes)
Karbasyanda
Kares (ruled by Tymnes)
Karpathos (island)
Karyanda* (island)
Karya
Kasolaba
Kasos (island)
Kaunos
Kedreai* (island)
Kelenderis
Keramos*
Killara
Kindya
Knidos*
Kodapes

Pedasa
Pedies (Rhodes)
Pelea* (Kos)
Perge
Phaselis
Pladasa
Polichne
Pyrnos*
Sambaktys (dynast)
Saros (island)
Sillyon
Siloi
Syangela*
Syme (island)
Taramptos (island)
Tarbana
Telmessos
Termera*
Telandria
Telos (island)
Thasthara
Thydonos
Tymnessos
Ydissos

HELLESPONT

(Chers.=Chersonese; Prop.=Propontis; c.=coast)

Abydos*
Agora* (Chers.)
Alopekonnesos* (Chers.)
Arisbe*
Artaiou Teichos (Prop. south c.)
Artake* (Prop. south c.)
Astakos* (Prop. east c.)
Astyra Troika
Azeia*
Berytis
Bisanthe (Prop. north c.)
Brylleion (Prop. south c.)
Bysbikos (island Prop.)
Byzantion*
Chalchedon*
Dardanos*
Dareion
Daskyleion* (Prop. south c.)
Daunion Teichos* (Prop. north c.)

Lamponeia*
Lampsakos*
Limnai (Chers.)
Madytos (Chers.)
Markaion
Metropolis (Prop. south c.)
Miletopolis
Mysoi (Prop. east c.)
Neandreia*
Neapolis (Prop. north c.)
Otlenoi (Prop. south c.)
Paisos*
Palaiperkote*
Parion* (Prop. south c.)
Perinthos* (Prop. north c.)
Perkote*
Polichne
Priapos* (Prop. south c.)
Prokonnesos* (island Prop.)

Didymon Teichos* (Prop. north c.)
Elaious (Chers.)
Eurymachitai (?)
Gentinos
Halone (island Prop.)
Harpagion (Prop. south c.)
Kallipolis (Prop. east c.)
Kebrene
Kios* (Prop. east c.)
Kolone
Kyzikos* (Prop. south c.)

Pythopolis
Serreion Teichos (Prop. north c.)
Selymbria* (Prop. north c.)
Sestos (Chers.)
Sigeion*
Skepsis
Sombia
Tenedos* (island)
Tereia (Prop. south c.)
Tyrodiza* (Prop. north c.)
Zeleia

AKTE

Antandros
Achilleion
Hamaxitos
Ilion
Kolone
Larisa
Nesos (island)

Ophryneion
Palamedeion
Petra
Pordoselene (island)
Rhoiteion
Thymbra

THRACE

Abdera
Aige* (Pallene)
Aineia*
Ainos
Aioleion
Akanthos*
Akrothoon (Athos)
Aphytis* (Pallene)
Argilos*
Assera*
Berge
Bormiskos
Chedrolos
Deire
Dikaia (opposite Thasos)
Dikaia (north of Spartolos)
Dion* (Athos)
Drys
Gale (Sithonia)
Galepsos
Gigonos
Haisa
Haison
Herakleion

Ikos* (island)
Kalindoia
Kamakai
Kithas
Kleonai (Athos)
Kossaia
Kystiros
Maroneia
Mekyberna*
Mende* (Pallene)
Methone
Miltoros
Neapolis (opposite Thasos)
Neapolis* (Pallene)
Olophyxos* (Athos)
Olynthos*
Othoros
Peparethos* (island)
Pergamon Teichos
Pharbelos*
Phegetos*
Pieres
Piloros (Sithonia)
Pistasos

Pleume
Polichne*
Posideion
Poteidaia* (Pallene)
Prassilos
Sale
Samothrake* (island)
Sane* (Athos)
Sarte (Sithonia)
Serme
Sermylia* (Sithonia)
Singos* (Sithonia)
Sinos
Skabala*
Skapsa*
Skiathos* (island)

Skione* (Pallene)
Smilla
Spartolos*
Stageira*
Strepsa
Stolos*
Thasos* (island)
Thestoros
Therambos* (Pallene)
Thyssos* (Athos)
Tindaioi
Torone* (Sithonia)
Trailos
Tripoai
Zereia
Zone

EUXINE

Apollonia
Dandake
Herakleia
Karkinitis
Karousa
Kerasous
Kimmeri---

Nikonia
Nipsa
Nymphaion
Patrasys
Tamyrake
Tyras

Appendix 6
THE QUOTA-LISTS

For the membership of the Empire from mid-century, for the loyalties and disloyalties of individual states, for their relative prosperity, for the annual income in tribute, and for the many vagaries of administration, the circumstances of payment and the conditions of assessment, the quota-lists are the most informative source. Here I essay an account of the lists as a whole that will, I hope, expand and clarify the scattered references of my narrative.

I have already commented on the surprising size of the stele of Pentelic marble that was selected in 454/3 to display the audited record of the *aparchai* (the "first fruits," the quota) offered to the goddess Athena: height 3.61 m., width 1.11 m., thickness 0.39 m. The choice of stele should not be ascribed to the stone-cutter; he received instruction from a representative of the Boule (to whom magistrates reported directly). This *lapis primus* ("the first stone," of which we know 183 fragments), inscribed on four sides, sufficed for fifteen years (to 440/39). The quotas of the next eight years (Lists 16-23, to 432/1) were entrusted to the four sides of a *lapis secundus* ("second stone," height at least 2.20 m., width 1.47 m., thickness 0.34 m.); 74 fragments have been recovered. Thereafter, each year claimed its own stele.

Of the first stone we have rather more than half; the reconstruction, in plaster, is one of the noble sights of the Epigraphic Museum in Athens. The extant sections of Lists 1-5 and 7-15 (there is no List 6) are enough to justify instructive reconstruction and conjecture. The damage suffered by the *lapis secundus* (much of it to the surface) has been far more severe; at first sight the stele, also rebuilt, strikes the visitor as an expanse of plaster. Only Lists 22 and 23 (433/2 and 432/1, cut on a lateral surface) approach their original wholes; not a letter of List 18 is legible and little of the remaining lists. Henceforth, from 431/0 to 406/5 (except that a harbour-tax replaced the *phoros* from 413 to 410 inclusive), the yield is poor: only Lists 25, 26, and 34 (430/29, 429/8, 421/0) preserve sufficient to raise the spirits; twelve lists have vanished. In retrospect the reader will appreciate the value of the two large stelae. Historians of the Empire cherish the hope that the American School of Classical Studies at Athens will resume excavations on the north slope of the Acropolis, where, in the early 1970s, five fragments of the quota-lists (three of them adding crucial information to the *lapis primus*) were unearthed.

A Prescript, cut in larger letters, ran across the top of each list; it gave the serial

number and the current secretary of each board of Hellenotamiae, counted from 454/3 as the era-date (for example, "In the year of the twelfth board, for whom Sophias of Eleusis was secretary"). Reference to the thirty *logistai* (auditors) did not recur after List 3. From 442 (List 12) the chairman of the board joined his secretary; in Lists 12 and 13 a co-secretary is granted mention (in the former in a Postscript, Sophocles of Colonus, the tragic poet). The inclusion of the complete board of Hellenotamiae, with the topographical demotics that identified the demes of Attica in which they were registered as citizens, became standard after their début in List 25 (430/29). From 420 (List 34) each Prescript included a date by archon and by the Boule as well as a descriptive final clause: "These cities delivered the *aparche* to the Goddess at the rate of a mina on the talent." List 7 alone lacks a serial number: "In the year of the board for whom Menetimos of Lamptrai was secretary." There had been no collection in 449/8 and consequently no list. So the report of 448/7 came from the seventh board but was only the sixth record; the perplexed clerk who provided the copy to the stone-cutter evaded a choice by omitting the ordinal. These numbered lists have proved to be a boon to the epigraphist, since they give him an unchallengeable chronological base for his study of the evolution of letter-forms, so vital for the dating of documents that lack internal chronology.

Appropriately, the lengthier Prescript of List 1 identifies the recorded sums as the first *aparchai*, computed at the rate of a mina on the talent, to be submitted to the thirty *logistai* for audit and presentation to the Goddess Athena. The eponymous archon (Ariston) supplies the date; a lacuna deprives us of the name of the secretary of the Hellenotamiae. The initial list of the series is unique in that the upper right lateral surface is occupied by a Postscript that announces a summation of the quotas registered; the money included silver coins and Cyzicene staters of gold (1 stater = 24 Attic drachmae). The cogent restorations of the partially preserved numerals presume a *phoros* of about 400 talents. It may be remarked here that, although assessments and numbers fluctuated (mildly), the scale of assessments and the totals collected varied little in the years that preceded the outbreak of the War. The *phoros* in this period never reached 400 talents. Fairly reliable totals can be computed for 444/3 (with the help of an independent financial document), 443/2, and 433/2: 376, 379, 388 talents respectively. The pre-war assessments of individual states ranged from 300 drachmae to 30 talents (Aegina and, after 446, Thasos). The great majority fell in the lower half of the scale; not one paid between 18 and 30 talents.

Below the Prescript, in each list, the contributing cities and their quotas form columns. Except in the first year, when the order is name, colon, quota (without word-division), the digits of the quota are set off in a column of their own preceding the column of names. The latter, more often than not, take their ethnic forms (for example, Mykonioi rather than Mykonos); a few dynasts from Caria stand for their communities (for example, Carians ruled by Tymnes, Pigres of Syangela).

The broad faces of the two large stelae regularly accommodate five or six columns (List 7 has four); exceptionally, the seven of List 2 are continued by three on the right lateral surface. In the two columns of the narrow surfaces (Lists 8 and 14-15 of the *lapis primus,* 22-23 of the *lapis secundus*) the cutter was at times constrained to crowd his lettering laterally.

Before commenting on the salient features of this fragmentary but important body

of primary material, I must bring to the reader's attention the criteria that guide us to reconstruction and restoration. An official document, for example, a decree of the Demos, was reproduced on the marble in the style called *stoichedon,* that is, all letter-spaces (*stoichoi*) were given the same dimensions, without word-division or punctuation (except of a very simple kind). Often the workman, before taking to his chisel, plotted his surface by drawing a grid. Thus, in a well-cut document we are able to count precisely the number of letters missing. The style was applied to the quota-lists, the Prescripts and the names, each letter-space conforming to the pattern.

In the early years the *phoroi* (and so the quotas) were written into the books as the carriers reached the appropriate bureau in Athens; the assessments had been recorded under geographical headings. With the fourth assessment-period the system of geographical panels was introduced into the quota-lists: Ionia, Hellespont, Thrace, Caria, Islands. In the assessment of 438 the Athenians officially dropped some forty inland communities of Caria from the rolls; consequently, the Ionic panel absorbed the Carian. Even before the adoption of the geographic principle we see the order of sections of a list repeated *in extenso* in the next (especially in the third and fourth periods, Lists 9-16) and throughout the lists there is a tendency for small groups to register together (one carrier might be employed by a number of neighbouring communities). When the records are not affected by such phenomena as revolt, late payment, defaulting, the signing of a peace, a community appears once in the published register and the amount deposited remains unchanged for the duration of an assessment-period. Finally, restoration is assisted by the testimony of the ancient authors (concerning such matters as revolt or the capture or loss of a city).

If, having taken full advantage of the opportunities for restoration, we restrict our examination to names, we discover that we have no complete list, although three lists approach that status: in 7, 12, and 13 the unrestored lines are 5, 3, and 1 in number respectively. The division into geographical panels has brought dividends: no fewer than eighteen of them possess their full complements, which enable us to identify the defaulters. Study of these texts as restored (conservatively) has produced fruitful results. In my brief notes the numbers should be regarded as approximate.

In the first assessment-period (Lists 1-4) the payers average 155. The commutation of most of the remaining allies to cash explains the increase of List 5 to about 190 entries; but at least 20 of these, engraved in the last column (indicating late delivery), are complementary to partial payments registered earlier in the list. Here we see the unmistakable influence of the pending Peace of Callias. The political debates that ensued are reflected by the moratorium of 449/8 (the absence of a sixth list) and the unusual nature of List 7 when payment of *phoros* was resumed (448/7): of 150 quotas at least 20 are partial and 9 are designated as late. The unique List 8, with about 218 entries, is the documentary evidence of the Athenians' resolution to enforce obligations and bring accounts up to date. To the names of List 7, repeated in the same order, is added a lengthy appendix: late payments (complete), complements for this and the preceding year, acknowledgements of amounts paid to commanders in the field (in the north). The effectiveness of Athenian measures is revealed in the third assessment-period (446/5-444/3), which produces three "normal" lists (9-11) averaging 160 entries. The number increases slightly (to 170) in the fourth period (443/2-439/8, Lists 12-16). The practice of levying a small fine for lateness is an innovation in List 15

(440/39) that is maintained for ten years. The dropping of Carian communities in the assessment of 438 explains the decrease of about a dozen bookings in Lists 17 and 19 (18 is lost). List 20 (435/4), of the same period, comes near to 170 once more: were the Athenians, sensitive to the delicate foreign situation, consolidating their position? The assessment of the same year increased the range of control: List 21 has 190 entries. Defections reduced the numbers until in the spring of 431 (List 23) the faithful scarcely topped 150; the absentees, however, can be traced directly to disaffection in Thrace. With the outbreak of the War the evidence becomes much more fragmentary. All we can be sure of is that in 429 and 428 (Lists 25 and 26) the count does not reach 140.

The extraordinary assessment of 425, which, *in toto*, tripled the monies demanded, has been discussed. While it is certain that the Athenians did not collect from every community assessed, it is equally certain that the numbers of those who paid these inflated amounts were far higher than we have so far seen in any quota-list. The assessment included 14 "Actaean Cities" (taken from Mytilene's peraea in 427) and 47 "Cities from the Euxine," a bold announcement of Athenian aspirations. For a quota-list we now leap to List 34 (421/0), which discloses the impact of the Peace of Nicias (spring, 421) and the assessment (postponed from 422 because of the prospects of peace) that was carried out soon afterwards. List 34 was very long indeed (lacunae make estimates difficult); the Actaean cities and the Euxine communities, of course, remained on the roster, along with many (we assume) inherited from the assessment of 425. The quotas, however, suggest an effort to return to the scale of Aristeides, the "Golden Age" to the allies, as indeed the Athenians had guaranteed in the Peace for some of the recovered tributaries of Thrace.

The lists (21-26) of the sixth and seventh periods (434/3-429/8) embody several special groupings, each with its own rubric. An influential factor that caused the introduction of new names to the lists was the breaking up of a number of syntelies (consortiums), especially in Thrace, that the Athenians had previously accepted under single names (the dominating communities). As early as Lists 19 and 20 we meet five Thracian poleis entered as unassessed. These had been enrolled, more or less voluntarily, by Athenian forces, who had levied money. In the assessment of 434 they and a few others concurred in accepting assessments and were guaranteed against increases. The lists call them "Cities that accepted assessment by special arrangement"; in the next period an adjusted heading acknowledges the guarantee. In 434, as is implied by the rubrics of the period, thirteen Thracian towns, on nomination by individuals, were added to the assessment referred by the *taktai* to the Ecclesia for final approval. Some cities appealed their assessments in 430; that procedure too is noted by headings in Lists 25 and 26. In 430/29 the privilege of paying the *aparche* alone was granted to three Thracian tributaries; the decision earned a rubric in the two lists of the period.

The Athenians, despite their apparently rich reserves, soon began to feel the financial strains of war. There were times when campaigning forces needed funds urgently. The circumstances are brought home to us vividly by three rubrics in List 25 that credit payments (sometimes partial) made before the due date to commanders or to Athenian magistrates abroad; the districts concerned were Ionian Erythrae along

with its neighbours, the Hellespont, and the Thracian Chersonese. Thus do the quota-lists enlighten us about Athenian negotiations in the field.

Enough has been written (I trust) to convince the reader of the inestimable value of the epigraphic evidence to those who would acquire more than a superficial understanding of the Athenians and their Empire.

INDEX OF PLACES

The numbers refer to the maps. The geographical district is added in parentheses for each Athenian tributary. A few well-known and easily-found places are used as points of reference, e.g., the three projecting Thracian peninsulas (Acte, Sithonia, and Pallene; for convenience they are assumed to run north to south), the larger islands, rivers. When, on the maps, the names of the chief polis and the island are the same, the community is indicated by a dot.

Abdera (Thrace): on the coast north-east of Thasos 2, 3

Abydus (Hellespont): on the Asiatic coast of the Hellespontine strait 3

Acanthus (Thrace): on the east coast at the base of Acte 2

Acarnania: a tribal territory in western Greece on the Ionian Sea opposite Leucas Island 2

Achaea: the northern strip of the Peloponnese west of Sicyonia 2

Acropolis (of Athens): 7

Acte: the word (Akte) means headland or promontory and is applied to pieces of land that project into the sea; there are many in Aegaean Greece. Two are referred to in this book: (1) the north-eastern of the three Thracian peninsulas that jut into the Aegaean 2; (2) the territory on the mainland opposite Lesbos occupied by her dependencies, the Actaean Cities 3

Adriatic Sea: 2, 6

Aegaean (Aegean) Sea: 2, 3

Aegina (Islands): in the Saronic Gulf, within sight of Athens 2, 4

Aegospotami: a river of the Thracian Chersonese flowing into the Hellespontine strait opposite Lampsacus 3

Aeneia (Thrace): on the north-east coast of the Thermaic Gulf 2

Aenus (Thrace): on the north coast of the Aegaean 3

Aeolis: the area inhabited by Hellenes on the coast of Asia Minor from the Hellespont (Dardanelles) southwards to a point just south of Lesbos 3

Aethaea: a town in Laconia (Peloponnese) 2

Aetolia: the territory (east of Acarnania) extending north from the entrance to the Corinthian Gulf 2

Amisus: on the south coast of the Euxine Sea east of Sinope 8

Ambracia: a Corinthian colony in southern Epirus (western Greece) 2

Amphipolis: on the Strymon River about three miles from the mouth (east of Chalcidice), on the site of Ennea Hodoi, the earlier Athenian colony 2

Anaea: the area of the mainland opposite Samos 3

Andros (Islands): in the northern Cyclades 2

Antandrus (Actaean City): on the southern coast of the Troad 3

Anthela: on the coast, just west of Thermopylae 2

Aphytis (Thrace): on the east coast of Pallene 2

Arcadia: the central area of the Peloponnese 2

Argilus (Thrace): on the coast about three miles west of the Strymon River 2

Arginusae Islands: between Lesbos and the Asiatic mainland 3

Argolis (the Argolid): the territory about Argos, including the peninsula projecting south-eastwards 2, 4

Argos: in the Peloponnese, some twenty miles south of Corinth 2

Artemisium: the cape at the northern end of Euboea 2

Asia Minor: 3, 5, 8

Assinarus River: the mouth joins the sea south of Syracuse 6

Astacus (Hellespont): on the coast of the bay at the eastern end of the Propontis 3

Athens: 2, 4, 7

Athos: the mountain on the promontory of Acte (the name is sometimes applied loosely to the peninsula) 2

Attica: 2, 4

Babylon: 1

Babylonia: 1

Bisaltia: the area (in the Thracian district) comprising the west coast of the Strymonic Gulf (partly Chalcidice) 2

Boeotia: 2, 4

Boion: in Doris, a small territory in Central Greece 2

Bosporus: the strait (Thracian) that divides Europe from Asia at the entrance to the Euxine Sea 3, 8

Bottiaea (or Bottice): an area at the base of Pallene 2

Bottice: see Bottiaea

Boutheia (Ionia): on the peninsula of Erythrae opposite Chios 3

Brea: the location is not certainly known but it probably lay west of the Strymon River, upstream, near Amphipolis 2

Byzantium (Hellespont): on the European side of the Thracian Bosporus, modern Istanbul 3, 8

Camerina: on the south coast of Sicily 6

Cappadocia: the territory east of the upper waters of the Halys River in Asia Minor, its eastern border abutting the upper Euphrates River 5, 8

Cardia: near the neck of the Thracian Chersonese 3

Caria: an area along the southern section of the Asiatic coast and its interior 3, 5

Carthage: 6

Carystus (Islands): on the south coast of Euboea 2

Catana: on the east coast of Sicily, some thirty miles north of Syracuse 6

Caunus (Caria): on the Asiatic mainland north-east of Rhodes 3

Cecryphaleia: islands in the Saronic Gulf between Aegina and the Argolid 4

Cephallenia: a large island in the Ionian Sea 2

Cephisus River: in the vicinity of Athens 7

Cerameicus: the potters' quarter of Athens 7

Chaeroneia: in western Boeotia 2

Chalcedon (Hellespont): on the Asiatic side of the Thracian Bosporus 3, 8

Chalcidice: the large peninsula of the Thracian district including the three peninsular fingers jutting into the Aegaean 2

Chalcis (Islands): on Euboea at the Euripus, where the island all but touches the mainland 2

Chalcis (Aetolian): on the north coast at the entrance to the Corinthian Gulf a few miles west of Naupactus 2

Chelidonian Islands: off the south coast of Asia Minor (Lycia) 5

Chersonese (Hellespont): the Thracian peninsula (Gallipoli) lying alongside the Straits of the Hellespont (Dardanelles) 3

Chios: island off the central coast of Asia Minor 3

Cilicia: the long coastal territory and hinterland in southern Asia Minor 1, 5

Citium: on the south coast of Cyprus 5

Colophon (Ionia): in central Asia Minor a short distance inland 3

Corcyra (Corfu): 2

Corinth: 2

Corinthia: the territory constituting the polis of Corinth 2, 4

Corinthian Gulf: 2, 4

Coroneia: in western Boeotia 2, 4

Crisaean Gulf: a bay south of Delphi on the north coast of the Corinthian Gulf 2

Crete: 2, 3

Croton: within the instep of Italy 6

Crousis (Thrace): an area in north-western Chalcidice along the east coast of the Thermaic Gulf 2

Cyanean Islands: in the Euxine Sea at the mouth of the Thracian Bosporus 3, 8

Cyclades: 2, 3

Cyme (Ionia): coastal, in northern Ionia 3

Cynossema: a promontory on the European coast (Chersonese) of the Hellespontine strait 3

Cynosura: the tongue of land on Salamis extending towards the mainland 4

Cynuria: the area bordering Laconia and the Argolid (Argolis) 2

Cyprus 1, 5

Cyrene: coast and hinterland in western Libya 5 Inset

Cytinium: in Doris, a small territory in central Greece 2

Cyzicus (Hellespont): on the south coast of the Propontis 3

Dardanelles: see Hellespont
Danube River: 8
Dascyleum: capital of the Persian Hellespontine satrapy, in the interior south of Cyzicus (on the Propontis) 3
Dascyleum (Hellespont): on the south coast of the Propontis 3
Deceleia: about fifteen miles north-east of Athens 4
Delium: on the eastern coast of Boeotia about two miles from the Attic border 4
Delos: island in the central Cyclades 3
Delta: the triangular territory formed by the lower waters of the Nile 5
Delphi: 2
Dicaea (Thrace): on the east coast of the Thermaic Gulf, east of Aeneia 2
Dios Hieron (Ionia): on the Asiatic coast north of Samos 3
Dipylon Gate: in Athens 7
Dium (Islands): on the north-western tip of Euboea 2
Dium (Thrace): on the west coast of Acte 2
Doris: a small territory in Central Greece 2
Doriscus: near the north coast of the Aegaean 3
Doros: on the coast of southern Phoenicia 5
Drabescus: in Edonian (Thracian) territory east of the Strymon River 2
Edonians: a Thracian tribe living east of the Strymon River 2
Egypt: 5
Eion: at the mouth of the Strymon River 2
Elaeus (Hellespont): at the tip of the Thracian Chersonese 3
Eleusis: about fifteen miles west of Athens 4
Elis: a district in north-western Peloponnese 2
Ellopia: a district in north-western Euboea 2
Elymi: a non-Hellenic people of western Sicily 6
Ennea Hodoi (Nine Ways): see Amphipolis 2
Ephesus (Ionia): coastal, north-east of Samos 3
Epidamnus (modern Durazzo): on the Adriatic coast 2
Epidaurus: on the eastern coast of Argolis 2, 4
Epirus: the territory of the mainland opposite Corcyra, bordering Thessaly and Macedonia 2
Eretria (Islands): on the west coast of Euboea 2
Erineum: in Doris, a small territory in Central Greece 2

Erythrae (Ionia): on the west coast of the peninsula opposite Chios 3
Euboea: 2, 4
(Straits of) Euboea: the waters between Euboea and the mainland 2, 4
Euphrates River: 1
Euripus: the narrowest point of the straits between Euboea and the mainland 2
Eurymedon River: runs into the sea in Pamphylia on the south coast of Asia Minor 5
Euxine Sea: the modern Black Sea 3, 8

Gale (Thrace): on the west coast of Sithonia 2
Mt Geraneia: on the Isthmus between Megara and Corinth 4
Gytheum: on the Gulf of Laconia 2

Haeson (Thrace): near the west coast of the Thermaic Gulf 2
Halicarnassus (Caria): coastal, on the peninsula north of Kos 3
Halicyae: a non-Hellenic town of western Sicily 6
Halieis: on the south coast of the Argolid peninsula 2
Halys River: a major river flowing north through the heart of Asia Minor into the Euxine Sea 8
Hellespont: (1) the strait (Dardanelles) between the Thracian Chersonese (Gallipoli) and Asia 3; (2) a name loosely applied to the district as a whole (the Troad and the interior) 3
(Temple of) Hephaestus: in Athens 7
Hermione: on the south coast of the Argolid peninsula 2
Hestiaea (Islands): on the north coast of Euboea 2

Imbros (Islands): island off the Thracian Chersonese 3
Ionia: the central section of the (Hellenic) coast of Asia Minor 3, 5
Ionian Sea: the sea between Greece and the West (Sicily and southern Italy) 2
Istanbul: see Byzantium
Isthmus: with a capital ("Isthmus") the Isthmus of Corinth, in particular the area where the crossing to the west is narrowest 2
Italy: 6
Mt Ithome: in central Messenia 2

Keos (Islands): in the western Cyclades 2
Kos (Caria): island off south-western Asia Minor 3

Lacedaemon (Sparta): 2

Laconia: the territory about Lacedaemon (Sparta) 2

Laconian Gulf: off the south-eastern Peloponnese 2

Lampsacus (Hellespont): on the Asiatic side of the Hellespontine strait 3

Latmus (Ionia): at the head of the bay south-east of Samos 3

Lebedus (Ionia): coastal, due north of Samos 3

Lemnos (Islands): in the north Aegaean 2, 3

Leontini: about twenty miles north-west of Syracuse 6

Leros (Ionia): island due south of Samos 3

Lesbos: 3

Leucas: island in the Ionian Sea 2

Leucimme: a promontory of southern Corcyra 2

Libya: 5 and Inset

Limnae (Hellespont): on the west coast of the Thracian Chersonese 3

Locris: (1) (Epicnemidian) Locris abutting Boeotia on the strait between the mainland and Euboea 2; (Ozolian) Locris on the north-western coast of the Corinthian Gulf 2

Lycia (Caria): a territory in south-western Asia Minor bordering Caria 3, 5

Lydia: the ancient kingdom, originally a small territory about Sardes (the capital) in central Asia Minor, eventually embraced the lands extending from the Aegaean (Ionia, Aeolis, much of Caria) to the Halys River 3

Macedon(ia): the kingdom abutting Thracian Chalcidice extending from north Central Greece as far east as the Strymon River 2

Madytus (Hellespont): on the east coast of the Thracian Chersonese 3

Maeander River: in Asia Minor, meeting the sea east of Samos 3

Magna Graecia: the Greek territory of southern Italy 6

Magnesia: on the Maeander River, near the Asiatic coast, due east of Samos 3

Mantineia: polis of Arcadia in central Peloponnese 2

Marathon: in Attica about twenty-six miles north-east of Athens 4

Mareia: on the western edge of the Egyptian Delta 5

Mareotis (Lake): in the west of the Egyptian Delta 5

Marmara: see Propontis

Maroneia (Attica): in the coastal area of south-eastern Attica 4

Maroneia (Thrace): on the north Aegaean coast 3

Mecyberna (Thrace): at the base of the Gulf of Torone between Pallene and Sithonia 2

Media: the land of the Medes, east of the upper Tigris River 1

Mediterranean Sea: 2, 3, 5 and Inset, 6

Megara: on the Isthmus of Corinth 4

Megara Hyblaea: a colony of Megara, a few miles north of Syracuse 6

Megarid (Megaris): the territory of Megara 4

Melos (Islands): in the western Cyclades 2

Memphis: at the apex of the Egyptian Delta 5 and Inset

Mende (Thrace): on the south coast of Pallene 2

Mendesian (arm): one of the seven outlets of the Nile 5

Messenia: a territory of south-western Peloponnese 2

Methone (Messenia): on the south-west coast of Peloponnese 2

Methone (Thrace): near the west coast of the Thermaic Gulf 2

Methymna: on the north coast of Lesbos 3

Miletus (Ionia): at the mouth (south) of the bay south-east of Samos 3

Munychia: one of three harbours in Peiraeus 7

Mycale: the Asiatic headland extending past the south-eastern point of Samos 3

Mytilene: on the south-east coast of Lesbos 3

Myus (Ionia): on the Asiatic coast south-east of Samos 3

Naupactus: on the north coast at the mouth of the Corinthian Gulf 2

Navarino: modern name of the bay off the west coast of Messenia formed by the island Sphacteria 2

Naxos (Islands): in the central Cyclades 3

Neapolis (Ionia): on the peninsula north of Kos 3

Neapolis (Thrace): (1) on the north Aegaean coast, north-west of Thasos, modern Kavalla 2; (2) on the east side of Pallene 2; the name was common throughout Hellas

Nemea: about twelve miles south-west of Corinth 2

Nile River: 5

Nisaea: Megara's harbour on the Saronic Gulf 4

Notium (Ionia): on the coast of Asia Minor, due north of Samos 3

Odessa (Euxine): on the north-west coast of the Euxine Sea 8

Odrysae: a Thracian tribe 3

Oeniadae: on the coast of Acarnania in western Greece 2

Oenophyta: in Boeotia on the Attic border 4

Olympia: in Elis 2

Mt Olympus: in northern Thessaly (at the border of Macedonia) 2

Olynthus (Thrace): in Bottiaea, inland from the gulf between Pallene and Sithonia 2

Orchomenus: in northern Boeotia 2

Oropus: on the Attic coast near the Boeotian border opposite Euboea 4

Pallene: the south-western of the three Thracian peninsulas that jut into the Aegaean 2

Pamphylia: a territory in southern Asia Minor bordering Lycia 5

Panactum: on the border dividing Attica and Boeotia 4

Mt Pangaeus: in Thrace just east of the Strymon River 2

Paros (Islands): in the central Cyclades 3

Patrae: on the north-western coast of the Peloponnese (Achaea) 2

Pegae: Megara's harbour on the Corinthian Gulf 4

Peiraeus: 4, 7

Pellene: in Achaea, about three miles from the coast west of Sicyon 2

Peloponnese (Peloponnesus): 2

Persia: 1

Persian Gulf: 1

Phalerum: on the coast of Attica east of Peiraeus 4, 7

Pharsalus: in central Thessaly 2

Pharus (Pharos): an area at the western mouth of the Nile 5

Phaselis (Caria): on the south coast of Asia Minor (Pamphylia) 5

Phocaea (Ionia): coastal, between Lesbos and Chios 3

Phocis: the territory between Boeotia and (Ozolian) Locris, including a section of the coast of the Corinthian Gulf and extending to the Strait of Euboea 2

Phoenicia: an extensive section of the coastal strip of the eastern Mediterranean 5

Phrearrhioi: a deme in south-eastern Attica 4

Pindus Mts: the range along the western border of Thessaly 2

Plataea: within Boeotia near the Attic border 4

Potidaea (Thrace): at the neck of Pallene 2

Priene (Ionia): on the south coast of the headland (Mycale) opposite Samos 3

Propontis (Sea of Marmara): the inland sea between the Thracian Chersonese and the Bosporus 3

Prosopitis: in the Nile's Delta on the western arm 5

Psyttaleia: the island between Salamis and the Attic mainland 4

Pydna: on the coast of the Thermaic Gulf (Macedonia) 2

Pylos: a slim peninsula in south-western Messenia 2

Rhamnous: on the east coast of Attica 4

Rhegium: on the toe of Italy 6

Rhodes: 3, 5

Salamis (Attic): in the Saronic Gulf 2, 4

Salamis (Cyprian): on the east coast of Cyprus 5

Samos: 3

Sane (Thrace): on the west side of the neck of Acte 2

Sardes (Sardeis): capital of ancient Lydia about fifty miles from the coast 3

Saronic Gulf: the waters between Attica and the Peloponnese 4, 7

Scione (Thrace): on the south coast of Pallene 2

Scolus (Thucydides) or Stolus (quota-lists) (Thrace): in inland Chalcidice 2

Scythia: the name loosely applied to the entire area north of the Danube and the Euxine Sea 8

Segesta: a non-Hellenic town in western Sicily 6

Selinus: on the south coast of Sicily 6

Seriphos (Islands): in the western Cyclades 2

Serme (Thrace): see Therme

Sermyle (Thrace): on the west coast of Sithonia 2

Sestus (Hellespont): on the Hellespontine coast of the Thracian Chersonese 3

Sicily: 6

Sicyon: twelve miles west of Corinth 2

Sicyonia: the territory about Sicyon 2

Sidon: on the coast of Phoenicia 5

Sigeum (Hellespont): on the Asiatic side of the Aegaean entrance to the Hellespont 3

Singus (Thrace): on the eastern coast of Sithonia 2

Sinope: on the south coast of the Euxine 8

Siphae: in Boeotia on the Corinthian Gulf 4

Siphonos (Islands): in the western Cyclades 2

Sithonia: the middle of the three Thracian peninsulas that jut into the Aegaen 2

Skiathos (Thrace): one of the Sporades, north of Euboea 2

Skyros: Aegaean island east of Euboea 2

Smyrna (modern Izmir): on the coast of Ionia (destroyed by the Lydians) 3

Sparta (Lacedaemon): 2

Spartolus (Thrace): in Bottiaea, inland 2

Sphacteria: island off western Messenia, forming the Bay of Navarino 2

Stageira (Thrace): in Chalcidice, eastward and inland 2

Stolus: see Scolus

Strymon River: it flows into the Gulf (to which it gives its name) at the western end of the Thracian coast 2

Strymonic Gulf: see Strymon River 2

Sunium: the headland of south-eastern Attica 4

Susa: capital of Persia 1

Sybaris: within the instep of southern Italy (Magna Graecia) 6

Sybota Islands: between southern Corcyra and the mainland 2

Syme (Caria): an island due north of Rhodes 3

Syracuse: in Sicily 6

Tanagra: in eastern Boeotia 4

Teichioussa (Ionia): on the coast due south of Miletus 3

Tempe: valley in northern Thessaly below Mt Olympus 2

Tenedos (Hellespont): island off the coast of the Troad 3

Thasos (Thrace): island a few miles off the Thracian coast 2

Thebes: in Boeotia 2, 4

Thera (Islands): in the southern Cyclades 3

Thermaic Gulf: formed by the sea lying between Thracian Chalcidice and Greece proper (Macedonia) 2 ·

Therme (Thucydides) or Serme (quota-lists) (Thrace): on the north-eastern coast of the Gulf to which it gives its name 2

Thermopylae: the pass that lay on the borders of Epicnemidian Locris and the north, looking eastward to north-western Euboea 2

Thessaly: a district of northern Greece 2

Thourioi: see Thurii

Thrace: the area bounded (approximately) by the north coast of the Aegaean and the Danube River, Macedonia and the Euxine Sea 2, 3

Thria: in Attica about twelve miles west of Athens 4

Thuria: in Messenia, a few miles from the south coast 2

Thurii: within the instep of southern Italy (Magna Graecia) 6

Tigris River: 1

Torone (Thrace): near the promontory of Sithonia 2

Tragia: Ionian island due south of Samos 3

Troad: the name is applied to the block of (Asiatic) territory north of Lesbos extending to the Propontis 3

Troezen: near the coast of the southern Argolid 2

White Fortress (Leukon Teichos): a district of Egyptian Memphis 5

Zacynthus (modern Zante): island of the Ionian Sea west of the Peloponnese (Elis) 2

Zea: one of three harbours in Peiraeus 7

INDEX OF PEOPLE

Adcock, F.E.: on the Peace of Nicias 152

Aeantides son of Hippoclus of Lampsacus: marriage to Archedice daughter of Hippias 11

Aelius Aristeides (*floruit ca* A.D. 170): on the Peace of Callias 69

Aeschylus of Athens (playwright 525-456): competitor at the Dionysia (468) 42

Agariste: see Pericles

Agesilaus son of Archidamus of Sparta (king 399-360): friend of Xenophon 3

Agis son of Archidamus of Sparta (king 427-399): victor at Mantineia (418) 154; his occupation of Deceleia (413) 157; effect of his presence at Deceleia 157-58, 160; seduction of his wife 160; besieger of Athens (405/4) 165

Alcibiades son of Cleinias of Athens (*ca* 455-404): *Life* of by Plutarch 4; intermediary for the King (411) 68; son of Cleinias 79; appearance in public life 153; intrigues in the Peloponnese 153-54; responsible for alliance with Argos (416) 154; rivalry with Nicias 154-55; collaboration with Nicias to avoid ostracism (416) 155; influence on policy towards Melos (416) 155; controversy with Nicias about expedition to Sicily 155-56; appointed to command of expedition to Sicily 155; charged with mutilation of the Herms and parodying of the Mysteries 156; arrest and escape to Sparta 157; his advice to the Spartans 157; in the east (412) 160; intrigues with Athenians and Tissaphernes 161-62; recall by the Athenians 161; raiser of funds in Asia 161-62; influential in restoration of democracy (410) 161; return to Athens (407) 162; appointed *strategos* with special

powers 162; mover (?) of decree honouring Archelaus 164; held responsible for defeat at Notium (406) 164; flight to Thrace 164; warning to the Athenians at Aegospotami 165; influence on eastern allies 171

Alcidas of Sparta: failure to relieve Mytilene (428/7) 138; advised by Brasidas 149

Alcmaeon (Alkmaion): ancestor and founder of the Athenian Alcmaeonidae 12

Alexander (the Great) son of Philip of Macedon (king 356-323): his Empire 167

Amyrtaeus: king of the marshes in Egypt 65

Andrewes, A.: co-author of *A Historical Commentary on Thucydides*, IV-V 6

Antalcidas of Sparta: signer of peace with the King (387/6) 69, 179

Anticles of Athens: mover of second decree about Chalcis (446) 88-89

Antiochus of Athens: second-in-command to Alcibiades, responsible for defeat at Notium (406) 164

Apsephion of Athens: archon (469/8) 42

Archedice daughter of Hippias: marriage to Aeantides of Lampsacus 11

Archelaus of Macedon (king 413-399); honoured by the Athenians 162, 164

Archestratus of Athens: mover of rider about Chalcis (446) 89

Archidamus of Sparta (king 469-427/6): his speech (432) 128, 131, 170-71; his invasion of Attica (431) 130

Aristagoras tyrant of Miletus: failure at Sparta and success at Athens in seeking assistance (499) 13

Aristeides son of Lysimachus of Athens (*ca* 525-*ca* 470): *Life* of by Plutarch 4, 38; ostracized 20; Athenian commander (478) 32, 42; prominence on Delos

(478/7) 32, 33, 106; administrator of the oath to the allies 33; his assessment and its scale 33, 35, 36, 105, 151-52, 170; a founder of the Confederacy 42-43; as a statesman 43, 175

Aristeides of Athens: leader of tribute-collecting expedition (425/4) 148; interceptor of Persian envoy 148; *strategos* in the Hellespont (424) 148; repossessor of Antandros 148

Aristeus of Corinth: commander in defence of Potidaea (432) 127; capture and execution (430) 136,174

Aristophanes of Athens (playwright *ca* 455-*ca* 385): writer of comic drama 5; author of *Lysistrata* 79; author of *Birds* 107, 109; on jurors' fees 118; his criticism of Cleon in *Knights* (424) 141; his *Peace* (421) 152; on Empire in *Knights* 173

Aristotle of Stageira (384-322): author of *The Constitution of the Athenians* and *Politics* 4, 5; on the meeting on Delos (478/7) 36; on Athenian officers abroad 107; on governing and being governed 116; on Athenian officers at home 118; on eligibility of thetes for the archonship 118; on the "champion of the Demos" 122

Arrowsmith, William: editor and translator of Aristophanes 5

Artabazus of Persia: commander in Cyprus (450/49) 66

Artaphernes of Persia (satrap in Sardes *ca* 510-490): his demand for earth and water from the Athenians (508) 12; importuned by Hippias 13; commander at Marathon 16; his assessment 35

Artaphernes of Persia: envoy (425/4) 148

Artaxerxes I of Persia (King 465-424): accession 43; patron of Themistocles 43, 68; advocate of peace (450/49) 66; death recorded by Thucydides 68, 148; claims to Asia Minor 68

Artaxerxes II of Persia (King 404-358): victor over his brother Cyrus 3; signer of Peace of Antalcidas (387/6) 69

Augustus Caesar (62-A.D. 14): contemporary of Diodorus Siculus 3

Badian, E.: co-editor of *Translated Documents of Greece and Rome* 6

Barrett, David: translator of Aristophanes 5

Boges of Persia: commander at Eion 38

Brasidas son of Tellis of Sparta (died 422): commander at Amphipolis (424/3) 1, 102; his record 149; capture of Amphipolis and other towns (424/3) 149-50; activity after the Armistice (423) 150; death at Amphipolis 151, 152; successes in Thrace 171

Brownson, Carleton L.: translator of Xenophon's *Hellenica* 3

Brunt, P.A.: reviser of Jowett's translation of Thucydides 3

Byron (A.D. 1788-1824): his *Don Juan* quoted 17, 27; his reference to Miltiades the Younger 18

Caesar, Gaius Julius (100-44): contemporary of Diodorus Siculus 3

Callias son of Hipponicus of Athens: leader of embassy (449) 66; Peace of 67-68, 69, 71, 74, 79, 83, 90, 94, 96, 100, 102, 108, 118, 160, 168, 169; recipient of honours 67; mover of alliance with Rhegium and Leontini (448) 86; member of peace-making embassy (446) 90; his Peace reaffirmed (425/4) 148

Callias of Athens: mover of financial decrees (434) 75, 76, 104

Callicrates of Athens: designer of door for the temple of Nike (*ca* 448) 79

Callimachus of Athens: polemarch (490) 16

Charmus of Athens: father of Hipparchus 19

Cicero of Rome (106-43): on Herodotus 4

Cimon "Koalemos" of Athens: father of Stesagoras 10

Cimon son of Miltiades the Younger of Athens: *Life* of by Plutarch 4, 38; a Philaid 12; payment of Miltiades' fine by 18; supporter of Aristeides (478) 32; commander of Confederate fleet (477) 36, 46; his division of booty 38; discoverer of the bones of Theseus 39; campaign to the River Eurymedon (469) 40, 42; redesigner of triremes 42, 49; his wall 42; judge at the Dionysia (468) 42; his reputation and politics in the 470s 43; *strategos* at Thasos (465) 45; in the Hellespontine region (465/4) 45; his record and policy in the 470s and 460s 46-47, 50; his oligarchic leanings 47; advocate of aid to Sparta 47; dismissed by Spartans 48; his ostracism 48, 50, 67; sympathetic to the Confederates 49, 70, 71, 167; a

moderate oligarch 53, 96; election after return from ostracism 64, 65; off Cyprus (450) 65-66; his death 66, 84; brother-in-law of Callias (son of Hipponicus) 66; his ostracism omitted by Thucydides 67; rival of Pericles 94, 96

Cleanenetus of Athens: father of Cleon 136

Cleandridas of Sparta: adviser to king Pleistoanax (446) 87; condemned 87

Clearchus of Athens: mover of decree about coinage (449) 76-77, 108, 168, 169

Cleinias of Athens: father of Alcibiades 79, 153; mover of a decree 79, 81, 82, 86, 108; death at Coroneia (446) 86

Cleisthenes son of Megacles of Athens (ca 575-ca 500): founder of democracy 12; his worsting of Isagoras 12, 119; expulsion and recall 12; his constitution 13, 15, 47, 48, 94, 112; effect of his constitution on morale 17; inventor of ostracism 18, 121-22; his constitution adjusted 19, 112; adoption of the lot 119; responsible for *strategia* 120

Cleombrotus of Sparta: father of Pausanias (the Regent) 28

Cleomenes of Sparta (king ca 519-490): interference in Athens 12; his plans for invasion of Attica 12-13; unmoved by Aristagoras of Miletus (499) 13

Cleon son of Cleaenetus of Athens (died 422): disliked by Thucydides 136; opposed to Nicias and Periclean policy 136; his speech advocating death and enslavement for the Mytilenaeans (427) 139; his motion to execute Mytilenaean ringleaders 139; opposition to Spartan offers of peace (425) 141; his debate with Nicias (425) 141; his success at Pylos (425) 141; mocked in Aristophanes' *Knights* (424) 141; his connexion with the assessment (425) 141, 145, 147; his motion to execute the Scionaeans (423) 150; his death at Amphipolis (422) 151, 152, 153; his motion to execute Scionaeans activated (421) 152; his views of Athenian popularity 173

Cleonymus of Athens: mover of decree to require appointment of *eklogeis* (426) 142

Clough, Arthur Hugh: reviser of "The Dryden Plutarch" 4

Constantine (Roman Emperor A.D. 306-337): his removal of the Serpent Column to Constantinople 29

Craterus of Macedon (321-ca 255): author (probably) of a collection of Athenian decrees 60

Crawley, Richard: translator (A.D. 1874) of Thucydides 2-3

Croesus of Lydia (king 560-546): his kingdom 9-10; his capture by Cyrus 10; his relationship with Sparta 10

Cypselus of Athens (died ca 590): father of Miltiades the Elder 10

Cyrus of Persia (the Great, King 549-529); his conquest of Lydia 10; his relationship with Sparta 10; beginner of war with Hellenes 34

Cyrus son of Darius II of Persia (ca 426-401); his campaign against Artaxerxes II (401) 3; satrap at Sardes (407) 164; his request for Lysander's reappointment 164-65

Darius I of Persia (King 522-486): his Scythian expedition 11; wooed by Hippias 12-13; angered by the Athenians 13-14; his death 20; the tribute of his day 67

Darius II son of Artaxerxes I of Persia (King 424-405): father of Cyrus 3; claim to Asia Minor 68-69; his accession 68, 148

Datis of Persia: commander at Marathon (490) 16

Demodocus of Athens: *strategos* in the Hellespont (424) 148; his repossession of Antandros 148

Demos: character in Aristophanes' *Knights* 141, 173

Demosthenes of Athens (died 413): with the fleet at Pylos (425) 141; his credit for victory at Pylos appropriated by Cleon 141; a character in Aristophanes' *Knights* 141; *strategos* at Nisaea (424) 149; operations based on Naupactus (424) 149; his record 149, 159; ordered to Sicily (414/3) 157; operations *en route* and arrival at Syracuse (413) 158; failure of his offensive at Syracuse 158; his retreat and defeat 159; his execution 159; his career 159

Demosthenes of Athens (orator, 384-322): aware of Peace of Callias 69; on Athenian activities (ca 450) 75

de Sélincourt, Aubrey: translator of Herodotus 4
Dieitrephes of Athens: father of Nicostratus 150
Diodorus of Sicily (age of Julius Caesar and Augustus): author of *Bibliotheke* 3; less discriminating than Plutarch 4; on the Pentecontaëtia 38; on the Peace of Callias 66
Diodotus son of Eucrates of Athens: his speech in opposition to Cleon (427) 139, 171
Diognetus of Athens: mover of decree about the Chalcidians (446) 88
Diopeithes of Athens: mover of a decree 117
Dorcis of Sparta: commander rejected by the allies (478) 31
Dover, K.J.: co-author of *A Historical Commentary on Thucydides*, IV-V 6
Dracontides of Athens: chairman of the Ecclesia (446) 88

Ephialtes of Trachis: traitor at Thermopylae (480) 26
Ephialtes of Athens: popular leader in the 460s 47; his attacks on Cimon and the Areopagus 48; associate of Pericles 94; his adjustments to Cleisthenes' constitution 112, 118
Ephorus of Cyme (*ca* 405-330): his *History* used by Diodorus 3, 66
Eucrates of Athens: father of Diodotus 139
Euelpides: character in Aristophanes' *Birds* 107
Euphemus of Athens: his reply to Hermocrates at Camarina (415/4) 173
Eurybiades of Sparta: naval commander-in-chief (480) 27
Eurymedon of Athens: *strategos* (425) 141; ordered to Sicily (414/3) 157; joined by Demosthenes off southern Italy (413) 158

Ferguson, W.S.: on the "age of idealization" 177
Fornara, Charles W.: author of *Translated Documents* . . . , I, *Archaic Times to the End of the Peloponnesian War* 6

Glaucus of Athens: father of Leagrus 45
Godley, A.D.: translator of Herodotus 4
Godolphin, F.R.B.: editor of Rawlinson's translation of Herodotus 4
Gomme, A.W.: author of *A Historical Commentary on Thucydides*, I-III 6;

co-author, *post mortem*, of vols IV-V 6; on Plutarch 6; on the population of Athens 113; on citizenship 113
Gryllus of Athens: father of Xenophon 3
Gylippus of Sparta: sent to defend Syracuse (414) 157; his energy 157, 158; his opposition to the execution of Nicias and Demosthenes 159

Hammond, N.G.L.: co-editor of *The Oxford Classical Dictionary* 6; editor of *Atlas of the Greek and Roman World* 6
Hegesistratus son of Peisistratus of Athens: leader of colony to Sigeum 10-11
Hellanicus of Lesbos (*floruit* 440): writer of a history of Attica (*Atthis*) 37-38
Hermocrates of Syracuse: his plea for unity among Sicilian Hellenes (424) 140; in the eastern Aegaean (412) 160; his polemic against Athens (415/4) 173
Herodotus son of Lyxes of Halicarnassus (*ca* 485-*ca* 420): his travels and work (*History*) 4; on Croesus and Sparta 10; on Aristagoras 13; his subject 15; on Marathon 16-17; on the Aeginetan war 20; his quotation of an oracle 21; his allusion to Themistocles' decree 21; disagreements of his text and Themistocles' decree 26-27; on Salamis 27; on Artaphernes' assessment 35; unfriendly to Themistocles 44; traveller to Thurii 96; on the *strategoi* at Marathon 120
Hierocles of Athens: to perform sacrifices (446) 89
Hipparchus son of Charmus of Athens: first victim of ostracism 19
Hippias son of Peisistratus of Athens (tyrant 528/7-511/0): his patronage of Miltiades the Younger in the Thracian Chersonese 11; his tyranny 11, 12; marriage of his daughter Archedice to Aeantides 11; his intrigues with the Peloponnesians and the Persians 12-13; his service as a Persian guide (490) 16-17; his retention of the archonship 119; his expulsion from Athens (511/0) 121
Hippoclus tyrant of Lampsacus: marriage of his son Aeantides to Archedice 11
Hippocrates of Athens: *strategos* at Delium (424/3) 149
Hippodamus of Miletus: town-planner responsible for design of Thurii 96

Hipponicus of Athens: father of Callias 66, 90

Hyperbolus of Athens: ostracized (416) 155

Inaros son of Psammetichus: Libyan king in revolt 50, 65, 71

Isagoras of Athens: his rivalry with Cleisthenes 12, 119; his expulsion from Athens 12; his worsting by Cleisthenes 119

Isocrates of Athens (436-338): on the Peace of Callias 67; aware of the Peace of Callias 69

Itamenes of Persia: his interference in Colophon (427) 68

Jameson, Michael: finder of the copy of the Decree of Themistocles 21

Jowett, Benjamin: translator of Thucydides 2

Kenyon, F.G.: Librarian at the British Museum and identifier of The Constitution of the Athenians 4-5

"Koalemos": see Cimon "Koalemos"

Laches of Athens: negotiator with the Lacedaemonians 153

Lamachus son of Xenophanes of Athens: strategos at Sinope (ca 437) 102; strategos in the Hellespontine region and the Euxine (424) 148; his appointment to command in Sicily 155; his death in Sicily (414) 157

Lattimore, Richmond: translator of Aristophanes 5

Leagrus son of Glaucus of Athens: strategos in Thrace (465) 45

Leocrates son of Stroebus of Athens: strategos at Aegina (460) 51

Leonidas of Sparta (king 490-480): his defence and death at Thermopylae 26

Leotychides of Sparta (king ca 491-469): naval commander (479) 28; his return to Sparta 29

Lewis, David: editor of Inscriptiones Graecae, I (3d ed.), 1 6

Lewis, Naphtali: author of Greek Historical Documents: The Fifth Century B.C. 5-6

Lycurgus of Athens (ca 390-ca 325/4): aware of the Peace of Callias 69

Lysander of Sparta (died 395): Life of by Plutarch 4; naval commander (407) 164; his friendship with Cyrus 164; his recall and reappointment 164; his victory at Aegospotami (405) 165; his voyage to Athens 165

Lysias of Athens (ca 459-ca 380): aware of the Peace of Callias 69

Lysimachus of Athens: father of Aristeides 20, 32

Mardonius of Persia (died 479): his expedition (492) 16; his influence on Xerxes 20; in Thessaly (480/79) 27; his occupation of Athens 28; his death at Plataea 28

Mascames: Persian commander at Doriscus 40

McGregor, Malcolm Francis: co-author of The Athenian Tribute Lists 6

Megabazus of Persia: King's emissary to Lacedaemon (457) 58

Megabyzus of Persia: successful commander in Egypt (456-454) 58; commander in Cyprus (450/49) 66

Meiggs, Russell: author of The Athenian Empire 6-7

Melesias of Athens: father of Thucydides (Pericles' rival) 96

Meritt, Benjamin Dean: co-author of The Athenian Tribute Lists 6

Miltiades the Elder son of Cypselus of Athens (born ca 590): leader of colony to the Thracian Chersonese 10

Miltiades the Younger son of Cimon "Koalemos" (ca 556-489): 10-11; tyrant in the Thracian Chersonese 11; his addition of Lemnos and Imbros 11; a Philaid 12; his flight to Athens (494) 14; his acquittal and election as strategos 16; strategos at Marathon (490) 16; his failure and death 18; attacked by the Alcmaeonidae 18; father of Cimon 18, 43

Myronides of Athens: victorious strategos (460) 52; his victory at Oenophyta 55

Myrrhine of Athens: priestess of Athena Nike 79

Neocles of Athens: father of Themistocles 15

Niceratus of Athens: father of Nicias 136

Nicias son of Niceratus of Athens (ca 475-413): Life of by Plutarch 4; his Peace (421) 135, 151, 152, 153, 157, 170; his capture of Nisaea (424) 135; advocate of Periclean policy against Cleon 136; his debate with Cleon (425) 141; a character in Aristophanes' Knights 141; his capture of Cythera (424) 148; his capture of Mende 150; his "Periclean" Peace 152; his rivalry with Alcibiades 153-55; his collabora-

tion with Alcibiades to avoid ostracism
(416) 155; his failure at Melos
(426) 155; his controversy with
Alcibiades about the expedition to
Sicily 155-56; appointed to the
Sicilian command 155; his letter
asking for reinforcements (414) 157;
joined by Demosthenes (413) 158; his
reluctance to retreat 158; his retreat
and defeat 158-59; his execu-
tion 159; the judgement of Thucydides
159
Nicomedes of Sparta: commander (458) 53
Nicostratus son of Dieitrephes of Athens:
 strategos in Thrace (423) 150

Oeniades of Palaiskiathos: honoured by the
 Athenians 108
Oldfather, C.H.: translator of Diodorus 3
Old Oligarch (of Athens): author of political
 tract (ca 424) 172
Olorus (king in Thrace): ancestor of
 Thucydides (the historian) 44
Olorus of Athens: father of Thucydides 1
Orestes of Thessaly: Athenian failure to
 restore him (454) 58

Paches of Athens: strategos at Mytilene
 (428/7) 138; his recovery of Notium
 (427) 138; his sparing of the
 Mytilenaeans 139
Paphlagon: character in Aristophanes'
 Knights 141
Parker, Douglass: translator of Aristophanes
 5
Pausanias son of Cleombrotus of Sparta: as
 Regent commander at Plataea (479) 28;
 commander (478) 31, 42, 50; his
 rejection by the allies 31, 37;
 acquitted of medism 31; allies in his
 fleet (478) 36; seizure of and eviction
 from Byzantium (477) 38; disgrace
 and death 43, 167
Pausanias of Sparta (king 408-394):
 collaborator in the siege of Athens
 (404/3) 165
Peisistratus of Athens (tyrant 561, 558-556,
 546-528): dispatch of colonists to
 Sigeum and the Thracian Cherso-
 nese 10, 11; his tyranny 10, 12;
 his property in Thrace 44, 101; his
 retention of the archonship 119
Perdiccas of Macedon (king ca 450-413):
 pre-War ally of Athens 102; hostile
 (433/2) 127; his unreliability 127,
 136; won over by Sitalces 136;

warned not to mistreat the Methonaeans
137; his collaboration with Brasidas
149-50; his quarrel with Brasidas 150;
his alliance with the Athenians 150;
his failure to aid Cleon (422) 151; his
influence in Chalcidice 171
Pericles son of Xanthippus of Athens (ca
 495-429): Life of by Plutarch 4, 38;
 Alcmaeonid through his mother
 (Agariste) 4, 12; son of Xanthippus
 28; popular leader in the 460s 47, 94;
 his policy to avoid pitched battle 55;
 successful expedition to Achaea and
 Acarnania (454) 58; in agreement
 with Cimon's foreign policy (450) 65;
 prominent (in 449) 69; mover of the
 Congress-Decree 72-73; his motives in
 moving the decree 73-74; mover of
 the Papyrus-Decree 75; his proposals
 after the Peace of Callias 84;
 strategos at Delphi (447) 86; strategos
 in Euboea (446) 87; briber (?) of
 Pleistoanax 87; his comment on
 Aegina 90; his prominence (449-446)
 90-91, 94; responsible (in Plutarch) for
 colonies 93-94; advocate of the
 southern Long Wall (445) 94; hostile
 to the Areopagus 94; his imperial
 policy 94; his rivalry with Thucydides
 son of Melesias 94, 96-98; on the
 building programme 96-98; his triumph
 over Thucydides son of Melesias 97-98;
 athlothetes (442) 98; strategos to
 Samos (440/39) 99-101; strategos in
 the Euxine (ca 437) 102; his motion to
 send colonists to Sinope 102; friend
 of Sophocles 115; his prominence in
 the 430s 105; his "Funeral Speech"
 (431) 105, 110, 169, 177; his view of
 Athens as a model 111, 112; his
 adjustments to Cleisthenes' constitu-
 tion 112; his law on citizen-
 ship 112; on kinship 112-13; his
 advice to evacuate the countryside
 (431) 115; on Athenians as judges of
 policy 119; his introduction of
 pay 120; on quality as a basis for
 preferment 120; mover of many
 decrees 120; his record in public
 office 121, 122; his power 122-23;
 the target of Spartan attacks (432/1)
 129; his speech (in 432) 129-30; the
 impact of his speech 130; attacks on
 his friends 134; his strategy 134-35;
 his foresight and the plague 135; his
 successes on the Peloponnesian coast

(430) 135; his speech in response to criticism (430) 135, 173; his fine and deposition 135; re-election and death 135-36; his successors 136; interference in Sicily in 427 a contradiction of his policy 140; his view of the length of the War 141; contradiction of his policy 149; his policy reflected in the Peace of Nicias 152; Alcibiades reared in his household 153; on Athens as "the education of Hellas" 166; on the hatred engendered by Empire 171; his statesmanship and idealism 175-76; his "idealization" of the citizens 177

Perrin, Bernadotte: translator of Plutarch's *Lives* 4

Phantocles of Athens: mover of rider to decree about Brea 93-94

Pharnabazus of Persia: satrap at Dascyleum (430) 136; his collaboration with the Spartans (412) 160

Pheidias of Athens (born *ca* 490): sculptor of the chryselephantine Athena 105; his "idealization" of the human frame 177

"Pheidippides" of Athens: name falsely applied to Philippides 17-18

Philaeus (Philaios): ancestor and founder of the Athenian Philaidae 12

Philippides of Athens: runner to Sparta (490) 17-18

Phormio of Athens: *strategos* in Chalcidice (432) 127-28; victorious at sea on the west coast (430/29) 140; his reputation 149

Phrynichus of Athens: playwright fined after production of *The Burning of Miletus* 14; author of the *Phoenissae* (476) 42

Phrynichus of Athens: on the allies' preference for *eleutheria* (411/0) 174-75

Pissuthnes of Persia: satrap in Sardes (440) 68; his collaboration with Samian rebels 99, 100; his collaboration with Colophonian rebels (430) 137

Pisthetairos: character in Aristophanes' *Birds* 107

Plato of Athens (429-348): familiar with the Presocratics 8; aware of the Peace of Callias 69; critical of democracy 119; on Athenian friends in the Empire 172

Pleistarchus of Sparta (king 480-460): a minor (479) 28

Pleistoanax of Sparta (king 460-446,

426-408): a minor (458) 53; his invasion of Attica (446) 87, 91; bribed (?) and fined (446) 87; his influence for peace (422/1) 151

Plutarch of Chaeroneia (born before A.D. 50): his *Lives* and other works 3, 4, 38; essay on by A.W. Gomme 6; on Aristeides' assessment 35; his value for the Pentecontaëtia 38; on Cimon's division of booty 38; on the early Confederacy 49; on the transfer of Confederate funds 59; on the "Congress-Decree" 72; on the bribing of Pleistoanax 87; on Athenian colonies 93-94; on the rivalry of Pericles and Thucydides son of Melesias 96-97; on the "naval mob" 116; his misunderstanding of Pericles' position 130

Polycrates of Samos (tyrant *ca* 540-522): opposed by the Spartans 10

Protagoras of Abdera: traveller to Thurii 96

Psammetichus: father of Inaros 50

Rackham, H.: translator of *The Constitution of the Athenians* 5

Rawlinson, George: translator of Herodotus 4

Rhodes, P.J.: translator of *The Constitution of the Athenians* 5

Robinson, E.S.G.: on Athenian silver coinage in the Empire 77

Rogers, Benjamin Bickley: translator of Aristophanes 5

Scopas of Athens: secretary of Boule 117

Scott-Kilvert, Ian: translator of Plutarch's *Lives* 4

Scullard, H.H.: co-editor of *The Oxford Classical Dictionary* 6

Sherk, Robert K.: co-editor of *Translated Documents of Greece and Rome* 6

Sicinnus of Athens: slave of Themistocles 27

Sitalces of Thrace: king of the Odrysae and friend of the Athenians 136; influential in winning Perdiccas' support 136

Smith, C. Forster: translator of Thucydides 2

Socrates son of Sophroniscus of Athens (469-399): friend of Xenophon 3; his trial 118; friend of Alcibiades 153

Solon of Athens (eponymous archon 594/3): his economic classes 93; popular elements in his constitution 112; his reforms 117, 119

Sommerstein, Alan H.: translator of
 Aristophanes 5
Sophanes of Athens: *strategos* (465) 45
Sophocles of Athens (*ca* 496-406): competi-
 tor at the Dionysia (468) 42;
 Hellenotamias (443/2) 98; friend of
 Pericles 115; his "idealization" of
 humanity 177
Sophocles of Athens: *strategos* (425) 141
Stephanus of Byzantium (6th century after
 Christ); his quotation from the assess-
 ment copied by Craterus (454) 60
Stesagoras son of Cimon "Koalemos" of
 Athens: successor to Miltiades the Elder
 in the Thracian Chersonese 10
Sthenelaidas of Sparta: ephor (432) 128;
 his insistence that the peace had been
 broken 128
Stroebus of Athens: father of Leocrates 51

Tellis father of Brasidas of Sparta: 102,
 149
Themistocles son of Neocles of Athens (*ca*
 528-461): *Life* of by Plutarch 4, 38;
 his family ind his archonship 15-16;
 strategos (490) 16; his abandonment
 of Miltiades 18; his exploitation of
 ostracism 18-19; his eminence after
 Marathon 19-20; his responsibility for
 construction of the fleet 20; his
 warning of attack by the Persians 20-21;
 his interpretation of an oracle 21;
 strategos at Tempe (480) 21; his
 decree 21, 24, 26-27; his strategy
 27-28; his triumph 28; his deception of
 the Spartans and the building of the
 walls 30; the completion of the
 fortifications of Peiraeus 30; Spartan
 opinion of him 32; his exaction of
 money from the Carystians 39; his
 escape at Naxos (470) 40; post-
 invasion popularity 42; producer at
 the Dionysia (476) 42; his ostracism
 (473) 43; his disgrace and exile 43;
 his flight to Asia 43; a Persian
 pensioner 43, 68; his death 43;
 hostility of Herodotus 44; Thucydides'
 verdict 44; influence of "his"
 navy 47; the consummation of his
 naval policy 52; his adjustments to
 Cleisthenes' constitution 112
Theseus: his bones on Skyros 39
Thrasybulus of Athens: *strategos* at Phocaea
 (406) 164
Thucydides son of Melesias of Athens:
 conservative leader 96; his rivalry

 with Pericles 96-98; his ostracism
 97-98
Thucydides son of Olorus of Athens (*ca*
 460-*ca* 400): author of *The Peloponnesian
 War* 1; on his subject and
 method 1-3; continued by Xeno-
 phon 3; supported by epigraphic
 evidence 5; on Themistocles 15,
 31; on the Spartan withdrawal
 (478) 31-32; on the aims of the
 Confederacy 32; his use of "autono-
 mous" 34; his use of *"phoros"* 36;on
 the meeting on Delos 36, 59; on
 allied ships (460) 36; his Pentecontaëtia
 to explain the fundamental cause of
 the War 37-38; on the capture of
 Carystus and the revolt of Naxos 39-40;
 his method in the Pentecontaëtia 40;
 on Themistocles 43-44; his property
 in Thrace 44, 101; on the Thasian
 appeal to the Spartans 45, 131; on
 Athenian intervention in the Megarid
 48; on the early Confederacy 49; on
 allies in Egypt 51; his "Boeotians"
 55; his omission of the alliance with
 Segesta 56; on the appeal by Segesta
 (416/5) 56; on Persian money
 (457) 58; on the synods 59; on the
 Confederates' failure to report 64; his
 omission of the Peace of Callias and
 other events 67-68; his knowledge of
 the Peace 68-69; on the death of
 Artaxerxes (424) 68; on allied reluc-
 tance to serve 70; on campaigns to
 Delphi (449 and 447) 84, 86; on the
 revolt of Byzantium (440) 100; on
 Persian involvement (440) 100-101;
 Pericles' "Funeral Speech" quoted 111;
 on Spartan government 112; his use of
 "Demos" 113; his use of "the
 Athenians" 114; his responsibility for
 the misunderstanding of Pericles'
 position 123; on Corinthian hatred
 124; on the grievances that led to
 War 124, 128; on the speeches in the
 Corcyraean debate 125-26; on the
 Corinthian and Athenian addresses to
 the Spartan assembly (432) 128; on
 Pericles' speech (432) 129-30; on the
 truest cause 130; on Hellenic sympa-
 thy with the Spartans 133-34; on
 the combatants (431) 134; his
 History 134; on Pericles' fore-
 sight 135; his dislike of Cleon and
 admiration of Nicias 136; impressed
 by Sitalces 136; on the Mytilenaean